WILD

WILD

THE LIFE OF PETER BEARD
PHOTOGRAPHER, ADVENTURER, LOVER

GRAHAM BOYNTON

ST. MARTIN'S
PRESS
NEW YORK

First published in the United States by St. Martin's Press,
an imprint of St. Martin's Publishing Group

www.stmartins.com

Designed by Steven Seighman

Library of Congress Cataloging-in-Publication Data

Names: Boynton, Graham, author.
Title: Wild : the life of Peter Beard : photographer, adventurer, lover / Graham
 Boynton.
Description: First edition. | New York : St. Martin's Press, 2022. | Includes
 bibliographical references and index.
Identifiers: LCCN 2022014109 | ISBN 9781250274991 (hardcover) |
 ISBN 9781250275004 (ebook)
Subjects: LCSH: Beard, Peter H. (Peter Hill), 1938-2020. | Photographers—
 United States—Biography. | Adventure and adventurers—United States—
 Biography.
Classification: LCC TR140.B39 B69 2022 | DDC 770—dc23/eng/20220331
LC record available at https://lccn.loc.gov/2022014109

Our books may be purchased in bulk for promotional, educational, or business use.
Please contact your local bookseller or the Macmillan Corporate and
Premium Sales Department at 1-800-221-7945, extension 5442,
or by email at MacmillanSpecialMarkets@macmillan.com.

First Edition: 2022

10 9 8 7 6 5 4 3 2 1

For Adriaane

And to the memory of my dear friend Karen Lerner,
who introduced me to Peter Beard and who just slipped away

Contents

Preface

The Going Up Was Worth the Coming Down

Whenever I hear Kris Kristofferson's song "The Pilgrim," I think of Peter Beard. In fact, Kristofferson could have been singing about Beard in what is essentially a romanticizing of a wild character who is both doomed rebel and carefree iconoclast. The song ends with the bittersweet couplet: "From the rocking of the cradle to the rolling of the hearse, the going up was worth the coming down." That line could have been written for Peter Beard, for it reflected his attitude to life precisely.

I was introduced to Beard in the late 1980s by a wonderful mutual friend, Karen Lerner. She had been a close friend of Jackie Onassis, had hung around with the Andy Warhol crowd, and through all of them befriended Beard in the late 1960s. As a *Newsweek* journalist, in the middle of the following decade she had helped him publish a version of his Dead Elephant Interviews with Francis Bacon. "You simply have to meet Peter," she insisted. "You have Africa in common. You'll love him. We all do." She drove me out to Thunderbolt Ranch, Beard's Montauk retreat. And thus began a friendship that lasted more than thirty years, until Beard's death in 2020.

Karen was quite right about Africa. I had grown up in Rhodesia, now Zimbabwe, and Beard had planted his flag in Kenya in the early 1960s and never entirely relinquished his relationship with the continent. Beard and I hit it off right away because we shared bleak views on wildlife

conservation—the latter being a word that Beard loathed—and also shared a somewhat pessimistic prognosis for the future well-being of the continent, agreeing that the postcolonial period had been one of incompetent and corrupt governance. These negative thoughts were, in both cases, tinged with a great affection for Africa. Having started his time in Kenya as a brave, some would say reckless, hunter of wild animals, Beard began to see with searing clarity the damage the colonial hunting industry had visited on the continent's ecosystems through the twentieth century, and concentrated on photographing the disappearing flora and fauna, turning his bushveld obsession into fine art.

Many memorable nights were spent around the campfire at his Kenyan "salon in the bush," Hog Ranch, a gathering place for conservationists, politicians, writers, journalists, and fashion models that is described in detail elsewhere in this book. It was like having your ear to the ground on all matters, social and political, in East Africa. And while many of the older white Kenyans lost patience with him, either because they regarded him as a reckless dilettante or because they became the butt of his sniping remarks, the less hidebound, more resilient younger generations regarded him as an artistic mentor and a wild spirit they could emulate. As his long-term Danish girlfriend Rikke Mortensen once told me, for Peter Beard age didn't matter. He could connect just as well with a child as he could an adult.

Frustratingly, he was a procrastinator and obfuscator as much as he was an action man. Sometime in the 1990s, I wrote a book about the end of colonial rule in Africa. Naturally, I asked Beard if he could read it and, if he liked it, write a cover blurb. He agreed, and the publisher sent a manuscript to him in Paris, where he was overseeing his landmark retrospective at the Centre National de la Photographie. Days and weeks passed. The publisher's deadline loomed and still there was no response from Beard. He kept insisting he was reading the manuscript carefully and would provide the necessary endorsement in good time. Eventually, I called him in desperation, asking him to read something for me over the phone. He replied that he was returning to Montauk that weekend and that I should

drive out there from New York, and he would hand me the precious blurb in person. I duly took the three-and-a-half-hour drive to the end of Long Island, and when I arrived at Thunderbolt Ranch his wife, Nejma, directed me to the beach, saying he was sitting out there finishing my manuscript. (Nejma for most of her life spelled her name Najma. It is that way on her birth certificate, her US green card, her daughter's birth certificate, and all other documents. However, in recent years, she changed that to Nejma, and it is her preferred spelling that I have used in this book.)

Arriving at the beach, I saw a single umbrella in the far distance with Beard sitting under it and a cloud of marijuana smoke rising up. When I finally reached him, I saw he had the manuscript in hand, but it was no longer an ordinary manuscript. Rather, like his famous diaries, it had been fattened with leaves, bugs, and general detritus pasted to the pages, streaks of blood were drawn across some passages, and his intense copperplate handwriting ran down the margins and across the top and bottom of pages. He had turned it into a work of art. However, such was my haste to rush back to the city with the promised blurb in hand that I left the manuscript with him and, over the years, both he and Nejma promised they would retrieve it from whatever corner of their house he had left it and return it to me. It may still lie in some dusty corner of Thunderbolt Ranch. Needless to say, Beard's blurb offered a generous appraisal of my Africa book. I was forever grateful.

Beard did not, however, always display generosity to his fellow Africa hands and their writings. The celebrated author Peter Matthiessen was Montauk's other alpha male in the last decades of the twentieth century and, like Beard, he was a handsome, romantic figure who attracted women around him in droves. Both wore their tribal uniforms with immense pride—Beard in his Kenyan *kikoi* (traditional sarong) and Pitamber Khoda open sandals and Matthiessen in his black *civara* (the robe worn by Zen Buddhists)—and women appeared equally susceptible to both. Unsurprisingly, the two men disliked each other intensely. So, when Beard was approached to review *The Tree Where Man Was Born*, Matthiessen's collection of writings that came out of his travels in East and Central

Africa, he accepted immediately. He was living with his brother, Sam, and sister-in-law, Pat, at the time, and Pat Beard, a journalist and author, remembers Peter showing her his review: "It was so scathing, I told him he could not possibly submit it. He did anyway. I think it was for *The New York Times*. In the end, it wasn't published. Obviously, there was competition between them over who was the Africa expert." I later found Beard's review and Pat Beard was right. "For nine chapters," Beard wrote, "Peter Matthiessen swaggers around tourist lodges with celebrities, zoo directors, princelings and park authorities. . . ." It was a pretty standard fusillade of Beard insults.

On one particular visit to Thunderbolt Ranch in late summer 2014, Beard and I sat in the large, somewhat wild, garden at the back of his house and we talked about past times and issues still at stake. He told me about his stroke at the end of the previous year and said he could no longer hold more than two names in his head at any one time. I responded that I was at least a decade younger than he was and had not had a stroke and I also couldn't hold names in my head any longer. We agreed we were just getting older. What hadn't changed was his intense awareness of nature all around us, a character trait that had drawn him to Africa back in the 1950s and that remained with him then. He was transfixed—and kept interrupting our conversation—by the sight of a pair of flycatchers flitting in and out of their nest in a nearby tree. As he pointed out, the entrance to the nest was tiny and the two birds shot in and out of this small aperture with the speed and accuracy of guided missiles.

That day he also repeatedly goaded me into writing another book about Africa. I had loosely suggested I write one with him as the central character and he said he wasn't entirely averse to the idea. "You've gotta write a book called The Galloping Rot," he said, thereby repeating one of his most familiar phrases about the parlous state of the world. Later, at lunch in Montauk with Nejma, the tone of the conversation changed, and he began ranting about how the two of them were now heavily engaged in lawsuits "against groups of people who are stealing my art." I was slightly taken

aback, as the Peter Beard I had known for decades was forever giving away his art, not only for the price of a restaurant meal but also to any beautiful woman passing by who had taken his fancy. This litigious Beard I did not know. He reeled off a list of names, identifying the so-called thieves, some of whom were mutual friends, and accused them of all manner of devious behavior. I was to learn much more about this in years to come.

That he was devastatingly good looking goes without saying. I remember him visiting me at Condé Nast's Midtown Manhattan offices in the 1990s, and as we walked along the corridor toward my own office, we passed the open-plan section where the predominantly female editorial assistants sat. It was as if a rock 'n' roll god had entered the building. They all stopped what they were doing and stared as this beautiful creature sauntered by. Although he affected not to notice, I was certain he was acutely aware of the impact he was having on these young women, which is why throughout his life he was able to seduce so many so effortlessly. He had the easy charm of the supremely self-confident, some of it a product of his privileged WASP background but mostly to do with the animal magnetism that he retained until his final days. As so many of his former lovers have said, he made each one feel as though she was the only person in the room.

Nejma, Beard's widow, was married to him for thirty-five years, remaining by his side despite enduring countless indignities. His previous two wives—the scion of Newport high society Minnie Cushing and the world's first supermodel, Cheryl Tiegs—had managed to put up with him for only relatively short periods of time. Whenever I visited, I always came away thinking that Peter Beard's well-being was uppermost in Nejma's mind, even if it was not in his.

As I was leaving Thunderbolt Ranch for the last time at the end of 2017, just months before Beard's eightieth birthday, after a day wandering around in the soft autumn sunshine, I did feel he had been diminished by the strokes he'd suffered. He appeared in no condition to discuss the big issues of wildlife conservation, of human population growth, and the like

that had been his meat and drink in former years. But as I left with a heavy heart, I looked back to wave goodbye, and I caught a flash of that familiar wild gleam in his eyes. He was still Peter Beard.

That day, more than anything else, I thought that the life and times of Peter Beard would make one hell of a story.

1

Montauk 2020—When the Lions Stopped Roaring

Sometime in January 2020, Morten Keller, Danish author Karen Blixen's grand-nephew, called Peter Beard at his Montauk home. They chatted for a good half hour, and Morten was pleased to note that his old friend was in good spirits. There even seemed to be some remnants of the old devilish, mischievous Beard banter, albeit delivered without the machine-gun intensity of his younger days. After a lifetime of hard partying, several strokes over the past decade had slowed him down but not entirely interrupted the streams of consciousness, the apocalyptic riffs, the all-purpose exasperation at the world around him. Morten hung up feeling good about the man who had been close to his family since Beard had met up with Blixen shortly before her death in 1962.

Two months later, on Sunday, March 29, London gallery owner Michael Hoppen, who, for decades, had been one of Beard's great champions and had held four major exhibitions of his work, called the Beard home, but there was no reply. Somewhat concerned, he emailed Nejma, and the next day he received a reassuring reply from her saying that she had just returned home to Montauk from New York City and "PB is locked up and good, thanks for asking."

On Tuesday, March 31, the East Hampton Town Police Department announced that an eighty-two-year-old man from Montauk had disappeared. Identified as Peter Hill Beard, the missing man was said to be

suffering from dementia. He had left Nejma at around 4:30 P.M. and had wandered into the woods adjacent to his six-acre Thunderbolt Ranch property. By early evening, when he had not returned, Nejma called the police. Within the hour police cars, tracker dogs, and officers on foot were surrounding the property and starting to probe the thick woodlands. Soon helicopters were hovering above, training thermal imaging cameras on the area. After several hours, the cops stood down and said they would resume the search the following morning.

By dawn the next day, the road near Thunderbolt Ranch was jammed with police vehicles as officers, using cadaver dogs and drones with thermal imaging equipment, probed the woodland. A few miles east of the search area, surfers had congregated at the Bench, a popular gathering place for the local surf community at Ditch Plains beach, and were figuring out whether the waves were going to work for them that day. Among them was Dave Schleifer, a sixty-year-old retired firefighter and longtime Montauk resident turned surfer, fisherman, and bow hunter. Word spread quickly that Peter Beard had gone missing. Dave had heard the helicopters circling overhead the previous evening and although it was an unusual occurrence in the area, he hadn't thought too much about it. Now he knew what the commotion had been all about.

As it happened, that Wednesday the wind didn't blow for the Montauk surfers, so Dave drove back to his home, filled up his Volcano vaporizer (a cannabinoid delivery system), took a couple of hits, and lay on the couch thinking about Peter Beard. Dave and his friends knew Beard as a local, albeit a rather colorful one, despite all his international celebrity. They would meet up in Montauk bars, most notably Shagwong Tavern, the locally celebrated bar and hamburger joint that was festooned with Beard's artwork, and engage in vigorous arguments about the state of the world. Beard had maintained a presence there since buying his six-acre retreat for $130,000 in 1972. What Dave and the Montauk gang really liked about him was that although he was down-to-earth, just like them, he also brought an energy, a connection to the outside world, to this sleepy fishing village.[1]

These days, the remote village at the east end of the Long Island peninsula is busier, more cosmopolitan, and much more expensive than it was when Peter Beard first arrived. Although the population has grown to more than 3,500, albeit spread over a large area, the locals say that the main difference between now and the 1970s is that Montauk has a few more restaurants and there are boutique hotels dotted along the island. The beaches, like Ditch Plains, have always attracted surfers, drawn here by the strong Atlantic rollers, and the New York State parks—Camp Hero, which was once a military base, and Napeague, where dramatic sand dunes separate the ocean from the tidal harbor Lake Montauk—attract nature lovers eager to escape the concrete intensity that is New York City. Montauk is sometimes called "The End" because that is what it is—the easternmost part of Long Island, where there is only the Atlantic Ocean between there and Ireland. This is beyond the Hamptons, farther than the Hollywood and Wall Street retreats that are Bridgehampton, Sag Harbor, and Southampton. This is why the village suited Peter Beard very well. As one of his local friends said, he could befriend anyone—be it a stripper or the country's president, it didn't make any difference to him. He was a WASP, but he was also a lifelong contrarian and this place was perfect for him.

It is said that although Montauk may be regarded as a fishing village with a drinking problem, it may equally be viewed as a drinking village with a fishing problem. Either way, it has always been pretty laid-back. In the 1970s, Peter and his celebrity neighbors and friends—Andy Warhol, Paul Morrissey, the Rolling Stones, Lee Radziwill, Dick Cavett, and Richard Avedon—had given Montauk a sheen of glamorous decadence. Warhol claimed that it was the Stones, Mick Jagger in particular, who put Montauk on the map. He said when word got out in the summer of 1975 that Mick and Keith Richards were staying at Warhol's Church Estate, right next door to Beard's Thunderbolt Ranch, the area was invaded. "The motels were suddenly overflowing with groupies. When Mick went into town everything stopped. Surfers chased him from White's Drugstore to White's Liquor Store."[2]

The place that Jagger really put on the map was the Memory Motel, a rather plain property on Montauk Highway near Fort Pond, which was

immortalized in song on the band's 1976 *Black and Blue* album. As with so many rock song lyrics, the poetry was in the name itself rather than the actual place. Peter Beard took Jagger there only once, and there was apparently no warmth shared between the Stones and the old couple who owned the Memory Motel. Still, it created a lasting legacy for an area that had given the British rock band some rather good summers. But Jagger, like his friend Beard, really enjoyed nights at the Shagwong, although he quickly tired of people putting "Get Off of My Cloud" on the jukebox the minute he walked in. It was the only Stones song on that jukebox but Mick, after several piña coladas, got so fed up that he put the disco hit by Shirley & Company "Shame, Shame, Shame" on and sang along in falsetto. It was a much-remembered Shagwong moment.

* * *

So, after much cogitation on the couch that morning in late March, Dave Schleifer decided to take a drive down to the Sanctuary, the area of thick undergrowth of Camp Hero State Park that runs alongside the Beard ranch, to see if he could help in the search. As a bow hunter, he had been operating in these woods since the mid-1980s, so he not only identified with Beard's distant past as a hunter in Kenya but, like all good trackers, knew these woods intimately. He jumped into his Toyota Tacoma truck and drove down to the spot, just fifty yards from the entrance to Beard's property. The area was crawling with cops, with police cars blocking all entrances, officers walking around, drones buzzing overhead. It was like Times Square before COVID-19. Dave realized that he had no chance of exploring the woods and reluctantly retreated to his house, grabbed another bag on the Volcano vaporizer and again considered his friend Peter Beard.[3]

One longtime friend of Peter's, the New York–based magazine stylist Anne-Laure Lyon, happened to be celebrating her birthday at her Montauk home that morning. Anne is the goddaughter of artist Man Ray and for many years worked at *Esquire,* overseeing many of Beard's photo assign-

ments for the magazine. The two were old friends. Her first visitors that morning were officers from the East Hampton Town Police Department. Announcing Peter Beard's disappearance the previous evening, they asked Anne whether the missing man was there. Clearly, they considered it a possibility that he had run off to his old friend's place. He hadn't, and the cops went on their way. Anne was left wondering what had made them think he might be with her. Somebody had clearly tipped them off to the fact that they were friends, and that Beard would, from time to time, escape the sometimes-strained atmosphere at his family home for the bohemian comforts of Anne's country house.[4]

When another of Beard's close, long-term Montauk friends, Noel Arikian, heard the cops had visited Anne-Laure Lyon, he said he was surprised they hadn't visited him. He had worked with Peter since the early 1970s, framing his work and latterly helping produce some of his post-African artwork. Over that weekend, Arikian's friend, and Beard's former lover and artistic collaborator, Natalie White, was his house guest. So, Noel's house was a much more likely refuge than the Lyon home. When Noel and Natalie heard Beard had gone missing, they thought he may have run off to the city as he had done on so many previous occasions. And it was not long before Natalie was receiving text messages from friends and colleagues half-jokingly asking her if she was hiding him. Although they had been close for almost ten years, she had not actually seen Beard since 2013.[5]

Noel Arikian first met Beard at the Shagwong Tavern in 1972. Natalie met him more than thirty years later. Both, having been drawn into Beard's frantic, rackety, creative world, remained loyal friends to the end despite the fact that they'd been banned for many years from seeing him by his wife, Nejma. Natalie candidly admits that she has built an entire art career out of her relationship with Beard, who was both her lover and art tutor. "There was no one in my life, before or since, who treated me as well as he did," she said. It soon became clear that he had not just run off to the city. Arikian said, "My first thought was 'Jesus, he's escaped this COVID pandemic and he had spent his life predicting it.' He was right

about everything—stress and density. Isn't this what the pandemic is all about?"

By this time, the story was out. *The New York Times* offered up its news report topped by a typically tortuous headline: "Peter Beard, Photographer Who Makes His Art From Nature's, Is Missing," and throughout the day the international media picked up the story and it spread across the globe. Gradually, old friends in Copenhagen, Paris, Cassis in southern France, Nairobi, and London heard the news and took to social media. Many echoed the thought Peter may have slipped away and fled to Manhattan in search of a party and some pretty women to hang out with, something he had done quite frequently over the past ten years.

For the next two days there were, according to the police, "multi-agency searches" involving state police, state park police, forest rangers, local fire personnel, drones equipped with thermal detection cameras, and dogs. There was no sign of Beard. When he heard that Beard had disappeared, Guillaume Bonn, the Franco-Kenyan documentary photographer and a friend and disciple of Beard's, immediately recalled something Beard had said to him many years ago. "He said that if you wanted people to keep talking about you then you had to go down to the beach, leave your shoes on the sand, and vanish. So, I thought he'd probably said, 'Fuck this, I'm going for my last swim.'" After three days, East Hampton police announced they were calling off the search, and by the weekend the talk among the surfers on the Bench was about whether he had, indeed, walked into the sea and ended it all on his own terms. Given that the various search parties in the woods next to Thunderbolt Ranch didn't find him, Dave Schleifer and his friends were becoming convinced that Beard had thrown himself at the mercy of the ocean.

Now, almost three weeks after his disappearance, there was still no sign of him. The surfers reasoned if he had died in the ocean, after weeks of consistent southwesters his body would most likely have already washed up on the Montauk shore. Dave Schleifer began to think that maybe his friend hadn't walked into the sea, so he decided to return to the woods of Camp Hero State Park near Thunderbolt Ranch. On Sunday, April 19, he

had a hunch he would find Beard's body and told his friend Billy to stay by the phone. Two hours later, Dave called Billy from the thick undergrowth. He had found a New Balance sneaker on a little rise just five hundred meters from Beard's estate. This was precisely where he had intended to start his search three weeks earlier. He was sure it was Beard's.[6]

Dave called the police. Two detectives arrived within fifteen minutes and Dave led them to the abandoned sneaker. The area was roped off, photographs were taken, and the three men returned to the forest edge, marking a trail as they walked. The two detectives then decided to return to the East Hampton police station to recruit helicopters, cadaver dogs, and police. As they were leaving, Dave asked the detectives if they'd mind if he went back and looked for Peter Beard. The detectives agreed and he set off into the now-familiar undergrowth. He attempted to put himself in the mindset of his friend "like a wounded deer, following a path of least resistance" and tracked a path through the bush. He traced the last fifty yards like the bow hunter he was, like the old African game hunter Peter Beard had been. Then he came to a stream.

"There's fucking Peter Beard," Dave heard himself shouting out, as he saw the body which lay half in, half out of the stream running through the thick tangle of bush. He called 911.

* * *

As the news got out, international newspaper obituarists went to work. Described variously as a bon vivant, African wildlife photographer and conservationist, a notorious ladies' man, an artist whose legacy as a twentieth-century innovator and creative force seems assured, the Beard of universal celebrity and indeed notoriety, this playboy of the Western world was not quite the Beard that Dave Schleifer and his Montauk friends knew. Sure, they were aware of his celebrity and his famous friends, many of whom he had brought out to his Long Island retreat, but the clamorous, colorful character who hung out at Shagwong was someone else. He was a local, and that was important to them.

In Nairobi, old family friend Anna Tzrebinski, whose property adjoins Beard's Hog Ranch, says that the day Beard disappeared she heard the lions roar at sunrise. "They continued to roar at the same time every day, just as the sun was rising. Then, on the day they found his body, the lions stopped roaring. I have grown up in Africa and I have never experienced anything like that," she said.[7]

Tributes from models, artists, stylists, gallerists, fashion designers, lovers—a lot of former lovers—all swirled through the various social media platforms, a clamor of grief and loss. Of course, Peter Beard had enemies, but the overwhelming emotion was love and affection. (There was also, it must be said, the usual small parade of lesser mortals, the hangers-on whose self-importance fed off Beard's generosity of spirit. He seldom spurned an admirer and there were some absolute shockers.) "We are all heartbroken by the confirmation of our beloved Peter's death," his family said in a brief statement shared on Instagram.

The more traditional print media platforms—*The New York Times, The Guardian, Vogue,* and assorted glossy magazines for which Beard had worked over the decades—joined the chorus in the following weeks. In *The Guardian,* Sean O'Hagan described Beard as "a man of often dramatic extremes: a leading character in an adventure of his own making. He saw Africa as the ultimate escape as well as a kind of vocation."

"The most interesting man in the world," said author and journalist Kevin Conley.

"His story is a fabulous one," said Philippe Garner, the former head of international photographs at Christie's. "The world doesn't seem to create characters like that anymore. There's no room for them. The world is too restrictive. He was a wonderful spirit. An adventurer. A wild man. And if you bought a Peter Beard you were buying part of that extraordinary story."[8]

The point is that Peter Beard lived many lives in his eighty-two years. Right from his privileged early years he had accelerated through the decades like a freight train, hunting wild animals, making art, taking photographs, celebrity friend–hopping, clubbing through the night in Man-

hattan's famous nocturnal dens—Studio 54, Nell's, Xenon, and more latterly the Bowery Electric, Buddha Bar, Provocateur, Bungalow 8— and effortlessly seducing some of the world's most beautiful women. It was a gilded path, but one that was fueled and accelerated by the consumption of industrial quantities of drugs. He'd often said, privately and in print, that he preferred to be "pleasantly pixilated," and so he was for all his adult life. Marijuana, ecstasy, cocaine, LSD, peyote, crack. He did them all. However, he never appeared out of control. It seemed the pharmaceutical magic carpet he rode through his life distanced him from the harsh vagaries of a world of which he did not instinctively approve, and allowed him to fully express his heady, free-wheeling mix of art and life. As many of his admirers and friends would observe in their published tributes, it was all one and the same. Just by having his explosive, collagist art on the walls, the Beard collectors felt they were buying into a lifestyle they could only imagine.

Then there was the physical presence of someone who generations of beautiful women regarded as the best-looking male they had ever met, a lithe, lean athlete of a man who was invariably clad in an East Africa kikoi and Pitamber Khoda open sandals, even during bitter New York winters. All his life he retained the devastating good looks of a roguish college graduate: a neatly clipped 1950s haircut that never gave way to hippie lengths, high cheekbones, a permanently tanned olive complexion, and bright, alert eyes always on the lookout for a new adventure. Ironically, for someone so perfectly handsome, his odd physical imperfections— large ears, big, gnarled hands, and sprawling feet often afflicted with what he called "African crud"—just intensified his overall appeal. This powerful physical charisma was amplified by an ability to fix on the people he was talking to—and not only if they were young and beautiful—and make them feel as if they were the only people in the room. This was a particular skill he employed in noisy restaurants or in the cacophonous nightclubs he favored, and which he exercised with impeccable Old World manners.

He planted his flag variously in Kenya, Cassis, Paris, Denmark, New

York City, and Montauk, and everywhere he went he stirred up the local waters, both riling and enchanting the burghers in equal measure. At Hog Ranch, his forty-five-acre patch of wild Kenya, his campfire gatherings were an African version of the Algonquin's Round Table, attracting diplomats, local politicians, international conservationists, foreign correspondents, and of course, global supermodels. It was a heady mix fired up by regularly circulating joints and impressive cocktails, often concocted and mixed by his wife, Nejma. In Denmark, he at first attached himself to the family of Karen Blixen, otherwise known as Isak Dinesen, whose classic memoir *Out of Africa* had inspired the young Beard, and then spent a great deal of time there with the extended Dinesen family and his lover and great friend, Rikke Mortensen. And in Cassis he inherited a bohemian European landscape that his cousin, Jerome Hill, had explored and opened up in the 1950s and '60s. It was a regular retreat for Beard throughout his life.

Then, there were his principal theaters of operation—New York City and Montauk. The city with its nightclubs, restaurants, art galleries, and seedy dives, and the relatively secluded Long Island, with a touch of remoteness and wildness.

His work was full of sly in-jokes, innuendo, double entendres, wicked put-downs, and outrageous passions. It spanned decades and raged across three continents, entrapping and enraging in equal measure. It was always said that Friday afternoon was the best time in New York to negotiate the price of a work of Beard's art. That was the time the coke stash was at its lowest and cash was in short supply. Beard's production of works of art was often based on that simple business model, paying bar bills and restaurant receipts, drug dealers, and cocktail waiters as the party rolled on. In the eyes of some art historians and gallerists, this proliferation of work has diminished the value of Beard's art, but the purists know that out there is a core of splendid, exhilarating photographic/collage art that could stand alongside Warhol, Julian Schnabel, and maybe even Francis Bacon. At his best, Peter Beard was an incandescent genius.

He had also been, albeit in a rather improvisational and sometimes random manner, at the center of the African conservation debate since the early 1960s. His standard harangues concerned the burgeoning human population in Africa, the postcolonial mismanagement of Africa's fast disappearing wildlife, and the inappropriate, sentimental interference in African affairs by Western "do-gooders who want to buy an elephant a drink," and the like, who have been playing an increasingly significant role in the continent's faltering progress in the years since the European colonists packed up their tents and went home. Beard's time in East Africa straddled the end of Empire and the emergence of postcolonial Indigenous rule. It was a perfectly tumultuous time for this rebel WASP young American to be in Africa, and he milked it for all it was worth. His mid-1960s paean to a disappearing wilderness, entitled *The End of the Game*, has become a reference work, both as an environmental cri de coeur and as a diary of another time.

He also ruffled many feathers in the African wildlife community, particularly among the big beasts who bestrode the conservation arena. What started out as fascination with this adventurous young American arriviste with Hollywood film star looks who dressed like a hobo soon turned to impatience with his reckless behavior in the company of wild animals. He was banned from Tsavo East National Park in Kenya by his former friend David Sheldrick, the park's warden. He was frequently warned that his insistence on close encounters with dangerous animals like rhinos and elephants would end badly, and so it did in 1996 when he was skewered and trampled by an angry matriarch elephant. It all but killed him. And although his close friends gathered around, many of Kenya's Africa hands just shrugged their shoulders and said it had been a long time coming.

But he was right about many things. In 1990, Beard predicted that Africa's human population, which was then numbering some 517 million people "would in 25 years number more than a billion." In fact, in 2016 it was 1.25 billion and is expected to reach 2.5 billion by 2050, almost

doubling again to 4.5 billion by the end of the century. At that time, it will make up 40 percent of the planet's population, growing faster than anywhere else on Earth. He was convinced this population explosion, beginning in Africa, was the key threat facing the future of humanity in the immediate future, telling the talk show host Charlie Rose that it was all hopeless "unless one of the world leaders decides population is an issue. We are completely blind and we're incredibly unevolved. And we are not educating ourselves to survive, and probably won't."[9]

Nobody else straddled the two worlds of postcolonial Africa and celebrity-obsessed, modern America with such facility, and managed to make it all sound like part of the same thing. At first Warhol found his *The End of the Game* mantra interesting but very quickly found him repetitive and even self-contradictory, as an excerpt from Warhol's diaries in December 1983 confirmed: "Decided to go to Peter Beard's party at Heartbreak. Peter was at the door showing slides. The usual. Africa. Cheryl on a turkey. Barbara Allen on a turkey. Bloodstains (laughs). You know."[10] And yet whatever Beard said, if you didn't listen too closely, had a fiery, impassioned logic to it. His insults contained particularly misanthropic poetry, like when he told the filmmaker Lars Bruun that Western environmentalists are "just do-gooders. The lords of poverty . . . the alms race . . . Oxfam . . . Save the Children . . . the whole industry of doing good. It's a huge cliché. To be an environmentalist is to be a joke."[11] They paid attention not because of his philosophical heft or his socio-political aperçus but because he was beautiful, dramatic, crazy, and an important social cog in the New York club scene. As Nell Campbell of Nell's nightclub said, when Peter was in the club there would always be a gaggle of women surrounding him "and I have never seen any other man have that effect on women."[12]

And yet he was strangely a man out of time. He grew up in late-1950s America but would no more have raved about Elvis or Little Richard or Buddy Holly than he would have considered joining a celibate religious order. In the late 1960s, his first wife ran off with the cast from *Hair*

and all he could offer was a derogatory swipe to a *Rolling Stone* magazine writer: "See, all the cast of *Hair* had moved back from Mexico to continue their pursuit of their newfound leader, my wife, the hippie's hero coming down from the Establishment to join the hippies in their rebellion, and (our) place was full of all those *Hair* actors and producers and God-knows-what."[13]

He was indeed from another era. In this age of woke sensibilities and political correctness it would be easy to see him as a sexist, racist, white privileged male, as many of the modern generation do, but this is to completely misread and misunderstand him. It is surely misguided to call a man who was married for thirty-five years to a woman of Asian heritage racist. And when asked in the days after his death whether he was racist his longtime mistress, the mixed-race model Maureen Gallagher, burst out laughing, saying: "If he had been he certainly wouldn't have dated me." Equally, accusations of his being a sexist predator are firmly rejected by the women he dated over the years. With one exception, his female friends and lovers describe him as a thoughtful, kind, and caring paramour and all retained affectionate relationships with him long after their various affairs had ended. Although he was a self-described remittance chum, a trust fund beneficiary, he was almost always penniless, depending on the generosity of friends and admirers to fuel the wild, whirling social life that he indulged in.

And yet his presence was so powerful among friends and admirers that after his death most of them continued to talk about him in the present tense. His longtime friend and fellow party animal, the New York gallerist Peter Tunney said: "I just don't like the world without Peter Beard. I prefer it with him, even when he is being a pain in the arse." Some took a more reflective, measured look at the vanished wild man. Jon Bowermaster, the author of *The Adventures and Misadventures of Peter Beard in Africa*, said: "All the friends I saw him with were getting something from him and him from them. It was transactional. He had no real friends. He was a carnival barker . . . that's why he organized

all those dinners."[14] Others, having accepted his passing, took a more laconic approach. Janice Dickinson, an international model who was a former lover and muse, said she had heard he had wandered off into the bush with two hookers. Whether she actually believed that or felt it appropriate to burnish the myth was not entirely clear.

A lifetime of contradictions: he railed against celebrity-led ornamental virtue-signaling Western conservationists and yet they were the very celebrities he partied with in the nightclubs of Manhattan and who paid six-figure sums for his artwork. Also, he declared frequently that he identified with the Africans on the ground, which was easy to do if you had, throughout your life, the financial safety net provided by an East Coast WASP family. He thought that money and the pursuit of it was vulgar and crass and yet he was always peddling his art to pay for restaurant and bar bills and for the constant supply of drugs required to keep him "pleasantly pixilated" throughout his adult years, as he told *Vanity Fair* magazine in the 1990s.

Now to the point, which is Peter Beard's legacy as a twentieth-century artist of significance. There are many, including Francis Bacon, the art historian Drew Hammond, Philippe Garner from Christie's, and Los Angeles gallerist David Fahey, who all regarded him as a powerful force on contemporary art. According to Hammond, Beard reinvented photography as an art form in the most complex, philosophical manner, "whether consciously or unconsciously, it doesn't matter. What is important is that he used the photograph as an image field for another work of art." To fully understand Beard's art, you have to understand his life. It's part Monty Python, part *Electric Kool-Aid Acid Test,* part *Macbeth* . . . a wild swirling adventure story that produced some great art, was constantly verging on catastrophe, and had as a supporting cast hundreds of beautiful women.

Although some mystery remains over the circumstances of Peter Beard's death, particularly why all those mustered forces of the East Hampton police department failed to find a body just five hundred meters from his family home and how said body could have remained out in the open wil-

derness untouched by predators for three weeks, everyone who knew him agreed that this was probably how he would have wished to end his life. Like an old African bull elephant, he went out into the wilderness and lay down and died.

2

Dynasty

While many of the Africans, Black and white, whom Beard encountered in his early days regarded him as an arrogant, privileged American like so many other arrogant, privileged Americans who visited Africa, he was much more than that. Although he would seldom, if ever, discuss his lineage with African friends, he was from one of America's most distinguished families. In fact, so dismissive was he of his ancestors that he frequently referred to them as a gang of "mackerel snatchers," a derogatory term for Catholics. But dating back to the early 1800s his two lines of ancestors—the Hills and the Beards—were almost as significant as the Rockefellers, the Morgans, the Harrimans, and the Vanderbilts in building modern America. And in attempting to understand this audacious, risk-taking, rebellious, and exceptionally intelligent man it is essential to examine the lives of his forebears and his immediate family.

The family's great wealth was due primarily to the brilliance and resourcefulness of two penniless immigrants who started as humble clerks and whose energy and vision helped transform the country in the nineteenth century, creating tens of thousands, probably hundreds of thousands, of jobs as well as multimillion-dollar fortunes for themselves and their descendants. It is the story of America.

Both immigrants sprang from rural Ireland. William Beard, Peter's great-great-grandfather, arrived empty-handed in Massachusetts from County Westmeath in 1825 at the age of nineteen,[1] while James J. Hill

was the son of Irish immigrants who had ended up in Canada, where he was born in a log cabin ten miles from Toronto in 1838. At thirteen, James had adopted the middle name Jerome, after Napoleon Bonaparte's brother. This was not uncommon among nineteenth-century youths who had fallen under the spell of Bonapartism, which celebrated the strength of individual will, the power of one dynamic individual to change the world.[2]

When William Beard arrived penniless in America, he found a country in transformation, and soon found work on the Massachusetts's fledgling railroads. The industrial revolution that had begun in Britain in the 1760s with James Watt's invention of a commercially viable steam engine was almost simultaneously beginning to transform America, as the country accelerated away from its reliance on agriculture and handmade goods to a new era of iron and steel, factories of heavy machinery and new forms of transportation. In the first decades of the nineteenth century, goods and produce were transported primarily by water, taken across the country by river or canal, on boats or horse-drawn barges and along the coasts aboard canvas-sailed vessels. By the time William Beard had arrived in Massachusetts the Erie Canal had finally reached New York, thus connecting the Great Lakes with the Atlantic and Europe, and, with the Manhattan waterfronts already lined with residential buildings and factories, the shorefront with the most potential was Brooklyn. The area with the most promise there was the marshy western point jutting out into the Upper New York Bay, overlooking Governor's Island at the entrance to the East River. It was called Red Hook and in 1843 William Beard, who by this time had made significant money as a railroad contractor, and his partner Jeremiah P. Robinson began buying up large swathes of the Red Hook waterfront.[3]

By 1856, Beard had secured more than a million square feet of land he needed for a harbor and a storage depot at the southwest tip of Red Hook and began filling in underwater areas he would need for dockside warehouses, dredging some areas as deepwater sections for ships to dock, and building piers and a protective bulkhead wall wrapped around the

man-made harbor. In 1864, William Beard opened up the Erie Basin—
the largest man-made harbor on the Eastern Seaboard.

By the late 1870s, Brooklyn was known as the Walled City due to its
veritable fortress of warehouses lining the waterfront, with Beard Street
warehouses alone offering more than seven acres of storage. Two-thirds
of the goods arriving in New York were now passing through Beard's
Erie Basin. Brooklyn had become the fourth-biggest city in America.
By the time William Beard died an extremely wealthy man in 1886, he
had reportedly had four wives and at least ten children, all of whom in-
herited considerable wealth. One of those sons, Colonel William (Billy)
Beard became one of the wealthiest and best-known men in Brooklyn,
according to *The New York Times,* and the father-and-son Beards were
perhaps the most significant public works builders in nineteenth-century
Brooklyn.[4]

The legacy of William Beard looms large in modern-day New York.
The city's Fashion Week now holds runway shows in the tobacco ware-
house of the old Empire Stores complex;[5] Cunard and Princess cruise
lines now make Red Hook their New York harbor home,[6] and at
1 Beard Street in the old Erie Basin docking area an IKEA retail store has
opened,[7] thus connecting twenty-first-century commercial imperatives
with William Beard's nineteenth-century equivalent. As Peter Beard
walked along these cobbled streets that bore the family name and visited
public buildings endowed by his family, even his unsentimental heart
must have swelled with pride.

However, if the Beard family had prospered because of the foresight and
ingenuity of an Irish immigrant, so the other side of the family, the Hills,
were even more successful. James J. Hill, Peter Beard's great-grandfather,
was one of the great economic leaders of nineteenth-century America, an
empire builder more than a robber baron, developing the most successful
railroad company in the west of the country, opening up the Pacific coast
and at the same time leading an agricultural revolution that would trans-
form large swathes of the country.[8]

In 1869, James Hill, having married Mary Mehegan two years earlier, set up in business with a partner, Chauncey W. Griggs, to form Hill, Griggs and Company, shipping coal, lime, cement, and salt on the Mississippi and Salt rivers. On his advice, the St. Paul and Pacific Railroad and the Milwaukee Railroad switched their fuel from wood to coal, and the profit he made from coal bankrolled his own entry into the railroad business.[9] In 1878, he bought the ailing St. Paul and Pacific Railroad and began extending the tracks across the Great Plains and the Pacific coast. Not that it was always appreciated. Hill's friend Elbert Hubbard noted that in the early days of the railroad "passengers go aboard but on being pressed for fares they felt insulted and just jumped off, as you would if you got a ride with a farmer, and he asked you to pay." Meanwhile, Mary, who was quiet, intelligent, and industrious, was either pregnant or nursing a baby for the next twenty years, giving birth to ten children between 1868 and 1885, all of whom grew up and married except for one, who died in infancy.

The early railroad business was thoroughly corrupt and manipulated. Wholesale subsidies led to railroad developers planning their lines over the longest viable route and laying track in inclement, icy weather, ensuring the rails would buckle and would need to be relaid. The Union Pacific and Central Pacific railroads, for instance, were built with federal subsidies that gave them twenty square miles of land for each mile of track laid, plus a $16,000 loan for each mile laid on flat prairie land, $32,000 per mile in hilly land, and $48,000 per mile in mountainous terrain.

James Jerome Hill prided himself on taking a different approach. He personally researched his routes, riding on horseback to discover the shortest route feasible with the least curvature. He imported expensive steel rails from Britain as the quality was better than cheaper American steel. Most crucially, he helped develop the land his railroads ran through by setting up agencies in Sweden and Germany to encourage farmers to immigrate, researched the most suitable crops to sow on the land, and then gave the new arrivals seed and livestock to help them establish their farms.

Despite endless double-dealing from his subsidized competitors, he never went bust.

In 1889, he renamed the St. Paul and Pacific the Great Northern Railway, and he continued to create a route to the Pacific coast, laying a mile of track a day, at around $30,000 a mile, arriving in Seattle in January 1893. Later that year, his main rival in the Pacific Northwest, the Northern Pacific Railroad, went bankrupt as did the Union Pacific and Atchison, Topeka & Santa Fe, leaving Hill's railway the only solvent transcontinental line. Thoughout this time agriculture remained an obsession. Besides pioneering railroads, his greatest achievement was his spreading of agricultural know-how through the rural communities, which was tried and tested knowledge based on his own research and experiments on model farms, as well as his passion for keeping abreast of modern developments in farming.

As Hill opened up the northwest with his railroads, agriculture developed into the foundation of the fledgling economies of the new settlements, becoming progressively more important to the region as the decades went by. One of his much-quoted aphorisms was "give me Swedes, snuff, and whiskey, and I'll build a railroad through hell."

James and Mary and their children lived in a thirty-two-room, 36,000-square-foot mansion built to Hill's detailed specifications at 240 Summit Avenue, St. Paul, Minnesota, a four-and-a-half-mile-long grand boulevard where the city's wealthiest had their houses on a bluff over-looking the city and the Mississippi.[10] The Hill home was the largest. Along with friends J. P. Morgan and William Rockefeller, Hill was a member of the Jekyll Island Club, Georgia, otherwise known as the Millionaires Club.

As his health deteriorated—Hill eventually died of intestinal blockage—in the last four years of his life, he donated most generously to various institutions and funded both the main library in St. Paul and the adjoining Hill Business Library. When he died in 1916, he left an extraordinary legacy. He was worth somewhere between $53 million and $100 million (between $1.3 billion and $2.6 billion in today's money) and reckoned to be one of the fifty richest people in the world. On the day of his funeral, at the family house on Summit Ave., flags in Minnesota flew at

half-mast, school was canceled, and at two P.M. all the trains on his system stopped for five minutes.[11]

In an article after his death, *The New York Times* quoted a colleague's description of Hill: "Somewhat below the average height, but built like a buffalo, with a prodigious chest and neck and head; his arms long, sinewy, powerful; his feet large and firm planted and his legs solid as steel columns—truly a massive imposing figure of a man. And the head— shaggy brows, shading an eye that bored right through; a mass of long iron-grey hair reaching to the collar of his coat; and a heavy, rough, iron-grey beard growing without restraint over the entire face, yet hiding nothing of the immense chin and powerful jaws, and the wide lips, between which showed two rows of teeth seemingly fit to crunch iron." He even made it into contemporary literature, with F. Scott Fitzgerald's Nick Carraway in *The Great Gatsby* declaring of Gatsby, "if he'd of lived he'd of been a great man. A man like James J. Hill. He'd of helped build up the country."[12]

Before James Hill's death, however, the Beards and the Hills had united when, in April 1902, Ruth Hill married Anson McCook Beard (a lawyer who according to *The Boston Globe* had "some years ago won lasting fame as a member of Yale's football eleven"). The event was recorded in *The New York Times* under the somewhat prosaic headline: "Well-Known Capitalist's Daughter is Bride of New Yorker." Peter Beard's grandparents were immediately launched into a life of luxury when Ruth's father gave her $250,000 in bonds "for pin money" and a brownstone house at 47 East Sixty-eighth Street in Manhattan. Hill also invited his daughter to choose whichever picture she liked from his gallery at the Hill home. In 1906, Anson Beard Sr. had the brownstone razed, as was the fashion, and a yearlong construction began on a six-story replacement in Italian Renaissance style, with three stone steps up to an entrance shaded by a stone balcony and a mansard roof. That house is still standing today.

Both Peter's grandmothers were feisty and independent-minded women and the genes they handed down the family tree undoubtedly helped forge

his full-blooded character. After Anson Beard Sr.'s death in 1929, the redoubtable Ruth mourned his passing for a year and then announced that she was to marry Pierre Lorillard V, heir to the Lorillard tobacco and Tuxedo Park property fortunes. And when the unfortunate Pierre died just eight years later, she immediately married an even wealthier man, Emile Heidsieck, scion of the French champagne family. Grandma Ruth, as she was known, remained the family's grande dame, traveling with an entourage of nine staff in tow, and moving gracefully between her various New York homes in Manhattan, Tuxedo Park, and Southampton. Both remarriages added marvelously to the inheritances—and properties such as Ruth Hill's Eden Cottage in Southampton and the estate at Tuxedo Park cascaded down through the generations and were always available for weekends or family holidays.

However, it was Virginia Goffe Hoar, Peter's maternal grandmother, who had the most direct influence on him as a young boy. She was one of the few women of her generation to go to college, where she majored in European languages (French, Italian, and Spanish). She later attended law school and was admitted to the bar in 1912. She married Friend Hoar in 1913, and a year later, the birth of her only child, Peter's mother, Roseanne, put an end to her career. Although not in the same wealth and social brackets as the Beards and Hills, the Hoar family was well established on Manhattan's Upper East Side and it was noted in the social register of the time that they took their vacations in the Hamptons and in Europe, as did society's other important families.

Roseanne married Peter's father, the third Anson McCook Beard, in 1934. She was, according to *The Brooklyn Daily Eagle*, "the ice-skating daughter of the Friend Hoars of 165 E 16th St, Manhattan and Southampton." The paper noted that "his clubs include the Tuxedo, Racquet and Tennis, Knickerbocker, Turf and Field and National Golf Links," and that their wedding was "a brilliant social event." Roseanne had graduated from Miss Chapin's School in Manhattan only two years before and had made her debut in—and been elected chairperson of—the Junior Republican Committee of One Hundred the year before. An excellent athlete, she held the

high jump record at Chapin and as a teenage figure skating champion skated with Olympic champion Sonja Henie. Much as he would resist the thought as he seemed unwilling to credit his mother with anything positive, Peter's extraordinary athleticism came from Roseanne.

Roseanne had her three sons, Anson IV, Peter, and Sam, in the space of thirty-nine months in the late 1930s. By the time the boys were starting to go to primary school, the family had moved to Alabama, their father having been called up to the army in the days after Pearl Harbor and posted to Maxwell Field army base just outside Montgomery. Having been a history major at Yale, and deemed to be too old (and with a young family) to serve on the front line, Anson Senior was tasked with writing the history of the Army Air Corps. From the comfort of the Upper East Side—and Islip during the sybaritic summers—the family found themselves billeted in a relatively modest bungalow in Montgomery with neighbors whose family had fought for the Confederates in the Civil War. The two older boys—Anson and Peter—were given a rapid lesson in north-south politics, called "Goddamned Yankees" by their southern neighbors, and engaged in frequent fistfights, most of which they won. Anson was a decent boxer but Peter was even better—a fearless street fighter at the age of five.

When Roseanne's father died a decade later, his widow, Virginia, now living on East Eighty-first Street, not far from the Beard home, became closer to the three boys, particularly Peter. She would take the middle Beard boy to exhibitions around the city, significantly to the American Museum of Natural History, where he began to develop a fascination for wilderness and wild animals. She was a genuine eccentric. For example, while other grandmothers had cats and dogs as pets, Virginia had a monkey. Her diet was also notorious, comprising "a continuous consumption of Coca-Cola . . . and she chain-smoked Lucky Strikes at the rate of two or three packs a day."[13] She also supplemented her meager income with winnings at card games that she played most days. And it was Virginia who presciently gave Peter his first camera, a Voigtländer, when he was around eleven years old, and set him on his life's journey.

The Beard family turned out en masse for Virginia's funeral and the burial service in a Bronx cemetery was briefly interrupted when Peter went missing. His older brother, Anson, went in search of the errant young man who had apparently gone off to inspect the gravestones at the far end of the cemetery. Anson found him relieving himself behind a tree. Everyone was sure the eccentric grandmother would have approved of the young man's unconventional approach to formal occasions.

Meanwhile, Anson III, Peter's father, had always claimed that he'd spent most of his life doing things he did not want to do, mainly managing the family's vast wealth, whereas he would have preferred to have lived the life of a country squire, hunting and fishing. So, he maintained a withdrawn and passive role in the house, gradually sinking into alcoholism, thus leaving Roseanne to run the household and maintain discipline among the boys.

Although Peter felt some affection for his father—love is too strong a word—he was generally dismissive, at least publicly, about his parents. When a reporter from *Women's Wear Daily* asked him in the 1970s whether his parents were still alive, he responded with a single word: "Physically."

He reserved his most caustic barbs for Roseanne. She was strict, sometimes sharp-tongued, and well organized and that, of course, brought her into direct conflict with her middle son. They were at odds throughout their lives and many years later, over lunches with Peter's second wife, Cheryl Tiegs, Roseanne would burst into tears and ask why Peter hated her so. Equally, Peter would tell anyone who was prepared to listen how much he did hate his mother whom he labeled a bore, which was about the biggest insult he could lay on anyone. One of his recurring nightmares as he got older was when he looked in a mirror, he started to see his mother looking back at him. It was ironic that of the three brothers he was the one who most resembled his mother physically.

The confrontations were continuous and almost always rancorous. When the boys were young, Roseanne gave each of them a clothing allow-

ance in an attempt to show them the value of money. She told them they should use the money wisely to buy clothes that would be suitable both for school and for play. Peter ignored her and spent all the money on cameras and related equipment, not caring what he looked like at school and at the back of his mind knowing that his mother would buy him the clothes he needed anyway. But their antipathy toward each other probably began in Montgomery. The schooling in the South was so poor, in Roseanne's eyes, that she felt she needed to homeschool Peter, only five years old at the time. (Half the children went to school barefoot and despite protestations from Anson, Roseanne declared that no Beard boy would go to school without shoes.) She used the Calvert System but Peter was militantly resistant from the get-go, showing no interest in any subject other than art.[14] Roseanne told older brother Anson that Peter was the most uncooperative boy she had ever met. At the same time, it was the Calvert System that gave young Peter the rudiments of fine art history, a knowledge he transferred to the backyard when the three brothers played games. He gave each one of them names before the mock sword fights began. One brother would be Leonardo da Vinci, one would be Raphael, and one would be Michelangelo.

Once the war was over and the family returned to the East Coast, all three Beard boys went to the Buckley School on East Seventy-fourth, just a few blocks from the family home. There they mixed with boys of similar socio-economic advantages, and both Anson and Peter were in the same classes as the sons of Nelson Rockefeller, Peter being friendly with Michael, who later disappeared in Papua New Guinea and was allegedly eaten by cannibals. Michael frequently invited Peter to the Rockefellers' luxurious place in Pocantico Hills for weekends and Peter returned to report to his eager brothers that they lived in a similarly unostentatious manner to the Beards, the only significant difference being they had a bowling alley in the basement. On the walls of the Beard's sumptuous nine-room apartment hung classical European paintings—great works by Honoré Daumier and Jean-Baptiste-Camille Corot—that must have seeped into the young artist's subconscious.

Back on the Upper East Side, both older Beard boys were happy to get into a good fight, as they had done in Montgomery, and although Anson was a school boxing champion, it was once again Peter who was the scrappier Beard brother, the one most likely to be involved in a fight. And to win. There were always tough kids coming across from Third Avenue to pick fights with the boys coming out of the posh schools. Anson remembered avoiding trouble, crossing the street when he saw the tough kids heading his way, not because he was afraid but because, pragmatically, he would expect to be outnumbered and thus beaten up. Peter would march right in. On one occasion, one of the tough kids tried to steal Peter's watch and although his first instinct was flight, he suddenly paused, confronted his assailant, and punched him in the face.

When the time came for further education, Sam and Anson were taken along the more traditional route to St. Paul's while Peter was sent off to smaller Pomfret School in Connecticut—his father had been schooled there—where Roseanne hoped her willful and ill-disciplined middle son might be brought to order. It was a forlorn hope. At Pomfret, Peter soon met up with Tony Hoyt, an old friend from the family's Long Island summers, a tennis opponent who was the same age. Hoyt, who remained Peter's good friend throughout his life, remembered that even back in his senior school days there was something "quite crazy and reckless about Peter." Hoyt used to play ice hockey, a sport the young Beard had no interest in, but one day he happened upon the school team practicing and noticing that the goalkeeper was covered in protective padding on his arms and chest, with a protective grille covering his face, Peter scoffed at them. "That's a load of bullshit. Let me show you," he said and took his place in front of the goal without any protective armor. "Shoot at me. Don't be nice. Come on, shoot at me," he said. According to Tony Hoyt, they all took shots "and he came away unscathed. That was what he was like. Brave and completely crazy."[15]

At St. Paul's the sensible, down-to-earth, and entrepreneurial oldest brother Anson was finding ways of supplementing allowances by start-

ing a shoeshine business, and pretty soon he was selling shares in the business to fellow pupils. It was a short-lived commercial adventure but gave the older brother a taste of the commercial opportunities out there, a taste that would eventually manifest itself in a seventeen-year career as senior partner at Morgan Stanley, during which time he helped transform the company from a small investment bank to a global financial franchise. All three Beard boys were instinctively competitive, with Peter being the most athletic, a natural outdoorsman, tough, hardy, and naturally extremely fit.

While Anson and Sam transferred smoothly from St. Paul's directly to Yale, Peter again took a scholastic detour to Felsted School in England and thus arrived at Yale in the same year as his younger brother, Sam. It was the first time in the history of this august institution that three brothers had attended at the same time.

On one occasion at Yale, Peter wandered into the gym while one of the star athletes was in the process of doing a hundred pull-ups. He'd been training hard to do this and when he finished he rightly expressed a certain satisfaction at his achievement. Peter Beard snorted contemptuously. "I can do that," he said, and proceeded to do one hundred pull-ups, having never attempted anything like it before.[16]

While his two siblings embraced their dynastic roots with some enthusiasm, Peter spent his life denouncing both his "mackerel snatcher" religious background and his WASP social and economic ancestry. And yet there were instinctive attachments that the rebel Beard could not quite shake off. When Anson was tapped up to join Skull and Bones, the most prestigious of the Yale fraternities, which at that time allegedly guaranteed success in later life—the two Bush presidents, George H. W. and George W., were both members—he was flattered and jumped at the offer. However, when Peter's great friend and fellow society rebel Peter Duchin was tapped by a Skull and Bones member to join, he told them to "fuck off." So, when Peter Beard was tapped up by rival Scroll and Key fraternity and leapt at the invitation, Duchin was mystified. "When

I kicked the Skull and Bones people out of my room my godfather called me and said I had ruined my life," Duchin recalled. "I guess Peter's father would have put pressure on him to join one of the top fraternities. He was very WASPy."[17]

However, more typical of Beard's already developed rebel tics was an incident in his senior year in 1961, when he broke into the Skull and Bones' halls and stole a precious Bones artifact, a skull that had the names of well-known old boys engraved on it, including one Anson McCook Beard II, the Beard boys' grandfather, who had been a member in his day. Eventually the Scroll and Key hierarchy decided that this was a stunt too far and returned the skull, an act that Peter regarded as an overreaction and a betrayal.[18]

The DNA handed down the generations from William Beard and James Jerome Hill manifested itself powerfully in all three Beard brothers, but expressed in wildly different ways. Anson, the sensible, morally upright, and fiscally smart Wall Street operator, made millions but ensured through public works and philanthropic endeavors that social responsibility played a major part in his life, just as it had for his great-grandfather James Jerome Hill. Sam, the youngest, spent a lifetime in public service. Following a year as a schoolteacher after graduation in the 1960s, he became an aide to Senator Robert Kennedy, then founded the National Development Council, and has been responsible for more than $100 billion of revitalization financing, creating over one million jobs. In the 1970s, he led President Richard Nixon's $100 million bank deposit program which, he has said, involved "the largest transfer to resources into the minority community in the history of the US." More recently, he founded Global Investment Foundation for Tomorrow, a nonprofit whose goal is to use the power of compound interest to double charity around the world.[19] Then there was Peter, the most famous and most notorious middle brother, whose life reads like a Hollywood movie and whose legacy will remain in the art he has left behind rather than the colorful, disruptive, anarchic lifestyle for which he became celebrated.

Beard's relationship with his family was complicated. For many years,

in his thirties in the 1970s, he lived with his brother, Sam, and sister-in-law, Patricia. When their children were growing up they were intensely aware of the constant presence of their uncle Peter, so much so that Alex would follow in his uncle's footsteps and become an artist. Then, when the family moved out of Midtown Manhattan, he barely saw them. By the late '70s, Cheryl Tiegs would write, reprimanding him for not maintaining contact with his family. Equally, his older brother, Anson, was at times dismissive of Peter's fecklessness, his indifference to fiscal probity, and his bohemian lifestyle. A striking example of the two brothers inhabiting opposite worlds occurred in 1994 when Peter was stranded in Japan and phoned Anson asking for money to buy a plane ticket home. Anson suggested that it was probably time his younger brother got a job and earned decent money. Peter replied: "Anson, I'm sixty years old, what kind of job am I going to get?"[20]

Probably the best example of Peter's distance from his family is provided by his lifelong friend, the pianist and bandleader Peter Duchin. He says he was sitting stark naked in the steam room at the Racquet Club in New York when Peter's father, Anson Senior, sat down next to him. "He asked me how I was. I said how nice it was to see him," remembers Duchin. "Then he looked me in the eyes and said, 'Could you explain my son Peter to me?' I said, 'I can tell you about Anson Jr. and Sam. But Peter? That's a bit too difficult.'"[21]

Peter Beard was, in many ways, as unknowable then as he was at the end of his life, to family, to lifelong friends like Duchin, to his many lovers. But he was essentially the same person throughout his life. He was a hoarder, a collector—of newspaper clippings, of old cigarette packets, of scraps of paper, of everything that passed in front of him through his life. He was also a driven artist, the combative descendant of one of the families that built America, an entitled East Coast WASP who spent his whole life just being Peter Beard.

But he knew where he was headed from a young age, as it became apparent one night in The Time Is Always Now, the Manhattan art gallery that served as Beard's artistic base in the 1990s. Beard and gallerist Peter

Tunney were rummaging through the boxes of his collected detritus when they happened upon a folded scrap of paper that was dated 1949. On it was written in an eleven-year-old child's hand the following words: "Get adventure and riches. Make yourself famous. PS All prisons empty."[22]

3

Into Africa

Africa has a strange effect on Western people. It offers up a primordial link that is instinctive rather than intellectual, visceral rather than factual. It provided young white adventurers such as Peter Beard with mythological links, almost tactile connections, with Homo sapiens of previous ages. He was sixteen years old and was becoming increasingly restless with boarding school life when he read Karen Blixen's *Out of Africa*. Decades later he said, "It was the first meaningful book I'd read on Africa, and clearly the best. All the dark mysteries of nature finally found a voice in one of the few outsiders who had the intelligence to go to Africa to listen rather than to tell."

Young Peter found in *Out of Africa* a dark, melancholic prose poem to a fabled Africa, which fired his imagination and filled him with a longing for what he imagined was a wild, untamed Camelot. In the book, Blixen described a world so far removed from this young man's preppy roots in 1950s America that it could have been another planet. Her Africa was a dramatic mix of endless landscapes filled with wild animals, of devil-may-care big game hunters, and of a slow, dreamy rhythm to life that was governed by the seasons and most important by the rains. It was a world where, in Blixen's words, "the pioneers lived in guileless harmony with the children of the land" and where "herds of elephants crossed the plains as if they had an appointment at the end of the earth."[1]

Out of Africa's narrative covered East Africa in the years that straddled World War I and drifted into the Roaring Twenties on a cloud of camp-fire smoke. Here European aristocrats and a smattering of well-to-do

Americans roamed the endless plains on safari and committed adultery in the bougainvillea-lined suburbs that spread out from the ordered little capital town of Nairobi. The well-worn adage of the time was "are you married, or do you live in Kenya?" and sex-and-drugs scandals erupted with some frequency, to the point that in the end nobody took any notice.

Until, that is, on January 24, 1941, when the philandering Earl of Erroll, Josslyn Hay, was found dead in his car with a bullet shot through his head. Lord Erroll was an English aristocrat and all-purpose reprobate who had a reputation as a serial philanderer. It was alleged that his dalliance with Diana Delves Broughton, the beautiful, socially smooth wife of Sir Henry John ("Jock") Delves Broughton, was the root cause of his sudden demise. Although the Delves Broughtons had signed a prenuptial agreement insisting that should either party fall in love with someone else, the other would do nothing to interfere with the romance, it may have been that Jock, as he was widely known, had not really taken this on board. Although he was found not guilty at the subsequent murder trial, it was widely alleged that he had shot his wife's lover, Lord Erroll, and then committed suicide soon after. Although this scandal signaled a temporary end to the unbridled promiscuity of Kenya's so-called Happy Valley set, it appears to have been a brief cessation that they resumed with gusto at the end of the war and rampaged through colonial society until Kenya established its independence in the 1960s. Or even beyond that.

What drew Beard to *Out of Africa* was its mournful, melancholy, and elegiac style. It is a place, in Blixen biographer Judith Thurman's words, of "clear darkness."[2] Blixen's stories take in death at close quarters, and a sense of loss and nostalgia for her early pre-War days in Kenya pervade her thoughts and writing. When she arrived in Kenya in 1913, it was regarded as a timeless paradise if you were European, less so if you were among the Indigenous people who had been recently overwhelmed by an alien culture and who had lived in blissful ignorance of the industrial age. President Theodore Roosevelt, whose famous 1909 hunting safari was the largest ever to cross Kenya, compared that Africa with "the late Pleistocene" era.

Thus, it was serendipitous that some months after reading *Out of Africa*, Peter Beard was presented with an opportunity to fully embrace his newfound obsession with that distant continent. On Saturday nights, the boarders at Connecticut's Pomfret boarding school—like Beard they were mainly the scions of wealthy WASP families—were treated to an event in the school's auditorium. Sometimes it was a movie, sometimes a play, and occasionally a talk delivered by a special guest. On that particular Saturday the talk was about Africa and the speaker was Charles Darwin's great-grandson, Quentin Keynes. Beard and his roommate Tony Hoyt sat close to the front and were transfixed by Keynes's descriptions of the continent's vast wildernesses and its abundant wildlife, of a cultural landscape that existed more in the nineteenth than the twentieth century, where Western-style progress was only beginning to show its presence. In other words, the dream world of Karen Blixen.

At the end of the lecture Beard told Hoyt he would see him later back at their room, and that he was going to introduce himself to Quentin Keynes. He returned at one A.M. buzzing with excitement. "I'm going to Africa with him this summer," he announced.[3]

So, that summer seventeen-year-old Peter Beard and Quentin Keynes traveled through southern Africa and Kenya, and Beard started absorbing the rhythms, the cadences, the intriguing nuances of these foreign lands. Here was a place emerging from European colonialism and trying to find its relevance in the modern world. Keynes—an explorer, writer, and filmmaker—was the perfect guide, for he, like the young Beard, was curious, impulsive, distinctly rebellious, and he, too, came from a privileged background. It was probably this early encounter with Keynes that taught Beard the importance of social connections and how to trade on them.

For Beard that lesson was utilized immediately. Carrying himself with the easy confidence of a well-bred, affluent young American, he met for the first time colonial African conservationists, the untethered young men of the bush who were trying to figure out how to deal with the transition from wild animals as the property of the king, the empire, and its servants to their more contemporary status as fast-diminishing species that

should be protected as the property of mankind. This was a debate that would fuel Beard's conservation arguments for years to come but there is little doubt his positions were forged in the 1950s when big game hunting was coming to an end and managing the diminished populations of wild animals in protected, fenced parks would become the future. Karen Blixen's world of endless plains filled with wild animals and devoid of people was fast disappearing. Keynes and Beard were already glimpsing Old Africa in the rearview mirror.

Also, on this first trip to Africa, Beard began developing an instinctive knack of meeting the right people at the right time, a talent that would serve him well for the rest of his life. In South Africa's Hluhluwe Park he encountered Ken Tinley at a time when this particular wilderness, under the guidance of the renowned conservationist Dr. Ian Player, was about to become the most successful breeding ground for endangered white rhinos on the continent. Even in these early days, Tinley was gaining a reputation as a brilliant naturalist whose basic philosophical plank of incorporating local tribal communities in animal protection was decades ahead of its time and was to become a distinct thorn in the side of the country's separatist apartheid government. Not surprisingly, Beard and Tinley found common ground and Beard headed north to Kenya with a clear view of where he thought wildlife management should be going.[4]

While southern Africa was still subdued by white colonial rule, Beard and Keynes found in Kenya a country in the throes of turbulent political and social change. The armed Mau Mau Rebellion, an insurrection of mainly Kikuyu tribespeople directed at the British colonial rulers, raged through the countryside for most of the 1950s. Members of the guerrilla army took blood oaths and inflicted terrible punishment on fellow Kikuyus who would not join the struggle. In response, the British authorities cracked down on the Indigenous people, abandoning civil liberties and herding tens of thousands of Kikuyu into internment camps. The author and activist Wangari Maathai estimated that in the mid-1950s, three-quarters of Kikuyu men were being held in detention camps. And by the time the uprising had ended, no more than thirty or forty of the white

settlers had been killed by Mau Mau insurgents whereas it is estimated that between 50,000 and 100,000 Black Kenyans had died, many of them in the internment camps.

At the end of this Africa trip, Beard returned to Pomfret to complete his senior year, loaded down with photographs and tall tales. Although he had been taking photographs since his maternal grandmother had given him a 35mm Voigtländer camera on his eleventh birthday, the Africa trip fired his imagination, and he said years later that this was the beginning of his work for *The End of the Game,* to be published a decade later.

At Pomfret he managed to do well enough academically to gain acceptance to Yale. But first his family had decided he should spend a year in England and thus he attended Felsted Preparatory School, a British public school that compared academically with better-known Eton and Harrow. Although Beard failed to record any substantial observations about his brief time in Britain, it undoubtedly rubbed off, even subconsciously. Throughout his life he would be credited with formal good manners, a politeness, and sense of etiquette that was not always evident in his American peers. He also obtained a quiver full of Anglicizations that would be with him forever. Years later his assistant Ivory Serra was in equal part amused and baffled at Beard's anglicized expressions. "He would say, 'She is full of pulchritude' and I was left wondering whether this was a good or bad thing. At one strip club we were at in New York City he turned to me and said, 'You might be the dark horse in the bunch' and again I wasn't sure whether that was a compliment or an insult."[5] He also developed a quick-witted sense of humor for which many credit his short time in an English school.

At Yale, Beard registered for a science-based premed degree but after his first term switched to fine arts, a course that was not widely pursued by the sons and daughters of Dwight D. Eisenhower's America. Here he flourished, as some of the artwork that has survived the years proved, and his skills as a draughtsman were clearly evident.

By 1960, with Beard firmly engaged in his fine arts studies at Yale, Africa continued to beckon and was never far from the young man's

thoughts. This was officially identified as the United Nations' Year of Africa, a milestone moment in the continent's disentanglement from its colonial rulers. One of the galvanizing events had taken place in the South African parliament in February where the British prime minister Harold Macmillan delivered his "Winds of Change" speech. Facing a recalcitrant South African House of Assembly dominated by stone-faced Afrikaner Nationalist Party apartheidists, Macmillan signaled the end of the British Empire in Africa and acknowledged that the Indigenous people of Africa were now determined to see the end of colonial rule. By September 17, African nations would be admitted to the United Nations as independent self-governing countries.

Although Kenya would not become independent in 1960—it was going through a legislative process that would see independence three years later—this transition period was a time of great optimism. The Emergency, as the white colonials called the fallout from the Mau Mau Uprising, was far behind them and relations between the emerging Black politicians and the retreating colonials was good. Nairobi was now a flourishing small African city, no longer the two-horse town that provided victuals to the coffee and tea farmers and hunters of Karen Blixen's time, but a center of merchandise and urban endeavor. And while the future of wildlife conservation was being hotly debated, hunting safaris remained the domain of wealthy and aristocratic Europeans and Americans.

In the summer of 1960, before starting his final year at Yale, Beard flew out to Kenya. He moved straight into the New Stanley Hotel and, employing the self-confident charm that would serve him well throughout his life, he began meeting Nairobi locals. One of the first people he encountered was Ruth Hales, an attractive young woman who was running the Ker & Downey safari desk at the New Stanley and who would organize Beard's first fully-fledged African safari. Ruth was about to marry Bill Woodley, the warden of Kenya's mountain parks, whom she introduced to Peter Beard. They would all become lifelong friends and it was Woodley, among all of Beard's long-standing Kenyan friends, who would stand by him when he plunged into verbal wars about conservation practices. And

it was Woodley, a former hunter and decorated game warden, who saw the value in Beard's creative thinking, encouraging his young sons Danny and Bongo to spend time with him and learn at his feet. "Dad used Peter as a barometer," says Danny. "When he was mulling over ideas he would always ask Peter what he thought. He used him as a sounding board because he thought differently."[6]

At around this time Peter also started hanging out at the Thorn Tree Café, named after the Naivasha thorn tree (*acacia xanthophloea*) that was planted in the middle of the outdoor café in 1959 and which, for decades, was the notice board for itinerant hunters, travelers, tourists, and local residents who would pass through there. The Thorn Tree was the place to meet in Nairobi and it was not surprising that within days of arriving, young Beard fell upon Douglas (Dougie) Tatham Collins, also known to his friends as Ponsumby, a well-known local hunting guide. Over drinks at the bar, plans were hatched for an epic safari that would explore Kenya's wild lands from Mount Kilimanjaro on the Tanganyikian (now Tanzanian) side of the border, Amboseli National Park and the great expanses of Tsavo East National Park in the south up to Makindu, and then through to the vast, underpopulated semidesert region of the Northern Frontier District that lies between the Tana River and the border with Ethiopia in the north and Somalia in the east.

After their meeting Beard went out and bought himself a secondhand Land Rover—actually it was fourth-hand and the odometer had been turned back—and a Mauser 98 bolt-action rifle from an elephant-control officer at the New Stanley's Long Bar. The initial plan was to take with them gun-bearers, skinners, and a cook, and strike out toward Somaliland, the neighboring country where Collins had once been district commissioner, and which held a special place in his heart. Just days before the pair were to launch into their safari, Somaliland was formally declared independent and changed its name to Somalia. The word went around Nairobi that the country might be better avoided for the time being, simply because in those early postcolonial days social unrest was expected to follow liberation from the colonial yoke. But the pair had been allotted the last ever visas issued by

the Italian consulate, the departing colonial rulers, and were raring to go. They decided to take a position once they had hit the road.

So, in separate Land Rovers, loaded down with staff and provisions, Beard and Collins headed toward Ol Donyo Sabuk, a mountainous region just eighty kilometers northeast of Nairobi where Karen Blixen had learned about local horticulture and Theodore Roosevelt had hunted hippopotami. It was here Beard met Josiah Mwangi Kariuki, popularly referred to as "JM," a prominent member of the Kikuyu tribe who, during the Emergency, had sworn a blood oath to Mau Mau. (A decade later Kariuki came to Beard's aid when he was thrown into Nairobi's notorious Kamiti Prison; he was later murdered in a political assassination and his body dumped near Hog Ranch.) They were guests of Major Ray Mayers on his coffee and sisal plantation, and for the first time, Beard came up against newly changed wildlife laws cutting off the Indigenous Kenyans from the wild animals that had, for eons, provided their nutrition and sustenance. Outrageously, locals were forbidden to hunt for food while the white colonials, in this case Dougie Collins and Peter Beard, were allowed to hunt because they were licensed gun owners.

There were some three hundred plantation workers who needed meat, so the two hunters went out early on their last morning to the river to shoot a hippopotamus. Armed with a .375 rifle, Beard took aim at the largest animal in the pod and squeezed the trigger. It was his first shot in Africa and as the hippo sank silently beneath the waterline, Beard said later he felt mute disappointment. It would take some hours for the gases in the hippo's stomach to expand, thus allowing its enormous body to rise to the surface, and when it did the eager plantation workers hauled it ashore and began cutting up the two tons of meat. Having fulfilled his role as a hunter, Beard now took to photographing the event, his graphic images revealing that the hippo he had shot was a pregnant female and the fetus lay abandoned beside the river because its tasteless meat was of no interest to the staff or even the dogs. The unborn hippo would eventually provide food for army ants. In the African bush, nothing is wasted.

Having fed the multitude, Beard and Collins headed south to Am-

boseli, the 150-square-mile reserve running along the Kenya-Tanganyika border that provides a most spectacular view of snowcapped Mount Kilimanjaro. Here the poetic images conjured up by Karen Blixen were made real, where "the cicadas sing an endless song in the long grass, smells run through the earth and falling stars run over the sky, like tears over a cheek." Now he realized he was, as Blixen wrote, "the privileged person to whom everything is taken." Later, Beard himself noted that "the mornings at Amboseli were the most beautiful I had ever known—cold opaque mornings when Mbuno or Morengaru [their two main manservants] would murmur some friendly Swahili and bring in the delicious coffee. This was the country of the Maasai—herdsmen, aristocrats, warriors, carriers of tall spears, drinkers of blood and milk, lion killers."[7]

In Amboseli, the pair had their first encounters with black rhinos, an animal that would later play a significant part in Beard's life. Their vehicles were charged several times by these powerful, aggressive, solitary animals that feature frequently in Beard's early photographs, symbolic exclamation marks of a disappearing wilderness. A full-sized bull rhino could tip a motor vehicle onto its roof with an economic flick of its head. What it could do to a fragile human was something Beard would find out more than two decades later.

Meanwhile, it is telling that in the heyday of Empire, when Blixen and the early settlers were celebrating the endless, teeming herds of wild animals roaming across vast plains, the numbers of wild animals around them appeared to be infinite. Just thirty years later, during this 1960 safari, the alarm bells were already ringing loudly about the decline of signature species, the black rhino being among the first. Beard and Collins were well aware that numbers were dwindling before their eyes and equally aware of incidents of mass slaughter that had taken place through the twentieth century. The Teddy Roosevelt safari in 1909 accounted for the killing of more than five hundred animals and although it was billed as a conservation mission, collecting important samples for the Smithsonian, Roosevelt at the time wrote that "game butchery is as objectionable as any other form of wanton cruelty or barbarity," and the slaughter seemed excessive.

There was even more disconcerting evidence of a massive decline in numbers. In the Makueni district, near where Beard and Collins were about to travel, there had been an unprecedented cull of black rhinos to clear the land for human settlements. In the twenty-six months between August 1944 and October 1946, 996 black rhinos were hunted and killed on government instruction to make way for the resettlement of a local tribe called the Kamba. In the end, but long after the event, it turned out that these lands were deemed unsuitable for human settlement. Such was the careless attitude the colonial settlers displayed toward wild animals that today are on the verge of extinction. Even at this early stage of his African adventure, Beard was gathering such experiences, writing detailed notes of what he was witnessing, and taking photographs that would contribute to his most celebrated book, *The End of the Game*. It may well have been here that the seeds were sown for his consistent, some would argue his most repetitive, refrain about the encroachment of Westerners, that "the deeper the white man went into Africa, the faster life flowed out of it, off the plains and out of the bush."[8] Even as a young American ingenue, Beard was becoming aware of the pending destruction of the wilderness and extinction of its species.

Before heading north toward the Northern Frontier District and the Somali border, Beard and Collins stopped off at the Makindu home of J. A. Hunter, one of the old colony's most famous white hunters. Here was a direct connection with the old days, the Kenya of Karen Blixen. Hunter had been friendly with the Blixens, although more with her husband, the hunter Baron Bror von Blixen-Finecke, than with the *Out of Africa* writer, and friendlier still with her lover, Denys Finch Hatton. And if Beard was enamored with the writings of Karen Blixen, he was completely seduced by the legend of Finch Hatton, who had come from a titled British family and was educated at Eton and Oxford. Just like the rebel American Beard, he was a lifelong nonconformist who had escaped to wild Africa to shake off his inherited shackles.

Although Finch Hatton lived with Karen at her farmhouse intermittently for more than four years, he refused to commit to her emotionally

and would disappear for long periods without explanation. Most of the time he was out hunting with the likes of Philip Percival, J. A. Hunter, R. J. Cuninghame, legendary hunters all, and even with Bror Blixen, who at the Muthaiga Club would introduce Finch Hatton as "my friend and my wife's lover."

It is easy to see how Finch Hatton became the young Beard's hero. Described by his biographer Sarah Wheeler as "vital and restless, and in his apparent paradoxical fusion of the rebellious and the traditional he was a curiously 18th century figure," he was also "elegant and boisterous, simple and sophisticated, with a gift for gracious living and for the parsed existence of the wilderness." Wheeler could just as easily have been describing Peter Beard, except in Beard's case he would have been a curiously nineteenth-century figure.[9] All of Finch Hatton's traits applied equally to Beard and one more beside: the sense of freedom he found in the air, flying his Tiger Moth across the African plains, made him feel more imprisoned by his relationship with Karen Blixen, who recognized this and said that he had the character of an Ariel and that "there is a good deal of heartlessness in this temperament."[10] As friends and lovers would discover as Beard's life unfolded, he was not above turning his back on those who had trusted him with their loyalty. (Beard revealed his attachment to the Finch Hatton legend in Montauk one winter to the writer Jon Bowermaster. He was driving a red BMW at the time and pointed to the number plate saying: "I really wish I had requested a DFH license plate.")

Bror Blixen and Denys Finch Hatton would have been the first to admit they were not the finest professional hunters of their time. Cuninghame, Hunter, and Percival were all regarded as the best in East Africa but Hunter, who trained Finch Hatton, had the reputation as the finest shot of them all. Hunter probably shot more big game than any other twentieth-century hunter, much of it on government game control assignments, for as the tribal populations grew and new settlements were established where previously there had been just wild bushveld, the game department increasingly brought in professional hunters to cull wild animals and make

way for humans. Significantly, in his later years, Hunter, like so many of his kind, became a game warden and devoted his time to conservation.

At Makindu, J. A. Hunter told stories of the old days with great relish. He said he regarded leopards as the most dangerous of the predators, for they would often charge from less than ten yards away whereas lions more often gave signals from a distance that they were going to attack. Understanding animal behavior gave hunters those extra seconds to make the right decision. J. A. rather famously believed that every hunter passed through three stages: first, the nervous stage, then the cocky and somewhat foolhardy stage, and finally the most sensible stage, which meant taking only acceptable risks. This was very apposite information for Peter Beard, who in incidents later in his life was often accused of being foolhardy, even reckless, and endangering not only his life but those of his safari companions. Plainly, he disregarded the great man's advice.

The photograph Beard took of J. A. Hunter just before they left Makindu is one of his most compelling early portraits. It is in black-and-white and shows an aging pioneer—Hunter died three years later—whose wisdom, experience, and the long road of life are all displayed clearly in his eyes. It is a dramatic portrayal of one of the last ghosts of a vanished Africa.

Beard and Collins finally split up after three months. They had stopped off in Garissa, a small town not too far from the Somali border, and there a clerk from the district commissioner's office delivered an official letter from Abdirashid Ali Sharmarke, the new prime minister of Somalia. It was an invitation to Collins, for whom Sharmarke had worked when he was a district commissioner, to visit the newly independent country and, most important, to hunt there. The offer was too good to resist. Having given his young companion clear instructions on how to get back to Nairobi, Collins disappeared in a cloud of dust.

On returning to Nairobi, Beard soon met up with Bryan Coleman, a friend and hunting partner of Dougie Collins, at the Thorn Tree Café. Within hours, another adventure was afoot, this time in Laikipia, a plateau some two hundred miles north of the capital that contains more than

two million acres of private ranch land between Mount Kenya and the Rift Valley. One of the largest cattle ranches in the area was Gilbert Colvile's 170,000-acre spread, occupied by twenty thousand Boran cattle. Coleman and Beard were hired to provide game control, which basically meant they were required to shoot wild animals that encroached on fields occupied by Colvile's cattle. Domesticated animals such as cattle were susceptible to tick-borne diseases carried by wildlife, so zebra, buffalo, and other plains game were their main targets, while cattle-killing lions were also in their sights.

As Beard would later recount in *The End of the Game,* this was hunting as a prosaic management tool and as far away from the macho romance of the big game hunter as you could get: "Stalking [the animals] required hard work and strategy. The stalks were long and low crouching, the approach slow, and the shooting had to be quick and usually from a considerable distance. For every zebra or buffalo, we had to walk about four or five miles. Relief lay in the daily bag counted up at dusk, and these totals ranged up to eighteen. The day of that triumph, I got sunstroke."

As with the Dougie Collins safari, Beard's time as a game control shooter in Laikipia was a tough, bare-bones, rudimentary African bush experience and the young American loved it. He and Coleman lived with skinners, trackers, and gun-bearers in a plain tented camp several miles from the comforts of the farm manager's house and spent long days out in the bush hunting the encroaching wild animals. Beard was young, lean, tremendously fit, and he was an extremely good shot, a skill he had learned as a young man growing up in America.

By the end of this extended sabbatical in East Africa—and he was required to return to Yale to complete his degree course—Beard had evolved into a hardened Africa hand, able to survive in harsh circumstances, live by his wits, hunt for his dinner, and remain mentally tough over long periods of isolation. Cheek by jowl with nature without a parachute. It forged a very particular character, one who had evolved rapidly from an East Coast trust fund kid to a naturalist, a conservationist, a hunter, and a man of the bushveld. And whatever dramatic, chaotic events were to be associated with Beard in the future—and there would be many—those

roots are the reason why Peter Beard will always be associated with Africa. His work, his passions, his reference points, all have their origins in the African continent, and they were formed in that short time in Kenya's disappearing wildlands.

4

Beginning of the End
of the Game

For America, 1961 was a tumultuous year. In January, John Fitzgerald Kennedy became the thirty-fifth president of the United States, and by April he and the country had been plunged into the Bay of Pigs debacle. At the same time the Russians had put the first man—Yuri Gagarin—into space, and he was followed a few weeks later by the first American, Alan Shepard. As the Cold War worsened, the USSR expanded its military influence and President Kennedy urged Americans to build fallout shelters. Cinemagoers were cramming into movie houses to see the hot new Hollywood films like *Breakfast at Tiffany's* and *West Side Story* and teenagers were swooning to the Shirelles' "Will You Love Me Tomorrow?" It was an age of angst and innocence.

Little of this mattered to Peter Hill Beard, who had turned twenty-three in January, and who had, later that year, graduated from Yale with the Class of '61. During the spring, he had taken the lead role in a quirky art-house movie called *Hallelujah the Hills,* which was directed by Adolfas Mekas. Among the film's more celebrated moments is a steady tracking shot of a naked Beard running through the snow, displaying his well-honed body with typical carefree poise. (His parents attended the premiere and his mother was so mortified at the sight of her rebel son's naked form appearing on the screen that she stormed out of the cinema.) The film was actually rather warmly received—*The New York Times* called it "the

wildest and wittiest comedy of the season"[1] and *Time* magazine rated it "a gloriously fresh experience in the cinema, the weirdest, wooziest, wackiest screen comedy of the year"—and for a brief moment in time it seemed that Beard might be destined for a career in cinema. But it was not to be.

By now Beard had developed a burning passion for Africa, more specifically for the continent's wilderness and wild animals. Those months living in harsh conditions, in remote, unforgiving wild lands, hunting both for food and for sport, and living alongside Indigenous trackers and hunters whose survival depended on finely honed instincts and an intuitive understanding of wild animal behavior had seduced him completely. In the time he spent with the African trackers working on game control in Laikipia, he enjoyed a camaraderie and friendships that were as strong as any he had made at school or university. These men—the calm, confident Larsili, who could follow lion spoor across granite outcrops; the peerless tracker Tereri, who knew every path, twist, and turn in the Lariak Forest; Galo-Galo Guyu, who could find water in a desert and who would become one of Beard's longest-standing bush companions; and the loyal Mbuno, who had worked for Dougie Collins in the bush but stayed behind with Beard at the end of that safari and remained with him at Hog Ranch until his death in July 1992—had all become fellow travelers. He learned tracking and hunting from them and formed bonds that would last a lifetime.

To these men, human qualities such as dignity and courage were more important than property and material wealth. They appeared to have a profound connection with the land, a quality that, Beard argued, we in the West had lost in the name of so-called progress. Throughout his life Beard was accused of being racist, accusations that were often founded on intemperate remarks he was inclined to make at the drop of a hat. And yet these strong ties to the Indigenous trackers and fellow hunters with whom he spent long periods of time in his early days in Africa, and his frequently repeated admiration for them, suggests he was anything but. One of his Kenyan friends said that rather than being a racist, Beard was in fact a misanthrope, an equal opportunities abuser of Homo sapiens who, in Beard's view, as a species were doing such a terrible job of looking after

the Earth. These days he would have more in common with Greta Thunberg than David Duke.

Although his film star good looks might have lured any other twenty-three-year-old American into a career in Hollywood, Beard's mind was now firmly fixed on returning to Kenya. As summer turned to fall, he began putting his plans into action. At the end of 1961, he headed back to Africa. However, on his way, thanks to an introduction from his cousin, the well-connected artist and raconteur-around-town Jerome Hill, Beard was able to arrange a meeting in Copenhagen with Karen Blixen, the fabled baroness whose maiden name was Dinesen and who wrote under the pen name Isak Dinesen. Frail and emaciated though the Danish author was in her last years, she still enjoyed receiving visitors at her home in Rungsted, located in a fishing village just outside the city. She was particularly fond of visits from young admirers, and she was keenly aware of Beard's matinee idol good looks.

She was seventy-six and, having contracted syphilis from her husband, Bror Blixen, soon after they were married in 1914, spent a lifetime suffering from ailments that were either a by-product of the disease or its radical treatments—regular doses of mercury and arsenic were the norm. Whatever the reason, and some believed her health problems were psychosomatic, she weighed little more than seventy pounds and had the appearance of an Egyptian mummy, her skin clinging to her skull like parchment. In her last years she was living on a diet of oysters and champagne. Beard described her appearance thus: "I can still see her Egyptian death mask of a face, with its refined nostrils and dry skinfolds. She had even taken to speaking of her great work as 'papyrus in a pyramid.'"[2]

When Beard arrived in Copenhagen, he headed straight for the Hotel d'Angleterre, as recommended by friends. Unfortunately, the desk clerk informed him, the hotel was full. Beard shrugged and was about to leave when the duty manager asked for his name. When he responded, the manager said, "Baroness Blixen has instructed us to reserve a room for you." As always, Beard's connections and his good fortune went hand in hand.

Having settled in he decided he would have to present himself correctly to the great author, so he visited the city's top tailor, Andersen Brothers (*Brodrene Andersen*), to have a suit made. On the appointed day he picked up his suit but, on his way out, his jacket brushed against the burning flame of a cigar lighter positioned at the shop's entrance and it caught fire. Although he managed to quickly extinguish the flame, he arrived at her house, Rungstedlund, in a somewhat disheveled state. Later in life, Beard would constantly celebrate the notion that accidents galvanized him and helped his creative juices flow; however, as a young American nervously approaching a meeting with his literary hero, arriving in a singed suit smelling rather strongly of smoke might not have been his best choice.[3]

He was led into an anteroom by Karen Blixen's secretary, Clara Svendson, and paced the room uneasily, waiting for her to arrive. Then he noticed some movement behind the half-open door and became aware that he was being watched. The baroness was carefully observing her young admirer and when she was satisfied with what she saw, she entered the room and introduced herself. They hit it off straightaway and soon fell into animated conversation about the key area of mutual interest—Africa.

What drew Beard to *Out of Africa,* apart from its clearly romantic evocation of a vanished continent that he had, by the time of their meeting, come to clearly understand and identify with, was the overpowering sense of darkness pervading the entire book. What he learned from this and subsequent meetings with the baroness was that this darkness was something she had carried with her since childhood. Karen's father, Wilhelm Dinesen, was a man of principle who died a dishonorable death by his own hand. He committed suicide at the age of fifty, when Karen was just ten years old, after it had been alleged that he'd fathered a child out of wedlock. But it was not the scandal that brought shame to the family, it was the manner of his death. In Denmark, to shoot oneself is an honorable method of suicide but to hang oneself is dishonorable. Wilhelm Dinesen hanged himself.[4]

During their meetings at Rungstedlund, they talked mainly of Africa and Beard showed the baroness photographs from his previous year's safari and also some of the notes he had taken during his time in Kenya, notes

that would soon become the core narrative of *The End of the Game*. She later expressed in a letter to Beard: "Very few could move me as deeply as your epitaph, or monument, over that Old Africa which was so dear to my heart—the continent of wisdom, dignity, and deep poetry, equally expressed in nature, beast, and man."[5]

They also talked about Denys Finch Hatton, about whom in a letter to her brother Thomas she wrote: "I believe that for all time and eternity I am bound to Denys, to love the ground he walks upon, to be happy beyond words when he is here, and to suffer worse than death many times when he leaves." Having already established friendships in Kenya with the likes of J. A. Hunter and the other big game hunters who had been close to Finch Hatton, Bror Blixen, and indeed Karen herself, Beard was thoroughly invested in those far-off days and, of course, shared her admiration for Denys. Even then young Beard must have been aware that his hero Finch Hatton was passionately independent and how, despite developing a strong relationship with Karen, right down to using her farmhouse as his home base for more than four years, he had always kept her emotionally at arm's length.

Finch Hatton was killed when his Gipsy Moth crashed after takeoff at the Voi aerodrome in May 1931. When the news reached Nairobi, a dark cloud of sadness enveloped the settler community, none more so than Karen Blixen, who later wrote: "For many years after this day the Colony felt Denys's death as a loss which could not be recovered."[6] For the two decades he had lived in East Africa, Denys had been the charismatic social lynchpin of Kenyan society, adored by almost everyone. He had been drawn to Africa by a strong desire for freedom and danger, neither being readily available to him in twentieth-century Europe. Half a century later, Peter Beard was to find himself lured to the continent for precisely the same reasons, unable to find such satisfaction in twentieth-century America, and he, too, would become a charismatic flame to which the social moths of Nairobi would be inexorably drawn. The similarities between the two handsome, well-bred young adventurers were not lost on Karen Blixen.

Beard and Blixen met once more at Rungstedlund in July 1962, just

two months before she died, and it was during that time he took particularly moving black-and-white portraits of her, which her biographer Judith Thurman said, "caught a depth and sadness she rarely showed, except in her prose." It was on this second visit that she gave Beard a letter of introduction to Kamante Gatura, one of her favorite members of staff at her Nairobi farmhouse in the 1920s. After her death, Beard located Kamante and invited him to live with him at Hog Ranch, his Nairobi property that overlooked the old Blixen farmhouse. By bringing the now old retainer into his life, Beard was able to maintain a spiritual connection to his literary heroine and a visceral association with the old Kenya she had inhabited.

On leaving Copenhagen after that successful winter visit, Beard headed straight to Nairobi where he was to meet Bill du Pont, an old school friend who he had agreed would accompany him on a walking safari through some of the country's most remote areas, hoping to re-create the adventures of the pioneers. Like Beard, du Pont was an excellent shot, so they would both be hunting for sport and for food. After a year softening up on the Eastern Seaboard of the United States, Beard was ready to return to the deep African bushveld. Within twenty-four hours of arriving in Nairobi, the two young Americans found themselves at the foot of the Nguruman Escarpment, a fifty-kilometer-long ridge that forms the western wall of the Great Rift Valley. There, they were introduced to their four trackers and gun-bearers, all members of the Waliangulu/Watha tribe. Two of them, Galo-Galo and Heekuta (whose father had been Bror Blixen's gun-bearer), had been employed by Bill Woodley during the Mau Mau Uprising, so both were peerless trackers. This was just what Beard was looking for, the opportunity to reconnect with the African wilderness with these trusty men at his side.

However, even by the time Beard and du Pont were taking this intrepid, bare-bones walking safari, hunting occasionally for the pot, occasionally for the sport, the world of the great white hunters was already over. Although Beard felt a young adventurer's romantic connection to the East Africa of Karen Blixen and Denys Finch Hatton, he knew in his heart that the waves of Western hunters that had poured out of Europe and North

America at the turn of the century had, in a spectacularly short time, all but emptied this vast wilderness. Even by this time the plains no longer teemed with the herds of elephant, buffalo, wildebeest, black rhinos, and all manner of ungulates that had roamed across Africa at the turn of the century. Things had changed dramatically in a short time. Theodore Roosevelt's 1909 safari alone had employed more than 250 African porters, used more than sixty tents to house this moving caravan, and had shot around 520 animals. And there were many others like it. Now, all that remained of those glory days, of the great hunting expeditions into the interior, were grainy, faded black-and-white photographs, diaries, and letters, many of which were illegible. The best connection with those far-off days was the recounting of great adventures around a campfire by the last surviving witnesses. So, it was with great anticipation and pleasure that the two young Americans welcomed Philip Percival, the most famous of the surviving great white hunters, to their camp for a few days.

Percival was known as the Dean of Hunters and had accompanied Theodore Roosevelt on that 1909 safari, had partnered with Bror Blixen and Denys Finch Hatton on safaris in the 1920s, and had guided Ernest Hemingway on his safaris in the 1930s. Percival and Hemingway became great friends, and the author based his character Jackson Phillips in *The Green Hills of Africa* on Percival. Another Hemingway character—Robert Wilson in *The Short Happy Life of Francis Macomber*—was apparently an amalgam of Percival and Bror Blixen, his "cynicism and womanizing" clearly being based on the Danish nobleman rather than the saintly Percival.

Percival, who was now eighty-four, stayed for five days with the young Americans and, like his friend J. A. Hunter the year before, anointed them with his campfire stories. One that particularly gripped Beard was the sport the hunters called "galloping lions" that was popular in the 1920s and '30s. At that time, Kenya's lion population was thriving. There were so many that they were a continual threat to cattle farmers and were, at times, regarded as vermin, so lion hunts were common. The sport was conducted in open country and involved hunters chasing down lions on horseback. They were only allowed light rifles—.256s or .275s—and chased until the

lion stopped to confront them. At this point, the hunter would dismount and face the lion as it charged, preferably from a kneeling position, which gave the rushing animal a smaller target. Although the odds were in the favor of the hunter, there were several occasions when hunter succumbed to lion. One such was Colonel George Grey, who was badly mauled by a massive male lion; he fired three rifle shots before the animal brought him down. He was shaken "like a rat by a terrier" and although Grey's fellow horseback hunters pumped many rounds into the lion, it had already all but killed the Colonel in the most brutal manner.[7] It was another salutary lesson for Beard about the power of wild animals.

Beard was equally fascinated by another set of stories that have resonated from Kenya for more than a century, the tales about the man-eaters of Tsavo. These were two massive maneless male lions that terrorized the construction workers on the railway line being built between the coast and Uganda, the so-called Lunatic Express. These two lions stalked the workers' campsite, dragging unfortunate individuals from their tents and devouring them noisily in the middle of the camps. The attacks went on for months and despite crews building increasing layers of protection—raging campfires during the night that would normally keep lions at bay, and six-foot-high thorn fences—they continued, even intensified their daily attacks. The lions seemed to become bolder, on one occasion seizing a man in the railway station, dragging his body back to the camp and eating him in front of his fellow workers. The renowned hunter, J. H. Patterson, who had been brought in to track the lions, recorded in his diary: "I could plainly hear them crunching the bones, and the sound of their dreadful purring filled the air."[8]

Finally, in December 1898, it was Patterson who shot the two lions, twenty days apart. He wounded the first, which began stalking him before he finally finished it off with a heart shot. It took eight men to carry the massive carcass back to camp. The second lion took eight shots before it finally succumbed. Although accounts vary widely, between 40 and 120 railway workers were killed and devoured by the man-eaters of Tsavo, and Patterson's long-awaited success was announced with great satisfaction

and relief by the British prime minister, Lord Salisbury, in the House of Lords. He told the Lords that "The whole of the works were put to a stop because a pair of man-eating lions appeared in the locality and conceived a most unfortunate taste for our workmen" and more prosaically couching Patterson's success in the formal language of the day: "It is difficult to work a railway under these conditions and until we found an enthusiastic sportsman to get rid of these lions our enterprise was seriously hindered."[9]

Given Peter Beard's fascination with death—*The End of the Game* is replete with animal carcasses in various stages of decay—it is no surprise that J. H. Patterson's dark tale of the man-eaters so gripped him that he included large excerpts from the lion hunter's diaries in the book and, almost gleefully, photographs of half-eaten humans.

As for Percival's other campfire stories, the two young Americans listened with respect and rapt attention as he reminisced "with the modesty appropriate to someone who had been elected to 34 consecutive terms as President of the Professional Hunter's Association."[10] Most important, Percival gave Beard a copy of Roosevelt's 1915 speech on wildlife conservation. Among many other observations, this declared that "when birds and mammals are left alone to reproduce at will within preserves it will ultimately be necessary to cull them. The foolish sentimentalists who do not understand this are the really efficient foes of wildlife and of sensible movements for its preservation." It was a message Beard would wholly and enthusiastically absorb on that 1961 safari and would hold aloft as a conservation banner for the rest of his life.[11]

The other conservation truth that Beard learned at this time, from old hunters like Percival and his Waliangulu trackers like Galo-Galo, was that however well-intentioned the colonial occupiers had been, once they realized that the wildlife was being shot to smithereens, they had created a protectionist system that was both unworkable and shamefully unfair to the Indigenous people. Across Africa they created national parks—Selous in Tanganyika in 1922, Kruger in South Africa in 1926, Wankie in Rhodesia in 1930 (called Hwange today), Tsavo in Kenya in 1948, and Queen Elizabeth Park in Uganda in 1952—that fenced in the wild animals and fenced

off the Indigenous people. Suddenly a harmonious relationship between wild animals and the local tribespeople who had lived off them for centuries was disrupted. The fenced parks were increasingly reserved for wealthy foreign visitors while the local hunters had become poachers. It was a toxic formula that would be at the center of Beard's conservation arguments throughout his life. Before the Europeans arrived in the nineteenth century, tribal Africans hunted for food and trophies on a scale that was comfortably sustainable, and the plains teemed with wild animals. After the arrival of these colonials, with their hunting safaris wiping out populations of wild animals and the spread of farmlands that encroached on ancient animal corridors, the balance was tipped in a matter of decades.

Beard and Percival shared the sentiment expressed in Roosevelt's message, identifying the deleterious effects on local communities of boundaries the government had erected around wildlife areas. As Beard later wrote: "discreetly located outside this boundary, in a sort of village-reservation near Voi, the Waliangulu became thoroughly accomplished alcoholics."[12] Not just the Waliangulu but other local hunting tribes, including the Wasanye, Wakamba, Wandaruma, and Giriama, had all been banished from lands they had occupied for centuries before the colonials arrived. Percival had also told Beard how the colonial government early in the century had banned the Kikuyu and the Maasai from performing their traditional dances, an edict that his friend Karen Blixen had railed against. In fact, she had encouraged the tribes to continue performing their dances in secret.

One passage from *The End of the Game* particularly summarizes Beard's bleak view of Africa in the twilight of its wild innocence: "There is another, more cosmic death mirrored in these pages. This is the shadow of the end—the end of nature's processes, patterns, cycles, balances: all equilibrium and harmony destroyed. As boundaries are declared with walls and ditches, and cement suffocates the land, the great herds of the past become concentrated in new and strange habitats. Densities rise, the habitats are diminished, and the land itself begins to die."[13] This was to become the underlying theme of Beard's rages against development, population

growth, and modern Homo sapiens' despoliation of wilderness, a view that was most assuredly formed on this safari.

All this time Beard was photographing and note-taking and accumulating information for *The End of the Game* and before Percival left the campsite he allowed Beard to take a portrait. This black-and-white photograph of the old hunter, his sad eyes looking unflinchingly into the camera lens, his expression one of resignation, is one of the most powerful, stirring images in his book. And as with his portraits of Karen Blixen and J. A. Hunter, it reveals Beard to be as accomplished a photographer of human subjects as he was of wild animals.

* * *

By the time Karen Blixen died, in September 1962, Beard was commuting between Africa and New York. His commitment to Kenya was fully realized when he bought a forty-acre plot of riverine forest that looked out at the Ngong Hills, so loved by Blixen, for $20,000 from Mervyn Cowie, the founder and the first director of Kenya's national parks. There was some surprise at first that a foreigner had been given permission to buy such a large tract of land and Beard and his Nairobi lawyers were obliged to apply for parliamentary exemption. Certainly, Beard's argument that he was planning to turn the property into a creative colony for writers, artists, filmmakers, and photographers won the day. It was clearly an exaggeration of intent, but it most likely saw off any opposition to the idea of a rich white American owning property in an emerging independent African country. Nairobi was a city in flux at a crucial time in Kenya's transition, so the promise of international celebrity artists swirling around the brand-new African capital was probably enough to close the deal.

The newly named Hog Ranch was a wild expanse of land that sat on a ridge overlooking the Mbagathi Forest and the Maasai Mara Plains with a view of the Ngong Hills to the west. This gladed bush camp in the suburbs was to become Beard's African home and retreat, a haven that he created, as he said, "so that I was never off safari, never indoors or far from a glowing

campfire." It was visited regularly by ungulates—giraffes, waterbuck, bush-buck, sunis—as well as smaller buck such as dik-diks, and the occasional larger predators such as leopards and hyenas. The most prominent visitors were of course warthogs, after which the ranch was named, and the most prominent of these was Thakar I, a three-hundred-pound monster with razor-sharp ivory tusks that ruled the domain for many years. (A succession of warthogs, named Thakar II, III, and IV lived on Hog Ranch in the following years but none had the sheer power and authority of Thakar I.)[14]

Although during Beard's more than forty-year tenancy Hog Ranch would be increasingly embraced by Nairobi's sprawling suburbs, in those early days it was remote, a safari camp twelve miles from the city center lying along an unmarked track off the red-dirt Mukoma Road. A kitchen tent and a green canvas mess tent were located up against a wall of thick bush that was marked by the floral canopy of a Cape chestnut tree. In front of the mess tent bare tree trunks were arranged, encircling what would become the permanent campfire, the famous salon-in-the-bush where, over the following decades, African politicians, wildlife conservationists, Hollywood film stars, international diplomats, and some of the world's most beautiful fashion models would gather. If Beard was in town, you really wanted to be sitting around the Hog Ranch campfire drinking cocktails, smoking spliffs, and arguing about the state of the world.

By the time that Karen Blixen died, Beard, ever the ultra-charming serial networker, had been working the room in Nairobi. He had met the Hollywood actor William Holden, who was out filming *The Lion,* at the Mount Kenya Safari Club; the well-known real-life Kenyan hunter Glen Cottar, whose family would become firm and loyal friends throughout his turbulent decades in Kenya; and David Sheldrick, the soon-to-be warden of Tsavo. This multi denominational amiability would define his life for decades to come. His WASP access to the rich and famous from America would also give him social standing in Kenya while his ever-deepening African roots would allow him wildlife credibility in America's fast-moving hip 1960s society. In early 1963, he did his first shoot for *Vogue* magazine—using Veruschka, the famously statuesque German

model, and his then girlfriend, the German actress Astrid Heeren—and so impressed was Condé Nast's imperious editorial director Alexander Liberman that he offered him a contract, thus elevating Beard's status as a fashion photographer alongside such *Vogue* names as Richard Avedon and David Bailey.

It was at this time that Beard's cousin Jerome Hill, whom he had photographed while he was still at Yale, in Cassis at his château with Brigitte Bardot, landed in New York and immediately began drawing Peter into his circle of friends. He introduced his young cousin to Mary Hemingway who in turn introduced him to Salvador Dalí. One winter's morning in 1963, Dalí, as was his wont, set up an artistic event in the streets of Manhattan and Beard ended up photographing the Surrealist with the model Nena von Schlebrügge (Uma Thurman's mother) draped over a car on Fifth Avenue outside the Metropolitan Museum. Days later Jerome introduced Peter to his friend Andy Warhol at a private screening of Jean Genet's banned homoerotic short film *Un Chant d'Amour*. The young African adventurer was now fully straddling two culturally opposed worlds, and feeling perfectly comfortable in both, quite a feat of social adaptability.

As significantly for his long-term reputation as an Africa hand, Beard was completing work on *The End of the Game,* a project he had started in 1955 with his first trip to the continent. He had been given an advance of $750 from Viking Press for the book before expenses, an amount that he rightly regarded as risible for an undertaking that would take the better part of a decade to complete. However, the reputational benefits of this work would far outstrip the paltry advance, starting with a rapturous review in *The New York Times* which described it as "a first-class piece of work which all Africanists, animal lovers, and photo buffs will want to own."

The most dramatic aspect of the book was Beard's powerful black-and-white photography of wild animals, often apparently charging at full pace toward the photographer. Beard was already acquiring a reputation as a devil-may-care, some would say reckless, wildlife photographer and the evidence was here that he was prepared to place himself in particularly

dangerous situations to achieve the results revealed in *The End of the Game*. Many of these photographs would become recurring images in Beard's later artwork. Two in particular—of a charging black rhino and of a male lion in full attack mode—are among the most dramatic ever taken of animals in the wild. And there were, as the critics pointed out, many photographs that recorded death, either of animals that had been killed or skinned or were in the process of dying. It was an echo of the darkness Beard had been so drawn to in Karen Blixen's *Out of Africa,* and he was unapologetic about it.

However, if the photography was arresting and eye-catching, the text was vivid, prophetic, and profoundly pessimistic. Nobody was spared, not even the colonial hunters who Beard admired for their ruggedness, bravery, and marksmanship: "But if the white hunters and poachers of the early days cannot be held responsible for the end of the game, neither can they be totally absolved, for it was certainly with them that modern poaching entered into the bloodstream of African life."[15]

Peter Beard may not have been a diligent enough conservation scientist for most Africans' taste, but he was intuitively right about so many things that he was hard to ignore.

5

Conservation Wars

The publication of *The End of the Game* in 1965 elevated Beard's status in America from trust fund roustabout to prophetic, if doom-laden, conservationist. The book had a more mixed reception in Kenya, where he was now spending a great deal of time. His closest, most well-established friends—mainly Bill Woodley, the highly respected warden of Aberdare National Park; David Sheldrick, the more controversial warden of Tsavo East National Park; and Glen Cottar, whose family were among the earliest and best established of the Kenyan hunting clans—remained loyal. However, others—even friends—attacked him for portraying East Africa in such a pessimistic light. One such, Tony Archer, who would remain close to Beard until he died, railed at him out in the open in the New Stanley Hotel, asking how he dared write a book claiming that hunting was over when he himself was "not a hunter, but a neophyte. What do you know about our business?"[1]

As Beard had proved, he did know something about it, having hunted and trekked and camped out across East Africa for some years, assiduously taking notes and photographs on his journey. But white East Africa, like the rest of colonial Africa, was in retreat and there was a prickly defensiveness among the expats who were fast losing their privileged positions. Having been buffeted and forced to relinquish control of the colonies by the "winds of change," as Harold Macmillan had so prophetically put it, these sons and daughters of the colonial pioneers were understandably touchy

about outsiders such as Peter Beard flying in and telling them what they should and shouldn't be doing. Even worse was to predict their futures.

The same applied—even more so—to the white conservationists who were conducting philosophical wars among themselves as they have continued to do for decades since; scientists versus field guides, abolitionists versus consumptive use (i.e. hunting) advocates, pro–game control versus laissez faire, let-nature-take-its-course advocates. Wildlife conservation in East Africa at the time of *The End of the Game* was a rough neighborhood of highly strung, highly committed combatants, many with big egos, all with unshakeable convictions about how to save the precious, diminishing wildlife legacy. And yet for all the controversy his book stirred up, Beard was, during the mid-1960s at least, on good terms with all these players.

Bill Woodley, probably the most widely respected of them all, was Beard's closest friend. Woodley had taken on the job of junior assistant warden of the fourteen-thousand-square-kilometer Tsavo National Park in 1948, at the young age of nineteen. As a teenage Kenyan hunter, he had shot ninety elephants for ivory in Mozambique before joining the ranger staff. By late 1952, he was serving in the British Army in the Aberdares, dealing with the Mau Mau Uprising, along the way winning the British Military Cross for bravery and forming alliances with trackers who, in later years, would serve as his anti-poaching operatives. According to the author Alistair Graham, Woodley was "an exceptional man. He could see it all and was usually unprejudiced about everything. His inspired use of former desperadoes—ex-Mau forest freedom fighters—as the nucleus of his ranger force and many other subtleties are a classic of game preservation."[2]

Another major player in Beard's African life was David Sheldrick, the son of a coffee planter, who was ten years older than Woodley and, as the first warden of Tsavo National Park, briefly his boss. Sheldrick was behind the development of Tsavo, a wilderness area twice the size of Yellowstone National Park. He established the park's infrastructure—there were no roads or buildings when he arrived—and was responsible for building a road network of more than a thousand miles for tourists and man-

agement within the park boundaries. Although Sheldrick had originally advocated culling and population control, he later changed his mind and stood vehemently against this practice.

Two other conservation players—Ian Parker and Alistair Graham—would also have a significant influence on Beard's African days. Parker was two years older than Beard and had also served in the army during the Mau Mau Uprising in the early 1950s, becoming a game warden with the Kenya Game Department in 1956. Quite early on, as Parker himself explained, he "broke ranks and advocated allowing the Watha people to hunt rather than treating them as poachers." This philosophical stance led to the creation of the Galana Game Management Scheme in 1960, arguably the earliest and largest community conservation project in Africa.

After eight years as a game warden, Parker resigned in 1964 and, with Graham, started Wildlife Services, which between 1965 and 1969 was to become known internationally for undertaking large-scale elephant culling operations in Uganda, Kenya, and Tanzania. The Ugandan operations had been initiated by the Cambridge University–educated scientist Dr. Richard "Dick" Laws, who was director of NUTAE (the Nuffield Unit of Tropical Animal Ecology), whose operations had been so successful in the country's Queen Elizabeth National Park that the government had asked him to extend it to Murchison Falls National Park. Laws designed an ambitious project to remove three thousand hippos and two thousand elephants from sample areas of the park to determine the effects of habitat recovery and to set in place permanent scientific management of Murchison. Laws's operation was to work in cooperation with the Ugandan director of parks and warden of Murchison, Roger Wheater, who agreed wholeheartedly with Laws that scientifically directed culling would not just maintain animal numbers at desired densities but would, most important, engage the local communities in commercial activities that would incentivize them to support wildlife parks and help conserve the wildlife.

Laws thus contracted Parker and Graham's Wildlife Services to carry out the task and, under Laws's tutelage, Parker was to become one of the

leading authorities on elephant biology at the time.[3] It was during this period that Beard pleaded with Parker to let him participate in the shooting of the elephants, pleas that at first Parker resisted, suspecting that the wild young American would provoke some sort of accident if he got involved. At this point Beard's friend Alistair Graham, a highly qualified academic with an honors degree in zoology and a master's degree in ecology, spoke up for him, telling Parker that Beard had promised him he would behave himself. Parker relented and for almost a month Beard joined Parker, Tor Allan, and Lionel Hartley culling elephants in Uganda.

The Murchison operation went very well, and Laws was particularly pleased with the response of the local community, whose consumption of hippo and elephant meat had persuaded them of the benefits of living alongside these wild animals. It was so successful that Kenya National Parks decided to introduce a similar program in Tsavo National Park, and invited Laws to take over as director of the Tsavo Research Project in Kenya, with a view to controlling elephant population numbers there. At a time when the Tsavo elephant population numbered anywhere between thirty-five thousand and forty thousand (population counts were less reliable in the 1960s than they are today), Laws again contracted Wildlife Services to carry out an initial cull of three hundred elephants taken from a single herd of three thousand. When he requested that a similar number be culled from each of Tsavo's other nine elephant herds, Sheldrick, who had initially endorsed the research project, joined the many objectors, and persuaded Kenya Parks to veto any further culling of elephants. As this meant that one of Laws's key ecological objectives—habitat management—would be quashed, he decided to resign his position and leave Kenya immediately, much to the consternation of Parker, Graham, and Peter Beard. Laws predicted that by avoiding the culls he requested, there would be an overpopulation of these voracious herbivores: basically, that they would eat themselves out of house and home. At that time, Tsavo teemed with game, not only massive elephant herds but also a black rhino population in excess of eight thousand. As Ian Parker later noted, "Three years after returning to Cambridge the Tsavo crash [Laws] predicted happened. More than 15,000 elephants died of starvation to be

followed by a wave of poaching and a population of around 38,000 elephants fell to around 8,000."[4] Today that population numbers around 10,000.

As Beard often observed, the abandonment of Laws's program was to be a key moment in Kenya's wildlife conservation philosophy and would lead indirectly, a decade later, to the outright banning of hunting. Until then, Kenya and the major southern African countries with large wildlife populations—South Africa, Botswana, and Rhodesia—broadly agreed that wild animals should pay their way. In other words, in the competition for land use between commercial farming and wild habitats, the argument was, and remains, that the country and local communities must reap benefits from living alongside dangerous and destructive wild animals. And that these benefits are more tangible and measurable than the mere aesthetic pleasures of wild animals that are so vigorously supported by Western wildlife conservation activists.

Although Beard was no conservation scholar, his time spent with the likes of Parker, Graham, and Laws greatly influenced his wildlife management thinking and he was smart enough to absorb the collective wisdom they were imparting. First, he could see that the colonial system that turned Indigenous hunters into poachers was not only morally wrong but also led to an environmental imbalance that scientists and politicians would spend the rest of the century trying to correct. In the years to follow, Beard would frequently speak out on this issue, telling one documentary filmmaker, "The problem with African wildlife is that we're pressuring it, squeezing it into impossible tight environments that don't work. There's no balance."[5] It is a problem that has cursed Africa to this day, only in recent years well-funded Western animal rights lobbyists have gained the upper hand and re-created the Tsavo problem across the continent. For example, in South Africa's Kruger National Park, that country's largest fenced reserve, scientists estimate that the ideal carrying capacity to maintain a balanced ecosystem is seven thousand elephants. Today the number in Kruger is more than 21,000 and as one ecologist said, "If you choose to leave the elephant population as it is you will end up with no forests."[6] As the Tsavo elephants did in the early 1970s, they will eat themselves out of house and home,

and this was what Beard meant when he coined the expression "Starvo," employing typically smart and deadly accurate wordplay.

After finishing work on *The End of the Game,* Beard headed straight back out into the bush with cameras and notebooks. His friend Bill Woodley, the warden of Aberdare National Park, had some years back given him permission to build a log hut in the middle of the rain forest, from where Beard and his trusty companion Galo-Galo operated for several years throughout the park. Set next to a waterfall, the hut was stocked with standard Beard safari supplies—food (inevitably the ungodly combination of Ritz crackers, Hellmann's mayonnaise, and bread-and-butter pickles); cameras (by now he was using Leicas); boxes of Tri-X film; and the glue, scissors, pen, ink, magazines, newspapers, and the rest that make up the components of his diaries. When he wasn't out pounding through the dense Aberdares forest landscape, he would be spread across the floor of his hut gluing, scratching, inscribing, and occasionally bleeding over pages of his ever-thickening diaries. These diaries are regarded by many critics as Beard's most important artistic contribution and the powerful, jammed, moment-to-moment intensity of the pages has been widely imitated over the years. He had begun constructing his diaries as a boy and filled them daily for the rest of his life although when asked about them, he would be offhand and often dismissive. Referring to these diaries, he told the journalist Edward Behr: "I am very petty. A small mind with a large scrapbook. I've never thought too much about it, it just accumulates, a little like dirt." He also told Behr that putting the diaries together is "like an addiction. It is because I am insignificant, for someone like me who does not know what to do with himself, it is a distraction."[7]

His regular traveling companion was now Galo-Galo Guyu, born in Voi and from the Waliangulu/Watha clan, the famous elephant hunters who had, for centuries, roamed the 14,000 square kilometers that is now Tsavo National Park. He was a traditional hunter; their arrows contained enough poison to kill an elephant seventy times over. They were known

as "the people of the long bow" but during the 1950s, their control over their traditional tribal lands had gradually been taken away by the colonial authorities, leaving many of the Waliangulu, in the words of one colonial observer, "as drunks and wasters." Galo-Galo was one of the first trackers Bill Woodley employed during the Mau Mau Uprising. Beard once said "watching him was my education in the bush. On safari there was no better companion."[8]

There was something else about the Waliangulu/Watha that caught Beard's attention. One of the most enduring clan myths is that humans and elephants are related, and this was something that would become one of Beard's oft-repeated mantras. There is a story about a Watha hunter preparing to go out and hunt elephant and being warned by his cantankerous and pregnant wife that if he did not come back with a big game animal for the table, he need not return. Unfortunately, he had a poor day in the bush and came back with but a dik-dik and a wild hare. His wife flew into a rage and as she shook her head violently, her ears grew, her teeth grew into tusks and as she threw her head back, she began trumpeting. Years later she was seen in the bush with a calf, and sometime after that the hunters noted a new herd led by a matriarch that resembled the woman. The tribe's elders declared these new elephants were a gift, a message from the gods, and ordered that they should not be hunted. Since then, it was said, that although the Watha continued to hunt elephant, they accorded them the respect reserved for relatives. Sustainable hunting with an eye on the survival of the species. Then the colonials arrived. Peter Beard embraced such African legends with open arms. It had a mythical story arc that appealed to the artist in him, although his attempts to justify it in terms of the biological sciences espoused by his friends Parker and Graham were, at best, regarded as risible.

It was around this time that Glen Cottar was seriously gored by a buffalo in Tsavo and was rushed to Nairobi hospital. Among his first visitors were David Sheldrick and Peter Beard, and as the old friends sat around commiserating with the injured Cottar, Sheldrick began mocking Beard

about spending so much of his time in the lush jungles of the Aberdares. "What's the matter with you, Peter?" asked Sheldrick. "Are you too soft to take the heat in places like Tsavo?" When Beard rose to his challenge, Sheldrick, as the park's warden, gave him full access, which meant he could wander far and wide without supervision. It was an unusual permission, but these were the days when such informality was commonplace. Beard began spending extended spells in Tsavo, with the trusty Galo-Galo by his side.

As far as African ecosystems go, the Aberdares and Tsavo occupied opposite ends of the spectrum. The former is a dank, mountainous area of steep forested ravines and craggy peaks that rise to 13,000 feet above sea level, while Tsavo is a low-lying endless plain, baked by the sun, once home to one of Africa's largest elephant populations, and now, thanks to the thorny thickets and a preponderance of plains game, an area where the Tsavo lion population has flourished. These are not your picture-postcard, easygoing lions that tourists find in the Maasai Mara reserves. These are the descendants of the Man-Eaters of Tsavo, the big, mean lions that terrorized those construction workers on the Kenya-Uganda railroad and, as their name suggests, ate many of them.

* * *

Peter Beard, of course, was no stranger to close encounters with wild animals. In fact, it was a criticism that was constantly turned into accusations of irresponsibility, leveled at him by both friends and enemies in the wildlife community. Most of these men of the bush would maintain that they studiously avoided taking risks with wild animals, and their experience and profound knowledge of animal behavior confirmed the wisdom of this position. Unfortunate encounters—lion attacks or elephant charges—occurred infrequently. Beard was, however, a known risk taker, a chancer who almost seemed to welcome accidents, which was why Ian Parker had been reluctant to take him into Murchison in Uganda.

There were numerous encounters where Beard's lust for excitement, danger, and accidents seemed to overcome any lingering instincts to avoid confrontations with animals and walk away unharmed. He gleefully told Jon Bowermaster, author of 1993's *The Adventures and Misadventures of Peter Beard in Africa,* of one such confrontation while he was on his monthlong elephant culling trip with Ian Parker and Lionel Hartley in Murchison Falls National Park. Beard said to Bowermaster that he had found himself shooting photographs of the cull from the other side of the hill the two men were firing from. Quite suddenly, a large bull elephant appeared, charging over the hill straight at Beard. He stood his ground and the elephant kept on coming. Fortunately, Hartley, who was a good hundred yards away, saw the elephant, took aim, and shot the bull with deadly accuracy. The animal came to a sudden halt and fell dead just ten feet short of Beard. Apparently unmoved by his imminent skewering, he waved his arms at the distant Hartley, not thanking him for saving his life, but for shooting too soon. He said he wasn't ready to run.[9] As with many of Beard's stories, this may well have been a fabrication, particularly as Parker had received assurances from both Alistair Graham and Beard himself that he would behave. "I have never heard of that incident," Graham told me. "And if Ian Parker had known he would have said so. If the story is true, I suspect that Peter provoked the attack exactly as we all knew he was likely to do, and Lionel prevented the accident from happening. Peter would have persuaded Lionel not to mention the incident to Ian. But who knows if it actually happened?"[10]

All this time Beard had remained close to David Sheldrick and his wife, Daphne, even living at their Tsavo home for some time. He felt part of the family, equally part of the great national park's ecosystem, and as he and Galo-Galo tracked lion prides and elephant herds in Tsavo, within walking distance of these wild animals, Beard assumed the freedom he was enjoying had the blessing of the warden and his staff. After all, as far as he was concerned, he carried Sheldrick's blessing and special permission to operate freely in Tsavo.

Then suddenly, early in 1966, a rift developed between Sheldrick the warden and Beard the photographer. It blew up into confrontation when a park ranger found Beard's Land Rover empty on the side of a track early one morning. He immediately contacted Sheldrick's office and the warden, fearing the worst, ordered up light aircraft reconnaissance. When Beard and Galo-Galo strolled back to their vehicle after their long morning walk, Sheldrick reportedly became enraged and ordered them out of the park. While Sheldrick maintained Beard should have stayed close to his vehicle and certainly should not have remained in the park overnight, Beard claimed that his permissions from the chairman of the board of trustees had allowed him to walk in the park at his own discretion. In the end, the fallout, which was never repaired, defined the stubborn characters of the two men—one rebellious, anti-authority, free-ranging, unpredictable and the other protective, possessive, and authoritarian about a park that he had created and that he increasingly regarded as his domain.

Beard had more luck in the remote northern expanse of Lake Rudolf, as it was called then, Lake Turkana as it is today. Here was a far-flung wilderness on the edge of the Rift Valley, the world's largest desert and the world's largest alkaline lake, a furnace of a place where the air temperature and the surface water temperature generally ranged between 81 and 88 degrees Fahrenheit, and sometimes on land it would get up to 120 degrees. This is about as far from the pretty, photogenic Africa that you can imagine, a wild, ungodly place where massive populations of Nile crocodile survive outside the reach of man.

It was here that Alistair Graham established a camp for two years to study crocodile behavior and biology. The project was a hand-to-mouth affair that Graham and his partner Ian Parker had initiated at the invitation of the Game Department (later renamed the Kenya Wildlife Department) in which the scientists would conduct the first ever study of a population of Nile crocodiles. To pay for the study, Graham was granted a tranche of five hundred crocodiles to be shot, whose skins would be sold on the open market. He would be required to get a certain number of skins to Nairobi every month in order to receive cash for the next month's study.

Graham was halfway through the project when he bumped into his old friend Beard, who he knew was an outstanding marksman, and invited him to Lake Rudolf to help with the required shooting.

This harsh, remote landscape is located on the floor of the Great Rift Valley, and the 155-mile-long lake is subject to violent storms, frequently creating turbulent seas and ten-foot waves. Minimal rain falls here, and while three rivers (the Omo, Turkwel, and Kerio) flow into the lake, the lack of outflow means the only water loss is by evaporation. Having once fed the headwaters of the Nile, the lake's aquatic fauna resembles that of the Nile Basin and it is full of giant Nile perch. Graham's rationale for the study was simple but typically quixotic: "It seemed to us that rather than abandon the world's last great crocodile population to the whim of man, to be exterminated in the name of inevitability, we might first enquire a little into their lives."[11] Incredibly, it was only recently that crocodiles had been reclassified from vermin to game animals.

Graham had arrived at Lake Rudolf on June 4, 1965 and spent the greater part of two years there. Beard made only two monthlong visits but later gave the impression that he, too, had been there for much of the two years. However, the pair did spend some time together in that remote place, hunting, dissecting and examining, studying and documenting the lives and deaths of these creatures, the longest surviving species on land, at 170 million years. And Graham conceded that Beard had been a great help hunting crocodiles, not least because they also had some time with the local Turkana people, who Graham wrote about eloquently and Beard photographed powerfully for the book.

The two men lived on the shores of the great lake in three locations (Alia Bay, Ferguson's Gulf, Moite). Their accommodations were rudimentary—a canvas canopy stretched over a metal frame, with sleeping bags placed on the hard ground. Food was equally fundamental, with fish they had caught providing the bulk of their meals supplemented by packet soup and Beard's *de rigueur* Hellmann's (supplied by Andy Warhol according to Beard, although this was probably nothing more than gratuitous name-dropping) and Ritz crackers, pickles, condensed milk, and tinned grapefruit. Although

there was obviously a surplus of crocodile meat, which the local Turkana tribespeople lived on as a staple, the pair found it disgusting. Beard described it as the worst meat he had ever tasted, with "an oily, pungent flavor however cooked, cut up, or disguised."[12]

Hunting crocs was quite a risky business. Much of it was done at night and the men had to get within fifteen feet of the animal in deep water in the dark. They had hoped to hunt from a boat but the high winds and choppy waters put an end to that. As a result, Beard devised a hunting method that involved him, covered in mud and pelican dung, floating up to crocodiles behind an inner tube on which he balanced his rifle. He and Graham were also inclined to leave their kills tethered in the water overnight, for if they brought them ashore, lions and hyenas would devour them while the camp was asleep. "Peter loved stalking the crocs," said Graham, "crawling along pushing that inner tube before him to fool his target. He was a natural marksman and never wasted a shot."[13]

Although Beard took photographs constantly, wrote copious notes and manically assembled his diaries, often through the night, initially neither of the men had considered writing a book or publishing an article about the experience. This had started out as a research exercise, pure and simple. However, Graham's impassioned text, which he would write up in New York a year later, and Beard's graphic, sometimes unsettling photography and instinctively arresting design, would later attract the attention of the New York Graphic Society.

Meanwhile, the conservation wars in Kenya continued to rage through the 1960s into the 1970s, with opposing parties taking increasingly bitter, polarized positions. Over the years, Beard was criticized by many in Africa for being alarmist without having the scientific background to support his claims. The expansion of the human component of Africa's population, with the attendant increase in domestic livestock, was his ongoing cri de coeur, and yet recent studies released fifty years after the publication of *The End of the Game* prove how prophetic a book it was. One academic paper, authored by a group led by Joseph O. Ogutu, a senior researcher in herbivore dynamics at the University of Hohenheim, published in 2016, noted

a striking increase in the number of sheep, goats, and camels, and a con-
current decline in numbers of fourteen of the eighteen common wildlife
species throughout Kenya's wildlands between 1977 and 2016. Sheep and
goat populations had increased by 76 percent while buffalo, giraffe, and
elephant populations had all fallen by about 50 percent. Zebra populations
had fallen by 73 percent, waterbuck by 68 percent, and eland by 60 percent.
So, Beard was right. We are indeed facing the end of the game.[14]

Beard's conservation gurus at the time—mainly Parker, Graham,
and Laws—while clearly holding relevant, scientific views on where
wildlife management should be headed, were increasingly marginalized.
After closing Wildlife Services in the early 1970s, Ian Parker worked for
a time as an independent consultant, and an ivory broker to govern-
ments and businesses, but eventually retired and moved to Australia,
as did Alistair Graham. Both men had become disillusioned with the
divisive, ego-driven conservation wars. Scientists across the continent
agreed they were a great loss. Dick Laws rejoined the British Atlantic
Survey, where he had worked before his African sojourn, as head of
its life sciences division, and in 1973 succeeded its founder-director,
the explorer Sir Vivian Fuchs. Under his directorship, BAS scientists
discovered the ozone hole in the Earth's atmosphere and he has since
been celebrated as one of modern science's most important innovators.
In 1978, Dick Laws threw himself into one final engagement in the
African conservation wars. In a letter to the editor of *Swara,* a Kenyan
environmental magazine, he heaped lavish praise on the second edition
of *The End of the Game* and wrote: "It is with a great sense of déjà vu
that I read the cunningly slanted review by Harvey Croze [a respected
Kenya-based ecologist who was highly critical of Beard] of Peter Beard's
brilliant book, for it was with such arguments that my work was at-
tacked ten years ago and with just such a dearth of evidence." He ended
by saying that nothing seemed to have been learned from past mistakes
and that "Beard has done a service to the cause of conservation by (in-
conveniently) making a pictorial record which will continue to remind
us that mistakes have occurred. This is his crime."[15]

So, Africa's conservation wars raged through the second half of the twentieth century—and continue to rage unabated today.

* * *

Whenever he was in Nairobi, the New Stanley Hotel remained one of Beard's chosen locations and in 1965, just as *The End of the Game* was being published, he met up there with a young American woman who swept him off his feet. While Beard was used to being in the company of striking females, there was something special about Mary "Minnie" Cushing. An East Coast society beauty from an old Newport, Rhode Island family, Minnie was called "society's girl of the year" by one glossy magazine and described as having "fashion model dimensions and traffic-stopping loveliness" by another. She had been on safari to Kenya before and had met Beard in passing, but this visit had come about because her father had been in the bush with friends and had contracted cerebral malaria. So, Minnie and her mother had flown out to rescue the ailing father. And on one evening Jack Block, who owned the Norfolk Hotel and who the Cushings regarded as Mr. Nairobi, persuaded Beard to bring Minnie to dinner at his house. Beard pounced, and so charmed was Minnie that, she says, "I decided to stay on . . . for a couple of months."

At this time, most Western visitors to Kenya were struck by its other-worldliness, the old-fashioned quaintness of Nairobi, the unpaved roads, the exotic expanses of wilderness right on the small town's borders, the wild animals that ventured into the suburbs. So it was with Minnie, but she was also enchanted by this high-octane young American who looked like a 1950s Hollywood film star and dressed like a down-and-out. His explanation for his scruffy appearance—that he'd just come out of the wilderness after a long safari—made him even more appealing. Pretty soon they were the glamour couple of Nairobi, "Tarzan and Jane" as one friend described them.

Over the following year, Minnie accompanied Peter on trips between Kenya and New York and even once to Copenhagen, when the couple

smuggled into the country a bushbaby (night ape) they had rescued at Hog Ranch, conveniently ignoring the charismatic animal's bad habits, e.g., ripping up the hotel's curtains and peeing everywhere. On the surface, at least, it seems that Minnie had bought into her new beau's spontaneous, chaotic, unconventional style of life. The African dream.

6

Salon in the Bush

On April 12, 1967, Peter Hill Beard and Mary Olivia Cochran Cushing, daughter of Mr. and Mrs. Howard Gardiner Cushing, one of Newport's oldest families, were married in an elaborate, no-expenses-spared wedding at Newport's historic Trinity Church. It was attended by more than four hundred members of society's elite, and all the right newspapers and magazines. The bride wore a long white Oscar de la Renta dress, which the designer himself had brought to Newport. Among the ushers on that misty afternoon was Alistair Graham, Beard's close friend from the crocodile safari at Lake Rudolf. The back row of the church was reserved for the household help from the Ledges, the Cushing family home, where the reception was held.

After the service, party guests were treated to traditional dancers from the Congo before settling down to the more conventional sounds of the Peter Duchin Orchestra. When the moment came for the bride and groom to take to the dance floor, nobody could find the groom. A quick search revealed him to be out on the rocks at the end of the property in intense conversation with his friend, the avant garde filmmaker Jonas Mekas. Beard had brought Mekas in to record the event and was discussing scenes, dialogue, and other technical matters away from the reception hubbub, including a planned dramatic moment to come when, as the climax of the film, the bride and groom would dive into the sea and swim off toward the horizon. However, the bride had not been consulted and the theatrical finale to the Newport wedding was duly abandoned.

Instead, the groom and bride departed by helicopter, on their way, according to *Vogue,* "to the Bahamas, to Europe, and eventually to Nairobi, where they will live." It all seemed like a fairy tale, albeit a conventional, moneyed, high-society East Coast fairy tale, the likes of which the rebel Beard had been denouncing for the past five years. As a disciple of H. L. Mencken, Beard was wont to quote extensively from the 1927 essay *The Libido for the Ugly*, and was particularly taken by the line "the love of ugliness for its own sake, the lust to make the world intolerable; its habitat is the United States." He fully believed, or so he said to anyone who would listen, that the society he had grown up in was responsible for many of the ills of the modern world. This was but one of the many dichotomies of his life. He frequently railed in vigorous, vituperative rants at modern American society, how it was despoiling the planet and polluting the atmosphere, and yet there he was in the belly of the beast, enjoying all the benefits of his privileged upbringing, now enhanced by his marrying even further up the social ladder.

In fact, the couple's much trumpeted honeymoon in the Bahamas lasted just forty-eight hours. "We stayed one night in Nassau," Minnie remembers, "and we packed up and left. We hated it." Instead, they flew to Paris and then briefly to Cassis before taking a cargo boat to Mombasa. "And from Mombasa we took the train to Nairobi," says Minnie. "It was called the Snake from the Coast. It was great to be back in Africa."[1]

On his return to Nairobi as a married man, Beard pretty much resumed his previous life. The couple were based at Beard's forty-five-acre bush camp, Hog Ranch. Although just twelve miles from the city center, it really was a safari camp—a cluster of Low & Bonar safari tents—with thatched roofs to protect against the long rains, around a campfire and a mess tent, that served as a gathering place for all manner of Kenyans and international visitors. The view of the Ngong Hills was exactly the same as Karen Blixen's had been from her coffee farm sixty years earlier. Kikuyu folklore has it that when God had buried a particular man of great character, he tipped his hand and allowed the soil to slip through his fingers, thus creating the fabled mountain range. It was there that Blixen's lover, Denys Finch Hatton, was buried.

There was no modern plumbing at Hog Ranch—the toilet was a traditional safari long-drop (basically a deep hole in the ground) and a generator powered the electric lights in the mess tent and the nearby artist's studio, while the refrigerator ran on gas. The mess tent was lit by an array of antique Dutch lamps, storm lanterns, and candles, giving it a dramatic, romantic feel, while there were animal skulls affixed to various posts, most notably that of a male buffalo with enormous horns in pride of place. Tables that stood along the canvas walls were crammed with more animal skulls, bowls, gourds, and African tribal decorations. Art covered the canvas walls, from Picasso posters to Beard's own photographs of elephants, eland, Somali model Iman, and Minnie Cushing. Separated by stone pathways, the scattered sleeping tents contained beds draped with muslin mosquito nets and folding camp chairs. The whole feel of the camp was rustic, bare-boned, devoid of the accoutrements of modern Western life that Beard so often denigrated. Right from the beginning, Hog Ranch was his perfect place on planet Earth.

Yet while he would spend much of his time sprawled on the studio floor creating his diaries, gluing, cutting, doodling, and writing in his copperplate style, with all the component parts spread across the wooden surface in front of him, his innate restlessness would soon catch up with him. Suddenly, without much consultation with his new bride, he would disappear, sometimes for days at a time, sometimes alone but occasionally with a flotilla of models and assistants in tow, on safari, on one mission or another, to Amboseli or Tsavo or the Maasai Mara or even just into town. He was doing fashion shoots for the New York glossies by this time so the regular appearance of glamorous models on the Kenyan landscape was becoming part of the Beard mythology.

Beard's gastronomic idiosyncrasies were also on full display at Hog Ranch. Here was a man who, through the decades, dined at the finest restaurants in Europe and America, and yet he seemed to have little interest in haute cuisine. As one friend noted, his staple breakfast of fried eggs mashed in with pieces of toast, with dollops of tomato ketchup and Worcestershire sauce, would have made Escoffier gag.[2]

It was around this time that *Life* magazine ran a special double issue on African wildlife that featured a strong Beard photograph of an elephant on its cover, accompanying a rather odd rambling essay by Romain Gary, the eccentric French novelist. Entitled portentously "Letter To An Elephant," it trod that fine line between anthropomorphizing wildlife and expressing the view (as did Dick Laws and thus Peter Beard) that elephant society resembled human society inasmuch as its future was under grave threat. The cover image was of an elephant known as Ahmed, a famous big tusker Beard had photographed when traveling with Bill Woodley in Marsabit National Park in the north of Kenya. Its tusks weighed one hundred forty pounds a side. While not being the biggest and heaviest ever, they were significantly larger than the tusks one finds on today's bulls. Today, the average tusk on an African elephant bull tends to weigh between twenty and forty pounds a side and this alone seems to be a discernible measure of the threat humans have posed for these wonderful animals; that they have evolved into less visible creatures in the face of destruction. Ahmed was a loner, quite elusive and seldom seen—better known by reputation than by sight. But legends surrounded Ahmed. One was that his tusks were so long that he could go up a hill only by walking backward. No one ever proved this, but he was often seen resting his head on his tusks. The increased threat of poaching, and three films from 1970 in which Ahmed starred, led to a letter-writing campaign by schoolchildren to Kenya's first president, Jomo Kenyatta, asking him to protect the elephant.

When Beard was in attendance, the campfire at Hog Ranch was, from sunset until the early hours of the morning, the liveliest salon in Nairobi. Cocktails would be poured and handed around, spliffs would be passed, and eventually, as the sun dropped below the Ngong Hills, Mbuno would bring out a tray of hors d'oeuvres, usually small squares of white bread, topped with Hellmann's mayonnaise, tuna fish pâté, chopped onions, and black pepper, more examples of Beard's primitive gastronomic taste.[3]

One of the more regular visitors was Gillies Turle, a diffident, rather proper ex-army Englishman who had landed in Kenya in the mid-1960s as a bodyguard to a Kenyan cabinet minister and had quickly turned into an

ex-pat entrepreneur, opening his Antique Gallery on Kaunda Street soon after resigning his commission. Soon married, he and his wife, Jill, lived a sedate life in a Nairobi suburb not too far from Hog Ranch.

Turle would arrive at Hog Ranch on his polo pony, tie it to the grevillea tree, and be greeted effusively by his host: "Hey Gillies, come on in, have a drink, grab a chair. Still out there with the hard-hat brigade, I see." Turle recognized his friend's mockery as his frequently expressed disdain for any evidence of what Beard saw as bourgeois domesticity. That included riding horses, wearing hard hats, or owning cats and dogs, all of which Turle had embraced. Within a decade, however, as Turle's marriage started falling apart, he retreated to Hog Ranch, set up a tent there, and for the following two decades became the camp's only other permanent resident. For the moment though, it was enough to join Beard and his cosmopolitan friends around the campfire and launch himself at the issues of the day. And this was a time when the political issues of the day were on every Kenyan's mind—the charismatic government minister Tom Mboyo had been assassinated in the streets of downtown Nairobi and days of rioting had ensued. Mboyo was the first Kenyan to make the cover of *Time* magazine and was being tipped as the obvious successor to President Jomo Kenyatta, so when his assassin was arrested and said immediately "Why don't you go after the big man?" suspicions abounded that this was an African political assassination directed from the top. *Fitina* (Swahili word for gossip) flew around the Hog Ranch campfire with Peter Beard right in the center, prodding, poking, and stirring it up.

Meanwhile, Minnie had at first taken to living at Hog Ranch with some relish, even though Beard was sometimes an absentee husband. But Beard later told *Rolling Stone* magazine of an incident that, he said, illustrated their gradual estrangement. He claimed Minnie had been bitten by an extremely poisonous snake at Hog Ranch and that her leg had swelled up. According to Beard's version of events, she lay for days in one of the Hog Ranch tents, aching, trembling, and barely able to move while her husband was out and about in Nairobi. He told the magazine that as he could not cure a swollen leg, there was no reason to hang around Hog Ranch and watch her suffer.[4]

The story turned out to be pure fiction; Minnie confirmed that she had never been bitten by a snake at Hog Ranch. It was, perhaps, a typically elaborate and fanciful way of explaining, long after the event, Beard's increasing distance from the bride of his recent fairy-tale wedding.

Minnie, by contrast, said that she was perfectly happy in Kenya and loved Hog Ranch.[5] Although from a patrician, old-money Boston family, she was anything but an entitled East Coast socialite, rather a free-spirited and free-thinking product of the 1960s who always seemed to be on the lookout for a new adventure. Some of the couple's friends thought Minnie was, in her way, even wilder and more antiestablishment than Peter. So, she claimed at the time, Kenya rather suited her.

That did not, however, prevent her from suddenly packing her bags and flying back to New York within a year of arriving at Hog Ranch. She later said that she "didn't know what I was doing particularly" but that an old friend, the Texan millionaire Bob Kleberg, had flown out to Kenya in his private plane and when he was due to return to New York he offered Minnie a ride. "I took up his offer," she remembered. "I don't know why. I wasn't upset with Peter or anything. We had not been fighting or arguing. It was a ride and I thought I'd take it, go and see my friends and then I'll come back. But I didn't go back."[6]

Clearly concerned about his wife's sudden and seemingly impetuous departure, a few months later Beard followed her back to New York. They moved into an apartment on West Fifty-seventh Street with their pet bushbaby and attempted to rescue their relationship. Beard later told *Rolling Stone* that Minnie had not really connected with his African life and her supposed love of Africa was "just an act in a sense, a real nice act, but basically just fear-oriented and it's at the heart of America, at the heart of spoiledness [*sic*] and all the disadvantages that come with advantages." Elliptical as always, Beard seemed pathologically inclined to spin every personal story into a vast web of societal conspiracy theories, thus associating Minnie's brief but, according to her, perfectly enjoyable African life with American capitalist society's destructive role in the modern world, particularly in the African world.

New York seemed to be a far better theater of operation for the glamorous young couple, where they started hanging out with Beard's cousin Jerome who had a permanent suite at the Algonquin. There they would attend dinners with Andy Warhol, Bob Colacello, then the new editor of *Interview* magazine, various passing socialites, and Hollywood stars, with Warhol continually eulogizing about the physical beauty of the couple. Beard was already an established acquaintance of Warhol and would soon become a regular photographic contributor to *Interview* and indeed a subject of laudatory articles.[7]

However, for all their high-profile glamour on the Manhattan social circuit, their relationship was disintegrating with regular heated arguments, an age-old story of true love gone bad. Friends who spent time with the couple describe endless bitter quarrels taking place in their Manhattan apartment, with Beard accusing Minnie, perhaps with some justification, of having an affair with Michael Butler, wealthy backer/producer of the hot new Broadway musical *Hair*.[8] This would explain Beard's sardonic remarks to the writer Doon Arbus about the cast of *Hair* moving into their apartment "to continue their pursuit of their newfound leader, my wife, the hippie's hero coming down from the Establishment to join the hippies in their rebellion."[9]

Then, on January 18, 1969,[10] in the couple's West Fifty-seventh Street apartment, Beard took an overdose of barbiturates. Minnie found him unconscious early the following morning and called the police, after which Beard was rushed to New York Hospital. Once there, Minnie called their friend Alistair Graham to give him the grim news. Graham hurried to the hospital to find Beard in a coma and the doctors saying there was little chance of him surviving. If, by some miracle, he were to survive, it was most likely that he would be severely brain damaged. One of the doctors asked Graham if he would return to Beard's apartment and search for the pill bottle as they had no idea what he had taken and required that information to apply the right antidote. Graham says he ransacked the apartment but could find nothing and assumed Beard had disposed of the pill

bottle to make sure he was not revived. It left him in no doubt that Beard had been serious about killing himself.[11]

However, the doctors had not factored in Beard's remarkable inner strength and physical resilience. Four days after his emergency admission to New York Hospital, he woke up. It was his thirty-first birthday.

He was soon transferred to Payne Whitney Psychiatric Clinic, where he would spend the next five months. Beard claimed that after a brief, twenty-minute conversation his supervisor at the clinic told him he was one of the most suicidal people he had ever met and that "you're going to be in here a long time." "Basically, I lost interest in everything," he told the writer Jon Bowermaster, "then I wasted weeks talking to psychoanalysts about my stressed world."[12]

The one person who visited him regularly was Alistair Graham, who was staying on in New York researching and writing the text on the Lake Turkana crocodile project for what would become *Eyelids of Morning*. At that time Beard and Graham's agent, Peter Schub, had started approaching New York publishers about the project but was already receiving long and vitriolic rejection letters indicating that this might not be the time to publish a book containing Graham's stance on consumptive wildlife use (shooting crocodiles for the money), and Beard's stark photographs of death and skinned carcasses.

However, Graham kept working and would frequently drop by Payne Whitney to take Beard out on long walks in the spring Manhattan sunshine. Surprisingly, he was pretty sure he was Beard's only regular visitor. Peter's younger brother, Sam, was away on his honeymoon, but his older brother, Anson, visited just once, early on when Peter was still in a coma. According to Graham, Anson's only interest appeared to be to establish contact details for Peter's power-of-attorney in Nairobi. There was certainly no evidence of the socialite friends who were such a part of Peter's Manhattan nightlife.

Graham finished his work before Beard was released and returned to Nairobi to resume his African life. When Beard was discharged from Payne

Whitney, he went straight to work on the design and photographic content of *Eyelids of Morning,* the complete absence of a viable publisher notwithstanding. However, a chance conversation with the head of the New York Graphic Society suddenly revealed a publisher who was interested, actually enthusiastic, about the project. A fine editor by the name of Betty Childs was appointed and the book was meticulously assembled. It was at this point that Graham and Beard, who was now ensconced back in Kenya, fell out badly. Beard altered a sentence at the beginning of the book, so it read "and it was Peter Beard who shared most of the time, and the work, at the lake with me." Graham was too far away to intervene, and the sentence went in despite his protestations that Beard's contribution had actually been short-lived and somewhat sporadic. However, Peter's further request that in the main text of the book the "I"—as in "I arrived at Lake Rudolf"—be amended to "we" was firmly and successfully quashed by the author.

Eyelids of Morning: The Mingled Destinies of Crocodiles and Men was published in 1973 to mixed reviews. In *The New York Times,* the author Joseph McElroy regarded it with some suspicion, declaring that Graham was dabbling "in crocodile symbolism, and here he has tried to do too much with a brief narrative." According to McElroy "the real problem is the collective tone of the photographs and other illustrations. . . . I think it is a murky, vulgar condescension. A bit of horror, bit of humor, something sensitive, something camp. The pictures speak louder than words, but what do they say?" Although McElroy made a strong point about the unusual marriage of Beard's photo-collage eccentricities and Graham's scientific observations, *Eyelids of Morning* did offer an impressive narrative of the arduous task of hunting down crocs for ecological analysis, of their feeding habits, and of the effects of overcrowding. It was a compelling, unsentimental story of a harsh, remote, forbidding environment where the inhabitants, the Turkana people who believed the Earth was flat, have found a way of surviving on the very margins of human existence.

That the book got rather lost amid Aleksandr Solzhenitsyn's *The Gulag Archipelago,* Martin Amis's *The Rachel Papers,* and Kurt Vonnegut's *Break-*

fast of Champions was not surprising, but it drew enough attention to out-perform its genre equivalents. It was, after all, a scientist's study of an ancient animal species, and it was the theatrical, artistic, dramatic photographic flourishes Beard brought to the book that drew a wider audience. He had also persuaded the artist Richard Lindner and the cartoonists Charles Addams and Saul Steinberg to contribute to the book, all important artistic embellishments. In a modest way, *Eyelids of Morning* elevated Beard's name among the society name-droppers he hung around with. The nightlife mob crowded even closer, although the models and attendant beautiful women hardly needed any further excuses. His well-publicized friendships with Andy Warhol, Jackie Onassis, Mick Jagger, author Truman Capote, and the rest added to his luster. And by this time, with his marriage to Minnie now long over, he had begun an affair with Jackie's sister, Lee Radziwill, a relationship that by today's standards attracted only discreet attention from the tabloid press.

There was just one dark cloud on Beard's horizon, and it lay back in Africa, where his celebrity was not quite as warmly embraced as it was in the United States. He continued to commute between the US East Coast and Kenya with some frequency and in November 1969 Beard and his trusty wingman, the tracker Galo-Galo Guyu, were arrested in Nairobi on charges of assault and wrongful confinement of a poacher, Jared Nzioka, an event that had taken place eighteen months earlier.

As with so many Beard stories, there are a number of versions. According to Beard, in April 1968, before he moved back to New York with Minnie, he and Galo-Galo had been clearing the bush surrounding his Hog Ranch compound and were constantly uncovering wire snares used to trap animals. When Galo-Galo found a trapped suni, a small and quite rare antelope, he waited in the bush for the poachers to retrieve their catch. The Mkamba tribesman Jared Nzioka walked straight to the trap and, as he was retrieving the dead suni, Galo-Galo pounced. Nzioka continued to deny setting the snare and when Beard and Galo-Galo interrogated him about the location of other snares he persisted in pleading his innocence.

Here the story spirals into many versions. Beard claimed he punched Nzioka once and then tied him up in his own snare, leaving him in situ while he, Beard, went into town for lunch, and to get the incriminating film he'd taken of the poacher processed. He then returned to find that his Hog Ranch staff had released the man, who had returned to the neighboring property where he worked. More colorful versions had Beard torturing the poacher for an extended period before stringing him up between the trees in a particularly dangerous part of the forest.

Either way, when Beard was in town he bumped into several old friends at the Norfolk Hotel and began boasting about his imprisoning the poacher. The reaction across the board was one of stunned opprobrium. Relationships between white colonials and Black Kenyans had changed through the 1960s and anything that suggested the old master-servant relationships of the colonial era was frowned upon across the board. Alistair Graham said he was amazed that Peter had thought he could treat Africans like that and was not at all surprised when Beard and Galo-Galo were arrested.

One of his most active supporters during his period was Carol Bell, an attractive young Kenyan who had been working for Gillies Turle in his Antique Gallery in downtown Nairobi, and by the time he had returned, Carol was both lover and supporter. On the eve of his court appearance, Beard and his girlfriend went to dinner at Turle's home, not far from Hog Ranch. Turle remembers his friend being "blithely unconcerned" about the precariousness of his position in the new independent Kenya."[13]

His insouciance was somewhat misguided, and the new Africa revealed itself quite explicitly in the Nairobi courts. While Beard and Galo-Galo sat in the court waiting for their case to be heard, the judge made a ruling on the case that preceded theirs. Before him stood a man convicted of killing seven of his children but who pleaded for leniency on the grounds that his surviving children were dependent on him. His plea was granted by the judge.

Beard and Galo-Galo's trial took five days; they faced charges of as-

sault and wrongful confinement. They were found guilty on both charges, Beard being sentenced to nine months imprisonment and twelve lashes on the first charge and a further nine months imprisonment on the second. Galo-Galo's sentence was three months imprisonment and six strokes on each charge. They were immediately hauled off, Beard's head was shaved, he was assigned prisoner number 41632, and the pair were taken to Kamiti Prison, a harsh and notorious place. Beard spent ten days sleeping on a concrete floor, eating dreadful prison food, and enduring the horror of postcolonial African prisons at their most rudimentary.

Beard's friends and political connections immediately went to work on securing an appeal and imminent release. Jack Block, the owner of the New Stanley and the Norfolk Hotel, together with JM Kariuki, a close friend of the country's president Jomo Kenyatta, led the local pressure group and abroad, international diplomatic pressure was exerted as Jackie Onassis and his other connected American friends lobbied on his behalf and generally rallied around him.

* * *

Mandy Ruben was at the family home in Nairobi when she heard that Beard had been thrown into Kamiti Prison. Mandy's family, and particularly her father, Monty, a prominent figure in emerging postcolonial Kenya and a friend of Jomo Kenyatta, were very close to Beard in the 1960s and '70s and he spent a lot of time with them in their Nairobi home. As with the Woodleys and the Cottars, Beard found himself fitting in very comfortably with this family away from home, in many ways more comfortably than with his own family. He became central to the passing parade of politicians, dignitaries, actors, writers, and artists who came through the Ruben home. Monty took it upon himself to keep an eye on the administration of Hog Ranch during Beard's long absences, while his wife, Hilary, an author, treated Beard like an errant stepson. In her book *African Harvest,* she described him with poetic accuracy as "a person of

dogmatic views and a tendency to express them in colorful diatribes rather than mere logic; arguments swarm around Peter like bees smoked from a hive."[14] The two daughters, Mandy and Lissa, visited Hog Ranch frequently, with Mandy being attacked repeatedly by Beard's bad-tempered monkey Northey-Chongo, and in later years, Mandy would spend days with Beard watching him working on his diaries. The Rubens also made sure to watch over Hog Ranch in those early days when Beard was abroad because, as Hilary later wrote, "You cannot lock tents and Peter with an unconcern for his possessions equal to his disregard of personal danger, leaves his domain with the trust of a priest and the light-hearted irresponsibility of a gipsy."[15]

So, when twelve-year-old Mandy was told that Beard had been cast into Kamiti Prison she immediately paged through her father's address book—her parents were out of town—and found the name and private telephone number of a senior government minister who was a regular dinner guest at the house—Minister of Defence Dr. Njoroge Mungai. She was trembling with fear as she told the minister that their mutual friend Peter Beard had been thrown in jail and asked if he could help. Dr. Mungai spoke kindly to the young girl and said he would see what he could do.[16] The wheels were thus set in motion.

After ten days in jail, Beard was granted bail and emerged shaven-headed and totally lacking in contrition. Friends who visited him in Kamiti said he had taken it all in his stride, typically amused at the random turns life tended to take and probably aware that it would all add to the myth, the legend of Peter Beard. While he wrote off his arrest and trial as racism, many of his old Nairobi acquaintances began to see his behavior as inappropriate and unchecked. While he certainly made disparaging remarks about Indigenous, postcolonial Kenyans with their hands on the levers of power, his affection for the Africans who he came into contact with on a daily basis was more than congenial. He admired without qualification their spiritual attachment to the land and the wildlife that had been so abundant before the arrival of the white colonials and identified viscerally with their spontaneous amorality. He felt he had more in com-

mon with them than many of his acquaintances on America's Eastern Seaboard.

So it was that rogues such as the giant Kinuthia came to work and live at Hog Ranch. When Kinuthia applied for a job at the camp, the first thing he told his prospective employer was that he had been to Hog Ranch before as part of a gang that had sneaked in at night and stolen all the ivory tusks Beard had collected from his dead elephants shoots in Tsavo. Another prospective employer in Kenya may have balked at the thought of hiring a thief, but Beard hired him immediately, and Kinuthia continued to work at Hog Ranch until he died from liver disease decades later.

The diplomatic pressure worked, and on January 8, 1970, Beard and Galo-Galo appeared in court on appeal. The judge handed down conditional discharges on the first charge and set aside both the prison sentences and the twelve lashes. Instead, Beard was fined £500 ($1,200) and Galo-Galo £25 ($60), and their victim was to receive half the fines as compensation. They emerged from courtroom relieved and exulted, greeted by local friends, and a celebration around the campfire at Hog Ranch followed.

While all this was going on, Beard's apocalyptic vision of Tsavo—or Starvo as he was now repeatedly calling it—was taking place before everybody's eyes. Dick Laws's prediction three years earlier that elephant overcrowding would lead to these animals eating themselves out of house and home had been borne out in the most apocalyptic manner. The drought, a common occurrence in Africa's turbulent weather landscape, had been the trigger in this case and the elephants ate everything in their path, taking out centuries-old baobab trees, until there was nothing left, and they starved and died in the thousands—the final death toll is widely disputed—of malnutrition and heart disease. It is broadly accepted that between ten thousand and fifteen thousand elephants died. In Beard's eyes, this was stress and density writ large and if it was happening to the world of elephants today, in years to come it would happen to the world of man. He was right when he said, "The elephants ate and destroyed a national park bigger than Israel or Massachusetts and then starved to death in the desert created at our hands."

Banned from working in Tsavo by his former friend, the park's warden David Sheldrick, Beard took to the skies in a light aircraft piloted by another friend, and he shot dramatic aerial photographs that brilliantly captured the ecological disaster taking place in Tsavo. One such shot showed the park border, marked by the Mombasa-Uganda railway track between Tsavo and Voi that had been laid there at the turn of the twentieth century. On the left is the park, denuded of foliage, a veritable desert landscape, and to the right of the railway tracks is a hunting block of land, showing thriving tree populations and varied flora, that suggested a flourishing, ecologically balanced landscape. Nothing told the story of Starvo more eloquently than this black-and-white Beard image.

Many of his photographs focused on the desiccated remains of the thousands of dead elephants, and they formed a dramatic and heartbreaking codicil to the second edition of *The End of the Game,* which was published in 1977. With the clandestine help of people like Ian Parker and Richard Bell, Beard was able to record this cataclysmic environmental event, sometimes from the air but often on the ground, entering the park wearing a borrowed red-haired wig.

The calamitous drought and elephant die-off in Tsavo took place at a time when the future of the country's wildlife management philosophy was at the center of heated debate. Beard and his allies, particularly Dick Laws, had strong views about managing contained wilderness areas such as national parks. They argued that whereas in the precolonial era elephants were able to move across the country, along traditional migratory routes, they were now restricted to finite areas with finite food supplies. Elephants are notoriously voracious herbivores, each adult capable of consuming three hundred pounds of vegetation a day. So, the solution was to measure a park's carrying capacity, its ability to sustain a certain number of elephants without doing terminal damage to the vegetation, and thus figure out how many elephants it could sustain. They would thus have to control the elephant population by culling, a practice that was in place in other African countries such as Uganda, Tanzania, and Zimbabwe. How-

ever, in Kenya, wildlife officials opposed culling in parks, feeling it was better to let natural causes regulate the elephant herds.

A few months after he was discharged from the Nairobi courts, Beard learned that Minnie Cushing had been granted a quickie divorce in Chihuahua, Mexico. They hadn't been in contact since his stay in Payne Whitney and clearly she had wanted to end their marriage. It was time to move on.[17]

7

Let's Spend the Night Together—Those Montauk Summers

After Minnie Cushing's impetuous departure from Kenya, Beard lost his appetite for the African bush, according to former girlfriend, the Nairobi-based Carol Bell, and "the society side of his life won him back." Minnie's quickie divorce signaled that the fairy tale was over. For the time being, Beard would set down deeper roots in America, starting with buying a stone cottage on a remote patch of land in Montauk, New York, at the far end of Long Island. He paid the princely sum of $130,000 for six acres of Thunderbolt Ranch and it became in many ways his Hog Ranch in the First World. He later bought the windmill from Sandpiper Hill House in Ditch Plains and moved it by road eight and a half miles onto his property. Dick Cavett, the celebrated talk show host, lived nearby; Andy Warhol and Paul Morrissey soon after bought Church Estate a half mile west of him; and after that Richard Avedon would build himself a home out there and become Beard's neighbor.

With Montauk as his wilderness retreat, Beard set about conquering Manhattan. He quickly befriended Bob Colacello, whom Warhol had anointed as the editor to transform *Interview* from an almost unreadable fanzine into a hip magazine for the creative cognoscenti. After a long night's drinking had fueled intense conversations about art, literature, and the place

of female beauty in the contemporary artistic world, Beard managed to persuade Colacello to commission him to shoot the next cover, featuring Jane Forth and Donna Jordan, the stars of the new Andy Warhol / Paul Morrissey film, *L'Amour*.

Peter managed to alarm everyone at Warhol's New York studio, the Factory, principally Warhol and Morrissey, with orders of cosmetic blood from Revlon and Helena Rubinstein, and when he found those concoctions underwhelming, he put in an order for pig's blood from a local butcher.[1] His plan to slather Jane and Donna's naked bodies with blood, whether it be the designer cosmetics variety or real pig's blood, was vigorously rejected not only by Warhol but by the models themselves. Morrissey phoned Beard and told him that the film *L'Amour* was an attempt to "do something a little less nutty, a kind of family comedy like *Lucy and Ethel Go to Paris*." Of course, *L'Amour* was nothing of the kind but all resources were employed to persuade Beard to cease and desist. And so he did, with the cover of *Interview* eventually showing a demure, and rather fetching, black-and-white photograph of the two actresses.

Warhol was not the only show in town demanding the attentions of the now charged-up Peter Beard. The Rolling Stones were embarking on their first American concert tour since the notorious Altamont concert in 1969, a nadir not only of the band's career but also of 1960s pop culture, the moment the peace-and-love mantra of the new generation turned ugly. So, the 1972 tour was to be the rehabilitation of the Stones. Truman Capote was commissioned to cover the tour for *Rolling Stone* magazine and Peter Beard was assigned to do the photography. At the same time, Terry Southern, the celebrated but somewhat damaged novelist, essayist, and screenwriter (and a great friend of Keith Richards), had been signed up to cover the tour by *Saturday Review* and it was no surprise to anyone that he and Beard immediately became friends. They were both rebel spirits, both were inclined to overindulge in illegal substances, and both were brilliant at their particular callings.[2]

It came to be known both as the STP (Stones Touring Party) and the Lapping Tongue Tour, a reference to the Stones' logo that had its first formal

outing on that tour (and is often incorrectly attributed to Andy Warhol, something that he coyly refrained from denying), and Beard, Jagger and Richards, and Terry Southern partied across America in the Stones' specially outfitted DC7 airplane. In Kansas City they were joined by Truman Capote and his friend Jackie Onassis's sister Lee Radziwill, who was, by this time, Peter Beard's latest lover. Radziwill was a sometime actress but a more successful socialite who was welcomed into the Warhol circle with open arms and even got to interview Mick Jagger in Montauk for *Interview* magazine. Beard watched with great amusement as Capote and Jagger failed to hit it off, Jagger intensely disliking Capote's camp mannerisms and Capote describing Jagger as "a scared little boy . . . about as sexy as a pissing toad."

Beard's affair with Lee Radziwill had started the previous summer and he, Lee, and the Kennedy children ended up spending weeks with Jackie and Aristotle Onassis on the latter's private island of Skorpios and on his yacht *Christina O*. There, Beard admitted to a friend, he played the court jester, "diverting his maj with such pranks as—yesterday—winning a $2,000 bet by staying underwater for over four minutes. They love it and so do I."[3] As the Kennedy gang segued into the summer of 1972 with Beard in tow, Andy Warhol celebrated their presence in Montauk as Lee rented a house in Montauk for the entourage, suggesting that they put up gold plaques that read: "Lee slept here" and "Jackie slept here."[4]

In the end, Capote didn't deliver the required article for *Rolling Stone*, although the magazine recouped some of its losses by having Andy Warhol interview him about the tour the following year. However, Beard's presence on the tour forged a firm friendship between him and Mick Jagger and Keith Richards and his dramatic live concert photographs—all black-and-white—would end up featuring in many of his collages down the years. At the same time, Terry Southern began expressing great admiration for Beard's photo collages, comparing them to the work of French artist Georges Braque and even Pablo Picasso, and using Beard catchphrases such as "stress and density" when observing the massive, frenzied crowds at the Rolling Stones' concerts. Nobody was surprised when it was announced that Beard and Southern were to collaborate on a film version of *The End*

of the Game, or that the project remained in development for twenty years until it was eventually abandoned by both parties.

It was on the Lapping Tongue Tour that, thanks to Beard, an exhausted Jagger discovered the rural charms of the tip of Long Island as he and his wife, Bianca, flew out to Montauk Airport and then spent a few days relaxing at the shore, waterskiiing on Lake Montauk, and unwinding far from the madding crowds. It had such a profound effect that prior to their next tour in 1975, the Stones rented Andy Warhol's Church Estate for $5,000 a month to rehearse and work on songs for their next album. It was during this stay that Jagger not only immortalized Montauk's Memory Motel in song but became a regular, with Beard at his side, at Shagwong Tavern. As Andy Warhol said, it was the time when Jagger put Montauk on the map.

The 1970s were also being marked by Beard's frequent trips to London to meet up with his friend, the artist Francis Bacon. The pair had first met there in the mid-1960s at the opening of one of Bacon's Marlborough Gallery shows. Beard had introduced himself and Bacon responded by telling him: "I know who you are." They had lunch together, Bacon having been seduced initially by Beard's devastating good looks and then, after a suitably boozy lunch, by what he saw as Beard's dark view of the world and particularly of Homo sapiens' contribution to this darkness in Africa. They met again later at a launch party for *The End of the Game* at the Clermont Club.

Bacon, who had family living in Rhodesia, had long had a keen interest in Africa and *The End of the Game* struck a powerful chord, particularly as he shared the young American's concern over the slaughter of the continent's wild animals by the invading white colonials. But the connection went much deeper than that. According to the British art critic Jonathan Jones, Bacon was the first artist to paint people as animals, "his subjects are rendered without souls, as flesh and bone, as blood and brain—in short as animated meat." Beard, too, often expressed the belief that elephant society mirrored human society and that their impending demise was a foretaste of what was to come for Homo sapiens.

The two men had much to discuss. They also had a good deal in

common. Bacon's background, like Beard's, was aristocratic and moneyed, claiming on his father's side descent from the Elizabethan statesman the First Viscount St. Albans, while his mother was heiress to a Sheffield steel business. And although his artistic output was existentialist and gloomy, Bacon was a socially active bon viveur, a habitué of top restaurants and late-night Soho drinking clubs, and he embraced the idea of his young American friend being at the center of a social circle that included Mick Jagger, Andy Warhol, and Jackie Onassis. Then, of course there was their artistic raisons d'etre. Bacon said his mission was to represent "the brutality of fact," while Beard had described his sensibility as "debonair morbidity." Bacon once told the British TV presenter Melvyn Bragg that "the reek of human blood is laughter to my heart" and that "people breed at such a rate they're bound to suffer." Words straight out of the mouth of his friend Peter Beard.

More prosaically, they also shared a unique ability to endure physical pain, Bacon often returning from violent encounters with the rough trade he tended to pick up in the East End of London with wounds, severe bruising, or occasionally a broken nose, waving such injuries aside as par for the course. Beard recalled a car running over Bacon's foot one day in London, leaving him almost unable to limp away, and so unconcerned was he that he never mentioned the incident again. Similarly, Beard's many injuries incurred in the African bush were always brushed aside after the event, while his frequent self-wounding incidents—scraping at his skin or even stabbing himself with a knife to draw blood for his collages—were performed without comment or fuss. And they were both attracted to blood in art, as Beard later told the journalist Edward Behr: "Blood is better than ink. Bacon would go through my diaries, and I would have Bacons in there on blood-covered pages and he'd be so happy to see how the blood had enriched his paintings."

The Bacon-Beard lunches, often conducted at Knightsbridge's fashionable San Lorenzo restaurant, were intense affairs. On one occasion Beard arrived with his agent, Peter Riva, to meet Bacon, and Riva was asked if he minded dining at a separate table as the two artists had serious matters to discuss. Riva duly took himself off to a corner table, had his lunch, paid

his bill, and was about to leave when the maître d' approached him with another bill. He was being asked to pay for the artists' lunch and although at the time he saw it as an appalling liberty, he duly shelled out.

The pair continued to meet whenever Beard visited London and it was during his 1972 visit that he took iconic photographs of Bacon on the roof of his studio/apartment at 80 Narrow Street. These images were to find a place in many of Beard's collages over the coming decades as were constant references to Bacon and their shared, rather bleak, view of the human condition. As always, Beard's presence in Bacon's life in the early 1970s came at a most fortuitous time—Beard had a habit of arriving at the right place at the right time throughout his life. The previous year, Bacon's lover, George Dyer, had committed suicide in a Paris hotel just before the opening of Bacon's major retrospective at the Grand Palais, which was to be a significant moment in the artist's life as only Picasso had been conferred such an honor before. With his significant artistic muse of the previous decade no longer around, Bacon almost unconsciously turned his attention to the beautiful male face that sat before him. Over the next decade he would create nine major portraits of Beard—two triptychs, a diptych, and two stand-alone paintings—that all sell for millions of dollars today.

On that 1972 visit Beard and Bacon devised two joint projects. One was the Dead Elephant Interviews, which had Beard interviewing his friend on a wide range of subjects including wildlife conservation, art, life, and a subject close to both of their hearts, death. The second project was a book to be entitled *Nor Dread Nor Hope Attend* (after a line in William Butler Yeats's poem "Death"), which, according to Bacon's biographers Mark Stevens and Annalyn Swan "sounded like Hemingway after too many martinis at Harry's Bar."[5] At the time, the acutely accurate Beard-watcher Owen Edwards wrote in *The Village Voice* that the book would deal "with such things as stress, death, and the lugubrious future in ways that one can hardly predict, but the elephant motif gives an indication of its tone. This may be the project that finally defines Beard's vision. Sooner or later, too, there should be an exhibition that orchestrates his singular nightmares in a way that they—and we—deserve."[6]

Although the book that Edwards thought would define Beard's vision was never published, The Dead Elephant Interviews survived in truncated form, and when Bacon traveled to New York in 1975 to launch his major show at the Metropolitan Museum a version of the interviews, expertly edited by *Newsweek* journalist and broadcaster Karen Lerner, appeared as the exhibition catalogue. (Further extracts from the interviews appeared in the *Stress and Density* catalog to accompany the 1999 KunstHausWien exhibition in Vienna.) Beard also provided Bacon with appropriate social connections during his brief New York stay and Lee Radziwill gave the British artist a luncheon where he met Andy Warhol, who later gave him a tour of the Factory.

Soon after Bacon's triumphant march through New York's art world—more than 200,000 visited the Met to see the exhibition—Beard was back in Montauk. The Rolling Stones were living in Warhol's Church Estate and Beard's new girlfriend, another society beauty named Barbara Allen, had replaced Lee Radziwill in his affections. Barbara had been sent out to Montauk to do a feature on Beard for *Interview* magazine but quickly fell for him. Although Andy Warhol was mildly titillated at the idea of Beard throwing over Lee Radziwill for the beautiful Allen—"who cares about Lee," he said bitchily—he was a little more concerned about the reaction of her husband, Joseph Allen, a newsprint entrepreneur who was one of the new investors in *Interview* magazine.[7] In fact, the newspaper magnate Allen had given his young bride a substantial share in the magazine "so she would have something to do" and she, too, had become part of Warhol's inner circle. In the end, Joseph Allen appeared to take her infidelities in his stride and Barbara became one of 1970s New York's most celebrated beauties. Mick Jagger was one who was seduced. He said, "she leaves me speechless" and during that Montauk summer of 1975 he climbed through a bedroom window in the early hours of the morning, presumably to restore his powers of speech, and found himself by mistake in Beard's bedroom with no Barbara Allen in sight. It was an event that apparently the three of them were able to laugh about later.[8]

* * *

Through the 1970s, Beard's visits to Hog Ranch were intermittent, but it was on one particular trip in 1975 that a rather important photoshoot took place at his Kenyan home. Although it is widely believed that he discovered the supermodel and future Mrs. David Bowie, Iman, in fact it was a close friend and part-time Hog Ranch habitué who first spotted and photographed the beautiful young Somali woman. Mirella Ricciardi had grown up in Kenya, the daughter of European immigrants—an Italian father and an aristocratic French mother who had studied sculpture under Auguste Rodin—and was to become a celebrated Kenyan photographer in her own right. In the early 1960s, she turned her back on a career as a film actress. Having appeared in Michelangelo Antonioni's *The Eclipse,* and having been inspired by Beard's *The End of the Game,* she had taken up photography.

By 1971, when she had published *Vanishing Africa,* a lavish coffee-table tome that many regarded as her African tribal equivalent of Beard's ode to disappearing wildlife, Mirella and Beard were good friends. Beard offered her tented accommodation at Hog Ranch as he did so many of his friends, an offer she took up through the 1970s. Mirella always claimed she was the only eligible woman of the time who did not wish to be seduced by the handsome young American and that their close friendship was rooted in their mutual love of photography as an art form. "Everyone was in love with him except me," she said. "I was only interested in photography and Peter was quite brilliant. I learned a lot." Throughout the early 1970s, Mirella would spend weeks on end staying at Hog Ranch, constantly working on her photography and learning from Peter Beard.[9]

On a summer morning in 1975, Mirella was visiting a travel agency in the center of Nairobi that was partly owned by her brother. There she spotted a young Somali woman sitting at a desk doing temporary clerical work. She approached her and, enthusing about her unusual beauty, asked the young woman if she had ever been photographed before. She hadn't and Mirella identified herself as a photographer and asked if she could photograph her. Zara Mohamed Abdulmajid (Iman's given name at birth) expressed genuine surprise that Mirella had found her to be photogenic, protesting that she looked like most other young Somali women, neither

better nor worse. Mirella insisted and then, having persuaded her, drove the young woman up to Hog Ranch, where they spent the afternoon shooting photographs in a relatively empty camp. The Hog Ranch majordomo Kamante Gatura was around but Beard himself was not. While they were at Hog Ranch, Iman revealed that she was a refugee from neighboring Somalia, albeit an educated and middle-class refugee whose diplomat father had remained behind in Somalia. She said that she spoke four languages and was studying political science at the university but had decided to drop out.

Two days later Beard and his Hog Ranch sidekick Kamante were walking past the same Nairobi travel agency when they too spotted Iman outside on the street. Beard was struck by her beauty and told Kamante he wanted to photograph her. The old retainer, who Karen Blixen said, "never paid much attention to what other people thought of him" and who she had praised for his "habitual silent resourcefulness,"[10] nonchalantly told Beard he knew exactly who she was as she had already been photographed at Hog Ranch just days earlier by his good friend Mirella. Beard received the same baffled response from Iman as his friend had. "I was a dime a dozen among Somali girls," she said. "I was average." However, she agreed to return to Hog Ranch and Beard did his portraits, which Mirella Ricciardi conceded, "were much better than mine."

Beard took the results of his shoot back to New York and showed them to several modeling agencies. A positive response had him telexing Iman relentlessly in Nairobi, insisting she prepare to fly to New York. "I didn't have a phone, but I knew that Pan Am was looking for me because they had an airline ticket for me," Iman later recalled. "And for five months Peter is sending telexes . . . you get a telex from him and it's like a novel, a book . . . telling me to come to New York."[11]

Eventually, Iman plucked up courage to fly to New York. She said she had never seen a fashion magazine before and was not sure what she was getting into. She insisted on a return ticket as she was sure she would return to her East African home quite soon, when all this had blown over. Iman still has that return ticket. To capitalize on his discovery, Beard arranged a

press conference at an Upper East Side apartment, announcing the arrival of Iman and declaring that he had found this wild African woman tending goats in the Africa bush, this primitive beauty, untamed and unspoiled by decadent Western society. She says she had an hour and a half to prepare for the press conference after landing, walked into the room and, for a moment, sat quietly in the corner while the assembled journalists were asking Beard questions about the African beauty who could not speak a word of English. "They discovered it was all a myth when I spoke out after the third question addressed to Peter," Iman remembered. "They all laughed. They realized right away the wild African story was a myth." Even after she had spoken out about Beard's fantastic claims, the two remained good friends and, a decade later, returned to Kenya together to do a tenth anniversary shoot for *Playboy* magazine. Appropriately, their mutual friend Mirella came along for the photoshoot.[12]

* * *

Soon after Beard had returned to New York with his Iman portraits, a significant photographic exhibition was launched in New York at the Marlborough Gallery on West Fifty-seventh Street. Richard Avedon had long been established as one of the world's most important portrait and fashion photographers and had visited and photographed Karen Blixen in Copenhagen two years before Beard met up with his literary heroine. The Marlborough Gallery show was a significant event in the perceived progress of photography from an upstart medium to a recognized art form and Avedon's gigantic black-and-white portraits drew a crowd numbering several thousand as well as a significant gathering of celebrities.[13] Warren Beatty was there as were Norman Mailer, Gloria Vanderbilt, Francis Ford Coppola, Lauren Hutton, Andy Warhol, and a rather bemused Truman Capote, who spent some time staring in horror at what he thought was a rather unpleasant representation of himself. Beard and his friend Peter Duchin were also there, and both were impressed by the range and

curation of the exhibition, but most of all by the sheer size of the portraits on show. This was a groundbreaker.

Two months after the Avedon exhibition, Warhol's *Interview* magazine published an issue devoted to the art of photography. It featured Veruschka on the cover and included a Cecil Beaton portrait of Gary Cooper, a James Abbe photograph of Fred and Adele Astaire, a David Hockney landscape, and a dead-elephants portrait by Peter Beard with a caption by Francis Bacon.[14] In the same month, Beard had his own first exhibition, a modest affair particularly when compared with Avedon's, at the Blum Helman Gallery on Greene Street. The model/actress Lauren Hutton, a close friend of Beard's, gave the opening night party, attended by American fashion designer Halston, Andy Warhol, and an array of Beard acolytes, but the exhibition ran for only two weeks. Most of the photographs were taken from *The End of the Game* and *Eyelids of Morning* and were displayed unframed. Some of the prints were made from copy negatives so the quality was questionable although this was something that Beard waved aside with typical insouciance. As he told *The Village Voice* writer Owen Edwards at the time: "I'm not a quality man."

Edwards, who would write extensively about Beard's photography in the years to come, was particularly taken by the display of diaries, which he described as "a combination of adolescent daydreaming, fiendish detritus, cosmic dandruff, frantic tangible psychotherapy and visual novas, page after exhausting page." He said they were so phenomenal that they could stand "on future bookshelves next to Pepys, Kafka and Woolf, not as literature, but as the copious archaeology of a particular mind."[15]

At the same time as these two diametrically opposed exhibitions were being held the debate continued apace as to whether or not photography was art. A symposium at Lincoln Center was led by John Starkowski, curator of photography at the Museum of Modern Art; Peter Bunnell, the director of the Princeton Museum; Weston Naef, a curator at the Metropolitan Museum of Art; and the curator, collector, and photographic art benefactor Sam Wagstaff. All four argued meticulously for photography's evolving

role in the wide world of contemporary art. Less convinced were some of the fine arts critics. *Interview* magazine asked several of America's most prominent critics what they thought. *Time* magazine's famously ferocious Antipodean art critic Robert Hughes, referring to the growth in gallery sales, said simply that "the fact that photography has become collectible has got nothing to do with whether they are works of art or not." Picasso biographer John Richardson was another who remained unconvinced, stating dismissively that "artists make excellent photographers—Degas, Eakins, Samaras, Hockney—but photographers seldom make good artists."[16]

These intellectual wrestling matches over photography and art irritated Beard as he made clear in February the following year when he delivered a paper at the International Center of Photography lecture series that he dedicated to John Richardson following his remarks in *Interview*. The paper offered significant insights into Beard's attitudes and lifestyle choices starting with an observation about one of his heroes, Picasso, who, he said, never took art history lessons but "knew more important things about art than Kenneth Clark, the difference being that Picasso could see. He didn't write about it because he did it. He once said about drawing: 'It's easy, just shut your eyes and sing.'"[17]

As many have observed about Beard's art, it was inextricably linked to his life. In fact, his art was his life and vice versa. That ICP presentation confirmed this as he continued Picasso's philosophy by saying if you wanted to take art photographs, find an excuse to pursue something straightforward or useful that has powerful subject matter and is not necessarily art. "The person concerned about getting hurt when making a tackle," he said, "is the one on the stretcher. The person who goes all out and doesn't care, never gets scratched." He said that one of the greatest essays on art was written by the British track athlete Christopher Chataway and it was all about how he ran.

He went on to rail about the "faithful activities of the Sierra Clubbers out there in the wastelands of their minds photographing dunes and pebbles with plodding dedication to self-seriousness," and declared that all the

Steichens, Stieglitzes, Westons, Cartier-Bressons, Adams, Bill Brandts, and Margaret Bourke-Whites were "boring." As always controversial, it was no wonder that Beard did not endear himself to the coming photo-art movement's establishment.

Nevertheless, during the summer after his ICP peroration, Beard began preparing what was to be the center's most ambitious one-man exhibition. Running from November 13, 1977 through January 22, 1978, Beard's fortieth birthday, it was to be called *The End of the Game: Last Word from Paradise.* It was to be curated by Marvin Israel, the artist and artistic director who had curated many of Avedon's exhibitions, with assistance from the young associate director of exhibitions, Ron Cayen, by now a firm friend of Beard's. Through June and July, the group worked on assembling the exhibition. They worked late into the night and often Beard would go home with Cayen and sleep on his floor wearing nothing warmer than a sports coat and still in the Pitamber Khoda sandals he'd brought back from Kenya.

Midway through the preparations on the night of July 27, Beard received a call from Montauk informing him that the mill at Thunderbolt Ranch was ablaze. "Peter and I drove out there that night," said Ron Cayen, "and by the time we arrived after eleven P.M., the mill was pretty much destroyed. Peter just wanted to see what had happened, and he didn't seem too upset, even though he'd lost a whole lot of his diaries and, apparently, a Francis Bacon original. But things like that didn't worry him. Material possessions. He didn't go back out there for at least a month."[18]

All through that summer Beard was or wasn't—depending on which version of his story you choose to believe—working diligently on the second edition of *The End of the Game.* This was a markedly different version from the 1965 original, not the least because this edition carried page after page of bleak images of the 1971 Tsavo elephant die-off. The text had also been significantly altered—Steve Aronson, who had edited *Longing for Darkness,* a collection of Kamante's stories curated by Beard, had been persuaded to help with copy revision, and the doyenne of New York designers, Ruth Ansel, art director of the Sunday *New York Times Magazine,* had been brought in to repurpose the book. As always, Beard's artistic

platform expanded to fill the space available, and just as he had turned friends' apartments into chaotic artistic studios strewn with his glue, clippings, photographs, and general detritus, so Ruth Ansel's office became the repository of everything that was intended to be part of the new book. "By midsummer, the Rappaport Printing Company began to surrender to a similar fate," according to the writer Doon Arbus. The printers were duly lured away from projects they were working on to deal with Peter Beard issues and it was only when the owner Sid Rappaport personally intervened, in an attempt to save his business from capsizing, did a pause on *The End of the Game* work occur. Not surprisingly, Beard employed his relentless, intense charm and pretty soon Rappaport's staffers were coming in over weekends to help finish the book.[19] This was how he had always worked and it was how he would continue to work. Chaos and urgency were his driving forces.

The Beard exhibition took over the entire ICP museum. Cornell Capa, the director of the ICP, a longtime photojournalist and a member of Magnum—in other words a traditionalist—didn't know what to make of Beard. He was nonplussed about his request to bring elephant dung in to fill the fireplaces and was surprised that Beard wanted to include a coffin in the exhibition, albeit as a receptacle for the charred diary pages that had survived the Montauk fire.[20] On November 13 Jackie Onassis opened the exhibition with a warm tribute to her friend Peter Beard. Kurt Vonnegut, Beard's good friend Lauren Hutton, Andy Warhol, and a collection of the Factory crew were among the opening-night attendees. One of the many innovations was a seventy-five-foot-long mural of elephants crossing the plains in Kenya which was wrapped around the building and which, unfortunately, blew down in a storm on the first night after opening. In those days the ICP was located on Ninety-fourth Street and Fifth Avenue and the following morning Beard and various ICP staffers were found chasing elephant images down Fifth Avenue as far south as the Plaza hotel. But as with all such accidents, Beard saw it as an artistic exercise.

To coincide with the opening of the show, the second edition of *The End of the Game* was published by Doubleday with a new introduction by

Joseph Murumbi, the former minister of state, foreign minister, and vice president of Kenya and, significantly, an epilogue by Richard "Dick" Laws, the director of the British Antarctic Survey and the former director of the Tsavo Research Project.

The Beautiful Americans

The summer of 1978 was particularly memorable for Cheryl Tiegs. Having already been on the cover of *Sports Illustrated*'s swimsuit issue a couple of years earlier, this year she was making news by wearing the famously revealing fishnet costume, described at the time as epitomizing her "perfect combination of girl-next-door innocence and innate sexuality." She had also just appeared on the cover of *Time* magazine as "The All-American Model," and was now regarded as the world's first supermodel. So, here she was, having dinner at Elaine's restaurant in New York with a girlfriend, when Peter Beard walked in with some friends. Cheryl immediately asked her friend who the handsome guy was and sometime later in the evening they were introduced. She was smitten from the outset, but they did not exchange telephone numbers and the supermodel assumed that was that. Also, she was married at the time to an advertising executive turned Hollywood film director named Stan Dragoti.

Elaine's was a favorite Beard hangout, its mix of high society, Hollywood, and haute literati suiting his nocturnal prowling tastes very well. Any night you'd find Woody Allen, George Plimpton, Tom Wolfe, Mick Jagger, Jackie Onassis, and the rest of Beard's voluminous social circle draped around various tables, unbothered by paparazzi, until the early hours of the morning. Owner Elaine Kaufman wouldn't permit paparazzi inside and had been known to attack any loitering photographer outside on the sidewalk. Only a few weeks before the Cheryl evening, Beard had

been there with actress Carole Bouquet, a model subject and briefly a lover.

Several days later Cheryl was playing in a social softball game in Central Park for *Sports Illustrated* against *Time* magazine and to her great surprise Beard turned up. He told her he had come to watch the game, but she knew he was there to see her. She also wondered how he had found out that she'd be playing in the game. After the game, Beard and Cheryl walked along Fifth Avenue to the Sherry-Netherland hotel, where she was staying. They made plans to meet at Studio 54 that night.

Studio 54 was at its wild, swirling peak that summer and although Cheryl was not as much a regular as Beard, they were both famous enough to swiftly pass through the velvet rope into Steve Rubell and Ian Schrager's pounding, shimmering netherworld to join Warhol, Truman Capote, Mick Jagger and his wives present and future (Bianca and Jerry Hall), and the rest of Manhattan's beau monde. After some time at Studio 54, they bounced around Manhattan to various friends' apartments "and we walked back to the Sherry Netherland as the sun was coming up. Peter told me he loved me that night, which was a big deal for him. In many ways he was very traditional." After a few hours in bed the couple rose, Cheryl packed her suitcases for the late afternoon flight back to Los Angeles, and then they headed down to Andy Warhol's Factory for lunch. Cheryl remembers it as "a fabulous, romantic New York occasion. It was no wonder that I'd fallen in love with Peter Beard."[1]

In fact, their coming together coincided rather conveniently, particularly for Beard, with the extraordinary rise of celebrity culture in the late 1970s. New York, and more specifically New York media, was the driving force here. Time Inc. had launched *People* magazine in 1974, much to the displeasure of the company's established managers. Two years later, Liz Smith's New York *Daily News* gossip column took off, and even that bastion of stodgy conservatism *The New York Times* launched its own gossip weekly, *Us* magazine. As Alexander Cockburn wrote in his *New York* magazine cover story, "The spirit of triviality lurking in the bosom of the average newspaper reader will never be quenched and is indeed now blazing

up more fiercely than ever before."[2] So, by the time the two beautiful Americans had joined up, celebrity gossip had entered the country's bloodstream.

Their drop-dead good looks apart, the beautiful Americans seemed, on closer examination, a rather unlikely couple. Despite Cheryl referring to herself as a Minnesota farm girl, she had actually left Minnesota as a five-year-old and had grown up in Alhambra, California, the daughter of a funeral director and an assistant in a florist shop. Hers was a stable, if rather dull, Los Angeles family upbringing and even in high school she was itching to escape suburbia. By the time she'd enrolled as an English major at California State college, the modeling offers were pouring in for the long-legged Californian with the sun-blessed countenance, even white teeth, and girl-next-door demeanor. So, she dropped out and headed for the bright lights. Beard was, of course, an Ivy League rebel who, for all his ranting and protestations against his lineage, was in his genes pure blue blood East Coast aristocracy. It had been no social accident that he and Minnie Cushing had, ten years earlier, hit it off. They were from the same tribe. This coming arrangement with the California sunshine girl was a different matter altogether.

However, for the time being this was the red-hot love affair of the day. Being the most in-demand model and magazine cover girl of the time, Cheryl was flying between Los Angeles and New York on modeling assignments, causing her new lover fits of jealousy as he felt she was not paying enough attention to him. Cheryl's letters, by contrast, were warm and reassuring: "Oh Pita I do miss you so—the thing that is hardest is not knowing when I will see you again—where are you?—not hearing from you soon enough. At least before I had a date to look forward to—it has been 4 days and forever. I love you, please write."

Toward the end of that summer, there was a gap in her schedule, and she flew to Kenya, where she and Peter had signed up to co-host an ABC documentary called *American Sportsman—Africa: End of the Game,* scheduled to air the following spring. It was her first time in Africa, and she could not have benefitted from a happier, more romantic, introduction to the continent. Like so many American first-timers she was held spellbound

by the abundance and proximity of wild animals—warthogs and giraffes wandering in and out of the camp, the sound of lions and hyenas at night—and was utterly seduced by the rustic charms of Hog Ranch. She met all of Beard's East African friends, who were both beguiled by this world-famous supermodel and seduced by her down-to-earth manner. The Cottars and the Woodleys, both of whom had been Beard's surrogate African families since the early 1960s, embraced Cheryl with typical African warmth and gusto. "We all loved Cheryl," remembers Calvin Cottar. "She was very cool, and she had brains. And she was aware that Peter was never satisfied with what he had."

Over the following weeks the couple worked on filming the ABC special and according to Cheryl: "Peter put me through some pretty wild chases, crawling on the ground, running through trees, chasing wild animals, posing with a baby elephant that kept trying to smash me against a tree. He made those photographs look so much fun but there was always a bit of danger there." They filmed much of the documentary at Glen Cottar's Maasai Mara Camp with Cottar himself acting as guide. It was on this trip that the experienced ex-hunter and Africa hand Glen Cottar became concerned with the recklessness Beard was showing with animals. Beard always pushed the limits, but Cottar was concerned for not only Cheryl's safety but also that of the cameraman who was hauling seventy pounds of equipment around. "Stop when I tell you to stop," he barked at Beard, and an uneasy truce followed.[3]

For all the frissons of danger, or indeed because of them, Cheryl was smitten with wild Africa. She was equally infatuated by her dashing new paramour, who had now revealed himself to be not only Hollywood handsome but also something of a buccaneer, a wild and fearless man of the African bush. By the time she flew back to the United States on October 20, she was truly besotted and although still attempting to maintain some privacy, she knew that the American gossip columnists were sniffing around, looking for a Tiegs-Beard romance story.

Beard remained in Kenya, and over the following months the separated couple exchanged a torrent of love letters pining for each other's company,

Beard's sometimes running to more than twenty pages of finely handwritten and intricately illustrated missives. Increasingly he implored Cheryl to cut back on her professional engagements and return to Hog Ranch. He described in intense detail the daily goings-on at Hog Ranch, the frequent trips to Tsavo, Amboseli, and other wild areas that he knew Cheryl had loved. He even co-opted his friend Bill Woodley to contribute a couple of pages, with Woodley offering a clear description of an anti-poaching operation the two men had run in Tsavo "with lots of success, including capturing the guy who shot at the plane and recovering a great amount of ivory—146 tusks—and 11 rifles and over 400 rounds of ammunition. Hopefully the effects of this operation will set them back a great deal and give us, and the animals, an easier time."[4] He signed off hoping she would return soon, clearly on instruction from his friend, the lovesick Peter Beard.

By November a theme had developed, and Beard's letters now had the tone of a heartsore teenager imploring "Churly," as he now called Cheryl, to write more frequently, and constantly beseeching her to join him in Africa. Cheryl was busy with modeling engagements and also filming a John Denver television special in Aspen, all of this briefly taking her mind off her disintegrating marriage to Stan Dragoti and her painful absence from Beard. "Why are you working, working, working?" opined Beard. But even in the early days of their passionate affair, Cheryl was aware that she was dealing with a complicated and wayward character. On the publication of a *Rolling Stone* article on Beard by Doon Arbus in November 1978, Cheryl wrote: "The article captured your personality better than anything else I have read. You are a terribly complicated character—as much as you try to hide your feelings or possibly don't want to face them yourself. One side of me knows you are wrong for me—your irresponsibility and your ability to ignore and shut out completely even someone very close to you. But then in many ways you have shown me more and meant more to me than anything in my life. You are such a special, complicated character."[5]

As the months passed there were, however, dramatic consequences to their increasingly public affair. On his way to the Cannes Film Festival in May 1979, Stan Dragoti, who admitted to being profoundly depressed by

his wife's ongoing fling with Beard, transited through Frankfurt Airport. There German customs authorities apprehended him with twenty-one grams of cocaine strapped to his chest. After being held for eight weeks in a German prison, Dragoti admitted guilt at his trial, stating that although he was not normally a drug user he had taken to cocaine "to kill the pain" of his beloved wife's much-publicized affair. Many of his Hollywood friends testified to his previous good character and Dragoti was much encouraged by a visit from Cheryl herself, who had flown to Frankfurt to offer moral support. Although Dragoti was facing a potential ten-year jail sentence for drug smuggling, the judge took pity on him and handed down a twenty-one-month suspended sentence.[6]

Back in Los Angeles Dragoti was delighted that Cheryl had joined him at their house, although this would turn out to be a short-lived reunion. At the end of July, *People* magazine reported that she had said to Dragoti that she didn't know whether to "spank you or kiss you. You don't know what you put me through." However, she later put this down to creative reporting, claiming "I would never say anything like that." The couple spent the weekend in their Bel Air home, but Dragoti's optimism about winning back his wife quickly evaporated the following week when Cheryl flew back to Kenya to rejoin her new love, Peter Beard. The couple announced that they were divorcing soon after.

For Cheryl, a return to Africa and to her vibrant lover was all she needed. "We traveled all over Kenya and through to Tanzania and south to Botswana and we traveled as people should in Africa—simple camps, small tents. At Hog Ranch, Peter and I would sleep in the same small wood-framed cot, which wasn't easy, but we were so in love we could not be separated. I loved the simplicity and reality of it all. We'd eat breakfast around the campfire then I'd go back to our tent, and it would be covered with baboons. I'd be too scared to go into the tent—baboons can be vicious—so I'd have to wait for the staff to chase them away.

"But it was also dangerous. There were poisonous snakes and sometimes leopards would walk in. But it was so much better than staying in a big safari lodge with modern facilities."

There were also the more eventful risks of living the frontier life in Africa. On one occasion Cheryl was to fly to Tsavo National Park in Bill Woodley's Piper Cub. They'd all had a good lunch in Nairobi and Peter was tasked with ferrying the equipment down to their camp by road in a few days while Cheryl would take the easy light aircraft option. As Woodley gunned the engine at the end of Wilson Airport's runway 014, readying the Piper for takeoff, he suddenly slumped forward against the joystick. Instead of racing along the runway to take off, the aircraft started spinning in a tight circle.

Inside the cockpit Woodley was immobilized; either he had had a stroke or had blacked out due to the stroboscopic effect brought on by the propeller spinning against sunlight. Fortunately, his foot had jammed forward onto the brake pedal so the aircraft hadn't proceeded to take off. Cheryl said afterward that she panicked and "tried to pull him upright but he was too heavy to move. His tongue stuck out clamped between his teeth and blood and froth were pouring from his mouth. I was sure he had had a heart attack." Aware that the wings were full of fuel, Cheryl was afraid that the Piper would career into one of the many other light aircraft parked beside the runway and burst into flames.

Two friends who happened to be at Wilson Airport that day—Tony Heard and Peter's great friend Tony Fitzjohn—saw what was happening and sprinted across the airstrip toward the spinning Piper Cub. According to Fitzjohn, he dragged Cheryl from the cockpit while Heard reached for the ignition key to turn the motor off. According to Cheryl, she threw herself out of the plane and the tail spun around to hit her on the bottom, causing great pain and a significant bruise. Either way it was a close call and had Bill Woodley's event happened a few minutes later the Piper Cub may well have been in the air and the consequences would most certainly have been fatal.

Tony Fitzjohn took a shaken Cheryl back to Hog Ranch, where she asked the staff to fill the tin bathtub with hot water and then she sat out in the front of her tent, bathing her bruised body and cogitating her close call. Africa had always been testing but this was an intense examination of

her resolve. Gillies Turle returned to Hog Ranch to find her wrapped in a towel and still clearly shaken. She explained what had happened, saying: "I got my side door open and jumped but the others couldn't hold the plane and the tail caught me on the butt as I landed and sent me flying. I was lucky. If the plane had been going around the other way the propeller would have caught me. It was as close to death as I have come in my life." She resolved never again to fly in a light aircraft.

However, there was another, slightly darker, side to the story, one that would become a regular occurrence in the Beard-Tiegs relationship. Beard had left her alone all day at Hog Ranch, finally sauntering back from his various appointments in the city and meetings with friends and acquaintances as dusk was falling. He had known all afternoon that the injured Cheryl was back at Hog Ranch but had not even bothered to inquire about her welfare, returning in the evening carrying a plant that he set outside her tent "knowing," according to Cheryl, "that by the morning a warthog would have come by and eaten it. But he had left me alone all day . . . and that was how he hurt me."

The ABC documentary, narrated by Cheryl and Beard, aired in 1979 and was conspicuous for the dramatic close-ups with lions, buffalo, and elephants, a Beard specialty, with Cheryl not realizing at the time how dangerous some of the situations were. "I was naïve," she remembers. "I mean I didn't know, for example, that you don't get between a female rhino and its calf." The documentary went out on a Saturday afternoon slot between football games. At the same time, Cheryl's stakes as a model and a beauty spokesperson were rising dramatically. Around the time *American Sportsman* was broadcast, she signed a two-year contract with Cover Girl cosmetics worth $1.5 million, the biggest such contract ever, soon to be followed by the launch of a signature line of clothing and accessories with Sears, the first retail venture by a supermodel. Over the next ten years, the Cheryl Tiegs Collection would net Sears almost a billion dollars in sales and make her the wealthiest model in the world. Cheryl was at the top of her game.

Back in New York after their African excursion, the couple moved into

the Carlyle Hotel on East Seventy-sixth, one of the Upper East Side's most prestigious and expensive hotels, a move initiated by Cheryl's desire to refurbish her apartment at 829 Park Avenue. They ended up staying at the Carlyle for a year, a massive extravagance that Cheryl could now easily afford, even though her ragamuffin boyfriend seemed unable to contribute anything financially. "I paid for everything. Everything," she said. "Name a piece of clothing, a taxi ride, a hotel bill, a restaurant dinner. It didn't bother me. I just did it. I never knew if he had money coming in from the Trust. I just assumed he had no money. He didn't have a dime. Or even a checkbook."[7]

This combination of apparent insolvency and complete indifference to financial matters could have resulted in serious problems, particularly at Hog Ranch, had Beard not been the beneficiary of great kindness not only from his new girlfriend at this particular time but also over the decades from a small group of loyal friends. Three in particular—the great family friend Monty Ruben, the American filmmaker and author John Heminway, and the wealthy Nairobi businessman Rajni Desai—covered at different times all taxes, electricity bills and, most important, staff salaries at Hog Ranch while Beard was nonchalantly floating around the world with various wives, mistresses, and gathered friends, seemingly unaware of the financial responsibilities that came with owning staffed properties.

Beard's apparent impecuniousness did not, however, prevent him and Cheryl from traveling the world, flying between New York and Paris and London on the Concorde, staying at some of the world's most expensive hotels, and dining endlessly at the top restaurants. On one occasion in London the couple were staying at the Connaught Hotel and Peter was eager to have dinner with his friend Francis Bacon. It was decided that Beard and Cheryl would host a small but lavish dinner party in their suite, courtesy of Cheryl of course. According to Cheryl, "Peter was just full of magical ideas, Francis was entranced, and a wonderful evening was had by all, particularly Francis, who clearly had a crush on Peter."

In the middle of all this in November 1979 Beard and his glamorous new partner hosted an elephant benefit with Fleetwood Mac at Studio 54. Beard had done the photographic artwork for the band's new album

Tusk, which had been released the previous month and although he had a somewhat fractious relationship with members of Fleetwood Mac (he is reported to have called Stevie Nicks a "lard-arse," which probably did not improve relations) and was unhappy about the outcome of his contribution to the album sleeve, they all collaborated willingly for the benefit.[8] In the end nobody was sure how successful the fundraiser was, but it was a great social occasion with more than three thousand guests in attendance according to Cheryl, and the glamorous couple were seen to be doing the right thing. Shrewd observers will have noticed that the fundraiser's appeal to "buy an elephant" was not entirely removed from Beard's oft-repeated contempt for Western wildlife sentimentalists, expressed in the derogatory term "buy an elephant a drink." However mixed Peter Beard's messaging was, it was a great night out in Manhattan's clubland for the beautiful Americans and, according to Cheryl, the evening raised $30,000 for the elephants.

The jet-set lifestyle and frequent press images of the smiling, seemingly loving couple, was not however an entirely accurate picture of their relationship. In private they frequently plunged into vicious, raging arguments, with Cheryl locking her errant partner out of their suite at the Carlyle, and with some regularity out of her apartment on Park Avenue, once even throwing his clothes out onto the street. She seemed unable to control his habit of wandering off for days on end, returning without explanation, and expecting Cheryl to take it in stride. As the months went by, these arguments became increasingly fierce and Beard was increasingly unable to control his rage. Despite all this, they continued with their plans to get married because, according to Cheryl, Beard, at his best, could be sweet and charming. "Often when it was just the two of us," Cheryl said. "When we'd go down to the Carlyle dining room and just have dinner for two or when we'd go out to Montauk and spend days together just talking and cuddling alone, it was wonderful. During those times Peter Beard was the deepest love I've had in my life. But then he'd run off again and we'd be back where we started."

Around the time Cheryl and Beard were splitting their time between the city and Montauk, another close Beard friend, Tony Caramanico, also

moved onto Thunderbolt Ranch. Caramanico, also known as the Surfing Mayor of Montauk, had owned a surf shop and a restaurant named Albatross in Montauk. Having just sold the restaurant, he bought a trailer that he parked in the local trailer park and was figuring out what to do next. Over drinks at the Shagwong Tavern one night, Beard told Tony, "tow the trailer up to Thunderbolt and come and live with me." This open-armed invitation to join Peter Beard's world was a typically generous gesture and although Tony didn't move the trailer there, he did take up residence in one of Beard's cottages on the property. Pretty soon Beard was teaching his young friend about art and collaging and how to create the diaries he still worked on day and night. "We used to stay up all night and do journal rubbings," says Caramanico. "We'd do drugs and go through the night. He lived his art."[9]

The longer Caramanico resided at Thunderbolt, and by now he was the caretaker, the more he came to like and admire Beard. He says his host was always gracious and polite "and he was always straight with me." However, his front-row seat in the Beard-Tiegs household revealed that Beard was not always straight with Cheryl. And nor she with him. "He was constantly sleeping with other women. They were two spoiled people—she could have any man and he could have any woman. And they both did."[10]

Despite all their emotional problems, the couple were still planning to get married, not the least because Beard said he desperately wanted a child. Cheryl had already been pregnant once and miscarried and now as their planned wedding date approached, she revealed she was pregnant again. However, some time into her pregnancy, while they were driving back to the Carlyle Hotel in Cheryl's Mercedes-Benz, a massive row erupted between them and Beard punched her in the stomach. "Why he hit me there I don't know," she says, "because he wanted a baby badly . . . and I had a miscarriage." They lay on the bed, both crying, and Cheryl asked him if he still wanted to get married. He said yes, of course.[11]

In May 1981, Beard and Cheryl Tiegs were married at the Montauk Community Church and Beard's brothers, Anson and Sam, were his best men and Cheryl was attended by two bridesmaids, her assistant Barbara

and her close friend Christy. After the ceremony the two hundred guests went to Thunderbolt Ranch for a reception where the Dom Pérignon flowed, the Peter Duchin Orchestra played (as they had at Beard's first wedding to Minnie Cushing), and happiness abounded. A white tent had been erected on the cliff at the edge of their property and Cheryl says she was so excited about the occasion she didn't drink so much as a glass of champagne all night.

Although Beard did not run off into the darkness on his wedding night, he did the following night, although quite where he went remains open to conjecture. Certainly, one of his current mistresses, Brenda Boozer, the mezzo-soprano with the Metropolitan Opera company in New York, was staying out at the Ruschmeyers hotel in Montauk and Beard had been sneaking out to see her in the days before and after the wedding, according to Tony Caramanico.[12] However, on that second night of their marriage Beard told Cheryl he had to go off to photograph Andrea Marcovicci, a jazz singer who was appearing at the Algonquin Hotel's Oak Room. His explanation was brief, and he was gone before Cheryl was able to complain about the unfortunate timing. Beard came home at dawn the following morning, without regret, without explanation, and Cheryl locked him out of their bedroom "because I didn't want to see someone who had been out all night. I was furious. Unhappy. Betrayed."[13] Although Beard made no attempt at explaining why he had been gone all night, he did later show Cheryl contact sheets of the Oak Room singer and made no mention of Brenda Boozer being in the neighborhood.

Despite all of this, perhaps because of it, Cheryl, coming as she did from a stable, loving family, was determined to make the marriage work, and getting along with her new in-laws was part of the solution. She was very fond of Beard's brothers, Sam and Anson Jr., but it was his mother, Roseanne, with whom she got on particularly well. Beard's relationship with his mother had been notoriously volatile and over the years he said many times that he simply hated her, painting a picture of a stern, rigidly formal matriarch who had little to do with raising three sons. That, according to Beard, was left to the house staff. (Beard got on much better

with his more compliant, undemanding, heavy-drinking father.) This version of events is vigorously disputed by other family members who claimed that Roseanne was a loving, attentive mother and that it was simply a case of "Peter being rebellious and refusing to do what his mother wanted him to do. He didn't understand her, and she didn't understand him."

Cheryl and Roseanne would often have dinner together when Beard was away and, with tears in her eyes, Roseanne would ask her daughter-in-law why her son so hated her. "What did I do?" she would say, imploring Cheryl to answer the unanswerable. When Beard returned from his African trips, Cheryl would invariably attempt to solicit answers about the family rift but, she says, she was never able to get a straight answer. She also tried to draw Beard closer to his brothers and although she said Anson seemed more remote, younger brother Sam and his wife, Pat, responded warmly to her approaches. Beard had lived in Sam and Pat's apartment in the city in long stretches from the late 1960s well into the '70s, sleeping on a sofa and in an alcove like a gypsy. They had really enjoyed his stays, not the least because he brought with him his range of interesting friends and had even managed to draw the conservative, political, civic service brother Sam out to Studio 54, albeit in a suit and tie.[14] Then Beard just drifted away, as he so often did, and he didn't see his younger brother and sister-in-law again for several years. Cheryl was trying to rectify this. She was also attempting to bring order to his chaotic financial affairs after his friends in Nairobi had urged her to talk to his family about the financial chaos he left behind when he went away. Here, she mildly reprimanded him, writing that "it is time us responsible citizens back in America have to organize you—I must get some practical sense into you somehow."

Around the time of his wedding to Cheryl, Beard met Peter Riva, a New York–based photographer's agent whose grandmother was Marlene Dietrich. They were introduced by the celebrated French photographer Lucien Clergue, friend of Picasso, Ansel Adams, and a generation of contemporary artists. Riva was Clergue's agent and when Beard and Cheryl came to dinner at the family apartment, Riva mentioned that he and Clergue were working on a book. He had Beard's attention right away. He, too, wanted

to put together another book and, equally important, he said he wanted to get rid of his current agent, Peter Schub. The following day Riva phoned Schub with some trepidation. He was friends with Andy Warhol and clearly not someone Riva would want to alienate. As it turned out, Schub was delighted and told Riva he "couldn't wait to get rid of that bastard." After delivering a litany of complaints, Schub said Riva should tell Beard that he was "throwing everything of his out in the dumpster in the morning and I'm done with him."

When Riva told Beard his photographs and negatives were about to be thrown in a dumpster, he said it didn't matter, that it was "just stuff," his standard response to the loss or destruction of material things. Nevertheless, the following morning Riva drove to Schub's dumpster and retrieved armfuls of prints, tear sheets, negatives, basically the whole of Beard's photo archive from the 1970s, including his Rolling Stones photographs from the 1972 tour. Beard viewed this collection with a certain indifference but thanked Riva for the trouble and said in a matter-of-fact manner: "You're my agent now."

Riva was delighted to be associated with Beard. He had known his work for some time, particularly liked *Eyelids of Morning*, and shared his new client's love for Africa. He didn't sign an agent agreement, instead following the practice of the time which was to work on a project-by-project arrangement, with Riva nominated as the agent at each signing.

However, very early on in their affiliation he realized he was dealing with a client whose relationship with financial matters was tenuous to say the least. They were riding through Manhattan in a cab one winter morning when, at a stoplight, Beard's accountant suddenly appeared and leapt onto the back seat with the two Peters. Apparently, the Internal Revenue Service had been in touch and, as Beard had not filed taxes for several years, they were threatening to take executive action. Beard said he thought his brother Anson paid his taxes "with the money he chisels out of me." He was warned that if he didn't straighten out his taxes, the IRS would come after Thunderbolt Ranch. It was a serious enough threat for Beard to ask Cheryl if she would buy Thunderbolt Ranch from him. The

required $125,000 was a pittance for the world's highest paid supermodel and the transfer duly went through. In a complicated arrangement, Cheryl loaned Beard the money and took the front two acres, the main part with the house on it, as escrow against the loan. And so it remained for the next thirty years, with Beard and his family occupying the property rent-free throughout those decades.

Despite the tensions his frequent absences initiated in private, out there in the flamboyant, fast lane of Peter Beard's public life, he and Cheryl were being celebrated as the golden couple of the age. Among other laudatory articles, *Outside* magazine ran a cover story featuring them dressed in African safari chic, describing them as "Wildlife's Avant-Garde." In the article the writer Donald Katz captured the standard Beard eco-rant very accurately: "Beard is so deeply immersed in arcane conservation politics that he harbors even greater ill toward wildlife experts and 'the bogus new ecologists' than he does toward the fund raisers and other 'sentimentalists' they work for. He names them and rails against 'polluted, raving, crank ecologists who help the cause by squeezing and hugging little animals.'" Beard had learned well at the feet of Ian Parker, Alistair Graham, Bill Woodley and, inevitably, Dick Laws.

In a typically fervent, obsessed manner Beard wanted to get that message out to the world and in Cheryl he saw an extremely beautiful eco-asset, a widely recognized media face, through whom he could channel his dark thoughts about Africa's future and, as Katz acutely observed, issue scatter-gun abuse at all the softhearted Western do-gooders. A typical fussilade at the time was directed at Daphne Sheldrick, wife of his old enemy David Sheldrick, who he scornfully dismissed as someone who "breast-feeds wild animals" and "French-kisses milk into lion cubs." Cheryl, having at least some connection with rural areas and having been bewitched by Africa, understood clearly and pragmatically what she needed to do. "I'm not as sentimentalist as Peter," she said. "He's like that because he's swinging hard to one side on the issue so he can knock the pendulum back and knock sense into people. I can feed it out more palatably." And so, she did.[15]

Early in 1982, Beard told Riva that his friend Dodi Fayed, son of

Mohamed al-Fayed, the owner of the Ritz Paris hotel, had approached him and invited them to stay at the hotel. Beard, Cheryl, and Riva flew to Paris on the Concorde to meet with Dodi Fayed, Beard assuring his traveling companions that the hotel bill would be taken care of, that they were guests of the al-Fayed family. Somewhere along the way, Beard later told a friend, Dodi took him aside and offered him a million dollars for Cheryl. Beard was mortified and told Dodi to "Just fuck off." (Cheryl later said she didn't believe Dodi had made any such offer seriously and that she later heard it was Dodi's father who had told him he would give his son a million dollars if he managed to land Cheryl.) Whatever the truth, at the end of their stay Beard and Cheryl were handed a bill for $35,000 for their nights in their lavish suite and Riva was charged $11,000 for his more modest suite.

By this time, Cheryl was traveling less frequently to Africa and whenever the couple was together, they would inevitably collapse into vitriolic exchanges. "I kept thinking I can change this," Cheryl remembers. "Even though I loved him so much, I wasn't nice to him, and he wasn't nice to me. Living with him was more than a pain in the arse, it was something I didn't understand. He hurt me. He could be sweet, charming, and endearing and then he could also be tough and mean and hurt me on purpose. I'd sit him down and say, 'Peter let's work this out. What's going on? Why do you disappear?'"

After one particularly long sojourn in Africa, Beard returned to New York to find Cheryl withdrawn and clearly unhappy about the way their marriage was going. He suspected she had been having an affair while he was away—and she now admits she was unfaithful during his long spells in Africa—and suggested they drive out to Thunderbolt Ranch to talk things over. They were sitting out on the Montauk cliff in the early evening, and, after some awkward exchanges, Cheryl suddenly turned to him and declared: "I want a divorce."

"He kind of gasped . . . he made this strange sound," she said. "And then I said I needed to go and make a telephone call from the caretaker's cottage, as we didn't have a phone in the main house."

She made the call and as she was hanging up, she heard rustling in the bushes outside the cottage. It could only be Beard and, armed with a can of pepper spray, Cheryl went out into the darkness and began calling his name. "I obviously thought my life was in danger," she said. "And to this day I don't think I was being crazy."

Cheryl's trepidation was borne out of a real fear, for there was a darkness in Peter Beard that was to reveal itself sporadically across the years and occasionally manifest itself in acts of violence.

Out of Out of Africa

Africa has long been a gathering place for Western eccentrics. In the nineteenth century impecunious aristocrats, adventurers, and dislodged misfits from Europe and the Americas found theaters of operation across colonial Africa. Even in the late twentieth century, when independent states were being established and African countries were taking their place at the United Nations, the continent remained a magnet for those ill-suited to contemporary Western society. Beard's friend and fellow Hog Ranch occupant Gillies Turle was one such character, an ex–British Army escapee from Swinging London in the mid-1960s, recruited by the founder of the Special Air Service, David Stirling, who arrived in Nairobi as a bodyguard for a white member of the Kenyan parliament. Turle had run away from a somewhat dissolute life as a gambler and found some kind of spiritual salvation among the giraffes, warthogs, hyenas, and occasional leopards in a forest clearing at Hog Ranch.

Turle had just turned forty when he arrived at Hog Ranch. His marriage had collapsed, and he was desperate to escape what he saw as the boredom and dull grind of suburban life in Nairobi. A friend in similar circumstances had temporarily moved into one of Beard's guest tents and suggested Turle follow suit. A quick visit for the first time in years and Turle realized that a spell at Hog Ranch was just what he needed. Peter Beard was about to return from New York and Turle would ask if he could move in for a while. What he saw in Hog Ranch was a bohemian retreat that was a home for artists, a Left Bank in the bush, and a gathering place

for writers, conservationists, politicians, film stars, and models. Add to that its beautiful forest setting, which constantly rustled with the coming and going of wild animals, and which was home to more than eighty species of birds, and you had the perfect retreat for a man going through a midlife crisis in Africa.

Beard duly returned from New York and greeted his friend's request with typical magnanimity. "Sure, put up a tent," he said. "There's plenty of room."

The camp was rather run-down, Beard having been consistently absent for much of the 1970s, and the main mess tent as well as the studio and the kitchen, the three most substantial walled structures, were all in need of refurbishment. Turle erected his own state-of-the-art, schoolroom Tarpo tent in the southern part of the forest, a discreet hundred meters away from Beard's top camp and the campfire that was the centerpiece of Hog Ranch life. A wooden veranda was created; a low bed and two heavy wooden chairs were constructed by the resident carpenter, the wild, heavy-drinking dreadlocked Mwangi; a bamboo-walled shower room was erected behind the tent; and Turle built his own long-drop, complete with an inverted elephant jaw as the toilet seat. He added a walnut-fronted cupboard, a mahogany chest of drawers, an antique drinks cupboard, and a leather-topped writing desk, all from a new antiques gallery in Nairobi, in addition to bringing brass table lamps in from his own gallery. When he proudly showed his friend the new construction, Beard said somewhat sardonically, "Hey, it looks great, Gillies. It's a bit bigger than I had anticipated," and then laughed and wholeheartedly welcomed Turle to the Hog Ranch life.[1]

Although under Turle it was taking on the characteristics of a rather comfortable, and dare one say, slightly luxurious, bush camp—Cheryl Tiegs had referred to it as Ralph Lauren in the bush—the basic Hog Ranch infrastructure, from the early days when Beard was married to Minnie, remained in place. The diesel generator had come from the set of the William Holden film *The Lion,* the paraffin fridge had been donated by Iman, and Beard's tin bathtub and the polyethylene shower tent, which Turle regarded as

an eyesore, had been there since the beginning. And although Beard was constantly complaining about the increasing encroachment of suburban Nairobi, the camp remained relatively unchanged, an oasis of wildness and calm.

Through most of his life, Beard was lean and fit, boasting a muscled torso that barely showed an ounce of fat. This was particularly remarkable given the gigantic breakfasts that formed the basis of his diet at Hog Ranch. Two fried eggs formed the centerpiece, and balanced on the edge of the plate would be two small stacks of toast liberally slathered in butter. To the pieces of toast that encased the fried eggs would be added tomato ketchup and Worcestershire sauce, and the pieces consumed after the eggs would be covered either in honey or jam. This was the Hog Ranch breakfast of champions for a man who regularly dined in some of the world's most celebrated restaurants.

For someone who eschewed routine and embraced the drama of accidents and sudden unforeseen events, Hog Ranch was a perfect theater, for every so often the camp's laid-back atmosphere would be punctuated by an explosive encounter that would alarm visiting guests but absolutely delight their host. One particularly colorful event involved Mwangi Kuria, the giant, dreadlocked resident carpenter and Hog Ranch artist. He had built a particularly handsome structure to house an American documentary film crew and although he was paid an agreed sum by the Americans for his work, as praise was heaped on his carpentry skills he felt he deserved more money, which was not forthcoming. In a fit of pique and with a shake of his Rasta locks, Mwangi stormed out of Hog Ranch, and it was the last anyone saw of him for days.

Then, one tranquil evening at dusk, with the sun setting behind the Ngong Hills, a group sitting around the campfire sipping cocktails, and Peter Beard taking a bath in his tin tub at a discreet distance, a roar came from the mess tent. "Where is the bloody American?" shouted the clearly drunk Mwangi. Having retrieved a large kitchen knife, he came careening out of the mess tent and to everyone's amazement he had his eight children following behind him. Beard realized he was the very American Mwangi

was so determined to hunt down, and he leapt from the tin tub, grabbed a towel to wrap around his waist, and ran for his life. The group around the campfire watched in mute astonishment as Mwangi, shouting "come here you bloody American," ran after the fleeing Beard, followed in single file by his eight children, who appeared to be trying to calm him down. Beard, by this time, was roaring with laughter as the train of humans ran across the glade and in and out of the bushes.[2]

Eventually, as the drunk Mwangi was running out of steam, one of the campfire guests brought him to the ground. He sat, out of breath, the alcoholic fury quickly dissipating and his children standing around him, grateful that he had not caught up with Beard. For his part, Beard immediately forgave his friend and arranged for someone to take him and his family home. It had been another day of drama at Hog Ranch.[3]

* * *

After commuting to and from Hog Ranch through the early 1980s, Beard and Cheryl spent Christmas 1983 together in New York. It was a last gasp attempt to save their disintegrating marriage and in a long, handwritten letter to Cheryl, Beard celebrated their sixth Christmas together while also noting that there had been "many years of warmest thoughts and harsh difficulties shared." He told her that he had learned a great deal when the mill had burned down with all his precious materials and original art inside, the loss of some of his most valuable possessions, and the most important fact was that "there wasn't a beating heart inside the mill" and "now it is Christmas and come hell or high water we are here together."[4] But it did not work. Their friends and companions had seen them unraveling for years. Gillies Turle had watched the white-hot arguments they had at Hog Ranch early in their marriage and Tony Caramanico had witnessed blazing rows at Thunderbolt Ranch throughout the early 1980s.

As a desperate attempt at reconciliation, Cheryl managed to persuade Beard to see a marriage counselor / couples therapist and after a few sessions

the counselor pulled down a book from his shelf and thrust it at the couple. It was a study of bipolar behavior and the counselor said to Beard: "You are bipolar." Cheryl's first thought was "there are other people like this?" She said she didn't know anything about the disorder, but the symptoms described were familiar to her. Beard had his own take on psychiatrists, dating back to his time in Payne Whitney after he attempted to commit suicide in 1969. Basically, he had no time for them, regarded them as "non-doctors" and railed at "couch time that drains my meager resources."[5] Unsurprisingly, the marriage counseling didn't work, and they were inevitably headed for the divorce courts.

Cheryl admits she became "a very angry woman. It was 50–50. The madness, the disease, the bipolar disorder, whatever you call it . . . drove me out," she says. "I have to take responsibility for my part but . . ." She ordered both Beard and his friend Tony Caramanico off Thunderbolt Ranch. After living in a tent for a couple of months, Caramanico managed to scrape enough money together to put down a deposit on a house, and Peter Beard moved in with him.[6]

Meanwhile, having failed to save the marriage, Cheryl instructed divorce lawyers and set about erasing all connections with Beard. She started with a four-day purge of his photo library which at the time was stored with Mark Greenberg's Visions photo agency. She arrived with her assistant Barbara Shapiro and an X-Acto knife and went to work on any print, contact sheet, or negative that contained an image of her. "They sat in my office for two days and my job was to ensure she didn't set Peter's archive on fire," says Greenberg. "By the third day they trusted me enough to help them and we moved the whole operation to her lawyer's office and did the same thing for a few more days. It was an ugly process. She was so bitter. For her it was monstrous anger."[7]

Another condition of the divorce was that Beard was forbidden to speak her name in public and he began walking around carrying a sign which read: "Under terms of my divorse [sic] agreement I am forcibly prevented from making any mention of the name of my ex-wife or the circumstances relating to the marriage." Although highly acrimonious, the divorce settle-

ment did allow Beard to continue living rent-free on Thunderbolt Ranch in perpetuity . . . or at least until she sold it back to the family thirty years later.

"I felt like I was getting divorced," says Tony Caramanico, "I was so fucked up and stressed by it all." He was not surprised, however, that his friend had swiftly moved on and had found a like-for-like substitute for Cheryl. Beard had already met a local Kenyan called Carrie Gammon in July 1983. She was twenty-six and a local schoolteacher who had completed her teaching qualifications in London and rushed back to East Africa. Carrie was also stunningly beautiful, another long-legged blonde, and on their first outings to Beard's Nairobi haunts, locals assumed he was still out with Cheryl Tiegs. Carrie admitted she was "totally infatuated" from the outset and the pair spent a great deal of time together that summer, socializing around the Nairobi restaurants and nightspots and on one occasion climbing into Carrie's Suzuki and driving out to Kora to visit the famous lion man George Adamson, whose assistant at the time was Beard's friend Tony Fitzjohn, who was witness to Cheryl's near-death experience in Bill Woodley's Piper Cub.

It was at the end of summer, just before Beard returned to New York, that they made plans to meet up the following July in Europe. "We were going to do a rail trip through Europe. But we didn't," Carrie remembered. "Instead, I was to meet him in Marseilles, spend a few days there before renting a car and driving around Camargue."[8] But not content with one post-Cheryl mistress, Beard had already met Marella Oppenheim, a striking young actress, through a mutual friend in London a few months earlier. They'd joined a lunch party at San Lorenzo, the trendy Knightsbridge restaurant, and as they were walking back after lunch Beard grabbed Marella's hand. "I told him to get off and that I was married," she said. "But there was an electric current between us, and I knew I wouldn't be able to stop it."[9]

She didn't. But in the meantime, he had to meet up with Carrie Gammon and spend the promised three weeks with her in July. They had a pleasant time driving around Camargue before Carrie dropped him off at a train station—he had to travel to Arles, he said, to meet up with Paloma Picasso.

Whether he actually met up with her or not is unclear. (All those years back he had failed to meet Pablo Picasso, even though he got as close as the great artist's driveway.) As with so many strands of Peter Beard's life, his affairs were a tangled web of mystery, half-truths, duplicity, and unconfined ardor. He wrote to both of that summer's lovers with equal promises of everlasting love and never-ending passion, just as he had written to Cheryl and to his many lovers before her, and would do to his many lovers to come.

And when he did meet up with Marella, he told her that their affair was perfectly kosher because, according to Marella, "he said, 'I'm getting divorced and you're getting divorced. There's no problem.'" He did not, however, mention Carrie Gammon. So, Beard and Marella spent some time in Paris, where Marella's mother had an apartment, but most of their time was spent in the south, in Cassis and back in Arles, both of which strongly resonated with Beard. He had been traveling to Cassis since his cousin Jerome, who had a home here, first invited him to stay in the late 1950s. Arles, too, had been a regular Beard bolt-hole. There is a memorable photograph of the handsome young Beard, in the center of the Arles bullring in his shorts with his Leica raised, standing just fifteen feet in front of a snorting bull. The fearlessness that he carried throughout his days in wild Africa in the face of mortal danger is evident in that photograph and was immediately noted by his French friends and admirers.

So, when Lucien Clergue invited him to exhibit at the 1984 Rencontres d'Arles, the annual summer photography festival he had founded with the writer Michel Tournier and the historian Jean-Maurice Rouquette, Beard did not hesitate. With Marella in tow he descended on the South of France in a cloud of marijuana smoke. The pair would spend some months there, swinging between Cassis and Arles and launching themselves into what they described as a "Van Gogh Walk," wandering through and photographing the important landmarks the Dutch master had painted during his brief but extraordinarily fruitful eighteen months in Arles. Beard was fascinated that Van Gogh had completed more than three hundred paintings and drawings in that short time, that it also had a dramatic effect on

his vision and technique and, of course, that it was here he had severed his left ear. If Beard needed further evidence that the best art was created in an intense, stormy, stressed-out environment, the proof lay here in Arles.

* * *

For all Beard's comings and goings in the South of France, Paris, London, and Kenya, he still found time to plant his feet firmly in the 1980s New York social scene. It was there he met Jay McInerney, who would soon publish his landmark ode to the decade, *Bright Lights, Big City*. The pair met in the spring of 1984 at one of author George Plimpton's parties which featured such glittering literary figures as Truman Capote (he was to die a few months later), Norman Mailer, and Robert Stone. McInerney and Beard hit it off straightaway and the young tyro watched the dashing adventurer Peter Beard moving effortlessly through this wall of highbrow literary types with the ease and confidence of someone who was born to such social circles. "Peter was comfortable uptown and downtown," McInerney recalls. "He had an air of casual entitlement. He had impressive social mobility." He was always, and would always be, the ultimate social chameleon.[10]

The following year—with McInerney now the hot new thing in literary New York—the pair began hanging out in the clubs, together with frequent traveling companion, the musician Nile Rodgers, who would provide the chauffeured limo that moved them around Manhattan. They'd bounce from club to club refreshing themselves with cocaine along the way and always attracting beautiful young women in their wake. They were quite a trio—the author, the photographer, and the musician—restlessly scything through clubs such as Area and Danceteria, dropping in at Keith McNally's Odeon restaurant, drifting through downtown in a stretch limo, effectively mirroring the edgy pleasure-seeking practices of one of the key characters in *Bright Lights, Big City*. ("Tad's mission in life is to have more fun than anyone else in New York City, and this involves a lot

of moving around, since there is always the likelihood that where you aren't is more fun than where you are.") It was easy to see what Mc-Inerney and Beard had in common.

* * *

Early the same summer, Beard read for the first time the script for Sydney Pollack's new film, *Out of Africa*. Although he welcomed the invitation to act as a technical advisor to what was proposed as a Hollywood block-buster, he hated the script, arguing that it bore no resemblance to Karen Blixen's memoir. Although Beard and his manager Peter Riva would con-test the legal legitimacy of the project there now seemed little doubt that the Pollack film, which would star Meryl Streep as Blixen and Robert Redford as Denys Finch Hatton, was to go ahead and that filming would begin early the following year in Kenya.

It was partly Beard's own fault that he had lost the rights to a film that he had wanted to be involved in from the early 1960s. He had prom-ised Karen Blixen at their last meeting that he would ensure any film of her book would be created in the same spirit in which it was written and although that was clearly open to wide interpretation, what was quite evident was that Blixen saw Beard as a soulmate regarding disappearing Africa and fully trusted his judgment.

The first attempt by anyone to put together a film script was made in 1963, a year after Blixen's death, when the Danish Ministry of Cul-ture granted money for a research trip to Kenya for the film producer and director Johan Jacobsen, his writing collaborator Annelise Hovmand, the widely respected screenwriter and director, and Blixen's brother—and Beard's close friend—Thomas Dinesen. Although the subsequent script would be written in Danish it was understood from the beginning that, given the success of *Out of Africa* in the English-speaking world, this would have to be an English-language film.

Although the three Danes were greeted with great warmth by Kamante Gatura and his family, who met them at Nairobi airport and presented

them with two live chickens, they were made aware very early in the visit that a film celebrating someone now perceived as a white colonial woman ruling over Black servants, on the eve of the country's independence, would not be well received. This antipathy was quite consistent throughout the trio's visit, although one of the old chiefs from the Blixen era, who now wore a suit and whose daughter was a department head in the Ministry of Health, demurred. He told them it was nonsense to turn one's back on the past. "We were wonderful in those days," he said. "You should have seen me naked. And the dances we had. We could dance all night."[11]

Slowly, the trio had started to win people over and by the time they returned to Copenhagen, they felt they had the basics for a film. For Thomas, the trip had been something of a chastening revelation. During the time he shared with his sister in 1920s Kenya, Thomas was well known as a big game hunter and on his return to Denmark was able to bring to the embryonic script the excitement those early twentieth-century hunters enjoyed, when the plains were full of game and the wildlife populations seemed infinite. On this research trip however, he, like so many of his peers, had found himself re-examining his role in the destruction of the wildlife. He said afterward it was a sobering moment and it had made him question the apparent joy hunting gave to his younger self. It was something he and his friend Peter Beard would discuss throughout the 1960s.[12]

Although the project was beginning to lose momentum, Johan Jacobsen remained committed enough to contact a young Vanessa Redgrave to play Karen Blixen. It was left to Beard to pick up the reins and in December 1967 the Rungstedlund Foundation, created by Blixen to safeguard her literary legacy, the family home, and its bird sanctuary, endorsed what they described as "the work that Peter Beard has in mind which can be expected to result in material suited for motion picture as well as for television . . . and we shall not grant television or film rights in connection with *Out of Africa* to others while work on these plans is in progress." However, it seems that the foundation had already granted film rights to Random House, the publishers of the book, and they claim that they had informed Beard of this at the time.[13]

Soon after, the author and playwright Robert Ardrey, who had recently

had great commercial success with his book *African Genesis,* was commissioned by Universal Studios to produce a screenplay but that, too, was abandoned. At around the same time, Beard was having talks with the British director Nicolas Roeg and discussions were held about casting Julie Christie as Blixen and a soundtrack composed by Beard's friend Mick Jagger. As with all the previous attempts, these plans also foundered and by the time Universal Pictures, Sydney Pollack, Robert Redford, and Meryl Streep began shooting the film in Kenya, Beard was forced to look on from the sidelines.[14]

But as Pollack's *Out of Africa* got under way there was a hostile exchange of letters between Peter Riva and the Rungstedlund Foundation: Riva claimed that the foundation had breached a firm contract with Beard and the foundation claimed that while there had been letters of intention issued, no actual contract was signed by either party. The foundation also claimed that Beard's interest in the project had wafted and waned over the years and there were accusations from the foundation's literary executor, Clara Selborn (formerly Svendson), who had been Blixen's private secretary, of a dysfunctional relationship with Beard. "While most of my correspondence is filed normally," she wrote, "communications from Peter Beard have at times been so voluminous I have them in cardboard boxes."[15]

If Beard had felt nonplussed by the script, he was singularly unimpressed and disappointed when his role as a consultant was withdrawn by Sydney Pollack on the grounds of his being regarded a disruptive influence.

* * *

On March 25, 1985, Kamante Gatura suffered a heart attack and a debilitating stroke that rendered him speechless. He was rushed to Nairobi Hospital from Hog Ranch and there he lay for several days as doctors fought to save his life. Beard had arrived back in Nairobi the previous month with a small entourage, including Iman and Peter Riva, to do various fashion shoots for a special adventure issue of *Vogue* as well as a shoot for *Playboy* celebrating the tenth anniversary of his discovery of the Somali supermodel.

His concern for his eighty-year-old retainer, who he had brought to Hog Ranch in 1962, was palpable.

When Beard last met with Karen Blixen in Denmark just before her death in 1962, he had promised her he would seek out Kamante in Nairobi and look after him. Blixen had, on her departure from Africa in 1931, left the young Kamante a twelve-acre farm and some chickens in Rengute Village just outside Nairobi, but his fortunes had diminished over the years and by the time Beard found him in Rengute, he was drinking too much and certainly not prospering. Beard's gesture, though generous, was not entirely altruistic. He knew that Kamante was a direct link to the lost world of *Out of Africa,* the wellspring of Beard's long-running African adventure, to the old Kenya forever mythologized in Beard's mind.

Whether or not Beard actually recorded Kamante's memories remains a contentious issue. He claimed to have done so and to have used these spoken recollections as the basis of the book *Longing for Darkness,* published in 1975. The book, which featured an afterword from Jackie Onassis, was billed as "Kamante's Tales as collected by Peter Beard," and featured page after page of scratchy, schoolboyish handwriting expressing the sweet but naive musings of the former Blixen *toto.*

However, Alistair Graham, Beard's former close friend and the author of *Eyelids of Morning,* said the whole project was a Beard scam and that he had, in fact, written the content of the book himself and then employed a professional Nairobi letter writer to transcribe his inventions as if it had all been written by the illiterate Kamante. Graham insists Beard had contacted him from Ari Onassis's yacht in the Mediterranean and had invited him to join a scam that he'd concocted around made-up letters between Kamante and Jackie Onassis. Graham says that Beard asked him to take letters that he, Beard, had drafted down to the professional letter writers in downtown Nairobi to reproduce in scrawly, semi-pidgin English. After which he was asked to secure Kamante's signature and then to post the result to Jackie Onassis and intercept her replies to create a book. Graham says he was offended his old friend would consider such a deception. "I told him that he was doing exactly what he had so often criticized in other

people and that I could hardly believe he was doing it," said Graham. "The only thing I could think was that the suicide attempt a few years earlier had damaged his brain, just as the doctors told me it likely would." Graham and Beard stopped talking to each other at this point and never spoke again.[16]

Kamante would later complain bitterly to *New York Times* correspondent Alan Cowell, "brimming with indignation against some of those who nurtured his fame." "Those" being Peter Beard. Kamante's complaint was that he had not seen a cent from *Longing for Darkness,* which he claims he wrote although overwhelming evidence suggests otherwise, and that clearly Beard had earned millions. In fact, Beard had earned a relatively small advance of $35,000 which, he said, had barely covered his expenses, and book sales had been so inconsequential that there were no further royalties. Kamante's further complaints to Cowell about the content and the interpretation—where he opined, "What is this darkness? What does it mean? When was I ever in darkness?"—indicated a plausible lack of understanding of the swirling imagery that carried Karen Blixen's pièce de résistance. Kamante's wife, Wambui, whom he had married on Blixen's farm some sixty years before, chimed in with the opinion that "Maybe this darkness nonsense means Kamante's business with Beard. Kamante thought he was in the light when he wrote that book, thinking it would benefit the family, and all the time he was in the dark."[17]

This simplistic reading of the economics of the international publishing industry clearly defined the disputes that would follow Beard around Kenya in the coming years. While his relationship with his staff at Hog Ranch was feudal, it was by circumstance rather than intent. For all the accusations that Beard was racist, he simply wasn't. He was fiscally incontinent, driven by art and ideas to the exclusion of all else, he was morally ambivalent, again not by design but by instinct, and he ordered his staff at the Hog Ranch Art Department to express themselves artistically in exchange for not inconsiderable sums of money. The so-called department began quite informally with Kamante contributing naive African illustrations (mainly of animals but including some narrative portraits) for *Long-*

ing for Darkness in the early 1970s. Beard encouraged his retainer—as he would encourage the other young would-be artists such as Mandy Ruben—to continue with his artwork, with Beard providing the inks, pens, and brushes. Nathaniel Kivoi, who had been a game ranger under Bill Woodley in the Aberdares and had been persuaded to join the Hog Ranch entourage in the late 1960s, soon became the lead artist in the art department and over the years was joined by other staff members. By the mid- to late-1980s this creative arm of Hog Ranch was playing a more significant role in Beard's photographic collages.

There is no question that by this time the extended families of these Kenyan employees were benefitting greatly from the creative presence of Peter Beard at Hog Ranch. For all their differences, Beard and Kamante remained very close; there was a mutual respect that transcended political, social, and racial divides. However, as the old man began to fade, so Beard's problems began to escalate.

On a Saturday at the beginning of June 1985, soon after Beard had done some photographs with Khadija Adam, a beauty queen who had taken part in Miss World and was fast becoming the new Iman, at Hog Ranch, the Kenyan police raided the property. Beard was arrested on a charge of cultivating forty acres of marijuana and as there were no judges presiding over the weekend, he was held briefly in jail. He was handcuffed to a fellow inmate, a man who had been frequently beaten by the police, and they warned Beard, "you're next, *mzungu* [white man]." But by Monday, Beard's international network, led by his agent Peter Riva and his devoted, and highly connected, friend Jackie Onassis, were talking to the US State Department. The Kenyan government was politely advised that it would not do to mistreat, or mischarge, such a well-connected son of America.

Precisely two weeks later, another Saturday, the Nairobi police again arrived at Hog Ranch, and again searched the premises. This time they came up with a catalog for the Paris Museum of Modern Art which featured on its cover a typically risqué portrait by Helmut Newton. It was denounced as pornography by the Kenyan authorities, Beard was charged with "trafficking in abscene [*sic*] literature," and again sent to jail for the

weekend. By this time Peter Riva had flown out to Nairobi as had Princess Elizabeth of Yugoslavia, an old friend and supporter, who checked into the Nairobi InterContinental Hotel. Meanwhile, the local lawyer Riva had hired warned him that the judge who had been appointed to try Beard's case was known locally as a "hanging judge" and that the prospects of Beard escaping a prison sentence were slim. While Jackie Onassis continued to pressure the US State Department, Riva and Princess Elizabeth were being told by US embassy officials in Nairobi to prepare to lift Beard out of the country. As Riva later said, "They all knew the charges were trumped up and that the best way to avoid a diplomatic incident between the two countries was to get Beard out of Kenya."[18] Beard refused to leave. He was determined to fight the case and began briefing his legal team.

That there was a coordinated campaign against Beard was confirmed in the two weeks between the police raids. On June 12, the *Kenya Times*, the country's leading newspaper, ran a front-page story claiming Beard had used Kamante for his own benefit and that "Karen Blixen's literary star was dying unnoticed." The editor's own take on the situation proved to be even more incendiary. He wrote: "At a place called Langata near Nairobi is a dying man called Kamante Gatura. He is passing away generally unnoticed, although for a long time he was presented as the prototype African—backward, uncivilized and animal-like—by writer Karen Blixen, the baroness who acquired a farm in Ngong at the turn of the century. When *Kenya Times* visited Kamante last week a chilling story of betrayal and disillusionment unfolded, and questions came to mind. Why, for instance, must we name the area and the college after racist Karen Blixen? Why not after Kamante, whose current predicament is a consequence of colonial injustice, an experience we are all very familiar with?"[19]

The main story was based on interviews the reporter, Mike Njeru, had conducted with Kamante's extended family, who were all living on Beard's dime at Hog Ranch. They claimed, quite incorrectly, that Beard had inherited Hog Ranch from Karen Blixen and that she had intended it to be split between Beard and Kamante and, most importantly, his family.

Njeru also repeated Kamante's claim in *The New York Times* that he had not received any royalties from *Longing for Darkness*. At the time of Njeru's visit to Hog Ranch, Kamante himself was unable to comment as he lay paralyzed in his cot, nearing death.

A week later the *Kenya Times* launched another attack on Beard, this time giving voice to Iman's disgruntled ex-husband Hassan Geddy, who claimed that ten years earlier Beard had stolen Iman (the paper actually called her Imam) from him and that he "had tried to murder me." Both attacks drew fierce response from Hog Ranch workers and from Beard's fast-gathering collection of supporters. The staff, led by Nathaniel Kivoi and Mbuno, denounced the articles as a tissue of lies and demanded to know who the sources were. Beard himself told a magazine writer, "Macomba tribesmen—very highly placed in the police and relatives of Kamante who I had kicked off the property for various transgressions—were interested in developing the land."[20]

Inside the halls of the *Kenya Times* not all the staff were happy about the editorial attack on Beard and on July 1 Tarichia Mugambi, the paper's marketing manager and a member of the editorial board, resigned in protest. He regarded the stories as "a relentless one-sided attack with obvious, libelous and racial overtones." He said the newspaper's editor, Horace Awori, had just smiled at his protestations and said it was his intention to "teach the American a lesson."

On June 29, 1985, Kamante Gatura died. Having established a place in literary history as Karen Blixen's boy chef, his unsuccessful later life had been turned around by Peter Beard, whose rescue of this unemployable old man in the early 1960s was both an act of kindness and a shrewd attachment to the mythology of the author he so revered; the thirty-year relationship between the two men was mutually beneficial. In his later years Kamante became, as Blixen's biographer Judith Thurman observed, "a majestic old patriarch who walks with a cane, wears Scottish sweaters against the damp and still knows how to cook. He can tell a story with great glances and epic pauses, and he is still a figure 'half of fun and half of diabolism' filled with mocking laughter."[21]

Sadly, Kamante's death unleashed an attempted land grab by his un-grateful family, led by his son Francis Kimani. While the police raids, trumped up criminal charges, and blizzard of unflattering newspaper ar-ticles were swirling around Beard/Hog Ranch, Francis Kimani visited a local estate agent to find out how much Hog Ranch was worth on the open market. Sensing this valuable property may be coming onto the market, the estate agents made a bid of $150,000, which Beard promptly turned down. Another offer of $200,000 was similarly dismissed. This did not deter Francis Kimani for a moment. He was now aware that were Beard found guilty of any of the criminal charges he faced he would forfeit the right granted to him in 1962 by Jomo Kenyatta to own Kenyan property and were he handed down even a short jail sentence he would be deported. Sensing blood, Kimani delivered what was effectively an extortion note to Beard suggesting that six million Kenyan shillings or $50,000 would be ap-propriate compensation for unpaid royalties from *Longing for Darkness*. The note read "Six million will do very nicely" and Beard rejected the threat with contempt.[22]

Through all of this, Beard's life as a fashion photographer, artist, ad-venturer, and wild man of the bush continued apace. That summer he had lured one of the hot models du jour, Janice Dickinson, out to Kenya for her first trip to Africa with typical insouciance. Janice had first met him years before as a seventeen-year-old aspiring model at a party at the society fashion designer Halston's house in 1973. Being a bright, inquisitive soul, she had approached Beard to tell him how much she admired his work. She remembers he was talking to Woody Allen, and she tapped him on the shoulder. He all but ignored her. "I was really mad that he could not be bothered to talk to me. Later I sat next to him and I was left feeling a little wounded. I got up and left the party and I swore that if I were to ever make it as a model I would never let him take my picture."[23]

Twelve years later she was one of the world's top fashion models and was staying in Milan with an Italian boyfriend named Francesco. The phone rang and he took the call, passing her the phone and telling her that it was someone called Peter Beard. Beard went into full overdrive:

"Hey JD, how are you doing? I'm calling from Africa, actually." Janice replied that she was still mad at him for ignoring her at the Halston party but asked what it was he wanted. He said he had been commissioned to do a photoshoot for *Playboy* magazine, that she would make "buckets of money," and then he begged for forgiveness for the Halston slight, excusing himself by saying that he was probably high.

For all her long-held promises never to work with Beard, Janice was immediately seduced by the idea of going to Africa. Within days, her agent had delivered a first-class air ticket and she flew to Kenya. "When I walked into Hog Ranch I thought I had arrived in heaven. There were three main tents, we all sat around a campfire, everything was beautifully lit. Unforgettable."

The *Playboy* editors accompanying the shoot had tried to persuade Janice to wear a Dallas Cowboys hat and a bra with tassels but both she and Peter realized that such outfits would look incongruous if not downright foolish in the African bush. "Fuck it, we don't need that stuff, we just need you," Peter said, and proceeded to talk Janice into posing with the largest cheetah in captivity. When she asked nervously how she was going get out there with a wild animal his reply was typically insouciant: "You're Janice Dickinson. Figure it out." So, Janice reasoned that above all animals sensed fear and to numb her fears she took to the bottle, a six-pack of Tusker beer to be precise. "And after six Tuskers I had no fear at all and went out there and rolled around with the cheetah."

The resulting photograph would become one of his best-known model–wild animal interactions. And, not surprisingly, a brief affair ignited between the pair, Janice blaming a roaring lion for persuading her to flee her Hog Ranch tent and to join Beard in his. "I made it clear that I would be sleeping in the far corner of his tent, but we did end up snuggling all night. I said to myself, 'What's it going to be, a snog with Peter Beard or getting eaten by a lion.' It was an easy decision."

Their affair was short-lived, and Janice said that by the time they returned to New York she had fallen out of love with him. "I had a small apartment in New York. I asked myself if I would have to clean up after

him with all that blood, and there was blood everywhere at his studio. "And I wouldn't have wanted to bring Peter Beard into my agency with me, with those filthy hands and feet, wearing sandals and a kikoi. It would be like having a homeless boyfriend."[24]

What Janice did notice at the time was when the camera came down, he would go into his shell. "There was obviously something wrong with him—maybe not enough affection from his mother," she said.

At around the same time that Janice was rejecting the idea of a long-term relationship with Beard, another young woman caught his eye. Nejma Khanum Amin was a twenty-nine-year-old Muslim woman whose father was a High Court judge and whose upbringing was as far from Beard's renegade lifestyle as the sun is from the moon. She had been educated at schools and colleges in London, Belgium, and Germany and had returned to Nairobi and the moral confines of her strict Muslim home. Fiammetta Monicelli, Turle's longtime partner and fellow Hog Ranch resident, remembers Nejma as a "sweet girl who I knew from the Nairobi scene. We used to go out dancing. At first, she was very timid and then she became bolder. She thought of herself as good looking and wanted to be a model. And famous. That is why she wanted to meet Peter Beard."[25]

Nejma began hanging around Gillies Turle's Antique Gallery, telling Turle she wanted to meet Peter Beard. Then one afternoon after Beard and Turle had had a long lunch at the Norfolk Hotel's Ibis Grill restaurant, Turle returned to the gallery to find Nejma there once again. This time he told her she could probably still find Peter sitting around at the Ibis, talking to friends. She headed for the Norfolk Hotel immediately.

"By the time I got back to Hog Ranch that evening, damn me if she wasn't sitting around the campfire with Peter," Turle said. "I checked on them the next morning and they were in bed together."

The sudden explosive relationship with this eccentric, glamorous American photographer did not go down well with the Honorable Justice Sheikh Amin or the Amin family and they attempted to lock her down and confine her to the family compound. Not surprisingly, this did not faze Beard. One night in December 1985 he managed to co-opt several

friends in what would become the first stage in Nejma's liberation from her family compound and its conservative constraints. Willie Purcell, an old Kenyan friend, and Antony Rufus-Isaacs, the British film producer, another old friend who had just completed producing the Hollywood blockbuster *9½ Weeks,* were persuaded that they should take part in physically freeing Nejma. So, they crept along to the walled home on a dark Nairobi night and set a ladder up against the perimeter wall. According to Rufus-Isaacs, Peter Beard had had his traditional evening marijuana spliff, and was thus rendered somewhat incapable of climbing the ladder. So, while he was leaning insouciantly against the wall, it was left to Willie Purcell, a man with one leg, to climb the ladder and haul Nejma over the wall to freedom.

The group then headed for Lamu for several days where they partied on dhows and had great lunch parties at Peponi, the island's celebrity hotel. It was a hedonistic excursion and for Nejma a dramatic departure from her conservative Muslim roots. Although she had often enjoyed nights out in Nairobi this was one step beyond—she had run off with a man who represented all that was profane to her conservative family. They hated Peter Beard and everything he stood for.[26]

This flagrant disregard for the family's code led Nejma's father to impose an even tighter curfew on her and she failed to appear at the offices of *Presence* magazine, where she was managing editor, and didn't show up as expected at a special screening of *Out of Africa.* The magazine's general manager penned an angry letter demanding that she call in to the offices as a matter of utmost urgency as they were looking for cover artwork, stories, and photographs that were all Nejma's responsibility and "the alternative is to cancel this issue with the printer and delay until March. This could spell disaster for the magazine."

Similar attempts to get hold of her by phone were equally unsuccessful. The last time her friends had seen her in public was at a lunch at Alan Bobbe's Bistro in central Nairobi when she had told them that her father had beaten her the previous night and locked her up as he did not want her to attend her new paramour's court appearance on January 31, which

finally saw him acquitted of charges of growing marijuana and possessing obscene material.

Against her friends' advice she had returned home after the lunch and had now disappeared from view. Further calls to the family home were deflected, and Beard and Gillies Turle were so concerned that they began to assemble a habeas corpus application through the courts to secure Nejma's release, thereby preparing to take on one of the most powerful judges in Kenya. While worried friends had been calling the Amin home, Nejma had, in fact, been spirited out of the country, sent to Germany on Lufthansa to stay with her uncle, a professor at Heidelberg University. Her father had walked her onto the aircraft. On the flight she wrote a hasty letter to Turle, noting down her contact details and, when she arrived in Germany, she gave a taxi driver eighty dollars on the promise he would post the letter to Kenya. Fortunately, the letter arrived the day that Beard and Turle were about to issue their habeas corpus application against her father.[27]

On receipt of the letter, Beard, together with his friend Princess Elizabeth of Yugoslavia and manager Peter Riva, immediately made plans for Beard to fly to Germany and free Nejma from the family bonds. Riva bought him an airline ticket to Germany and arranged for him to spend two nights in the Steigenberger Hotel. Meanwhile, Beard had no clothes that were suitable for the European winter, so his friend Turle loaned him his very expensive tweed suit, made by Rupert Lycett Green in London's Savile Row. (Beard returned the suit two years later with a big hole burned in the jacket and a heartfelt apology that he had foolishly put the jacket over a lamp in a hotel. Turle threw the suit away.)

Once he had arrived, Beard phoned Nejma, and arranged for her to leave her uncle's home on the pretext of going to the shops. The couple then flew to London, where Princess Elizabeth was waiting for them.

Among the most touching aspects of this high-drama beginning to Beard's relationship with Nejma Amin were the somewhat melancholy but movingly articulate letters she wrote to Beard's wingman Gillies Turle during her sudden exile in Heidelberg. While she admitted to having rather hazy thoughts because she had been prescribed Limbitrol, a drug

used to treat depression, by a family psychiatrist, she was unstinting in her praise and admiration for Turle for all his support. "So much love I can't express but if ever you need me you can count on me," she wrote. It was a promise she was to abandon more than a decade later when she turned her back on her old friend and refused to speak to him again. She also wrote another letter to Gillies asking, "please don't say rotten things about my parents to anyone, they are prisoners of their own fantasies, just as we all are to some measure."

Years later, when Beard and Nejma were in the throes of serious marital troubles, Beard would tell people that he had only married Nejma to help her escape Kenya and get her a US green card. This was always regarded as an unlikely story as Beard was not inclined to indulge in random acts of humanitarian kindness and had never before or since displayed such a deed of selfless chivalry. As with all Beard's emotional affairs, the truth is elusive and extremely complicated.

Soon after the couple had arrived in London, on their way to America, they were given a dinner party by the art dealer Martin Summers. Among the guests was Beard's old friend, the photographer Mirella Ricciardi, who had known Nejma for some time before Beard met her and described her as "a tough Kenya chick who knew on which side her bread was buttered." She sat Nejma down and asked her if she knew what she was taking on and warned her about "giving up her life to someone like Peter. He was my friend, but I knew very well what he was like. The wildness. The unpredictability. She said, 'Don't worry Mirella. I will tame him.'"[28]

As always, Beard was financially broke, and it was left to his friend Francis Bacon to lend him £10,000 to see the couple through the next few weeks and buy them airline tickets to New York.

Beard's marriage to Nejma the following December was a low-key and seemingly spontaneous affair compared with his past two weddings. The previous night he'd been out clubbing with his friend the art historian Drew Hammond. It had been a typical Beard night—partying, clubbing, drinking, and drug taking—and by the time Drew drove them back to Thunderbolt Ranch in the early hours of the morning, he was exhausted.

Typically, Beard rose early and, fresh as a daisy, mixed himself a bullshot (vodka, beef bouillon, freshly squeezed lemon juice, Worcestershire sauce, salt, and black pepper) before rousing Drew, who was sleeping on the sofa, and asking him: "Are you coming to the nups?" This was the first Drew had heard of said nuptials but readily accepted the invitation and a few hours later joined a handful of Beard's Montauk friends and the local justice of the peace for a ceremony that lasted little more than five minutes on the cliffs of Montauk. Beard's former caretaker and old Montauk friend Tony Caramanico was best man.[29]

Nejma was now the third Mrs. Peter Beard.

10

Of Man and Nature

African rhinos are divided into two subspecies: black and white. This has nothing to do with the animals' color; they are both the color of mud, sort of brownish gray. Rather, they are distinguished primarily by the shape of their mouths. The name white rhino (*ceratotherium simum*) is believed to be derived from the Dutch/Afrikaans word *wijd*, which means wide but sounds like white. It was the Dutch settlers in South Africa who first gave the name to these grazers who feed on the grasses of the bushveld, their square wide mouths acting as something resembling lawnmowers. They are large animals that are social and generally docile, a wildlife version of cattle. Black rhinos (*diceros bicornis*) are, by contrast, smaller, hook-lipped creatures that are more solitary than their white cousins, and short-tempered, unpredictable, and often extremely dangerous. They are browsers, using their hook lips to strip foliage from low-lying branches.

Peter Beard's acquaintance with African rhinos dated back to his first trip to the continent with Charles Darwin's great-grandson Quentin Keynes in the mid-1950s, when the pair visited the southern African parks Umfolozi and Hluhluwe, at the time the base camps for the rehabilitation of the almost extinct white rhino species. However, his more spectacular escapades involved black rhino translocations in hunting blocks around Tsavo National Park, some two hundred kilometers southeast of Nairobi almost a decade later. The Kenya Game Department had hired Beard's

eccentric friend and neighbor Ken Randall, a weather-beaten man of the bushveld, to capture and translocate black rhinos, some to southern Africa in exchange for Hluhluwe's white rhino.

As Randall's cohorts, Beard and two of his trusty companions, Galo-Galo Guyu and Kamante Gatura, spent several months tracking and roping wild black rhinos like American cowboys. They would chase down the ferocious, charging, bucking beasts in Randall's wheezing old Land Rovers, bring them down with rope lassos, and then pen them in log bomas. It was dangerous, adrenaline-pumping work, and given that it was all conducted in 110-degree Fahrenheit heat and dust, these were perfect Peter Beard high-adventure conditions.[1]

This rhino translocation exercise had also provided Beard with two important insights relatively early in his African life. First, insight into the futility of man's attempt to manipulate wild Africa, the white colonials' role as the gardeners of Eden, by moving animals around, fencing off reservations to preserve ecosystems, and attempting to micromanage vast expanses of wilderness. And second, it offered a front-row view of the awesome wild power of animals like the black rhino. As he said later, "the waste of time was immense, but the way of life was rich."

More than two decades after the translocation safaris in Kenya's Darajani region, Beard was back in the country and about to come face-to-face with the all too physical manifestation of that second insight. Yet again he had arrived in Kenya with a film crew. This time it was to work on the ABC TV documentary *Last Word from Paradise: With Peter Beard in Africa*, a million-dollar production that was planning for Beard and entourage to crisscross Kenya for four months, taking in among other locations Lake Turkana (formerly Lake Rudolf), where Beard had lived during the making of *Eyelids of Morning* in the late 1960s, Amboseli, and his old friend Glen Cottar's camp on the Athi River.

They arrived at Nairobi National Park on Valentine's Day 1987 and met up with Terry Mathews, a professional hunter, safari guide, and old friend of Beard's, who had been hired by ABC as a wildlife consultant.

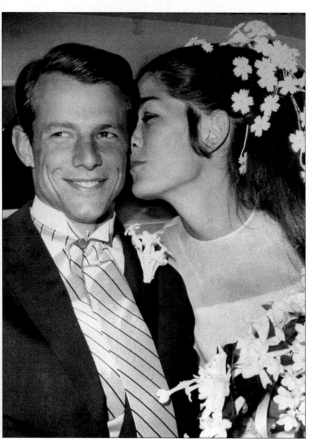

(Above) Life in the afternoon: young Beard photographing bullfighting in Arles in 1966. *(© 2022 Lucien Clergue / Artists Rights Society (ARS), New York / SAIF, Paris)*

High society: Minnie Cushing and groom at the couple's Newport wedding in 1967. *(Getty Images)*

(Top) Kennedy connection: with close friend Jackie Onassis at the opening of the ICP show in 1977. *(Orin Langelle/Langelle Photography)*

(Center) Night life: with Truman Capote and friends at Beard's 40th birthday party at Studio 54. *(Orin Langelle/Langelle Photography)*

Role reversal: supermodel Iman wields the camera and Beard offers his profile at Lake Turkana in 1985. *(Mirella Ricciardi)*

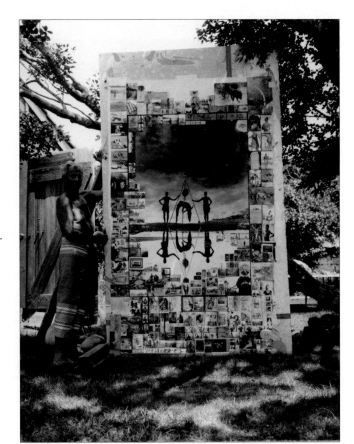

Major works: Beard is dwarfed by one of his dramatic trademark photo-collages. *(Ivory Serra)*

Beautiful Americans: with second wife, the supermodel Cheryl Tiegs. *(Ron Gallela/Getty Images)*

Bleeding for his art: Beard takes a pair of scissors to his forearm in preparation for a new work.
(Orin Langelle/Langelle Photography)

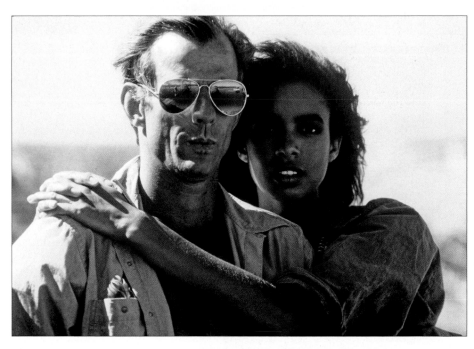

Living sculpture: with his favorite muse and long-term lover, Maureen Gallagher.
(Mark Greenberg)

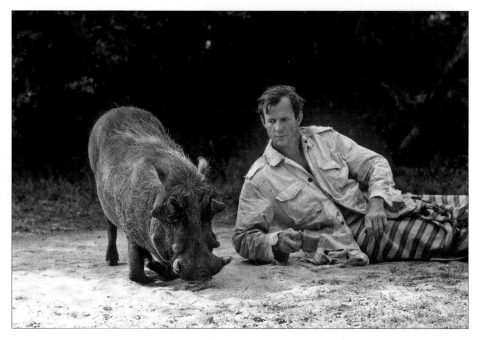

The main hog: Thakar III was one in a long line of dominant male warthogs at the ranch. *(Mark Greenberg)*

Old friends: Iman with fellow Hog Ranch habitué Gillies Turle. *(Gillies Turle)*

Arles affection: with Marella
Oppenheim in the south of
France in the autumn of 1984.
(Marella Oppenheim)

(Below) The art of the diarist:
Beard examining years of wild
thoughts. *(Ivory Serra)*

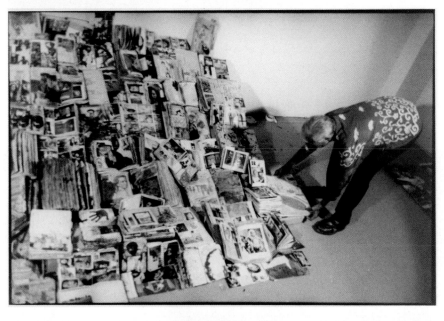

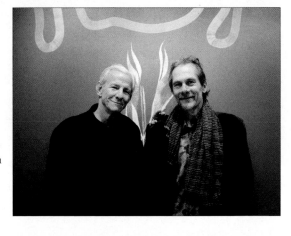

The Blixen connection: in
Copenhagen with Morten
Keller, grandnephew of
the *Out of Africa* author.
(Morten Vilhelm Keller)

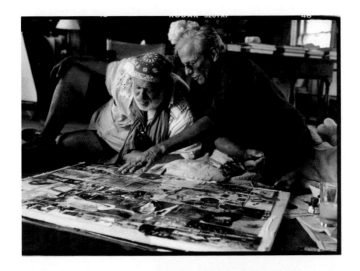

(Above) Photo artists: with the fashion photographer Bruce Weber at Thunderbolt Ranch. *(Ivory Serra)*

Danish delight: with Rikke Mortensen in Los Angeles in the early '90s. *(Diana Barton)*

(Below) Bloody bodies: working with his favorite subjects, living sculptures. *(Ivory Serra)*

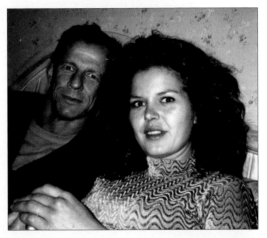

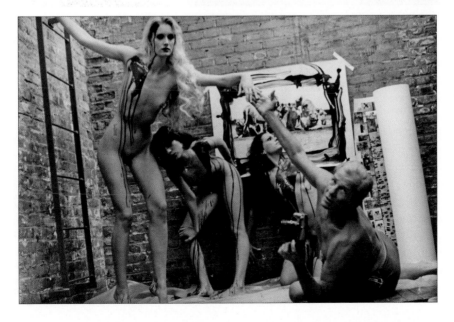

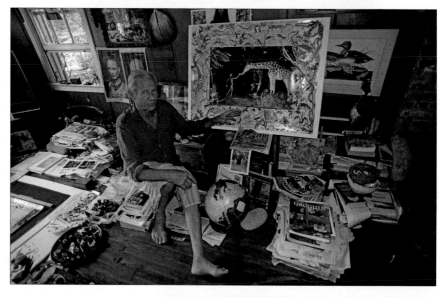

(Top) Signing in: performing
one of his ritual, intensely
filigreed book dedications.
(Graham Boynton)

(Center) Thunderbolt studio:
like most of his addresses, his
Montauk home became an art-
strewn studio. *(Graham Boynton)*

Montauk truce: in the later
years, Beard's long-suffering
wife Nejma controlled his
wanderings with steely
determination. *(Graham Boynton)*

That day they were to locate and follow a black rhino in the park with Beard adding his voice-over later. With two camera crews in tow, the ABC team soon found a female black rhino and calf crossing the open plain, with both Mathews and Beard tracking the animals on foot.[2]

What happened next has been vigorously disputed across Kenya's wildlife community and in New York's law courts. Beard and Mathews, in tracking the black rhino and her calf, gradually and almost imperceptibly came closer and closer to the animals. Suddenly, it seemed that the calf was startled by the presence of humans on foot and that in turn caused the female to stop in her tracks, turn, and face Mathews. At this stage Mathews, who was probably about ten meters away from the animals, began waving his arms above his head, shouting, "Bugger off. Bugger off." Rather than buggering off, the black rhino just charged at Mathews. In a second, it was on him and, with a single upward thrust of its sharp, long horn, tossed him into the air like a rag doll. By the time Mathews hit the ground, the rhino had wheeled around and was facing him again, ready for a second charge. To the neutral observer, what was most striking about the attack was the enormous power and extraordinary mobility of this one-and-a-half-ton animal. Beard, of course, having worked closely with black rhinos in the 1960s with Ken Randall, was fully aware of this.[3]

Once the rhino had established that the perceived enemy was not going to rise again and threaten her and her calf, she turned away and ambled off across the bushveld. Mathews was gravely injured, the rhino's horn having opened him up from thigh to sternum, leaving a dreadful wound and broken bones that would see him hospitalized for months and carry injuries for the rest of his life. He blamed Beard, claiming he had moved too close to the pair of animals and had spooked the infant rhino and then run, causing the mother to attack the only human in her sight line . . . Terry Mathews.

While Beard and Peter Riva, who was witness to the attack, argued that Mathews had brought on the charge himself by standing in front of the

animal waving his arms when he should have fled to the safety of a rocky outcrop where Beard and the two camera crews had taken refuge, the Kenya wildlife community aimed their criticisms unerringly at the American. Many pointed at what they saw as Beard's recklessness in the wild over the years, a recklessness that had contributed to many of his more dramatic photographs of wild animals. He was seen as an adrenaline junkie, always pushing the boundaries, always prepared to take risks when the more pragmatic men of the bush would treat wild animals with caution. Years later Danny Woodley's son Bongo, now a security consultant in Tsavo National Park, said his family had discussed the Terry Mathews accident at length. "We all agreed that provoking that rhino into charging was squarely on Peter," says Danny. "He was 100 percent complicit. He just got closer and closer and if you watch the footage on film you realize, as Terry did that day, they got too close. And it was something Peter did repeatedly in the bush, in Tsavo East, in the Aberdares, and finally it caught up with him."[4]

Although Beard shrugged off the accident and vehemently denied any responsibility, he did feel he needed to explain things to some of his old Kenyan traveling companions and in the days after the attack he composed a beautifully written, seventeen-page letter to his close friend Glen Cottar. As far back as the late 1970s, when he was on safari with Beard and Cheryl Tiegs for their *American Sportsman* shows for ABC, Cottar had warned Beard that his recklessness in the bush was going to get someone killed. At the time, Beard mocked him saying he was not like the Cottar of former days. "What's wrong with you, Glen? You're getting old and soft." Now that Cottar's grim prophecy had almost come true, Beard felt obliged to fully explain the circumstances of the rhino incident, in a plea for exoneration, in his long letter. Glen Cottar was unmoved. As his son Calvin later said, "He didn't want to know any more. His friend Terry had been almost killed by what he saw as Peter's recklessness and there was nothing left to say." It was the end of a friendship that had lasted almost thirty years. Beard was devastated.[5]

Beard continued to protest his innocence and was profoundly irritated at the lawsuit that followed the attack, which ABC was obliged to defend. He saw it as yet another example of the New York legal system engaging in what he called "prolonged parasite-ism" and while he had no problem with Mathews benefitting from insurance compensation, he was angry at having to perform in front of lawyers. In the end, the case never went to court, and during depositions Peter Riva produced an audio tape of a conversation Beard had with Mathews prior to the attack in which Mathews talked about "putting our necks on the line" and said, "I'm going to rely on my lungs for this one, I'm going to give the well-known Terry Mathews 'Bugger off! Bugger off!'" Mathews ended up with New York state compensation for life as per his original contract. In New York legal terms, at least, Beard was exonerated.

Bravery in the bush, fearlessness of wild animals, was a badge of honor among the old bush brigade, although they would be the first to say that they respected the power and unpredictability of wild animals enough not to actually risk their lives. It was a fine line, not the least because out in the bush nobody could quite predict how an elephant or a black rhino or a buffalo (often regarded as the most dangerous), or a lion would respond to the presence of a human on foot. However, Beard's various encounters with animals in the bush over the decades had suggested an edge, another dimension, that evoked recklessness. It was almost as if he would be willing a dangerous, potentially fatal, encounter.

There had been many examples of hair-raising encounters, not always brought on by Beard. On one occasion he had been camped on the banks of the Tiva with his trusty bush companion Galo-Galo Guyu. Together with a welcome visitor to the camp, the anthropologist Robert Soper, they sat around the campfire drinking gin and tonics, warmed by the roaring flames, and reflected on the state of the wilderness. At some point Beard had stood up and told his companions he needed to pee. He walked away from the light of the campfire into the inky darkness that cloaked the African night, just thirty feet away, but into another world. He had just relieved

himself when the blurred form of a large male lion came charging out of the blackness. Within a second Galo-Galo was beside him, waving his arms wildly and yelling at the top of his voice. The lion stopped in his tracks, growled, and then sauntered off into the landscape. "My stomach went through the back of my neck and into my brain in an instant," Beard later told the writer Jon Bowermaster, "creating a mental nightmare of speed and terror, one of those ultimate reminders of human puniness and frailty."[6] He relished every second of it.

It was for these reasons that the old Kenya bushveld gang, including some of his closest friends and supporters, often took a step back when they were talking about Peter Beard, the dashing American remittance chum, in the African wilderness. They saw something wild and untamable about him. He had no discipline. He was crazed, an artist in a pragmatist's landscape. For that old bushveld gang, discipline was the key ingredient to survival in wild Africa. For Beard that meant emotional shackles and he simply disregarded them. So, throughout his time in Africa that rift, dividing pragmatism from artistic spontaneity, defined his place in this rather conservative postcolonial environment.

After Terry Mathews was evacuated to a Nairobi hospital, the ABC documentary crew carried on filming around the country, eventually returning to Hog Ranch in the middle of March. Soon after, the crew, with Beard and Peter Riva alongside, packed up their equipment and flew back to New York. While they were bracing themselves for Terry Mathews's lawsuit, Riva and the documentary's director, Bob Nixon, an old friend of Beard's, sent ABC a rough edit of the footage they had shot. ABC vice president John Hamlin immediately rejected the edit, blaming Nixon for out-of-focus camera work, poor camera angles, and poor lighting. Hamlin insisted that Nixon be replaced by Mel Stuart, the Oscar-nominated film director famous for *If It's Tuesday, This Must Be Belgium*, as the new director, and Bert van Munster be employed as the main cameraman. The photographer Mark Greenberg was also to be added as the production stills man and Riva, having found a further $200,000 to refloat the project, planned for the crew to fly out to Kenya again.[7]

During this New York layover, Beard took to the New York clubs. Although his old haunt Studio 54 had long closed, there had been a raft of new nightclubs—Nell's, Heartbreak, Area, Zodiac, Xenon—opening up in the 1980s. Whenever he was in town, Beard was a regular presence on the club circuit, spinning African wildlife stories and railing against softheaded, celebrity Western do-gooders (many of whom were probably standing right beside him), who he believed were damaging African wildlife conservation. Nell Campbell says that from the day she opened her eponymous club in 1986, Beard was a constant presence and was always surrounded by women. She says, "I suppose the white hunter aspect was part of it, and he was the best-looking man in the city. He was like Rudolph Valentino." The fact that Nejma, his bride of less than six months, was either unaware or was strategically unconcerned about his wanderings through nocturnal New York did not appear to bother Beard. As had been the case with Cheryl Tiegs during their years together at Thunderbolt Ranch, Beard would simply disappear for days on end and return without guilt or explanation. Such was married life with Peter Beard.

It was in the Heartbreak disco in the summer of 1987 that the singer Grace Jones introduced him to Maureen Gallagher, a stunningly beautiful model whose mother was German and whose father was an African American serviceman. "You're bananas from the same bunch," Jones had told her. Maureen says they were attracted to each other at first sight, and despite the fact that he came across as rather arrogant, even narcissistic, "when our hands touched there was an electric current." He raved about untamed Africa, about the clear starry nights, the endless plains, the drama and danger of living among the wild beasts. By the time they left Heartbreak in the early hours of the morning, Maureen had been hypnotized. The following day, an airline ticket to Nairobi had arrived at Maureen's Elite Model Agency offices, and with the assurance that she would be taking part in the repurposed ABC television documentary *Last Word from Paradise,* she dived right in. Thus began a love affair that would run, on and off, until 2014. (Again, Nejma would probably have been aware

of Beard's assignment and the presence of a beautiful model as part of the assignment, but no more information would have been shared by her errant husband.)

It was Maureen's first trip to sub-Saharan African and she was both enchanted and intimidated. She loved what she saw in the wildness of Hog Ranch but was so afraid of the wild animals that for the first few nights she refused to sleep in a tent, instead bedding down in the library, the only solid, walled structure in the camp. Beard laughed at her timidity, reassuring her that Hog Ranch was no longer a bush camp but that it had been engulfed by creeping suburbia and that she was more likely to be kept awake by the beat of disco music than the roaring of lions. She took his word for it and moved into his tent.

For several weeks that autumn the new ABC crew traveled across Kenya's wild country, hopping in and out of vans, Land Rovers, and light aircraft and shooting at Lake Turkana, Amboseli, and even downtown Nairobi. When they returned to Hog Ranch, Greenberg discovered that the photographic gear he'd left behind had been rifled through and more than thirty rolls of film had been stolen.

After a late-night drive to the airport, they boarded a 747 for New York and as they were boarding, Peter Riva took Maureen aside and told her that Beard was married. "I had no idea," she says. "I was in love with him, and I was prepared to put my career on hold to be with him. I was going for three days, and I stayed for three weeks." Clearly Beard felt the same about Maureen and when Mark Greenberg negotiated a return trip to Kenya with ABC and the insurance company as compensation for the stolen camera gear, Greenberg says, "I told Peter I had business class tickets to Nairobi and would he and Maureen like to go back. They both jumped at the opportunity."[8] Now hopelessly in love with Beard, Maureen tried to talk him into leaving Nejma but he warned her that he would never leave his wife despite his declaration that, according to Maureen, "I was the love of his life. He asked me if I expected him to abandon her. He said he's married her, and he had a commitment to her." Clearly a decidedly unconventional commitment.

At the end of this trip, Beard, Gallagher, and Greenberg were scheduled to take the late-night flight from Nairobi to New York and were in their last hours at Hog Ranch. At around ten P.M., as all their bags were packed and they were preparing to leave, a large giraffe ambled into Hog Ranch to feed. Beard immediately visualized a photograph of his "living sculpture" girlfriend feeding the long-necked, elegant giraffe. Maureen gamely posed with the giraffe, somewhat nervously as she had been aware of her friend Iman being kicked in the head by a giraffe some time earlier, but it wasn't quite right. She then turned to Beard and suggested she try the shot naked. With Greenberg providing the lighting and Beard buzzing around Maureen on tiptoes feeding this wild giraffe, they created one of Beard's most enduring and iconic images, which he called *The Night Feeder*.[9]

Just six months after *The Night Feeder* shoot at Hog Ranch, Peter Beard was at Maureen Gallagher's New York apartment when his daughter was born on the morning of September 22, 1988. He immediately headed across to Mount Sinai Medical Center and held his precious only child in his arms. Maureen had already expressed her disappointment when Beard had told her that Nejma was pregnant. "He used to tell me that I was the love of his life but then he told me that Nejma was pregnant," Maureen says. "We were at the Gramercy Hotel and doing lots of coke and he mentioned it in passing as if it was an unimportant detail. I was surprised because I didn't even think they were having sex. In fact, I could have sworn they weren't. Anyway, I was devastated."[10]

Zara Sofia Beard was born at 11:50 A.M. at Mount Sinai and weighed seven pounds and two ounces. Her parents were listed as Nejma Khanum Durrani Firoze Amin and her ancestry as Afghani and Peter Hill Beard, whose ancestry was listed as English-Scottish. In the years to come, friends would say that the only person in the world Beard loved without reservation was Zara and although he would constantly be an absentee father, when he was around his focus was intensely directed on his only child.

* * *

When Richard Leakey was appointed head of the Kenya's Wildlife Conservation Department (which he later renamed the Kenya Wildlife Service) in 1988 and immediately set about reforming the country's corrupt wildlife management structures amid a poaching pandemic that threatened to wipe out much of the country's wildlife assets, Beard was loudly skeptical. It was a skepticism amplified by Leakey's much-publicized public burning of twelve tons of elephant tusks in July 1989.

In that made-for-television spectacle Leakey had put together 2,500 tusks—twelve tons of ivory worth more than $5 million—on a pyre in Nairobi National Park, not far from the city center, and invited the world's press to witness the bonfire. They duly turned up. The tusks had been drawn from the KWS vaults and represented a stockpile made up of tusks retrieved from animals that had died naturally as well as those poached and thus confiscated from poachers. Leakey had corralled the support of fellow Kenyan Kuki Gallmann, author and self-described conservationist, who in turn secured the services of Hollywood special effects virtuoso Robin Hollister to add cinematography to the stunt. Hollister figured out that given the fact that ivory tusks were not immediately flammable, a combination of flammable glue to coat the tusks, and a hidden system of pipes to spray them with sixty gallons of gasoline and diesel fuel would be needed to create the pyrotechnics required to satisfy the international media.

As Kenyan president Daniel arap Moi lit the torch to the pyre, television crews from all over the world obediently recorded this conservation statement of intent. Beard was disgusted. He had spent a lifetime railing against the Kenyan conservation model, which he said pandered to a Western donor aid mentality that depended on the support of the animal rights lobbies based in London, New York, Washington, etc. He often cited Graham Hancock's book *Lords of Poverty* as a model analysis of the failings of Africa's aid dependency and saw it writ large in the Kenyan conservation program Leakey had constructed since his appointment as the head of the Kenya's wildlife program. Meanwhile, Leakey unasham-

edly declared his dependence on World Bank funding—an initial grant of $140 million was given and more was promised along the way—and proudly announced that his ability to raise these large sums of foreign money to shore up Kenya's fast-disappearing wildlife populations was the only way forward.

Peter Beard's purported role as "a wildlife conservationist," a common sobriquet attached to his name by the Manhattan nightlife celebrity crowd he ran with, was widely questioned and criticized by active frontline African conservationists. To these stoical, unbending, practitioners he was a flaneur, a wealthy American, a flashy character who ranted and raved about habitat destruction and the end of the game and then flew off to Paris, New York, or Los Angeles to hang out with his celebrity friends and beautiful women. In fact, Beard's admittedly repetitive rants about the end of wild Africa, the end of the game, showed an instinctive, if not scientific, prescience. His main mantras centered on exploding human populations, misguided Western sentimentalists who were driving the conservation agenda through their donations, and the corrupt African political elite who were facilitating this decline and pocketing a good proportion of these donations. Broadly, with all of these accusations, he was absolutely right.

Having been influenced early on by the hunters and then by consumptive-use scientists such as Dick Laws, Beard firmly planted his conservation flag alongside the southern Africans, who were most unpopular in East Africa. Not much had changed in the conservation wars since the late 1960s, if anything the divides were deeper twenty years on. In that time, well-funded Western animal rights lobbyists—the targets of Beard's most virulent insults—had gained a substantial foothold in the African conservation arguments, rewarding the anti-consumption operatives with funding and public relations / press support. It was time for Beard to connect with his fellow travelers in southern Africa.

Toward the end of 1989 he managed to secure a commission from *Forbes* magazine to photograph the Namibian wilderness, a remote and

relatively unfashionable part of the African continent that happened to be embracing many of the wildlife conservation programs that Beard instinctively supported. Namibia and Kenya were worlds apart in terms of landscape and population densities—the former a largely empty desert with a population of two and a half million and the latter a fertile tropical environment that was agriculturally rich and varied and that supported a population of 52 million. However, Namibia, which in February 1990 would formalize its independence from South Africa, had announced a policy of community-based conservation initiatives whereby wild animals were regarded as economic assets and the wildlife business was regarded as a viable contributor to the country's GDP. Thus, Namibians' protection of these wildlife assets was regarded as a pragmatic rather than a sentimental approach to wildlife conservation and thus a more sustainable model.

This was just what Beard had been ranting and raving about for all these years. In Kenya, the wild animals were owned by the state, and while some lived in fenced-off national parks that were visited only by wealthy Western tourists, the majority actually lived in the vast rural areas that they shared with the Indigenous people. Hence the locals who lived among these often-dangerous creatures reaped no benefits whatsoever. In Namibia, if an animal wandered onto your land and interfered with your crops, your life, or your children, you were entitled to do with it what you wished.

At the philosophical center of Namibia's conservation program was Garth Owen-Smith, a man widely acknowledged as the godfather of community conservation in the country. In the late 1980s, Owen-Smith had established the Integrated Rural Development and Nature Conservation which was, in 1990, adopted by the fledgling Namibian government as the platform of its community-based approach to wildlife management. As Owen-Smith said at the time, "The long-term conservation of wildlife will not be achieved by military tactics, on computer screens, or at workshops but by field conservationists who build relationships with people living

with wildlife or around our national parks." It was a wildlife philosophy that Beard immediately gravitated to and was the polar opposite of that employed in Kenya.

At the end of 1989, Beard flew to Namibia and Owen-Smith's remote desert camp Wereld's End via Johannesburg where he stopped off for a few days. In Johannesburg, he was entertained by the Endangered Wildlife Trust, who had been funders and supporters of Owen-Smith and various other southern African community-based conservation organizations over the years. Even in a far-off politically isolated city like Johannesburg—these were still the days of apartheid—Beard managed to attract attention. He did radio interviews, charmed local female radio broadcasters, and ended up splattering enough blue paint around his room at the Rosebank Hotel for the head of the EWT, John Ledger, to be obliged to contact Peter Riva in New York asking for compensation for repairs to the room. Riva responded by telling the hotel to send him the bill and that it would be settled immediately. This was, he told Ledger, nothing out of the ordinary.

On his final morning in the South African capital one of his hosts, Marilyn Thomas, drove Beard to the airport with a Harrods bag filled with cans of beer and put him on the plane for Namibia. What followed was a weeklong stay with Owen-Smith and his partner, Dr. Margaret Jacobsohn, a writer, anthropologist, and expert on the local Himba people, at their headquarters Wereld's End (Afrikaans for World's End). The camp was even more rustic and remote than Beard's own Hog Ranch. Set in the rugged mountainous northwestern corner of the country, it was an uncompromising desert environment where the footprint of Homo sapiens is only lightly felt and where the hardiest of wild animals survive—desert elephant, desert black rhino (*Diceros bicornis bicornis*), and desert-adapted oryx. It is, in the eyes of many, Africa's last true wilderness and Beard was thrilled to be there.

His host was a tall, rangy bearded man whose skin had turned nut brown from decades in the desert sun. Owen-Smith had a trimmed white

beard, piercing blue eyes, and a kindly expression. He spoke quietly and thoughtfully, the very antithesis of his guest's rapid, machine gun delivery and existential restlessness. These two opposite characters hit it off from the outset and while Beard was quite taken by Owen-Smith's approach to wildlife conservation, quite different from the protectionist, animal rights–based thinking that he constantly railed against in Kenya, Owen-Smith was charmed by the amusing, eccentric iconoclast who entertained his hosts at sundowners with wild tales from the First World. Margaret remembers that every morning Beard took handfuls of pills. She assumed they were health supplements.

After several days at Wereld's End, they drove Beard north to Puros where they set up a temporary camp among the local communities they were working with. Here were Himba people who had little contact with the modern world and, within hours, Beard had connected with them despite a significant language barrier and was showing them his diaries. Margaret remembers they were filled "with explicit photos of sexual encounters, graphic images that these people were not used to. The gasps from the Himba were probably because they could not have imagined people would photograph such intimacy. I think I lectured Peter rather sternly, suggesting he should probably be a bit more culturally sensitive but I'm pretty sure he just laughed. We all really enjoyed having this uninhibited stranger out there."[11]

A little more than a week later and he was gone, flying via Johannesburg, endearingly returning to Marilyn Thomas her Harrods bag, now tattered and torn and completely unusable, and on to Nairobi. It was on the next leg of the journey, to New York via Frankfurt, that yet another Beard drama played out. He had shot more than thirty rolls of film during his Namibian safari and carried these, and several rolls belonging to Owen-Smith that he promised to have developed, onto his Lufthansa flight home. Packed together with collage boards and diaries, it was all too bulky to take into the cabin, so Beard checked the canvas travel bag. It was the last he was to see of it as Lufthansa lost his luggage and thus the photographic record of a trip that he later described as having "rekindled

a long-lost affinity, optimism and belief in the soul-searching way of the Old Africa—the indescribable Africa before the inevitable neuroses."[12] The Namibia he had just seen reminded him of Kenya in the late 1950s and early '60s. Sadly, he had no photographic record of his life-affirming safari.

11

The World of Moi

By the turn of the decade, Hog Ranch was a vastly improved encampment under Gillies Turle's consistent presence and practical management. It was also becoming one of Nairobi's most interesting political salons at a crucial time for the country politically. The president, Daniel arap Moi, had enjoyed fifteen years as a typical African autocrat with substantial benefits. By this time, he was being strong-armed by the West into democratizing Kenya and addressing the rampant corruption that was strangling the country economically. Around the campfire would gather the OKHs (Old Kenya Hands), political activists, tribal leaders, young conservationists, ancient big game hunters and, inevitably, the gang of foreign correspondents who were flying in and out of Africa's dreadful, destructive regional wars on a weekly basis.

When Beard was in town they came in numbers to share their experiences around the campfire. These were his arteries of information, his direct channels to what was happening in Africa's many combat zones. Although he would volubly express his own long-held, dark, doom-laden opinions, this was one place where he seemed able to sit still and listen to the tales and reflections of those around him, the frontline witnesses to the decline of his beloved Kenya and surrounding countries.

The foreign correspondents were a particularly interesting group who would remain good friends of Beard's over the years to come. The principal players were Aidan Hartley, a super-stringer who worked for the Associated Press and Reuters; Julian Ozanne, the *Financial Times*'s Africa correspon-

dent; Sam Kiley, *The Los Angeles Times*'s Africa correspondent; and Dominic Cunningham-Reid, a cameraman who was another Reuters stringer. All four were Kenyan born, all were higher educated in the UK—two at Oxford University—and all were highly intelligent, extremely wild, young men who were firsthand witnesses to the raging civil war in Ethiopia, the US intervention in Somalia, the grim kleptocracy that was Mobutu Sese Seko's Zaire, and the looming genocide in Rwanda. In journalist parlance they were "firemen," speeding in and out of the calamity that was postcolonial Africa, developing a weary skepticism for the so-called liberation of the continent, at the same time sharing concern and compassion for the ordinary Africans on the ground who, having been finally released from the colonial yoke, now found themselves tethered to a more venal and murderous group of masters.

In addition to this group was the artist Tonio Trzebinski, and young tyros like the photographers Dan Eldon and Guillaume Bonn who would later say that the two friends followed Beard "because he was the only artist in Nairobi in the '80s and '90s." Dan Eldon had been doing his own diaries since he was a preteen, and in many ways was similar to Beard—full of restless energy, highly creative, and somewhat wild and untethered. So, while Beard was feeding off the frontline journalists, he was also sharing his time, enthusiasm, and wisdom with the young artists who he saw as his creative successors. (In July 1993, while covering a United Nations raid in Somalia to arrest the rebel leader Mohamed Farrah Aidid, Dan Eldon was killed. He was with three other photojournalists when a mob attacked them, and all were stoned and beaten to death. He was just twenty-two. For all the braggadocio and tall war stories that would circulate around the Hog Ranch campfire, Dan Eldon's death served as a reminder that Africa remained a cruel and unsentimental theater of operations, where danger was ever-present, and life was cheap.)

Also, Professor Wangari Maathai, a future Nobel Peace Prize winner, was a sometime visitor, as was Dr. Njoroge Mungai, the former cabinet minister a young Mandy Ruben had telephoned to help spring Beard from Kamiti prison twenty years back, and the dissident defense lawyer Gibson Kamau Kuria.

With Beard in residence, and the sun setting over the Ngong Hills, this was the place to be and there was no more appropriate time for the *fitina* (gossip) to be flying, for Kenya was going through a particularly volatile time under Kenyatta's successor, Daniel arap Moi. It seemed to many around the campfire that Moi was yet another in a long line of corrupt postcolonial African leaders, following the well-trodden path of Angola's José Eduardo dos Santos, Equatorial Guinea's Teodoro Mbasogo, and Zimbabwe's Robert Mugabe. When Moi solemnly called on Kenyans who had stashed their money abroad "to exercise patriotism and bring such resources back to build their motherland," the Hog Ranch salon cracked up. The word was Moi had an estimated $6 billion stashed away in foreign assets.[1]

Kenya had been the West's principal Cold War ally in Africa. While many of the emerging postcolonial independent governments in the region—mainly Ethiopia and Tanzania—had hitched themselves to Russian or Chinese communist bandwagons, Kenya, under its first leader Jomo Kenyatta, had remained pro-British and pro-capitalist. Initially the capitalist First World turned a blind eye to Kenyatta's corrupt administration and equally to the succeeding Moi regime with its turbocharged version of the same. However, rising internal unrest led to a ratcheting up of Western diplomatic pressure and in 1991 Kenya was obliged to hold democratic elections. All of this was grist to the Hog Ranch campfire mill and provided Beard with the kind of political excitement that he would never get in the staid, ordered, somewhat less corrupt old democracy that was his home country. For Beard, this was life on the sociopolitical edge.

Democratic rights were eggshell thin in Kenya and opposition to one of Africa's Big Men was a dangerous pursuit . . . as Josiah Mwangi "JM" Kariuki, Beard's friend from the 1960s, had discovered. He was murdered in 1975 and his body dumped at the bottom of Hog Ranch. In 1990, the popular foreign minister Robert Ouko had been assassinated with a single bullet to the head. Neither the assailants nor the motives were ever uncovered despite years of inquiries and the involvement of Scotland Yard detectives. However, Detective John Troon named Nicholas Biwott,

a politician, businessman, close ally of the president, and Peter Beard's next-door neighbor at Hog Ranch, as a person of interest in the murder. At the time of his death, Dr. Ouko had been preparing a report into high-level corruption in the country and Biwott, a much-feared Big Man, was allegedly one of the people named in his report.

Publicly, Beard's views were ambiguous on Africa's decline in the half century after the Camelot that the early European settlers had enjoyed. In 1993, he told the television talk show host Charlie Rose: "In Kenya there are too many people, too little territory, and no resolutions except continued breeding, hopeless mismanagement, and misrepresentation of all the problems."[2] Overpopulation and the flow of aid to Africa—often cynically described as poor people in rich countries sending money to rich people in poor countries—were two of the cornerstones of Beard's African rhetoric. And although too often clouded in wild haranguing flourishes that were hard to follow, like manic brushstrokes across a canvas, the points he made had a resonance and, as the subsequent years have proved, he was pretty much *en pointe*.

* * *

One night in September 1991 at the Horseman, the restaurant in the salubrious suburb of Karen (named after Karen Blixen) that at the time was one of the gathering places for Nairobi's smart set, Peter Beard and his friend EZ (real name Gerald Miller) were holding court when an attractive young woman by the name of Rikke Mortensen caught his eye. When he established that she was Danish, he immediately launched into a soliloquy about Karen Blixen and his own close ties to her extended family, to Thomas Dinesen and his grandsons Thomas and Morten Keller. Rikke was vaguely aware that the good-looking American dressed in a kikoi and Pitamber Khoda sandals was a well-known figure around town but was not aware of his celebrity back in America. She had arrived two years earlier with her husband, Henrick, a sometime photographer, and a year earlier had given birth to their son, Jonas, in Nairobi Hospital. Like many

young Europeans at the time, Henrick and Rikke thought they would find adventure and escape from the dull grind of European winters in East Africa, but not too long after they arrived in Kenya their marriage began falling apart. As always, Peter Beard's arrival on the scene was serendipitous.

That night at the Horseman, Beard insisted that Rikke visit Hog Ranch. Nejma and Zara were on the property when she and her friends arrived a few days later and after brief introductions Nejma carried on preparing for her return to New York. The following day Beard's wife and daughter left. Rikke visited her new friend several times in those first few weeks and although she and Beard were not yet lovers, there was a definite spark, so much so that he began leaving messages with mutual friends in Nairobi, imploring Rikke to spend even more time with him at Hog Ranch. As her domestic life with Henrick disintegrated so Rikke began to consider Beard's offer of accommodation at Hog Ranch more seriously. She finally left her home and moved into one of the Hog Ranch tents. She stayed for a month, all the time watching this driven American frenetically creating his intricate collage diaries and turning his work from photography into pieces of art. At this point Beard proposed an escape route for his newfound Danish friend. "Let's go to Tsavo," he said. "Henrick won't find us there." And so they drove to Tsavo, the landscape Beard knew so well, the ecosystem that had helped launch his conservation diatribes in *The End of the Game* almost thirty years earlier. They stayed in Tsavo for a month, escaping the attentions of a dangerously irate Henrick and introducing Rikke and her son, Jonas, to a remote, wild Africa that they had not previously encountered. They spent hours playing backgammon, sitting by the river watching the passing parade of wild animals and in the evening being bitten by swarms of mosquitoes that had invaded the camp. When Rikke returned to Hog Ranch she came down with malaria and spent an uncomfortable week in bed, thus discovering that the African bush was not all wine and roses.[3]

In Rikke, Beard had found an independent-minded young European woman—she was twenty-seven and he was fifty-four—who shared his love of art, poetry, and eventually drugs, although she says she had barely touched

drugs before she met Beard. While he was used to women falling at his feet, here was someone who challenged him, daring him to indulge in the kind of WASP chauvinist behavior that had been his reputation. And just as he was finding this outspoken, self-sufficient woman stimulating company, she was emerging from a desperately unhappy relationship to discover a man who could be kind and thoughtful.

Beard's marriage to Nejma was also beginning to come apart. Her absence from Hog Ranch coincided rather conveniently with her errant husband's increasing focus on Rikke and, over the next few years, his relationship with Nejma would become so toxic that they would often end up communicating through lawyers. Mirella Ricciardi had warned Nejma in London, before they'd flown to America, that she wouldn't be able to tame Beard and she had ignored the omens that had long been apparent to all their friends. Beard had a very clear view of marriage, which was basically to ignore the constraints. Monogamy was certainly not a part of his lifestyle choices. He had started his passionate affair with Maureen Gallagher within six months of marrying Nejma on the Montauk cliffs and had had many affairs in the years between Maureen and meeting Rikke.

However, out in Africa with his newfound soulmate, Beard was, for the time being at least, finding a new Zen-like calm that was quite new for him. For Rikke was quite unlike any of the other women he had dated.

* * *

Remote African idylls and his roller-coaster love life apart, this was a busy period in Beard's life. The American writer Jon Bowermaster had spent some months at Hog Ranch researching a book he was writing with Beard, provisionally titled *The Adventures and Misadventures of Peter Beard in Africa*. At the same time, Beard and Turle were working on their study of Maasai art, a hugely controversial project, commissioned by the New York publishing house Knopf, which had aroused extreme anger among wildlife managers such as Richard Leakey, and a number of other anthropologists.

In Beard's last weeks at Hog Ranch, before heading back to New York,

there was one further local political issue that was grabbing Beard's attention. Some four years earlier, a twenty-eight-year-old British tourist named Julie Ward had come to a rather ghastly end in the Maasai Mara. She had been a passionate photographer and, in what should have been her last week in Kenya before returning home, she and an Australian friend drove to the Maasai Mara Reserve for a short safari. When their Suzuki jeep broke down in the Sand River, her friend returned to Nairobi, and Julie remained with the vehicle while it was repaired. Days later she was reported missing, and her hotelier father, John, immediately flew out from the UK to join the search. Just a week later, her father found her burned and dismembered body in the ashes of a fire beside the Sand River. The *fitina* had crackled through Nairobi ever since, a storm of theories and superstitions, including the rumor that one of the president's sons may have been involved in the murder. The original police investigation offered the theory that lions had attacked and eaten Julie, but these were swiftly dismissed after Julie's father had returned from the UK to conduct his own investigations with the help of Scotland Yard detectives he had hired at great expense. Clearly the Kenyan government was attempting to manipulate the facts, fearing that the publicity might damage its tourism industry. Then an even wilder theory was put forward by the coroner's office that she may have committed suicide, which apparently would have required her to have climbed a tree and beheaded herself, with her body conveniently falling into a fire below. It was later discovered that the coroner's report had been altered to conceal the fact that her bones had been cut by a sharp instrument as opposed to gnawed at by a wild animal. A British pathologist had also found that the young British woman's body had been dismembered with a machete, doused in gasoline, and set alight.[4]

Finally, almost four years after Julie died, two Maasai Mara park rangers, Jonah Magiroi and Peter Kipeen, were brought to trial. The case was heard in Court 3 of Nairobi's Supreme Court, the same splendid colonial wood-paneled courtroom where Sir Jock Delves Broughton had stood accused of murdering Lord Erroll in the celebrated "White Mischief" trial in 1941 at the height of Empire. Peter Beard's interest in the trial of the two park rangers was intense. Here was Kenya's political and institutional

corruption, that he had been raging about for years, on public show in all its satirical glory.

On the first morning he took a quick detour to the holding cells under the Supreme Court, a nostalgic visit to remind himself of the misery he had endured during his own brief period of incarceration. If anything, the cells had become worse, filthier and more malodorous. On one side of the bars were the shuffling friends and relatives of the inmates and on the other the hopeless ranks of prisoners awaiting trial, a forlorn collection of desperate souls whose only promise of freedom lay in the evenhandedness of the Kenyan judicial system. "Some promise," thought Beard, as he entered Court 3.[5]

In the following days Beard watched as the English hotelier John Ward described in meticulous detail how, after a three-day search in the Maasai Mara game reserve, he had found Julie's charred remains. Ward had to speak particularly slowly because the presiding judge, Fidahussein Abdullah, resplendent in crimson robes and a powdered white wig, was hard of hearing and faithfully wrote down every word in longhand, his labored attention to fine detail often leading to exchanges that resembled Monty Python sketches:

Ward: I then obtained Julie's dental records, my lord.
Judge: Where did you get the dental records, Mr. Ward?
Ward: From the dentist, my lord.
Judge (aloud, as he was writing): Mister Ward says . . . he got . . . the dental records . . . from the dentist.

Painstakingly, Ward described how he had flown out from Britain as soon as his daughter had been reported missing and, with the help of the local expat community, had organized search parties to sweep the game reserve. The Kenyan police had remained indifferent to her disappearance, he said, and refused to help with the search. He said on the third day they found Julie's abandoned Suzuki jeep and within hours Ward was staring at his daughter's dissected jawbone and the lower half of her left leg; most of

her body had been burned in a fire. Despite this evidence, Ward testified, the police remained uninterested, favoring the wild animal theory and bizarrely not ruling out suicide. Ward told the judge that he had undertaken more than twenty-five trips to Kenya. It was only after the British foreign secretary Douglas Hurd had leaned diplomatically on President Daniel arap Moi that the case was pursued with any kind of commitment.

Ward said he was aware from early on that a ham-fisted but determined cover-up was in progress and told the judge that he left his meetings with Commissioner of Police Philip Kilonzo feeling angry and impotent. The judge seemed more interested in clarifying small details of evidence than addressing the larger issues of corruption.

Judge: You say you felt angry, Mr. Ward.
Ward: Yes, my lord, I felt angry.
Judge: I see. (Pregnant pause, then he began writing) Mister Ward . . . felt . . . angry.

At the end of each day in court Beard would race back to Hog Ranch, where the usual gathering of journalists, political activists, socialites, visiting Hooray Henrys, and Old Kenya Hands had arrived at the campfire and, after puffing at a relaxing spliff and passing around the gin and tonics, he'd report on the day's court proceedings and lead the debate on the sorry state of his adopted country after fourteen years of autocratic rule under Daniel arap Moi.[6]

What John Ward's testimony revealed was a story of high-level cover-ups, police incompetence, civil service corruption, and, above all, a complete indifference to truth and justice, with the two defendants seemingly incidental to the proceedings. Ward went on to describe how the government's chief pathologist, Dr. Jason Kaviti, had illegally altered the postmortem report to suggest Julie had either committed suicide or had been eaten by wild animals, and how the police commissioner Kilonzo had continually refused to open a murder investigation despite overwhelming evidence gathered by Ward. Eventually, in June 1992, the presiding judge

acquitted the two hapless rangers for lack of evidence and recommended the investigation of the head park ranger, one Simon ole Makallah, who was arrested in 1998, subjected to another tedious trial before being found not guilty a year later, again on the grounds of lack of evidence. Over the years, Julie's father spent more than $3 million conducting a private investigation into his daughter's death.[7]

This was the dark, comic, tragic African scenario that Peter Beard reveled in. And around the campfire he would contemplate events like the Julie Ward trial with wild-eyed rage at the African political corruption he saw all around him with two of his most frequently repeated words—"galloping rot."

* * *

In the same year (1992) that the first Julie Ward trial was grinding its way through Kenya's courts, in America, *The Art of the Maasai: 300 Newly Discovered Objects and Works of Art* was published by Alfred Knopf, authored by Gillies Turle and, according to the cover at least, with "photographs by Peter Beard." In fact, the photographer was Mark Greenberg, friend and business colleague of both Riva and Beard who had overseen Cheryl Tiegs's angry demolition of her photographic records in the Beard archive. That cover credit caused a serious rift between Greenberg and Beard, "because he simply didn't want to have my name on the cover," said Greenberg. Beard had in fact acted as art director for the project and, as with his involvement in the *Eyelids of Morning* book, it was his artistic input that drew attention to *The Art of the Maasai*. Long after the event all the key participants—Riva, Turle, and Greenberg—admitted it was Beard's inspired art direction after days of getting nowhere that gave the book its dramatic visual feel.

The objects themselves—the bones, the pipes, the *rungus* (traditional Maasai throwing clubs), and assorted artifacts that made up the "newly discovered objects"—were the source of great controversy when the book was published and continued to be so decades later. It all started with

Gillies Turle. As the supply of colonial antiques had started to dwindle in the late 1970s, Turle began taking an interest in Indigenous artifacts such as warthog teeth, ivory snuff boxes, bracelets, pendants, and spinning tops. The Maasai collection started out rather modestly when in 1982 a scruffy *moran* (Maasai warrior) by the name of Salaton ole Tekui arrived at the gallery and told Turle that he had rare historic items hidden away in a *manyatta* (a group of Maasai huts) at the foot of the Ngong Hills. Salaton pulled out a rhino horn *rungu*. Turle had previously only seen *rungus* made from wood, but it was explained that this weapon was made from more precious material because it belonged to a Maasai *laibon*, a traditional shaman. Turle remembered paying $150 for the piece but did so with some trepidation since the trading of products from listed animal species—mainly rhino and elephant—had been banned in Kenya in 1977. Salaton then revealed other rare objects—horn and bone pipes, arm bands, amulets, and the ornamental splints that Maasai warriors used on lion hunts when these initiation ceremonies were still legal.[8]

Through the 1980s, Turle acquired more and more of these "secret" Maasai artifacts, and there was a growing suspicion locally that the word had gone out that a new market in artifacts had been created and that they were now manufacturing these "traditional" objects. More field trips to meet the *laibons* ensued, now with an increasingly enthusiastic Beard in tow. As the collection grew, Turle applied for permits from Kenya Wildlife Services and also donated pieces to both Kenyan and Tanzanian museums. In 1990, Andrew Cheptum, curator in the National Museum of Kenya's Ethnography Department, wrote to Turle thanking him for the donation of 144 artifacts and noted that an expert at the Institute for African Studies had confirmed that such objects had been used by Maasai *laibons* at the end of the nineteenth and in the twentieth centuries "for practicing medicine and divining purposes."

While questions were increasingly being asked about the authenticity of the artifacts, the book was published by Knopf in 1992 and was an immediate success. Greenberg had carried out to Hog Ranch a 4x5 view camera with a roll film back—it was too dusty in Africa to use sheet

film—and a bulky lighting rig. This combination of high-tech equipment, something Beard was too often disparaging about, and Beard's own artistic sensibilities, made for a visually alluring book. But did it bring to the world a collection of previously hidden Maasai artifacts of inestimable cultural value, as Beard and Turle claimed, or was it a collection of production-line fakes, manufactured at the foot of the Ngong Hills and aged with potassium permanganate, as a large group of doubters claimed?

Foremost of the doubters was Richard Leakey. As head of the Kenya Wildlife Service he was the moral policeman protecting his country against any trade in prohibited wildlife body parts, particularly rhino horn and elephant ivory. In Kenya, trophy hunting and the trade in wildlife parts had been banned in 1977, thus bringing down the shutters on all of the tourist trinket shops selling ghastly souvenirs like elephant feet transformed into umbrella stands and gorilla hands made into ashtrays. Beard and Turle were arguing that their Maasai artifacts were of cultural and historic importance, predating the various bans and having significant cultural relevance. Leakey accused "the very clever Peter Beard" of masterminding a massive fraud "from which a great deal of money will be made." He also said there was clear evidence of potassium permanganate on artifacts his KWS staff had tested.[9]

Back at Hog Ranch, Beard was furious about this and asked everyone around the campfire whether he should sue. Then he reeled off the names of the experts he had hauled in from all over the world to authenticate the collection. They included Dr. Rod Blackburn, an anthropologist and an associate with the American and Kenyan Natural History museums; Henry Fosbrooke, the Tanzanian Maasai expert and curator of the Tanzanian Natural History Museum; and Dr. Hans-Joachim Koloss, curator of the Berlin Natural History Museum's African section, who had recently travelled to East Africa to examine the collection. "It's incredible that anyone could question the authenticity of these pieces," Beard raved. "How could anyone fake these pieces? You have to have a twisted mind to think that."

A key witness, but for some years a reluctant one, was Rod Blackburn, who had been studying Maasai culture for the past twenty years. He became

embroiled in the affair in 1991 when he photographed a number of Turle's artifacts and took them on a field trip through remote Maasai communities. Four *laibons* recognized the *rungus* and the pipes and the bowls, gave them names, and were able to explain to Dr. Blackburn what roles they played in Maasai culture. He was so impressed and convinced of their authenticity that he introduced Gillies Turle to Enid Schildkrout, a distinguished ethnologist who was curator at the American Museum of Natural History's Division of Anthropology. She examined a number of pieces and said right away she was anxious to acquire a collection for the museum. She even wrote Turle a letter confirming her interest. Leakey meanwhile had expressed his misgivings to Turle and had confiscated more than a hundred pieces on the grounds that they were carved from rhino horn and elephant ivory and were thus illegal in Kenya.

When news of Leakey's pronouncements began circulating, some—such as Schildkrout—began distancing themselves from Turle and Beard. Dr. Blackburn wrote a paper on his ethnographic findings on the Turle collection and was on the verge of publishing when Schildkrout asked him to desist. "The museum found the subject controversial and embarrassing and I agreed not to publish," is all Dr. Blackburn would say. However, it is no secret that he had already been refused permission, by Enid Schildkrout, to host a TV documentary about the Turle collection.

According to Dr. Blackburn, "[Leakey] said they were made recently, and he pointed to what he said were hacksaw marks. I thought they were the marks of simi knives, traditional Maasai weapons. I was quite convinced of the authenticity of the articles I had seen." He said that if the Maasai didn't recognize these objects and couldn't describe how they had used them or where they found them, that would be pretty important evidence that they never existed, but he insisted that when he showed the Maasai photographs of the objects they had "confirmed the forms and had described how they were used. Some knew about them, and others knew about different forms. A lot of these pieces are idiosyncratic—they were made by one guy for one person and the next *laibon* wouldn't know about that object. The *laibons* freely admit they're all a little different and they all

have their own specialties, some use bones, some do not . . . but I went to some who didn't use bones but still seemed to know about them."

Dr. Blackburn's stout defense of the Beard and Turle collection cut no ice with other ethnographic experts. In April 1994, Donna Klumpp Pido delivered a withering review of the book which she described as a "richly colored contrivance built on the already distorted and fantasized image of the Maasai people." She accused Turle of writing a meandering account laced with "popular mythology about the Maasai, bad and antiquated anthropology, factual distortion and inaccuracies, New Age metaphysics and Turle's own fantasies about the pieces."[10] It was a highly detailed and penetrating attack that left the reader in no doubt that if Beard and Turle were innocent of a gigantic act of artistic and cultural fraud, then they had been well and truly suckered by the people who had supplied the artifacts.

Beard and Turle were immovable in their own defense. Turle pointed out that he started attending Maasai ceremonies in the early 1980s and had been collecting these artifacts at his Antiques Gallery since 1982, "I would say why would anyone, if they were trying to make money out of banned species, shave down a rhino horn to a traditional *rungu* instead of selling the entire horn?" Turle asked.

In the early 1990s, Sheena Gidoomal, a young anthropology student based in Nairobi, also traveled through Tanzania asking the Maasai about the artifacts Turle had collected. Two *laibons*—Laitayioni and Birrika—showed her ivory pipes very similar to those in the Turle collection and told her that these pipes had been used between the middle of the nineteenth century and early into the twentieth century, the same time span highlighted by the National Museum's Andrew Cheptum. It also coincided with the timeframe the *laibon* Taiyanna had related to Dr. Blackburn. Most significantly, Birrika had looked at a photograph of a pipe in the Turle collection and recognized it as the identical pipe that he had used to cure madness.[11] Also Turle maintained that "two of the arrest items I collected had been recorded in books written around 1900—one by AC Hollis, a British government official in Kenya, who mentioned a medicine pipe cut from rhino horn, and Moritz Merker, a German government official based in

Tanzania, who possessed a photograph of an arm band (*erap*) in ivory worn by Sendeu, eldest son of Mbatian. Most important is the fact that both of these colonial authors were Maa speakers." A further point Turle made was that when colonial rule was imposed such artifacts became technically illegal, so the Maasai became more secretive about them.[12]

After the book's publication, Turle continued to buy artifacts from Maasai sellers who knew him and were regulars at the Antiques Gallery. Much to his great concern, however, it became apparent that unscrupulous Kikuyu dealers were now targeting Beard with more questionable *objets*. Beard had little interest in the ethnographic veracity of the objects. His interest lay in their aesthetic appeal and, whatever else was happening around, the aesthetic qualities were improving greatly with many of the pieces now resembling Constantin Brancusi's shapes and forms and Henry Moore's dramatic visions.

The controversy bandwagon continued to roll, picking up new passengers along the way, all tending to express implacable convictions about the veracity of the artifacts and whether or not the two principals, Beard and Turle, were perpetrating one of the great frauds of the antiquities world. A few years after *The Art of the Maasai* was published, the American broadcaster PBS decided to make a documentary on the Maasai artifacts entitled *Secrets of an Ancient Culture* and Turle accompanied the American filmmaker Bill Kurtis on a journey through Tanzania to meet the Maasai *laibons* and yet again attempt to establish the authenticity of the book's artifacts. The group was led by Peter Jones, a well-known local guide and his American heiress wife, Margot Kiser. The documentary was inconclusive but Jones and his wife both expressed doubts about the artifacts' provenance. Soon after, Kiser, who at the time was developing journalistic ambitions, contacted and met up with Richard Leakey, and then spent time with Peter Beard at Hog Ranch, all the time agreeing with Leakey's view that the collection was fake. She was to pursue this course for decades to come.

The dispute continued through the 1990s with equal vehemence being expressed by both sides. Beard used every contact and every opportunity

to rally support for the book and the collection and denounce Leakey, Klumpp Pido, and Schildkrout. Donna Klumpp Pido told *Vanity Fair*'s Leslie Bennetts that she thought "they're both perpetrating a fraud. I can't imagine they could be so dumb as to believe this stuff is real." And on Beard: "I must say, the guy's got balls: artistic balls, social balls, every kind of balls you can think of. He's a genius, but he's a fruitcake."[13]

Peter Beard took such abuse with well-practiced nonchalance.

12

The Time Was Always Now

Peter Tunney was an energetic, smooth-talking car salesman in Smithtown, Long Island, selling Pontiacs and Hondas in the early 1980s when a friend came by and told him that, with his selling skills, he should be working on Wall Street. He said Tunney could earn a million dollars a year. It was just as the stock market boom was taking off and this entrepreneurial, driven young man from the suburbs didn't think about it for too long. He joined Paine Webber, a banking and investment company that had come to New York from Boston in the early '60s and was now an international company with branches in forty-two states and offices in Europe and Asia. For three years, Tunney traded in the royalty streams from the new pharmaceutical products and while not quite becoming a millionaire, he was certainly making enough money to enjoy the New York high life. Yet almost more important than the money was his introduction to fine art. The chairman of Paine Webber, Don Marron, was also the president of MoMA, the city's most prestigious modern art museum. The young man hung around with Marron as much as he could, learned from him, and became a regular visitor to MoMA. He remembers being transfixed by the giant Francis Bacon retrospective.

Then came the Wall Street crash of '87. Tunney quit Paine Webber to become a sole proprietor broker. He says at that moment he also realized that he wanted to be involved in the art world and decided to declare himself an artist. On the day the Gulf War was announced, Tunney moved

into a double town house on the Upper East Side, a spectacular dwelling built by the Rockefellers in the 1930s, which boasted ten bathrooms and ten fireplaces. Pretty soon he had constructed a library with 6,500 books (complete with a librarian) and had commissioned a mural called *The Ascension of Life* that ran up the staircase and cost him almost $200,000 (about half a million dollars in today's money). Clearly the self-described "hayseed from *Leave It to Beaver* Land" was on the way up.

One day, while browsing through the shelves of Rizzoli Bookstore in Midtown Manhattan, Tunney found a copy of Peter Beard's *The End of the Game*. He was immediately hooked, so much so that he brought the book home and, after poring over it for days, asked the textile designer Liora Manne whether it was feasible to make a rug based on a black-and-white photograph in the book. She said yes and he showed her a photograph in the book of the shadow of a light aircraft passing over the African plains. A year and $30,000 later he had a ten-by-ten-foot carpet that would become a talking point among friends, several of whom said he should show Beard.

Some weeks later, Tunney was sitting in his Madison Avenue investment banker offices when his phone rang and the voice at the other end said: "How are ya doin', Pete? It's Peter Beard here. What are ya doin' right now, bubba?" There was a warmth and familiarity in the voice, as if they'd known each other for years. "Why don't you come over and have a little inspiration?" Beard continued, "Come and have a little lunch. I'm at Nello. Come now. We're here." Tunney arrived at the restaurant to find Beard and Peter Riva at a corner table and was greeted like an old friend. The handsome, craggy-featured man before him was dressed in worn jacket and jeans and Tunney noticed his large, gnarled hands were paint-splattered and his fingernails stained with paint. The walls of Nello were adorned with Peter Beard prints, and as far as Tunney was concerned, it appeared to be the extent of his exposure in New York City.[1]

After a long lunch the three men wandered over to Tunney's apartment and Beard roared with laughter when he saw the carpet that had caused

such discussion among their mutual friends. "That's better than a photograph," he said. "Better than an image on a piece of paper. I love it."

Thus began a friendship and a business partnership that would last almost a decade and would help transform Beard's reputation from photographer, eccentric, and party guy/socialite to an internationally recognized, and highly marketable, artist. At the same time, it would also conjoin two hedonistic characters who over that decade would throw themselves into the consumption of industrial quantities of drugs—mainly cocaine and marijuana—that would eventually drive Tunney into rehab.

Tunney's immersion in the art world had already advanced markedly that fall when he had rented a space on Broome Street in Lower Manhattan that he would transform into an art gallery. He called it The Time Is Always Now. This was to become the nerve center of Peter Beard's most creative period, what his nephew Alex Beard called "the time of great clarity for Peter."

Beard first set foot in The Time Is Always Now at the end of January 1992, the day after a water main had burst and flooded the gallery's basement. To add to the apocalyptic scene, a thin coating of black engine oil had settled on top of the floodwater, the aftermath of an oil burner exploding and leaving behind a slick of black slime. By the time Beard arrived, it had been hosed down and what he saw on the floor were the remains of a cardboard battleship that had been flattened like a pancake by the flood. As both men gazed down on the detritus that had resulted from the gallery's flooded start, Beard declared: "That's one of the best pieces of art I've seen in years." As Tunney recalls, "That's where we began, two days before his 54th birthday." This basement would become Beard's studio and the gallery above on the ground floor would be his permanent exhibition space for the decade ahead.

Although Tunney's arrival in Beard's life was a significant moment, he was not the first American gallerist to take an interest. On the West Coast the Fahey/Klein Gallery in Los Angeles had been showing interest in Beard's work for some time. A committed Beard supporter since he read *The End of the Game* as a teenager, David Fahey had opened the gallery in 1986 and for the first three years had concentrated on exhibiting and sell-

ing fine art. But Fahey's heart was in photographic art and by the end of the decade the gallery was showing works by Herb Ritts, Helmut Newton, Mary Ellen Mark, and other popular photographers of the time.

At around the time Tunney was setting up his gallery in New York, Fahey tracked Beard down in Japan and told him he wanted to curate an exhibition at his Los Angeles gallery. Beard was in Tokyo with Rikke overseeing an exhibition at the Seibu Museum of Art, and he liked the idea; however, he pointed out he did not have any important prints to show. No matter, responded Fahey, if Beard could send him negatives, "we would make the prints." Two weeks later a shabby, eleven-by-fourteen-inch envelope that was torn in several places, arrived at Fahey's office. He was rather surprised Beard appeared be so indifferent to his priceless work, but as the two came to know each other he would discover that he was working with an artist whose relationship with material resources was tenuous to say the least. Soon Fahey's people began working on the precious negatives and the exhibition began to take shape.[2]

Fahey took over a raw space in Beverly Hills in July 1994—it may well have been the world's first pop-up art gallery—and Beard came to town the week before the show to work on some contemporary, evolving pieces, for which Fahey was deputed to go downtown and find a place that sold bovine blood. This he did and soon there was blood splattered on multiple images, thus turning the exhibition into what was to become over the decades a typical Beard event, with a smattering of celebrities—Jacqueline Bisset, Ali MacGraw, and other Hollywood names attended—mingling with friends, acquaintances, and all-purpose Peter Beard groupies.

"The response was, like all of Peter's shows, overwhelming," said Fahey. "It was the place to be, the place to be seen." Although the exhibition was a social success, it was not so commercially. Collectors were buying traditional photographic art—principally classical black-and-white photography from the 1920s—and Beard's work was a digression from this traditional format. It would take some time for his work to gather commercial momentum but the exhibitions—really Peter Beard social experiences—were drawing big crowds. The other factor that Fahey had

not computed into his Beard business model was the free-spending enter-
tainment machine that came with all Peter Beard exhibitions. They were
high-rolling circuses that bore no relationship with the economics of the
photographic art market.

Thus, on the opening night of the inaugural Fahey/Klein Gallery Peter
Beard exhibition, the three principals (Tunney, Fahey, and Beard) took twenty-
five people out to dinner at Matsuhisa (now Nobu) restaurant and ran up a
bill for $6,000. In 1994, this was a small fortune and as the evening finished,
Tunney and Beard entered into swift negotiations with Matsuhisa himself to
trade Beard's artwork for the dinner, a standard Beard practice at the time.
At that time Beard's pieces were selling at $2,000 each, so after the legend-
ary party there wasn't much change. However, this inaugural show marked
the beginning of an important relationship among the profligate and fiscally
irresponsible artist Peter Beard, his wild and adventurous New York partner
Tunney, and the more experienced and down-to-earth David Fahey.[3]

* * *

Back at The Time Is Always Now, a philosophical tug-of-war was tak-
ing place about what constituted fine Beard art and what was pragmatic,
commercial art that would sell enough to pay the bills. What most people
wanted to see were familiar images that included beautiful women like
Iman or Magritte Ramme or Fayel Tall in various stages of undress, and
other staples such as the orphan cheetah cubs, Beard in the crocodile's
mouth (*I'll Write Whenever I Can*), or a naked Maureen Gallagher feeding
the giraffe at Hog Ranch (*The Night Feeder*) at two o'clock in the morning.
According to Tunney, "Every artist from Ansel Adams, to Warhol, to Peter
Beard has their greatest hits, just like a rock band has hits. And as with
rock bands, the audiences want the hits, they don't want the new mate-
rial." Just as Warhol had his Campbell's soup cans images, so Peter Beard
had the baby cheetahs.

Tunney says that over the ten years of his partnership with Beard, with
thousands of negatives at their disposal, there was a small number of clear

favorites. "Beard hated that people like the cuddly baby cheetahs," Tunney says. "There was a point when he said, 'I'm not signing another fucking baby cheetah picture.'" Years later Michael Hoppen, the London gallerist who in the late 1990s would mount a series of successful Beard exhibitions, said that he and Tunney had counted the number of cheetah cub prints that were out there, "And there were 97 different prints, from little Polaroids to huge pieces. There was occasional talk about retiring certain negatives—the cheetah cubs, Beard in the crocodile's mouth, the hunting cheetahs—but nothing ever came of it. He was broader than those fluffy animals."

At the same time, Beard knew he was obliged to do commissioned work to help pay the bills and although under normal circumstances that would require the artist to make some compromises, this merely encouraged Beard's obduracy. Such was the case when the award-winning designer Jeffrey Beecroft contacted Tunney as he was preparing to redesign the actor Kevin Costner's Hollywood home. Beecroft knew exactly which Beard images he wanted, a selection he had made from several books, with very specific dimensions—16.5 square inches live area, framed with two inches of cream linen mat—and he placed an order with Tunney.

This was The Time Is Always Now's first major sale, and it was Kevin Costner.[4] Tunney and Beecroft exchanged a series of faxes establishing Beecroft's meticulous requests. Having printed up some of the images discussed, Tunney sat down with Beard to hash out the commission and Beard went overboard. "This is the fucking picture they pick?" he raged. "This Victor Mature bullshit fucking picture. That's what you printed without my permission." Tunney told Beard he thought it was perfectly reasonable to research the pictures Beecroft had requested, pull the negatives from the files, and print them out. "Fuck that," said Beard. "I'm not giving them that picture. I want to give them this picture. He's got to have this picture." Beard pulled out another image from the files. Tunney then tried to explain that Costner's designer had ordered eleven specific pictures and was paying $11,000, a significant amount at the time and much-needed income, and

that Beard could not just change the order at a whim. "Then I'm not doing it," said Beard. "Send them back the money."

Not only did Beard rail against the images that Beecroft selected, but he also refused to do them in the dimensions or in the framing that Beecroft had ordered. He changed nine out of the eleven pictures in different sizes and in different frames and attached a note for the actor which read: "Dear Kevin, this Victor Mature bullshit will not go. This is what it's really about." He urged Costner to read the medieval philosopher Moses ben Maimon and proceeded to write insults all over the photographs in his intense copperplate hand. Tunney duly packed the work up in crates and shipped them to California. It was their first commercial shipment. A week later, Tunney took a call from Beecroft. "They are *amazing,*" said the designer. "We both love them. Beyond our expectations."

The successful outcome of the Costner/Beecroft commission pointed to two major talking points around Beard's work at the time. The first was the accusation being leveled at him that he was churning out work to pay for his extravagant lifestyle. Tunney was adamant that Beard never churned anything out. "In fact, he did the opposite of churning out work," he said. "He would refuse to do it, as he did with Beecroft. He would mess up my naive plans and wishes every day." Tunney would regularly print up three powerful Beard photographs and suggest to Beard that he get to work on them, and he would typically respond, "Actually I'm going to tear this one in half for a start." Then, he would go to out to lunch for the rest of the afternoon, then come back and say, "Let's set this picture on fire and then we'll take these other pictures to Africa for the Hog Ranch Art Department to work on." Then, he would take the last photograph and suggest they take it onto the roof of artist Andy Moses's apartment building and leave it out for the pigeons to defecate on it. He'd tell Tunney he had arranged for this beautiful girl to come over to the gallery to see it "because she really knows pigeons." Beard's creative output was anything but churning. Rather it was protracted, spontaneous, combustible, accident-prone, and quite often brilliant.

The second talking point revolved around his creation of the Hog

Ranch Art Department in Kenya. The trusty Kamante had been adding his childlike, naive African drawings to Beard's work sporadically since the publication of *Longing for Darkness* in the mid-1970s. But with the arrival of Nathaniel Kivoi and several others, the contribution of the local artists, all fastidiously instructed and guided by Beard himself, became more important to Beard's hand-worked art pieces.

Days and nights at The Time Is Always Now revolved around Beard's comings and goings. When he was in situ, there was always something happening. There was the drift of marijuana smoke from the basement, the clack-clack-clack of credit cards on mirrors as the coke was chopped up into lines. Blood being brought in and music playing. Between ten P.M. and midnight was when the action started.

Peter Tunney says that he never realized at the time, "But I was living an insane life. Peter Beard was a monster. Now that I've been sober for 15 years, I have made a big discovery. Half the people who were hanging out at The Time Is Always Now and in the clubs were not actually doing blow. I'd walk into a club with an 8-ball in my pocket and I figured everyone had an 8-ball in their pockets. But nobody did cocaine as voraciously as I did. Who else drank and stayed up for eight days? Peter sucked the marrow out of every day. He'd have a little bag of blow and it would last for days. He'd give a girl a line. To keep her going. I was a drug addict with no regulator. So, I wouldn't get the girl, I'd end up at the dealer's house, duct-taped in the basement, cooking coke all night. That wasn't social. Peter was always special. When the party left, I left alone."

Fueled by cocaine and intermittent spliffs, Tunney and Beard talked incessantly, mostly about art, with Beard unloading his encyclopedic knowledge of art history and the place of contemporary artists such as Francis Bacon, Lucian Freud (Beard called him Bacon's weak sister), Andy Warhol, Robert Rauschenberg, and the rest in the great art pantheon. Beard would often quote Bacon, telling Tunney that Bacon worked in chaos because it bred images for him and that an artist had to put himself at risk all the time.[5]

"Bacon would say no one should have any security, let alone want it. That

is death to art," says Tunney. "Bacon wouldn't paint your face as you appear. You would be in there somewhere, but you were mixed up with the angst of mankind for 5,000 years. Boom. That's a fucking painting. And that's why they sell for $100 million. You can't fake that shit. I learned all that from Peter Beard. So, Peter and I were always discussing that edge, that precipice, pushing. The minute I got comfortable and wanted to sell a picture, Peter wanted to tear it in half and turn one half upside down. Always one step ahead. And always right. He was a really good artist, and he knew about his work in the context of the history of art."

Through the early to mid-1990s, Beard's "years of clarity," Rikke Mortensen was almost constantly at his side. Through 1993 he had been imploring her to come and stay with him in New York, spending a small fortune of Tunney's money on long, international calls from The Time Is Always Now, declaring his undying love. Finally, in November, he jumped on a plane and flew to Copenhagen, where he managed to persuade her to come back to New York with him. She had never been to America before. When they were set to depart from Copenhagen Airport, clutching their one-way Delta Airlines tickets Beard had bought, they immediately discovered that she required a return ticket to get into the United States. Neither of them had the money for a return ticket and Beard stood at the Delta counter arguing forlornly that he would sign a document promising the US government that Rikke would return to her homeland rather than become an illegal immigrant.

Just as they were about to give up, a stranger who was standing behind them in the queue, a well-dressed and obviously well-off Danish business-man, stepped up and said: "I'll buy you the return ticket." As Rikke later observed, this was what happened in Peter Beard's world. Chance meet-ings. Fortuitous coincidences. Impromptu encounters. Lucky accidents. Unplanned engagements. "We had never seen this man before," Rikke said, "and suddenly he is buying us a really expensive airline ticket. Peter wasn't even surprised."[6]

Soon after they landed in New York, Beard was booked to appear on the *Charlie Rose* show on PBS, an arrangement Peter Riva had set up to pro-

mote the new Jon Bowermaster book, *The Adventures and Misadventures of Peter Beard in Africa*. Riva, Mortensen, and Beard had enjoyed a pleasant lunch before arriving at the studio, but it became very clear shortly after the interview started that Beard was in a strange frame of mind. Something had happened in the half hour leading up to the interview that shook Beard up. He ranted to Charlie Rose about his usual pet subjects—overpopulation, the demise of wild Africa, man's distance from nature—and then, when Rose brought out the book Beard was supposed to be promoting, he cringed, covered his face, and changed the subject. Riva, who was the book's agent, was furious and said that after the show Rose and his producer Peter Kaplan "told me never to bring any of my clients to the studio again. It was a disaster."[7]

Riva was adamant that Beard's dismal performance was the result of Nejma calling him while they were waiting in the greenroom, fifteen minutes before he went on air, and railing at him for ten minutes. The content of that conversation was not clear, but Riva said that Beard was quite shaken by it.[8] Beard's girlfriend Rikke said she remembered him being nervous but nothing more than that. What others remembered most acutely from the interview was Beard's insouciant response to Rose's questions about the fate of the Hog Ranch poacher Jared Nzioka. "I put him in a snare for an hour and a half. Big deal," Beard shrugged.[9]

After *Charlie Rose*, Beard and Rikke headed out to Montauk, spending a few days there with friends before flying out to Japan for Beard to do a photoshoot for *Esquire* magazine. However, with a minimal advance and Beard's proclivity to spend until the money ran out, the couple were soon out of cash. They had been hanging out with Eiko Ishioka, the celebrated art director and graphic designer, and one of Rikke's old friends from Copenhagen, master cabinetmaker Soren Matz. It was Matz who had persuaded the couple to join him in Kyoto, to spend two nights at the Tawaraya Inn on the way, and then have several expensive dinners eating sashimi with him in Kyoto. By the time that sojourn was over, they were broke and could not afford to get home. Desperate, Beard called Peter Riva and then called his brother Anson, asking for financial help. It was

on that call that Anson told him it was time he got a proper job, to which Peter replied: "Listen, I'm 60. What am I supposed to do?"[10]

* * *

During this time, Nejma, with Zara under her wing, had begun living a separate life in Manhattan. Finally exasperated by her husband's serial infidelities, and particularly as Rikke seemed like a steadier attachment than many of his previous paramours, she started consulting lawyers. Pretty soon she and Beard, the latter often accompanied by his friend Drew Hammond, were communicating through their separate attorneys in increasingly acrimonious exchanges.

Beard's access to Zara was limited to phone calls and brief, monitored visits, and as the arguments raged in late 1993, Nejma issued a formal complaint of child molestation against Beard with the New York Department of Social Services. This was not the first time she had raised this issue. The previous year Nejma made the accusation at Hog Ranch to Turle's partner Fiammetta Monicelli. She told a somewhat nonplussed Fiammetta that she was worried about the relationship between Peter and his three-and-a-half-year-old daughter, Zara, implying that he may have been molesting the child. Then, days after making the accusation, Nejma flew off to Zanzibar with the actor Woody Harrelson and their friend, the journalist Harry Minetree, for a ten-day holiday, leaving Beard in sole charge of his daughter. "It was a horrible accusation," Fiammetta said. "And yet she was quite happy to leave her daughter with the man she was accusing while she went off on holiday with an attractive man. I told her several times I could not support her accusations." She said Nejma cut her off soon after. The irony was not lost on Beard who, later, in a Japanese restaurant in New York, recorded a formal statement from Fiammetta expressing her skepticism about Nejma's accusations. (According to friends, Nejma had a brief affair with Woody Harrelson. She also had a similarly brief affair with one of Beard's closest friends.)[11]

As the allegations about Zara spread through Beard's social circle, his

shock gradually turned to anger. "When he heard this terrible accusation," said Beard's close friend Drew Hammond, "it was the closest I ever saw him to shedding a tear. He was so shocked. He said, 'How can anyone think of such a disgusting thing?' He loved his daughter and, in his old-fashioned WASP way, was very proper. He felt betrayed and shocked that Nejma would resort to this." In Peter Beard's letters to Nejma, he said despite her "looney and preposterous cry of child molestation" that he still loved, admired, and cared for her. But he implored her to stop hounding their daughter over something that did not happen and to stop parading her in front of Californian psychiatrists he described as "border-line doctors" and "quacks." It would end up, he wrote, "with a daughter lured into something that could ultimately cause guilt and questioning and confusion when considering the banishment of her father from living in the same house."[12]

Officially, the allegations disappeared as fast as they appeared. In May 1994, Beard received a letter from the New York State Department of Social Services declaring that as a result of an assessment made by the local Child Protective Service, "no credible evidence was found that the child named in the report had been abused or maltreated. This report, therefore, has been considered unfounded."[13] It had been erased from the New York State Child Abuse and Maltreatment Register. Although Beard and his friends were relieved, they were still shocked that Nejma would resort to such heartless tactics. But, as they were to discover, the burning wrath of his third wife was far from extinguished.

Away from the dark recesses of his collapsing marital life, times were good for Beard. His photographic art was becoming more widely appreciated, thanks to The Time Is Always Now's growing reputation as both a party place and the engine room of his creative work, and the commitment of galleries in the United States, Europe, and the Far East.

Beard's work was becoming increasingly popular in Japan and he and Rikke made two trips to Tokyo in the space of several months, one to set up the second exhibition of his work at the Seibu Museum of Art featuring his diaries and entitled *African Wallpaper: Diary from a Dead Man's Wallet*. This was followed by preparations for another major show at La Hune bookstore

in Paris. Beard and Rikke thoroughly enjoyed traveling together—Beard seemed adept at securing upgrades, and they particularly enjoyed flying to Japan first-class on All Nippon Airways. Before leaving New York on that last trip Beard asked Rikke to throw a clutch of A3-sized papers into her cheap, soft-sided Chinatown suitcase. When they arrived in Tokyo she pulled the papers from her case and realized that they were original Andy Warhol diary pages. Beard had promised to include them in the exhibition but smuggled them in because he did not have the money to pay the appropriate insurance. "I've always wondered whether Warhol ever got them back," Rikke said.

In the spring of 1995, they took time out to stay in Copenhagen, where Rikke celebrated her thirtieth birthday. It turned out to be an emotional day, not so much for Rikke but for Beard. He broke down and wept and told Rikke that it was on his thirtieth birthday that Minnie Cushing had walked out on him and admitted for the first time that he had attempted to commit suicide. "He said she couldn't stand living in Africa. I had never before seen him so emotional," remembered Rikke.

* * *

The La Hune exhibition in early 1995 was a big turning point for Beard as an exhibition artist and, according to Peter Tunney, a perfect example of his instinctively good judgment. He and Rikke were in the city, staying at the delightful Hotel Rue de Grenelle, when the idea struck him to have a show at this celebrated Parisian bookshop. For decades La Hune had been the meeting place for French intellectuals such as Jean-Paul Sartre, Simone de Beauvoir, and Albert Camus, and was famous for its collections of French and international literature, history, art, and design. It was located between the Café de Flore and Les Deux Magots in the city's 6th arrondissement, both of which would, during the Beard show, be major gathering places for friends and admirers.

When Beard called Tunney to tell him about his idea, insisting that a historic bookshop on Paris's Left Bank would be the perfect venue, the

gallerist was unconvinced, but he eventually folded as his client's enthusiasm gathered momentum. Once persuaded he went to work on producing prints to Beard's order, taking the dimensions down meticulously over the phone. When he arrived in Paris with these expensive, high-quality giant photographs, the pair went to hang them at La Hune "and I realized the specific dimensions he had given me didn't mean anything. I made them in inches, he had given me the dimensions in centimeters without mentioning it. But he just said, '*C'est la vie*. It will be great.' And it was."

To add to the theatricality of the exhibition, Beard had secured a selection of stuffed animals—foxes, a jaguar, squirrels, and a seventeenth-century baby elephant—from a local taxidermist. Tunney also invited the Café de Flore to cater for the opening night guests, "and they agreed to give me a bill at the end of the night. That was a shock." To everyone's amazement, more than two thousand people turned up to the opening. The street between La Hune and Café de Flore was mobbed with fashion models, rock stars, film stars, designers . . . *le tout Paris*. It was on that opening night that Peter Riva, who had flown in for the exhibition, introduced Tunney to Robert Delpire, director of Paris's Centre National de la Photographie. Delpire was so impressed with the exhibition that he quickly agreed to stage a major Beard retrospective the following year.

Beard and Rikke spent Christmas and New Year's Eve 1995 together in Copenhagen and then in North Jutland with her parents. Rikke's parents, despite being younger than her boyfriend, embraced Beard with traditional Danish warmth, and he regaled them with great stories of his adventures in Africa. There were no drugs, little drink, just Beard as the dynamic, charismatic American adventurer amusing and entertaining his hosts. Rikke felt this was a particularly good time for Beard, a man who she said had few, if any, close friends. "He knew a lot of people," she said, "but I don't think he had any friends, except maybe Gillies Turle. People befriended him—they seemed to want a part of him or, in some cases, to be him." But he felt comfortable in Denmark. He liked the down-to-earth unpretentiousness of the Danish people and was particularly fond of Rikke's family.

Back in Manhattan, Nejma's crusade against her husband continued to gather momentum. Peter Riva wrote Beard an angry letter informing him that Nejma had subpoenaed all his company records, something he regarded as an outrage, given that much of Riva's business operated separately and independently from Beard and his work. "I now have to hire a lawyer ($5,000 down payment) and fight the court order. This stupid divorce is costing me time, money, and now, real anger." According to Riva, the judge in the case had indicated Beard would be responsible for his estranged wife's legal bill—"$30,000 straight from your trust fund, which she has the power to take."

The legal sparring was exacerbated by a personal confrontation in Midtown Manhattan in January 1996. Beard, Riva, the filmmaker Bertram van Munster, and others were having lunch at Mortimer's restaurant on Seventy-fifth and Lexington when Beard spotted Zara heading south down the street outside the restaurant. Apparently, Beard had been granted a formal visit an hour later so there appeared nothing untoward as he leapt out of his seat, went into the street, and greeted his daughter with open arms. As Zara smiled with pleasure at seeing her father, Nejma yelled, "No!," grabbed Zara, and hustled her off, out of Beard's reach. Beard called after her, trying to reassure his daughter, "Don't worry, it's alright, I'll see you later," but undoubtedly the little girl had been distressed by the confrontation.[14]

Clearly disturbed by her parents' acrimonious exchanges, Zara began to behave quite peculiarly. In one incident reported by her godmother Heide Rufus-Isaacs when Zara was staying overnight in her Los Angeles home, Beard's young daughter claimed that a stranger, an intruder, had entered a room where she was staying with Heide's children. She was the only one of the children who had seen this man and although Heide was inclined to dismiss the claim, Zara was so insistent and so precise in her description of the man's features, clothing, and mannerisms that all those present, including Nejma, persuaded Heide to call the police.[15]

The police duly arrived and made a thorough search of the house and the surrounding area but found neither footprints nor any evidence of an

intruder. However, Zara remained insistent and consistent in her description of the intruder. Everyone believed her despite the complete lack of any evidence. Finally, Heide took Zara aside and whispered to her: "You really made it all up, didn't you?" Zara bit her lip and broke into a broad grin, then nodded vigorously. It had been some performance. Beard later told his brother Anson that Heide had told him: "Nejma will kill me for this but I never believed any of it from the beginning."[16]

Beard's concern for his daughter persuaded him to write to Judith Grandes, a well-respected psychotherapist employed by Nejma at the time, imploring her to help save Zara from what he described as "crazy hostage holding and glum propaganda in smoky rooms" in New York City.[17] The intense eight-page letter railed at the various lawyers and psychotherapists Nejma had hired and discarded, at his expense he claimed, over the three years of divorce proceedings. He expressed particular apprehension over how this was affecting his seven-year-old daughter, who he now regarded as vulnerable to the anger radiating from her mother.

13

Elephant Memories

Peter Beard reveled in the sight of blood. Increasingly, blood had become an integral part of his artworks and the source would depend on the quantity required. If a large volume was needed, Peter Tunney would go out to Lobel's, the local butcher, and pick up a gallon.[1] If a lesser quantity was needed or there was an urgent need to finish a piece of work, Beard provided his own blood. Andy Moses remembers Peter promising to make a piece of art for one of Carter Coleman's Tanzania Wildlife Fund benefits and, as the days passed there was little evidence of Peter actually completing any artwork. Suddenly, just three hours before the benefit, Peter turned to Andy and said, "I told you not to worry. I'm going to do it now." Having laid out a large black-and-white photographic print, he then took a pair of Japanese scissors and stabbed them into his thigh. "I've never seen a wound like it," Moses said. "It poured onto the photograph, and he just kept bleeding profusely. I told him he needed to go to hospital, but he wouldn't think of it."

Once he had completed the piece, Beard had a quick bath to wash off the excess blood and when he climbed out "the bathwater looked like tomato soup," according to Moses. The pair jumped into a cab and headed for the TWF event at Nell's nightclub, the collage drenched in blood, still wet and smelling so strong that it was attracting flies. The piece was a large print of one of Beard's diary pages worked over with the writings and the markings that typify a Beard piece. The sole bidder was the book publisher Julie Grau, who remembers paying "$650 to spare him embarrassment. It

was an astronomical sum for me at the time. It hangs on my living room wall today and I wonder what it's worth."

For Andy Moses, this was just another day in the world of Peter Beard, a world he regards himself as lucky to have shared for the better part of the 1990s. Moses, a California artist who relocated to New York in the early 1980s, had moved into an apartment on Broome Street a couple of years before Tunney opened The Time Is Always Now. His apartment looked down onto Tunney's gallery and from 1993 Beard became an almost permanent occupant. The two became firm friends instantly. He remembers that the phone would ring at around nine o'clock in the morning and it would be Tunney saying, "Wake him up and send him over here. There's work to be done." Beard would take the call and he'd be sharp as a tack. Nobody could keep up with him.

Invariably, Beard had been out clubbing the previous evening and arrived home at dawn. Typically, he was getting no more than three hours' sleep a night. "I've never seen anyone sleep as little as Peter," Moses recalls. "He loved everything about life except for sleeping . . . he thought that was a waste of time. He could function for two or three weeks on two or three hours' sleep a night. Then he'd crash out for 12 hours . . . then go another two or three weeks. That's how he lived his life during those years. I'd never seen energy and stamina like Peter had."[2]

In the summers through the mid-1990s the Broome Street entourage, together with journalist-writer Harry Minetree, German artist Thomas Müller, and Peter's nephew Alex Beard (son of his younger brother, Sam), would move out en masse to Thunderbolt Ranch in Montauk and live as an artists' community. Moses and Müller had studios in Montauk and, together with Beard, would hold small exhibitions of their work. They created a foundation—the Earth's End Foundation—and donated most of the proceeds to Carter Coleman's Tanzania Wildlife Fund. Rikke Mortensen was Beard's constant companion in those summers and Nejma was nowhere to be seen (they were permanently on the verge of getting divorced). Alex Beard, who took up residence in Thunderbolt Ranch's goat shed, remembers those summers as "warm and collaborative for Peter."[3] That is not to say the

regulation Beard-initiated chaos was far away because, as Andy Moses observed, "Peter loved drama, loved chaos. There was an open door so people who came in were jostling for position. All sorts of people would come out there and it didn't take long before it was a battlefield. He enjoyed that. We were doing these shows in the summer in my studio and people would come and buy small things for little money. This was before Tunney came up with the idea of blowing the photographs into gigantic pieces and consequently charging big prices. Within a year of Peter being involved with Tunney, pieces had gone from between $2,000 and $3,000 to between $60,000 and $70,000 for the big collages."

Initially during those Montauk summers, when well-known photographers would drive out from New York and ask to buy Beard's work, according to Andy Moses, "Peter would be laughing about it but eventually they'd talk him into selling a few prints and he'd say, 'Well, give me $2,000 for these three prints.' He only got to understand the value of his work a bit later, when Peter Tunney really got things rolling."

* * *

As Peter Tunney and the wild, bloodstained nights at The Time Is Always Now took center stage in Peter Beard's life, the man who had first tethered Beard and attempted to bring some order and value to his artistic life began to find himself increasingly in the shadows. Peter Riva had never approved of Beard's drug-taking. He wasn't bothered about the occasional joint, but he wouldn't sanction using cocaine, crack, and the various hallucinogens that Beard and some of his entourage favored. In the early days, before Beard began living with Andy Moses in the Broome Street apartment, he would use the Riva family apartment on East Ninety-fifth Street as his Manhattan base. Riva remembers several occasions in which he threw Beard out on the street when he found him snorting cocaine. Riva argued that he was bringing up two young sons in that house and the last thing they needed was to associate their much-loved uncle Peter with street drugs.[4]

It was also widely known among Riva's friends and business partners

that he wasn't exactly making a lot of money representing Beard. His client's overhead and high-maintenance lifestyle saw to that. But there was a higher reason, Riva argued, for continuing to represent a difficult and willful client. "When I heard Ansel Adams saying Peter's photography was brilliant," says Riva. "And then Lucien Clergue, Franco Fontana, and Jay Maisel, and then Eliot Porter and the Weston brothers. And then hearing artists like Robert Rauschenberg talk about how significant his images are. And then, of course, Francis Bacon. After all that, you simply had to put his needs as an artist first. And that is what I did."

Riva also found himself frustrated by Beard's inability to make decisions and to commit to projects that he had invested time organizing. Every year Beard and Riva would meet up and have lunch with the partners of the Blum Helman Gallery, which handled artists such as Andy Warhol, Larry Rivers, Ellsworth Kelly, and Robert Moskowitz, and every year the partners would say they were very keen to do an exhibition of Beard's diaries. (Irving Blum was always for including Beard, while Joseph Helman was skeptical and at one meeting called Beard a rich dilettante, which Beard took as a compliment.) Finally, Riva came up with the idea of doing a combination of worked Giant Polaroid pieces and diaries. Having teamed up with Barbara Hitchcock, the director of cultural affairs at Polaroid, they went ahead with the project, with Beard doing three shoots, ten images each. Beard and Riva had agreed with handshakes that they would provide the Giant Polaroid images for the Blum Helman walls and that the diaries would be placed in display cabinets, an arrangement that would become standard fare years later for Beard exhibitions.

After a few months, Riva confronted Beard about the diaries and Beard said he didn't know where they were and, in fact, that some had been lost. Eventually, the Blum Helman Gallery lost patience and said their arrangement with Beard was over. He had been on the gallery's lists for eight years and had not produced anything, despite annually promising to deliver. They said: "Forget it, we're no longer your gallery."

For all the frustrations, Riva hung on because "Every once in a while, Beard would produce a piece of art that was generous, strong, powerful,

and wonderful, and it made it all worthwhile. But some of his stuff was pure illustration. I don't think he knew the difference—that's why he kept working on everything."

While he understood there was a deep and profound artistic symbiosis between Beard and Francis Bacon, Riva was also deeply skeptical about the motives behind his client's relationship with the great Anglo-Irish artist. Every year when he and Beard were traveling together in Europe, Beard would insist that they had to stop off in London "to see Bacon and get some cash. We'd go to that stupid restaurant in Beauchamp Place (San Lorenzo), where Peter got terrible food poisoning once by the way, and at lunch Bacon would hand him £500 in cash.

"This is a guy who was relying on me and my good offices to pay his bills, pay restaurant tabs, flights, etc. It was always discussed. I was his business manager, his personal manager, his literary agent. Everything. Fucking nightmare." Riva insisted that in those days, at least, the sale of Beard's artwork was not covering the cost of running the profligate artist.

In May 1996, Beard headed back to Hog Ranch and was joined by Maureen Gallagher, who had agreed to be one of the models for an *Elle* magazine photoshoot in Turkana, a favorite retreat that she and Beard had visited several times since their first romantic, drug-fueled liaison a decade earlier. On this trip they were also accompanied by Guillaume Bonn, the Franco-Kenyan photojournalist who had become a Hog Ranch regular after first meeting Beard as a schoolboy at Richard Leakey's rhino horn bonfire in 1990, which had been sandwiched between two much-publicized ivory bonfires in 1989 and 1991. Also present were the fashion designer Azzedine Alaïa, and Mischa Haller, who would become a regular assistant. The Turkana shoot was a typical Beard fashion job with dramatic shots of the models amid traditionally dressed Turkana people, all set in this barren East African landscape that Beard had been drawn to for more than four decades. Guillaume Bonn—who has called Beard a significant mentor who "taught me that the only thing worth pursuing as an artist is to explain to others the complexity of the [African] continent, to create better understanding and knowledge in a foolish attempt to save it and to save us all"—

had been invited along as an observer. However, he had borrowed a Hi8 video camera and was now filming the events. Little did he know that in the coming months he would soon be filming the most dramatic moment in Beard's life.

Soon after the Turkana shoot wrapped, Rikke Mortensen arrived at Hog Ranch with her friend the Danish filmmaker Lars Bruun to work on a documentary to be called *A Study of Peter Beard*. Beard and Rikke had been spending more and more time apart, not the least because Rikke felt she needed to create her own life in Denmark. She was, by this time, in the restaurant business and was raising her son, Jonas. Although Beard had asked her to marry him several times, she says she knew that would have been a mistake and routinely turned him down. Nevertheless, with Lars in tow, Beard and Rikke traveled down to Tsavo and spent ten days on safari in the place where they had enjoyed such good times three years earlier.[5]

Not long after Lars Bruun and Rikke left Kenya and flew back to Denmark, Peter Tunney flew in from New York. He had been very concerned about Beard's preparations for the big one-man show at the Centre National de la Photographie in Paris, which both Tunney and Peter Riva had seen as a big moment in Beard's career as an artist. He was hoping to convince Beard that, on this occasion, some pragmatism and preplanning would be more appropriate than the traditional frenetic, uncontrolled approach, even if that had served them well enough in the past.

They had been planning this show for more than a year and Tunney, knowing that it was at least twenty thousand square feet of exhibition space, was painfully aware of how much artwork would be required to mount a compelling show. He had also spent considerable sums having Beard's voluminous diaries bound by the New York bookbinder Herb White, and they had agreed broadly which artworks were appropriate to hang and how many more were needed to complete the exhibition. His conclusion was that a great deal of work was still required, and he began pressing Beard to get back to work in The Time Is Always Now. Tunney had dutifully printed an assortment of Beard photographs (black-and-white, color, diary shots, small prints, large prints, Polaroids), but they required the intense marking,

writing, streaks of blood, and filigree handwriting that made up original Beard artworks, and very little had been produced. Typically, Beard had other ideas, telling Tunney it would all be done in good time and that the most important thing to concentrate on right then was to get out to Africa. He had already agreed to the *Elle* magazine fashion shoot commission with Maureen Gallagher and had promised Rikke to be out there to help her put together the Lars Bruun documentary.

Having fulfilled his obligations to *Elle* and Lars Bruun, he now informed the hapless Tunney that there was another obligation to fulfill. His old and dear family friend Calvin Cottar had invited him down to his new 1920s Safari Camp in the eastern Maasai Mara, both to get Beard's view on the new camp and also to celebrate their common past, most particularly the memory of his father, Glen, who had recently passed away. Although Beard and Glen Cottar had not spoken since the rhino attack on Terry Mathews in 1987, Cottar had been one of Beard's great allies and friends in his early days in Kenya, while he was writing *The End of the Game*, and many of the most famous wildlife photographs in the book were shot when Peter and Glen were traveling together. Now Glen's son and old friend wanted to raise a glass to the departed man of the bush. It was here, in this remote uninhabited corner of the Maasai Mara reserve, near the border with Tanzania, that Calvin's great-grandfather had been killed by a rhino in 1940 and where Glen had been almost killed by a buffalo in 1964.

Tunney was agitated about Beard accepting Calvin Cottar's invitation and once again attempted to persuade him to return to New York immediately. On Tunney's birthday, September 1, they smoked a spliff together and he made one last attempt at persuading Beard to attend to his work and prepare for the Paris show. "They want you here to shoot a tourist brochure," he said, "and you have more important work to do." Beard was unmoved. Four days later he waved his gallerist goodbye and promised he would get back to New York in the following weeks and everything would be fine.[6]

Beard, Calvin Cottar, Alexandra Crosskey, a young Englishwoman who was working for Cottar's safari operation, Guillaume Bonn, who was

now filming and photographing Beard, and a few others, headed out to the Maasai Mara and the new Cottar safari camp. On Monday, September 9, the group decided to recce the wild bushveld surrounding the camp. The plan was to have a picnic lunch at a waterfall some six miles north of the camp. They had set up tents and were photographing the area. About a mile from the Sand River, the group spotted a herd of elephants, which they thought would make a good photographic backdrop for the camp's brochure. There were around twenty elephants and although there were youngsters in the group, usually a sign of tension and danger for interloper humans, the herd seemed very relaxed. Beard and Cottar left the vehicles and began following the herd up the shallow incline of the hill on foot.

Importantly, the wind was in the right direction and the two experienced trackers followed the herd at a safe distance, keeping the elephants at one hundred fifty to two hundred meters away. Cottar and Beard were enjoying just being in the proximity of these magnificent animals. Then the wind shifted. Immediately, the herd became aware of the presence of humans on foot, and yet, even at that point, the adult elephants appeared unconcerned. Suddenly, a mature female at the back of the herd wheeled around in a cloud of dust and faced the two men. She made a mock charge, covering no more than ten yards, and Beard and Cottar retreated slowly, carefully, as their training had taught them. There was still no problem.

The female then did another mock charge, this time over twenty yards, and they broke into a trot, all the time watching what the matriarch was doing. Even at this stage the two men, vastly experienced as they both were in animal behavior, were sure this was no more than a warning for them to clear the area, which is what they were doing. Then she came on and they ran, one to the right and one to the left. The matriarch chased after the one to the left and that was Peter Beard. As he stumbled and fell, the female elephant was on him, boring into him with her massive forehead and tusking him through the thigh. Somewhere in the frantic movement and swirls of dust, the onlookers could see Beard hanging on to the matriarch's foreleg. Calvin looked back in horror and saw the rest of the herd following the matriarch. "From what I could see, there was no chance that he had survived,"

Cottar later said. "But he is a very tough and a very brave human being. I think grabbing onto that elephant's leg saved his life."[7]

At the same time, Guillaume Bonn, who had been filming Beard and Cottar tracking the elephants, ran for his life as the rest of the herd joined the matriarch's charge and headed in the general direction of the group. Through clouds of dust the onlookers saw the large, angry female elephant run her tusk through Beard's thigh, crush his midriff with her head, and smash his pelvis. As the vehicles drove at the circling herd and saw them off, nobody was sure what injuries Beard had sustained. He lay in the African dust groaning in pain and with typical Beard wit, croaked at his friend Cottar: "Looks like my screwing days are over. Don't worry, Curly."

There was little blood, so those gathered around Beard's body were not sure how badly injured he was. But Beard said he could feel blood "swishing around inside me."[8] Alexandra Crosskey thought maybe he'd suffered only a few broken bones and was OK. The problem was they were in remote bushveld, and it was a fifty-minute drive to the closest dirt airstrip. On the drive Beard, clearly in agony, gritted his teeth and kept saying "something's not right." Alexandra says she just kept talking to Beard, hoping to distract him from his pain. Eventually they arrived at the Keekorok airstrip, where there was a doctor and a small clinic to administer pain killers while they waited for the flying ambulance. When it arrived, the stricken patient was gently levered on board and Cottar asked Alexandra to accompany Beard to Nairobi Hospital. At that moment, the drama of the events overcame her, and she fainted. Instead, Guillaume Bonn climbed on board and the plane took off, headed for Nairobi.

Having landed at Wilson Airport, Beard was rushed to Nairobi Hospital and as they wheeled him into the accident and emergency entrance, he was clinging to life. Bonn said: "I had to scream and shout at the hospital staff that this guy was dying. Fortunately, in an emergency ward that was full of ailing patients, the doctor on duty saw the gravity of the situation and Beard was wheeled immediately into the operating theatre."[9] As Beard was taken into the operating theater he was, according to Bonn, clinically dead. Fortunately, that doctor on duty that day was Imre Loefler, a skilled

surgeon who was familiar with injuries caused by wild animals. (Ironically, it was Loefler who had operated on Terry Mathews after the rhino attack all those years back.) What he discovered was that Beard had a ruptured spleen and was bleeding to death internally; he also had a severely crushed pelvis, broken in five places. Ironically, the most visible injury, his left thigh pierced by the elephant's tusk, was the least serious and was quickly stitched up. He operated on the stricken Beard immediately, and undoubtedly saved his life.

News of Beard's almost fatal elephant attack spread quickly. Rikke Mortensen, now back in Copenhagen with her son, Jonas, immediately got on the first flight she could to Nairobi. Peter Tunney was in a meeting with Ted Hartley and Dina Merrill, owners of RKO Pictures, in their New York offices over the potential purchase of the film company, when he was told there was an urgent call from one of his staff at The Time Is Always Now. He said they could wait; "I'm in an important meeting here." He was told that Peter Beard had been crushed and killed by an elephant and that he had to take the call. "Crushed and killed?" Tunney shouted down the phone. "Are you making that up?" Once he had established the facts, that although Beard remained in a serious condition, an operation had apparently been carried out and he was stable at Nairobi Hospital, Tunney decided to contact his friend Dr. Andrew Feldman, the head of the orthopedics department at New York's St. Vincent's Hospital, who was also a good friend of Beard's. Dr. Feldman was finishing an operation at St. Vincent's when an orderly burst into the operating theater and said, "There is an emergency. You must take a call from Peter Tunney." He did. Tunney explained what had happened but expressed reservations about the treatment he believed Beard would be getting in an African hospital. By contrast, Nejma and her family were trying to reassure everyone that because of their experience with victims of elephant attacks, Nairobi Hospital was the best place for her estranged husband to recuperate.

Feldman told Tunney to connect him with the Nairobi doctors as soon as possible and, over the next few days, Tunney tried to do just that, eventually managing to make the telephone connection on the fifth day.

"I know my stuff, so I knew what questions to ask the Nairobi doctors treating Peter," remembers Feldman. "When Tunney called back I told him that if he didn't get Peter back to New York urgently he was going to die. The responses I'd had to my questions were very troubling and there was a lot of stuff they weren't addressing. Peter was septic, he was bleeding internally, and I knew he probably had a urinary issue."

In the meantime, Rikke had arrived in Nairobi and despite Beard's cavalier attitude to his injuries and his condition, assuring her that he was fine in Nairobi Hospital, she, too, was very concerned about the situation. "There was such a strange smell in Peter's ward," said Rikke. "He was playing the brave superhero but there was something wrong and I phoned Peter Riva in New York and told him."

Rikke also spoke to Beard's older brother, Anson, who she says seemed at first quite unsympathetic, indicating that he was not prepared to pay for his repatriation. He said that Peter had no insurance and that this would surely teach him a lesson, that he should have lived his life more responsibly. A recurring theme in Anson's relationship with his wild, wayward brother, the response reminded Rikke of Beard calling Anson from Japan when the couple were flat broke and trying to scrape together the funds to pay for a pair of airline tickets back to New York.

As Anson appeared initially reluctant[10]—he later paid the $25,000 air fare bill for the repatriation entourage[11]—Beard's two New York business partners, Riva and Tunney, started arranging to get him back to the States. Tunney flew from New York to Nairobi with the two doctors required to accompany a gravely ill patient on such a long-haul flight. For the return flight with the stretchered Beard on board they had to buy ten seats and build a makeshift bed. While Beard's welfare was uppermost in his mind, Tunney was also aware of the fact that the Centre National for Photographie in Paris was booked for November 3, and so he carried with him on the outward flight some five or six large Beard prints which he would take to Hog Ranch for Kivoi and the Art Department to add their distinctive decorative borders.

When Tunney arrived at Nairobi Hospital, he said he expected to see

"my buddy Peter Beard, weak and in pain and I presumed I would be sitting at a diminished man's bedside, holding his hand, comforting him and reassuring him about our impending journey home." Instead, he opened the door and found Beard a bit stoned and roaring with enthusiasm and astonishment at a video a friend was showing on the television set. Old Kenya family friend Dominic Cunningham-Reid had just returned from Somalia, where he had been filming a distressing sharia law court case involving a nineteen-year-old who had been accused of stealing a woman's scarf at knifepoint in the streets of Mogadishu. Dominic was one of the foreign correspondent gang who, returning from the front line, would usually head straight for the Hog Ranch campfire and relay his harrowing experiences over cocktails and circulating spliffs. Now that his friend and mentor Beard was in Nairobi Hospital, it seemed appropriate to share his latest exposure to the heart of darkness. The film footage he shared with Beard showed the boy sitting on the courtroom floor, handcuffed and unrepresented, while the prosecutor, dressed up as the woman victim, theatrically entertained the courtroom audience, who were howling with laughter. Eventually the boy was found guilty, led to a room, and in front of Dominic's camera, first had a hand hacked off with a Somali knife and then a foot. "It was horrific," he said. "This young boy, clearly in intense pain with no anesthesia, did not make a sound."[12]

It could have been a scene out of Joseph Conrad's *Heart of Darkness,* a book to which Beard constantly referred. Even in his weakened state he remained fascinated by the brutality and darkness of Africa, the Conradian horror, and insisted that Tunney "Watch this. Watch this." This gruesome piece of theater seemed to confirm to Beard the much-quoted line from *Heart of Darkness* that "The mind of man is capable of anything."

Once the turmoil of Dominic Cunningham-Reid's video had subsided, Tunney was able to assess Beard's situation with some clarity. In repose, Beard was clearly diminished by the accident and although the surgery may have saved his life in the short term, things were not right. He had suffered an "open book pelvic fracture" and although his bones were now

held in place by stainless steel pins connected by an external scaffolding, one of the pins had been inserted into soft tissue and was causing serious infection. Also, his ruptured spleen had not been fully addressed, so there was more infection. Tunney quickly concluded that Andrew Feldman had been right—Peter Beard needed to be transferred to an American hospital urgently or he would die.

* * *

Dr. Andrew Feldman and Beard had been friends for some time, and even though Feldman was a modest drinker and didn't touch recreational drugs, he enjoyed the wild happenings at The Time Is Always Now and the nightclub scene Beard and Tunney circulated around and has described himself as a lifelong bachelor. In other words, perfect Beard companion. As he later said, he was part of the Beard posse but would jump off the rolling bandwagon at eleven P.M. every night and get a good night's sleep before the next day in theater.

On September 23 Beard, accompanied by Peter Tunney and two doctors, left Nairobi for New York. Tunney says they enjoyed "a rather pleasant morphine-infused plane ride home." One of the doctors was a specialist in medical rescues and during the flight told the pair in granular detail about the many cases he dealt with that involved Munchausen's or Munchausen's by proxy, people who were actually faking paralysis to get attention, "paralyzed from the waist down because they didn't want to face their husband or face divorce, faking paralysis to get attention, and of people who were putting diseases on their children." The two stoned Peters were a captive audience and were fascinated by the doctor's dramatic tales.

After a brief stopover in London, they finally landed at New York's JFK airport, and Tunney was wheeling Beard through the airport after clearing customs and passport control, when he heard a woman's voice raised above the terminal din. "I'm Mrs. Peter Beard," the voice trilled. "I'm in charge here. Is there anything for me to sign?"

It was Nejma, Beard's long-estranged wife, who Tunney had not seen

for several years and who, as far as all of Beard's friends, various mistresses, gallerists, and colleagues knew, was in the throes of divorcing him.

Suddenly, Nejma Beard was back in the picture and her presence would have a profound impact on Beard and his huge global body of friends for the rest of his life.

14

Enter the Governess

As soon as the plane carrying the wounded Beard landed at JFK in the afternoon of September 26, Dr. Feldman was on the phone with them. Knowing the urgency of the situation, he had assembled a medical team that included a pelvic surgeon and a trauma surgeon. They were all on standby, expecting Beard to be transported directly to St. Vincent's Hospital and for the operation to commence immediately. Tunney told him Beard had other ideas. He wanted to stop off at The Time Is Always Now and show his daughter, Zara, some artwork. Feldman couldn't believe it. He told Beard he was completely septic, and his life depended on a long and complicated operation as a matter of urgency. "Don't worry, Doc, we'll get there," said Beard.

The party did finally arrive at St. Vincent's in the late afternoon and Feldman found his patient surprisingly lucid. "Doc," said Beard. "I have a big show opening in Paris in just under six weeks and I'm walking into it." Feldman replied: "Peter, I don't know if you are going to make it through surgery . . . hopefully we'll get that far. But I'm not sure you're ever going to walk properly again, and it is highly unlikely you're even going to be at the opening in Paris in six weeks."[1]

Dr. Feldman and the team, which included the prominent orthopedic surgeon Stephen Sheskier, operated soon after he arrived that afternoon. Peter Tunney sat up all night waiting to hear how the operation had gone and Dr. Feldman duly called to tell him it had been a success. The operation had taken twelve hours; twenty-eight titanium screws had been inserted to stabi-

lize Beard's pelvis, his ruptured spleen had been repaired, and the potentially infectious wound in his thigh had been thoroughly disinfected. The good doctor also said that getting Beard to New York had just saved his life and that after a couple of weeks' recuperation in St. Vincent's he would be ready to start on the long road to recovery. He also revealed that Nairobi Hospital had faxed him asking for the return of the two stainless steel rods that had kept Beard's pelvis in place prior to the operation. "In New York if you tried to reuse those rods, you'd go to jail," he told Tunney.

At ten A.M. the following day Tunney drove down to St. Vincent's and entered Beard's ward to find his friend's bed empty. There was blood everywhere and the IV drip was standing beside the bed, so he assumed something had gone wrong and that Beard had been returned to the operating theater. Then the bathroom door swung open and there was Beard, holding on to the railing and gingerly, agonizingly, making his way back to his bed. "Fuck it, it's hard to walk after one of these operations," he said grimacing and dropped onto the bed. "But I'm not going to take a shit in one of these pans."

Soon after, Dr. Feldman arrived to be told by Tunney that his patient had just walked to the bathroom and back. "That's just not possible," he said. Beard confirmed it and Feldman asked if he would do it again. "Nope," said Beard, "that was a one-time performance."

Within days, Beard's private ward became a social gathering place and friends, girlfriends, and many passing acquaintances came by to see the stricken artist and to join in the party. Nobu delivered dinner. Beard also took to calling old girlfriends, inviting them to visit. One was Janice Dickinson, who he'd last seen ten years earlier and who was raising her children in California. "I got this call out of the blue," she said, "and it was Peter saying, 'JD, JD, you gotta get over here immediately. I just got gored by an elephant, there's drugs and everyone in the room is partying. You'll be the star of the party.'" Janice didn't take up the invitation. However, Nejma and the Beard family soon put a stop to the partying, rightly concerned about the recovery of the fragile patient.

It was while Beard was recovering at St. Vincent's that the November

issue of *Vanity Fair* hit the streets, containing a major feature on Beard written by one of the magazine's star profile writers, Leslie Bennetts. The wide-ranging article covered the various controversial aspects of Beard's life from his drug-taking, serial womanizing, and fiscal irresponsibility through to his recklessness with wild animals. However, the most startling and headline-grabbing part of the story repeated—for the first time publicly—Nejma's allegations that Beard had sexually molested their daughter, Zara.

Tunney, Riva, and Beard's close circle of friends were mortified that *Vanity Fair* had raised the issue without reporting that the allegations had been thrown out as groundless by the New York State Department of Social Services two years earlier. Equally disappointing to Beard's friends was Nejma's statement to Bennetts, denying that she was using the accusations for tactical advantage, and claiming that "when I felt my child was in danger, I had to do something about it." In the article, Beard repeated his cri de coeur, telling the writer that "what's really disgusting is the utilization of child molestation as a divorce technique" and then, almost in the same sentence, saying, "I love my wife. She's a totally good person. I think she got spoiled by America."[2]

The long-running and extremely bitter divorce process that had started some time in 1993 and had rumbled on through the following years until Nejma's dramatic intervention at JFK Airport had not only consumed the Beard entourage's attention but also cost a great deal of money. It wasn't long before Beard's attorney Leonard I. Spielberg was writing to his client, politely asking him to settle the $30,000 bill that had been run up during the protracted divorce proceedings.

The strained relations between the newly reinstated Mrs. Beard, Tunney, and Riva surfaced in the corridors of St. Vincent's Hospital. Nejma and Zara were visiting Beard just days after the *Vanity Fair* article had been circulated. Tunney asked Nejma if they could have a word outside the ward. As they stood in the hallway Tunney asked Nejma whether she really did think Beard had sexually molested his daughter. He said he wanted

to know because if that was the case, he said he did not want to represent Beard.

Nejma's response was terse and venomous. "You're a leech and a parasite," she spat. "Get out of here."

Tunney said those were the last words Nejma ever spoke to him, and that after that day he refused to deal with her again.

However, at that moment, Tunney had a great deal more to concern himself with than the Beards' marital dysfunction. The clock was ticking, and the Paris show was now just five weeks away with the principal player still recovering in the hospital, the work that had been promised still far from finished, and more than twenty thousand square feet of exhibition space to fill. There were probably five pieces out in Kenya being worked on by members of the Hog Ranch Art Department, who were hopefully adding their distinctive artwork to the photographs' borders. And Tunney did have some of the classic African wildlife prints and some large images of the diary pages, but he was agonizingly aware that there would be empty walls unless Beard somehow got to work. Tunney now had to tiptoe around the hostile Nejma and somehow hope that Beard's remarkable powers of recovery would allow him some time in The Time Is Always Now to handwork some pieces.

It was in St. Vincent's that Peter Riva first heard Beard declaring that the ever-present Nejma "will now be my Jacqueline, the Governess." It was a typically dramatic, theatrical statement and a reference of course to Picasso's second wife, Jacqueline Roque, who had taken control of the great master's "late Picasso" artistic output. So, Riva knew what to expect. The parallels were crystal clear. Jacqueline and Picasso were married in a secret ceremony in 1961 when the artist was eighty and she was thirty-five. After years of being a discardable mistress, marriage transformed her from victim to victor, and they remained together for the last years of his life. During that period, he produced a vast range of paintings that art historians regard as some of the finest artworks of the late twentieth century. He created more than four hundred drawings of Jacqueline, seventy portraits in one year alone and

many more than he had produced during any of his previous relationships including those most persistent muses Dora Maar and Françoise Gilot.

Unquestionably, Jacqueline played a vital role in this productivity by virtually isolating Picasso from the passing parade of tourists, admirers, acquaintances, dealers, celebrities, and general flotsam and jetsam that felt the need to touch the hem of his artist's smock. She had the keys to the gates of Notre Dame de Vie, their beautiful thirty-five-room mansion on a hillside above Mougins, and only a select few passed through. But it all came at a heavy emotional price.

She became an increasingly difficult woman and began telling Picasso lies about his children, claiming that they had no love for him and that their mother, Françoise Gilot, was constantly dripping poison in their ears. She also told Picasso that his fourteen-year-old son, Claude, was a drug addict, so both he and sister, Paloma, were promptly disinvited for the Easter holidays. Increasingly, Jacqueline began to refer to Picasso's paintings as their children, and as he worked more and more feverishly, in isolation, and he began calling Jacqueline "Maman." In 1963, Picasso saw his children for the last time, after which they were shut out by the Governess. Paloma later noted that she was refused access to her father for the last ten years of his life, "the person I loved most in the world."[3] Even worse, as Picasso was approaching death, his grandson Pablito tried to see him, arriving at the gates of Notre Dame de Vie on his motorcycle. He was turned away and when he tried to plead his case, the dogs were set on him.

Jacqueline barred his children, Paloma and Claude, and grandchildren, Pablito and Marina, from attending Picasso's funeral (Pablito took it so badly that he committed suicide by drinking a bottle of bleach) and then set about protecting his artistic estate with a ferocious intensity that offended his lifelong friends. Many of Picasso's biographers raised serious questions about her motives. According to Picasso biographer Arianna Huffington, "Picasso became the tool through which she could assert her will over the rest of the world, the means through which she could experience a sense of power that, even if her imagination had not been limited as it was, she would never have imagined possible."[4]

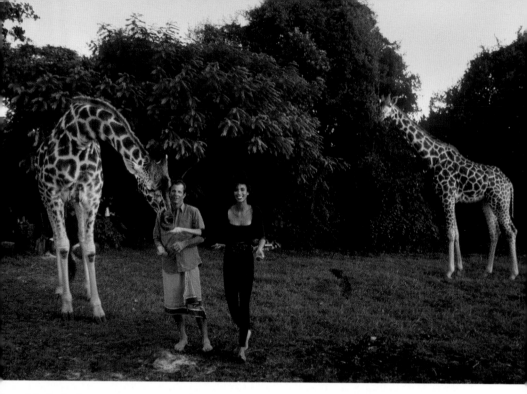

Night feeders: at Hog Ranch with the subjects of his most famous image—giraffes and Maureen Gallagher. *(Mark Greenberg)*

Creative clutter: Beard's studio at Hog Ranch. *(Hakan Ludwigson)*

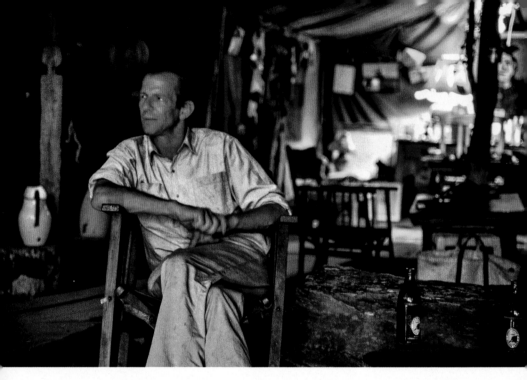

Into Africa: Hog Ranch was Beard's source of inspiration for four decades. *(Hakan Ludwigson)*

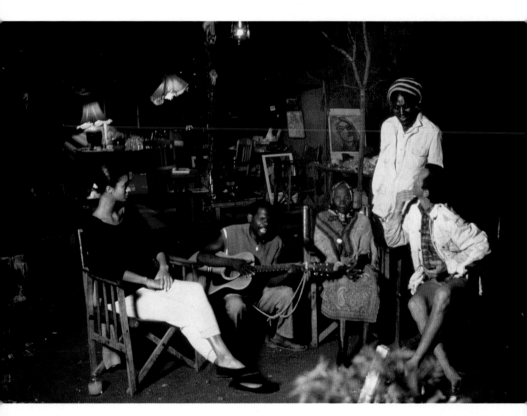

Hog Ranch regulars: (from left) Maureen Gallagher; blind Mburo; his mother, Wambui; and Mwangi with an animated Beard. *(Mark Greenberg)*

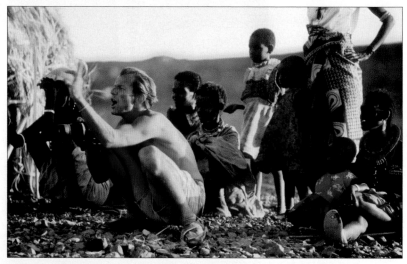

(Top) Camera ready: Beard with his muse, Maureen Gallagher, at Hog Ranch. *(Mark Greenberg)*

(Center) Turkana fashion: Beard's fashion shoots at Kenya's frontier location always attracted local interest. *(Mark Greenberg)*

Danish connection: Rikke Mortensen remained a trusted friend long after their relationship ended. *(Rikke Mortensen)*

(Top) Cassis creativity: with friends in his French Riviera retreat, including one of his mistresses, "Nina the Maid." *(Lis Kasper Bang)*

(Right) In the diary: Beard continued to revisit and work at Hog Ranch. Here with the London *Times* journalist Sam Kiley. *(Hakan Ludwigson)*

Objects of desire: the controversial art of the Masai artifacts. *(Mark Greenberg)*

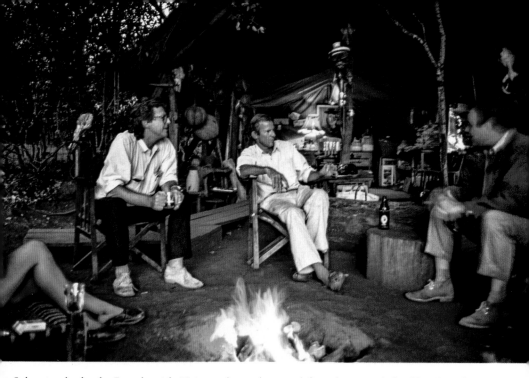

Salon in the bush: Beard, with Nejma, the author, and friends around the Hog Ranch campfire in 1992. *(Hakan Ludwigson)*

Blood pact: Beard and the model Cindy Crawford at London's Hoppen Gallery. *(Michael Hoppen)*

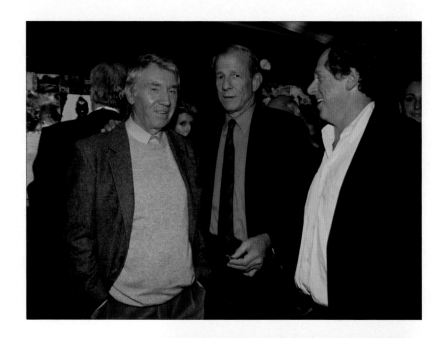

(Above) Photo call: Beard with the celebrated war photographer Don McCullin and London gallerist Michael Hoppen. *(Michael Hoppen)*

(Right) Art for art's sake: Gregory de la Haba, Natalie White, and Beard at the opening of the *Who Shot Natalie White?* exhibition in Soho, New York. *(Elise Gallant)*

Trusted friend: with Elizabeth Fekkai at his 70th birthday party at Cipriani Downtown. *(Ivory Serra)*

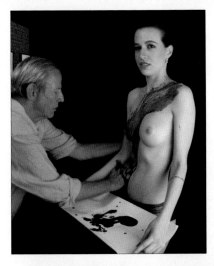

Shooting Natalie White: creating artwork with his latter-day muse and lover. *(Noel Arikian)*

(Below) Paying the bills: Natalie White in front of one of Beard's major artworks at Cipriani Downtown. *(Graham Boynton)*

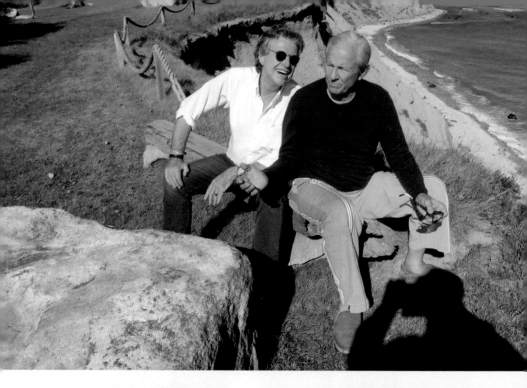

(Top) Long Island moment: author and subject on the Montauk cliffs in the fall of 2017. *(Graham Boynton)*

(Above) Determined hunter: Dave Schleifer, the retired fireman and bowhunter who found Beard's body in April 2020. *(Graham Boynton)*

(Right) Gang of four: Beard's old friends (from left) Tony Caramanico, Paul Forsman, Noel Arikian, and Gregory de la Haba gather at the Shagwong Tavern. *(Graham Boynton)*

The stress of such widespread opprobrium together with the pressure of dealing with the gigantic, messy, sprawling theater of fine art that Picasso's prolific output had created did not provide the unhappy Jacqueline with a contented life. In 1986, she put a gun to her head and committed suicide. However, there was a salutary lesson in all of this for the Beards. In the years following both Picasso's and Jacqueline's deaths, the name Picasso became a feeding ground for fakers, con artists, imposters, an industry of corruption, so much so that in 2016 he was reckoned by *Vanity Fair* magazine "to be the most reproduced, most widely exhibited, most faked, most stolen and most pirated artist in the world, one of the hottest commodities in a white-hot art market."[5] In her life Jacqueline had ensured, at any cost, a manic burst of creativity from the great man, and at the same time she had managed to keep a lid on the market. Once they were both gone, market forces, legal and illegal, just took over.

So, the weakened Peter Beard's choice in St. Vincent's Hospital that day of Jacqueline as a role model for Nejma to emulate was probably more a typically off-the-cuff, quixotic declaration without much forethought than a carefully thought-out strategy for the immediate future. It may also have been Beard deluding himself into thinking that he, like Picasso, would obey the rules laid down by the Governess; that he would isolate himself in the family artist's studio pouring out great work, occasionally taking a break for a cup of coffee or a glass of wine, and then retiring to bed at a civilized time so as to charge his batteries in preparation for the next day at the easel. The coming years would prove the folly of this hypothesis, mainly because the principal player in this sub-Shakespearean melodrama would refuse to abide by the constraints of the new deal and would continue to live life as he always had—wild, reckless, abandoned, drug-fueled, and priapic. Which, of course, would bring him into constant conflict with his newly anointed Governess.

On a more pragmatic and immediate level, Peter Beard was injured and vulnerable and as he lay in St. Vincent's Hospital in those early days of October, he did not know whether he would walk again. Clearly, in those moments when he confronted his mortality more profoundly than at any

other time in his life, he felt he needed somebody sensible, down-to-earth, and reliable to run his affairs. In addition to the Picasso/Governess references he began calling Nejma "the professional mother," and as Peter Riva listened to this new, oft-repeated catchphrase, he gradually realized that his days of managing Beard were beginning to run down. Not that he had ever been under any illusion that when the appropriate moment came, Peter Beard would drop him like a hotcake. Way back in the winter of 1991, when he first introduced Beard to Peter Tunney, he had warned him that Beard would not hesitate to cut him dead and walk away if it suited him. Loyalty was not, according to Riva, one of Beard's strong suits.

On October 11, Beard was formally discharged from St. Vincent's Hospital and although he had persuaded an old friend to pick him up from the reception area and take him to a local bar so they could discuss pressing matters of African elephant conversation, that friend was swept aside by Anson Beard, who said he was taking the black sheep back to the safety of a family home to recuperate properly. There was now less than a month to go before the opening of the Paris show and Beard's input was urgently required. Tunney did manage to move Beard to The Time Is Always Now for a couple of days and set him up in the basement on a mattress with all his materials around him. What had not changed during Beard's agonizing convalescence in the two hospitals was his obduracy. Where Tunney was hoping for at least a few hand-worked pieces, Beard concentrated all his efforts on creating the poster for the show, a four-by-eight-foot MRI scan of his head surrounded by hundreds of small, collaged images, including his IV bag and various medical tubes glued to the artwork. As with all his creations, he worked on it obsessively and produced an outstanding piece of work.

Tunney just shrugged his shoulders. "It wasn't in the show. And it didn't have to be done for the show," he said. "But in the end, as always, it was an amazing piece of Peter Beard art that would later be sold at auction." (It was later bought by the German collector Gert Elfering.) As for the pieces that were required to fill the exhibition hall walls, Beard told Tunney not to worry. "We'll do the rest in Paris," he said.

Two weeks later—just seven weeks after the elephant attack—Beard flew to Paris. He would occasionally be pushed around in a wheelchair but much of the time he hobbled around on crutches, working on pieces at the last minute and directing the assembly of this vitally important retrospective. Andrew Feldman said Beard had called him before his flight to Paris, inviting him to come with him to the exhibition. "I accepted right away," said Feldman, "but said, 'You are not walking into that, are you?' He said, 'Yes I am.' And he did. Nobody else I've met in my life could have done that after such an operation. He was remarkable."

Soon after Riva, Tunney, and Beard arrived at the Palais de Rothschild, the two oversized prints that the Hog Ranch Art Department had been working on were delivered by DHL. When the trio opened up the consignment, they were ecstatic. They and the show organizer, Robert Delpire, thought they were the best pictures in the show . . . unframed, dirty, organic, and authentically African, they were just what the exhibition needed.[6]

Despite the dramatic reentry of Nejma into Beard's life, he had asked Rikke Mortensen to fly to Paris to join him in the weeks running up to the show. Peter Riva picked up Rikke from Charles de Gaulle Airport and on the drive into the center of the city warned her that Nejma was now reestablishing herself at Beard's side and that she should begin to distance herself from him. She wasn't too concerned about the warning as she and Beard had been slowly drifting apart as lovers for some time and her life was now firmly focused on Copenhagen. However, like so many of Beard's paramours, she continued to hold great affection for him, and when he'd asked for her help in Paris, she did not hesitate. And while Nejma was clearly transitioning rather spectacularly from outcast and Beard divorcée to general manager of the Beard business, she was still obliged to accept the ongoing presence of the procession of mistresses and female friends and artistic collaborators that had driven her to the brink of divorce in the first place. There is no record of her reaction to Rikke arriving in Paris, but there is no doubt she knew this was happening and, as she had throughout the turbulent years of her marriage, she kept out of the way. Nejma was playing

the long game and as Peter Riva observed when he picked up Rikke from the airport, her time was coming.[7]

For the weeks leading up to the opening night on November 6, Beard worked hard on his prints, transforming them from impressive but straightforward black-and-white photographs into intense, original, dynamic works of art. The gallery provided him with a mattress, and he lay on the floor hand-working the prints, wielding tubes of glue, cuttings, and the paraphernalia of collage in a blur of artistic frenzy.

Tunney had known that they were required to fill twenty thousand square feet of exhibition space and as the opening day loomed, they went to work on various displays. A dead elephant room—Tunney called it the Dead Elephant Swimming Pool—compromising two floor panels of six-by-eight-foot aerial black-and-white images of dead elephants from *The End of the Game*, surrounded by two thousand small cutouts of dead elephants, each one meticulously glued down, all with plexiglass on top so people could walk across the carcasses of these endangered creatures. A twenty-foot-long display case in the middle of one of the rooms displayed a selection of Beard's voluminous splayed diaries. Given the events of the previous months and Beard's almost pathological procrastination, it was a miracle, but the massive retrospective at the Centre National de la Photographie did indeed open on time.[8]

The opening was attended by friends, acquaintances, and assorted celebrities from across the world. The Dinesens, Karen Blixen's descendants, came down from Copenhagen, Hog Ranch co-habitué Gillies Turle flew in from Nairobi, Peter Tunney's parents came from America as did Beard's older brother, Anson. Andrew Feldman and Stephen Sheskier, the two doctors who had operated on him at St. Vincent's, many celebrities including the rock star and photographer Bryan Adams and David Bowie and his wife, Iman, attended, as it seems did every model within a hundred-mile radius of Paris. When Anson arrived at the Palais de Rothschild, he complained that "they wanted me to pay to get in." Peter Beard responded with typical waspish wit: "They picked the wrong man."

For all the friends and celebrities in attendance at the opening, the per-

son whose presence seemingly most thrilled Beard was his daughter, Zara, now eight, who had arrived in Paris a few days earlier. He took her around the exhibition slowly and thoughtfully, explaining what it was all about. According to Tunney, it was a touching family moment "and that smart kid just got it." If ever the pair's warm relationship was clearly evident to outsiders it was in those days before the opening of the Paris exhibition. As Guillaume Bonn's film on Beard graphically preserves this moment in time, the two displayed a warm, affectionate bond, with Zara looking adoringly at her father as he hobbled around the Palais in some discomfort. He explained how the name Zara meant "yellow desert flower in Arabic" and how his "little dark-haired beauty is a born storyteller." After the little girl insisted that her wounded father take to a wheelchair, she spent the rest of the afternoon piloting him around the halls in said wheelchair. "My lovely wheelchair chauffeur" was how he described her.

It would be several weeks before Nejma arrived, discreetly after the disappearance of Rikke. The show ran until January 20 and, according to Tunney, it broke every attendance record.

* * *

If Beard's principal surgeon, Andrew Feldman, was astonished at his patient's remarkable recovery from what was very nearly a fatal elephant attack, Beard's friends were even more amazed. Just two months after being discharged from St. Vincent's, and having successfully navigated the Paris show, he was in contact with Rikke Mortensen, who had returned to Copenhagen, persuading her to come out to Kenya for one last safari. Over New Year's, together with their friend Sally Dudmesh, they spent two weeks in the bush in Kenya and, as Rikke said, "I knew it was our last proper time together." The role of ex-mistress was further confirmed a few months later when she visited Montauk with a Danish boyfriend named Hugo. Nejma had invited her out to Thunderbolt Ranch. She wanted to formally make peace with her. When Rikke arrived at the house, she was astonished to be greeted by Nejma wearing an item of clothing Rikke had

left behind when she lived there two summers ago. Nothing was said, but Rikke was left feeling distinctly uncomfortable.

Once back in New York, it seemed that Beard's appetite for African adventure had only intensified. The short Kenya safari had given him a taste. However, that had been a pleasant but unchallenging social occasion and he was clearly looking for something more authentic, something that would reconnect him with the Africa of his younger days. His old family friend Ralph Bousfield had whetted his appetite with stories of the Kalahari bushmen, the San people who had lived in the harsh and remote desert landscapes of what is now Botswana and Namibia. What intrigued Beard most about Bousfield's stories was the magic and mysticism associated with these nomadic hunter-gatherers who, even today, appear to be living as close to their traditional lives as the political authorities in these two countries allow. Beard also recognized that these were people who were slowly being subsumed by the modern world, lured into the towns and the cities by governments that wanted to monitor and control them. These governments were also trying to force them into farming and in Botswana, in particular, there were ongoing legal battles about their rights to roam the land freely.

This was a perfect mission for Beard, even if he was slightly weakened and wounded. With his friend Peter Tunney, together with a Discovery Channel television crew, Beard headed for the Kalahari Desert. Bousfield organized the logistics, and it was the kind of bare-bones safari that Beard had embraced in his early Kenya days in the 1960s, one that afforded the uncompromising connection with raw nature. This was safari basic, with mobile camps, short-drop toilets, rising at dawn, and long bush walks despite Beard's painful hips. They covered vast tracts of this empty desert landscape. On one occasion they'd driven out some thirty kilometers from their camp to look at the famous Dorsland baobab tree, reputedly the oldest tree in the world, when their vehicle broke down. Bousfield told the group that he would have to walk back to the camp to fetch a rescue vehicle, an unenviable mission under the fierce desert sun. He set off and then looked around to find Beard trekking right beside him, damaged

pelvis notwithstanding. That day they walked together for the entire thirty kilometers back to camp and Beard did not waver.[9] As Peter Tunney said when the duo arrived back seven hours later in the early evening with a flatbed truck: "You could never overestimate how tough Peter Beard is."

The raison d'être of the safari was, of course, to connect with the local San people, of whom there are fewer than 100,000. They survive across the six southern African countries where they are known as the First People, chiefly because they were here for centuries before the Bantu people migrated from the north and the European settlers arrived from across the oceans, both of whom came to dominate the region at the expense of the San. Beard had brought with him some of the controversial Maasai artifacts used by the East African *laibons* in the somewhat forlorn hope that these remote southern people would recognize them. They didn't. He was also hoping to engage the San in the mystical ceremonies that would feed into the Discovery Channel documentary filmmaker's central theme—the series was to be called *Medicine, Magic, and Healing*.

This latter part of the safari met with mixed success, not the least because the ever-resourceful Peter Tunney could perform magic tricks to a startlingly professional level and not only bewitched the San with his Western trickery but also saw through some of the sleights of hand employed by their medicine men. To cure Beard's post–elephant attack hip problem, for example, the San witch doctor cut three slits in each side of Beard's upper buttocks, then placed his mouth over the cuts and sucked and coughed. At the same time Tunney saw the witch doctor's sleight of hand as he reached under a nearby scrub and retrieved something, lifted his hand to his mouth, and then coughed up some tiny bone fragments. Needless to say, Beard's painful hips remained uncured. However, the local San were mightily impressed with Tunney's Western magic. He performed a couple of card tricks, a classic transfer of sponge balls from his hand to those of a woman in the audience, and a cut-and-restored-to-whole rope trick. The San were transfixed. "This had been the best audience I'd had in my life," said Tunney. "I woke up every morning and there would be twenty people sitting outside my tent waiting for more magic."[10]

Nevertheless, Beard and Tunney left the Kalahari and the company of the San people feeling quite reinvigorated and the trip reinforced Beard's life view that authenticity lay with man's closeness to nature. He told the filmmaker Lars Bruun that among the happiest days of his life were those spent in the vast emptiness of Lake Turkana back in the mid-1960s. "I got very relaxed in that existential emptiness," he said, "and I realized that less is more. The rest of my life has been congested, sensory saturated. Over dosed. Over filled."[11]

For a brief moment, this bare-bones safari in the Kalahari offered Beard a reminder of that existential emptiness.

15

The Artist as Exhibitionist

As much as The Time Is Always Now gallery was Peter Beard's creative springboard (his endless-partying artistic engine room on the US East Coast), so the Fahey/Klein Gallery in Los Angeles was performing an equally important function not only on the West Coast but outside the United States. By the late 1990s, Beard's Paris show had racheted up awareness of his work by several notches, and David Fahey had noted, with some satisfaction, that the prices of Beard's artwork were gathering momentum. Back in 1993, Sotheby's had sold two Peter Beard pieces, donated to the AIDS charity Friends In Deed, for $1,150 (a two-panel picture called *Kamante at Karen's House*) and $2,875 (a collage called *Eyelids of Morning*).[1] In 2010, *Fayel Tall at Lake Turkana* sold for £39,650 ($55,500) at Christie's in London and two years after that the *Orphan Cheetah Triptych 1968* sold for $662,000 at a Christie's auction in New York.

As always, Beard had arrived at the right place at the right time, although as his business partners and friends frequently observed, he had no interest at all in the commercial side of the market. The photographic art market had, in fact, grown organically since the early 1970s. There were a number of key players in the industry. One was Philippe Garner, whose passion for photographic images went back to the 1960s when, in his teenage years, he was snipping pictures from magazines in much the same way that Peter Beard was similarly cutting and pasting existing visual images to assemble his diaries. In 1964, he had bought the issue of *Queen* magazine that featured Beard's trip to Africa with the models

du jour Veruschka and Jill Kennington. "I was 16 and it had mesmerized me. That's the kind of teenager I was, and Peter Beard was there in my pantheon," Garner says.[2]

Garner had joined Sotheby's in November 1970 and was selling art nouveau / art deco the following year, with his first sale of photographs taking place in December 1971. The photographers featured in that first sale were essentially British nineteenth-century masters—Julia Margaret Cameron and William Henry Fox Talbot—and it would be some time before a market developed for twentieth-century photographic work. Photographs had been sold before as part of collections or one-off events, but this was Sotheby's taking the first step in what Garner describes as "an intended long-term strategy of selling photographs." After that it was a slow and steady progression toward selling photography of the twentieth century.

Photography's place among the arts has been questioned from its formative years in the middle of the nineteenth century, and there are still rumblings today, even though the market has long since left the critics behind. The argument back in the early days was that photography couldn't qualify as an art in its own right because it lacked "something beyond mere mechanism at the bottom of it" and that it "can never assume a higher rank than engraving."[3] It was, the critics chorused, no more than a useful tool for painters to record scenes that they would later recreate artistically with their brushes. One of the major turning points took place in New York at the turn of the twentieth century when a photo-secession movement (mirroring the art secession movement in Europe at the same time led by Gustav Klimt) was founded by Alfred Stieglitz with the active backing of Edward Steichen. The group held exhibitions, at the Little Galleries of the Photo-Secession on Fifth Avenue, of Modernist painters and sculptors alongside the works of photographers who were using a range of printing processes that required extensive handwork, resulting in one-off artworks.[4]

Almost a century later, this was precisely what Peter Beard was producing with his collaged, blood-spattered, inscribed individual pieces of work

that the art historian Drew Hammond says are unquestionably important and original pieces of art. Hammond compares Beard's modus operandi to that of the German photographer/artists Bernd and Hilla Becher who, for forty years, photographed the disappearing industrial architecture of Europe and North America. "Their best-known work *Water Towers 1972–2007* is a work of art and not merely illustration. It is a ready-made (a term coined by Marcel Duchamp to describe prefabricated, often mass-produced objects isolated from their intended use and elevated to the status of art by the artist choosing and designating them as such). Peter Beard invented a way of doing that too and it is not something that people writing about his art recognize."[5]

One who did recognize this was Philippe Garner, who by 2004 had joined Christie's, and with the two main markets—New York and London—developing in parallel, he became the international head of photographs and twentieth-century decorative art and design. Michael Hoppen says it was Philippe Garner who brought Beard to market: "It was quite a big thing for him to encourage Christie's to take Beard on. A lot of photo dealers were pissed off because they saw Peter as a jet-setter who had no real photographic talent." Around this time one of the key events was the first sale of works from the collection of Gert Elfering, a wealthy German who had become one of Europe's prime collectors of modern photographic art. (Elfering's collection became the subject of four highly successful dedicated auctions with Christie's.) The works were from a range of photographers who had previously been marginalized at auction because they were largely associated with fashion and related editorial photography, which the aesthetes of the art world regarded as far too superficial to be considered fine art. These included pieces by Irving Penn, Richard Avedon, Helmut Newton, Horst P. Horst, and Cecil Beaton. It also included some important pieces by Peter Beard.

Apart from the fashion photography slur, the overarching reason most of these photographers were marginalized as artists was that they were engaged in a commercial practice, hired and often retained by glossy magazines

such as *Vogue, Harper's Bazaar, Esquire,* and *GQ.* In other words, if you were a gun for hire, you did not have the integrity of the photographer equivalent of the starving artist working in a garret. "Many such photographers were naively dismissed as whore picture-makers, somehow compromised by the financial aspect of the transaction that enabled them to work," says Garner. "So, for example, Cindy Sherman found her own way of funding the construction of her pictures, but the integrity of the Avedons, Penns, Newtons and the like was questioned because they accepted Condé Nast's and Hearst's resources to fund their picture making. That *wasn't* well received in the art world."

Another key player in the market was Denise Bethel, who was with Sotheby's in New York for twenty-five years and ended up as chairperson of the photographs department there. Like Garner, Bethel was ambitious for the genre and helped push the price of photographs to new, undreamed-of heights, at the same time playing a significant role in photography's transition from camera-club collectibles to a legitimate category of fine art. She was the first auctioneer to break the million-dollar mark for any photograph at auction, classic or contemporary, when Edward Steichen's pictorial masterpiece *The Pond-Moonlight* sold for $2.93 million on Valentine's Day in 2006. By the time she left Sotheby's in 2015, Bethel had sold eight more classic photographs for more than a million dollars each.[6] Since then, photographs by Cindy Sherman, Richard Prince, Jeff Wall, and Andreas Gursky have been sold in contemporary art auctions for more than $3 million each, with Gursky's *Rhein II* selling for a record $4.3 million at Christie's in 2011.[7]

In the early 1990s, however, the idea of selling a photographic work for a million dollars was fanciful, and Bethel remembers well auctioning those two Beard pieces—*Kamante at Karen's House* and *Eyelids of Morning*—for just a few thousand dollars each. By contrast, Edward Weston's *Nautilus Shell*—one of the most famous photographs ever made and a benchmark of modernism in photographic art—had sold at Sotheby's in 1989 for $110,000, the first photograph to pass the $100,000 mark at auction. Seen as the glass ceiling for photographic art at that time, this price was sur-

passed in 2007 when the very same print came up at Sotheby's again and sold for more than a million dollars.

* * *

Given the emphasis of the photographic auction market back on more classic material, it was left to Beard's gallerists—initially Peter Tunney in New York, David Fahey in LA, and later Michael Hoppen in London and Kamel Mennour in Paris—to take Beard's art to market. And they did so in the most spectacular manner. After the La Hune exhibition in Paris in 1995, which had packed the surrounding streets with queues of eager visitors, each show became more extravagant, more a joyful, partying celebration than the usual sober, cerebral art exhibitions that were more common at the time. The Beard exhibitions became dramatic experiences with the introduction of foliage, stuffed animals, often thousands of pounds of stones from the beaches of Montauk, dancers, people in fancy dress, and models, models, models. At the center of it all was Beard himself, most often working on pieces of art in the middle of the show, photographing scantily clad women in front of the art-filled walls, or just holding court surrounded by of a scrum of admirers.

After the great success of the 1996 Paris show at the Centre National de la Photographie, Tunney brought the entire exhibition back to New York and reassembled it at The Time Is Always Now and opened it on April Fool's Day the following year. However, even more ambitious plans were afoot. Having agreed to mount a new show in Milan entitled *Oltre la Fine del Mundo* (*Beyond the End of the World*) at the end of the year, Tunney rented Andy Warhol's Church Estate in Montauk for the summer and Beard went to work creating new works on its expansive lawns. The Milan venue was the spectacular Sala delle Cariatidi (Room of the Caryatids) in the Royal Palace, where, in 1953, Picasso had first exhibited *Guernica*, and Tunney's plan was to create the biggest art exhibition ever held at that venue.

Tunney remembers that summer's work at Church Estate as among the most creative periods of the Beard/Tunney era. The Palazzo Reale was a

splendid palace but an extremely difficult location for an art exhibition. "You couldn't put a screw in the wall," he recalls. "It looked like a massive church and Peter said right away, 'We should use the diaries like stained glass windows.' It was a brilliant idea." He helped Beard create big diary collages through the summer at Church Estate and that autumn, once they had arrived at the palace, they placed them above a large collection of rocks they'd also flown out from Montauk. They also built eight-by-sixteen-foot platforms running more diary collages down each side, and at the end of the main room hung one of Beard's best-known images, an enormous—thirty-five by fifteen feet—photograph of a lion pride. For the opening night they brought in a forest of bamboo trees, turning one of the rooms into an African jungle at the end of which was another of Beard's gigantic images, a mounted picture of a huge bull elephant. The overall effect was sensational.

Further dramatic exhibitions were to follow. In 1998, the Fahey/Klein gallery mounted a *Fifty Years of Portraits* exhibition during Oscars week and Hollywood celebrities flocked to it. The following year, the *Stress and Density* exhibition was launched to great acclaim in Vienna at the Kunst-HausWien, and the same *Stress and Density* show later opened at the Museo Nacional de Ciencias Naturales in Madrid.

The 1990s were a particularly fruitful time for international Peter Beard exhibitions. There were seventeen in all, compared with just three in the 1980s and five in the 1970s. But commercial rewards in no way matched the costs of mounting each exhibition, and although Peter Beard neither knew nor cared about the economics of the business, his partners were painfully aware. The costs of running the international shows—with Beard's traveling circus gathering at every opening—were significant. Even the incidentals alone—the hospitality, the entertainment, the dinners—tended to leave the principals out of pocket. Once, in Vienna, Fahey, Beard, and entourage went to a performance of *Dance of the Vampires,* the Roman Polanski–directed musical, at the Raimund Theater. After the show the ever-ebullient Beard led a group of twenty friends to a restaurant and a typically lively dinner followed. When the bill for $4,000 arrived at the end of

the evening, Beard declared with typical magnanimity, "We'll get that bill," and proceeded to pull out of his back pocket a hundred-dollar note, all the money he had. Without flinching, Fahey paid.

Beard's indifference to financial matters went hand in hand with an apathetic approach to the value of his work. Quite often it was his gallerists and agents who appeared to be more attuned to the commercial value of his images. Michael Hoppen remembers once sitting around Ruschmeyers in Montauk, which was owned by Shagwong Tavern's Jimmy Hewitt and where Beard had an informal studio and thus was the location for much of his Montauk work. He was idly going through contact sheets when "I found an amazing picture of a giraffe sitting down. I had not seen it before, and I had been talking to Peter about looking beyond the group of images that formed the core of his work. I was right, as I later sold that photograph for a good sum to John Rocha, the fashion designer, and it's in his house in the South of France. But I don't think Peter ever made another print of that image." Hoppen also remembers finding what he thought was a wonderful image of a Turkana woman with a handbag and "the first time they printed that image up was for me. I found it in one of those contact books sitting on a sofa. These were photographs that were not part of *The End of the Game* or *Eyelids of Morning*."[8] Hoppen believes that in the Beard archive there are many more similarly valuable images to be unearthed.

The other invaluable assets in the Beard archive are the diaries many regard as his most important work. Some of the diaries have been displayed at the international exhibitions, and it is estimated that Nejma has some twenty to thirty Peter Beard diaries in a safe at Crozier Fine Arts storage in New York. Fifteen years ago, Bernard Sabrier, the wealthy Swiss collector, offered the Peter Beard Studio a million dollars for a diary and they turned him down.

* * *

In the midst of the international exhibitions, and the gallery shows at The Time Is Always Now, Fahey/Klein, and the Hoppen Gallery, Beard was

still accepting commissions, sometimes from magazines such as *Vogue,*
Elle, and *Esquire* and occasionally from advertising agencies. One such of-
fer came up in the late 1990s when Jeep paid Beard a $50,000 advance to
produce seven giant posters featuring their vehicles in a series of dramatic
American terrains. Beard duly arrived at Albuquerque Airport to meet the
art director Brian Stewart and start the monthlong shoot. Stewart, a long-
time admirer of Beard's work, had hired him because he liked "the artifice
of his photographs." He later said that he was intrigued by the "rock 'n' roll
aspect of the job." He added, "I hoped Peter would bring some mayhem to
the shoot. As an art director, you have to frighten the horses sometimes."
Even with this anarchic plan in mind, Stewart was surprised when he met
Beard at the airport. "He arrived without any cameras to shoot the ad,"
Stewart remembers. "He was wearing yellow wellies [Wellington boots]
and was disheveled. He looked like a bag man. He had almost no luggage
but did have a little bag with him that he treasured and claimed was vital
to the project. Throughout the trip he would be pulling things out of that
bag—glue, pencils, newspaper cuttings, whatever."[9]

The Jeep crew flew all over the United States, from New Mexico to
Utah, using Instamatic cameras and borrowed 35mm cameras, all the
time processing the rolls of film at drug stores and Fotomats just as tour-
ists would do. Beard even left some of the photography to Stewart and his
assistants while he sat in a Jeep doodling and imagining the large art pieces
he would eventually deliver. Stewart also remembered meeting a man in
Arizona off whom they had bought a white antelope skin and who was
fond of saying: "Well, I'll be a blue-nosed gopher." It was a phrase Beard
loved and would carry with him, and which, in coming years, he would
repeat ad infinitum, apropos nothing at all.

After a month on the road, Beard and Stewart returned to New York
and began working on the ten-foot-wide collages, adding bits and pieces
of found *objets*—Native American beadwork, snake skins, chips of rock,
and so on—at the Soho Grand Hotel. As with all of Beard's artwork, the
seven canvases exuded great energy and the postproduction work was as

energized as the shoot itself. "It was an extraordinary experience. Every photograph—that is essentially a mechanical thing—became something more with his art," says Brian Stewart.[10] All seven pieces have since disappeared.

* * *

In the years following the elephant attack, Beard was spending less time at Hog Ranch and was becoming somewhat disconnected with the political and social and sturm und drang of the Africa continent. When Beard had appeared on *Charlie Rose* in 1993, his host had asked him whether he was losing his love affair with Africa, and he had responded in a typically elliptical manner. While accepting that the continent, and his home away from home Kenya, were facing increasing problems, he'd said, "It's never too late. While there's life there's hope. All the clichés are true." Then, as he so often did, he'd slipped into one of his standard rants about population growth and the destruction of nature. "There's 8,300 square miles of forest eaten (referring to the elephant die-off in Tsavo) and we're raising money to buy drinks for elephants? What is ecology? It's a word used by frivolous people at cocktail parties." But, however accurate his observations, the message was the same one he'd been repeating for decades, and, to his exasperation, hardly anyone was listening anymore.[11]

Charlie Rose had made a good assumption. It was clear Beard was losing his connection with, if not affection for, the continent that had provided him with his emotional and creative base for the past five decades. Although his artwork continued to draw almost exclusively on the photographic work he had done over those decades, his friendships and creative relationships were becoming centered in New York. There was also the matter of his health. Although he was still a relatively fit sixty-year-old in 1998—celebrating with two big birthday parties, one in New York and one in Paris—the elephant attack had left him with severe hip pains and increasingly affected his mobility. His friend Dr. Feldman said

he had a remarkable constitution, comparing him before the attack to Paul Newman as a model of youthful flexibility, and noted that he had never complained about the pain he was clearly in. However, toward the end of the 1990s it became apparent that Beard no longer had eternal youth on his side and that probably did contribute to the curtailing of his African adventures.

He did, however, visit Hog Ranch in the spring of 1999 and was dramatically drawn back into the long-running controversies surrounding *The Art of the Maasai* artifacts. In the years following the publication of the book in 1992, Richard Leakey had maintained pressure on the Kenya Wildlife Service and the National Museums to disrupt what he saw as a cynical attempt to create a market in endangered animal parts, mainly rhino and elephant, thus encouraging poaching. In May 1999, Leakey ordered a raid on Hog Ranch. Seven armed KWS rangers, two Kenyan policemen, and two agents from the US Fish and Wildlife Service arrived in a convoy of vehicles led by two Kenyan policemen carrying search warrants.

They were disappointed to find that not only was Gillies Turle, the main protagonist in *The Art of the Maasai* controversy, not on the property but he wasn't even in the country. He had, for the past two months, been visiting an ashram in India, working with a charity he supported. Their other target, Peter Beard, was at the ranch with his gallerist Peter Tunney and they appeared to rather enjoy the drama of the moment, with Beard photographing the heavily armed officers tramping in and out of the tents. While the officers' backs were turned, Beard managed to instruct one staff member to carry a suitcase full of Maasai artifacts that had been tucked under his bed down to his friend Tonio Trzebinski's property at the bottom of Hog Ranch. A young KWS *ascari* armed with an automatic rifle then herded Beard and Tunney into one of the main tents and kept close watch on them while his colleagues scoured the property in search of contraband artifacts. And then, to Tunney's amazement, Peter Beard fell asleep and started snoring. "I couldn't believe it," Tunney said. "Here we

were being detained at gunpoint and Beard is so disinterested that he falls asleep. By the time he woke up, they had all left. I'll never forget that."

Leakey never hid his view that the Maasai art collection was a "massive fraud" perpetrated by Peter Beard. "Very clever—that's Peter Beard," Leakey said at the time. "I'm certain he's the author of the scam."[12] Leakey said that tests had been made on some of the artifacts and there was evidence of potassium permanganate—often used by forgers to artificially age such objects—on some of them.

Although the agents found nothing substantially incriminating at Hog Ranch that day, they did gain access to Turle's filing cabinet, and in it they discovered a receipt for a storage locker at Express Transport in Nairobi's industrial area in the name of Elrut Seillig, Gillies Turle's name in reverse. It was the stash they had been looking for—eighteen trunks containing more than 2,600 items that could be broadly described as Maasai artifacts. By the time Turle arrived back from India, and was arrested soon after, Beard had left the country. (The farcical nature of the entire investigation was made clear when Turle claimed that he had been placed on the FBI's top ten most wanted criminals list while he had been meditating at his ashram.)

It seems that Kenya's officials, led by Richard Leakey, were determined to prove at all costs that Beard and Turle were using *The Art of the Maasai* book as a cover for an ivory and rhino horn smuggling operation that also engaged poachers in its web of criminality. In an extensive report by the American journalist and author Susan Zakin, published after a decade of research into the subject, the point was made that "for anyone who knew them the idea that Beard and Turle were running a poaching operation was laughable. Not only were both men passionate about wildlife, but they were also terrible businessmen."[13]

Nevertheless, at the behest of the Kenyans, US Fish and Wildlife agents questioned officials at the American Museum of Natural History after the curator had expressed interest in the artifacts, and, as Zakin reported, in Chicago agents descended on the PBS filmmaker Bill Kurtis, who had

brought back a single rhino horn *rungu* from Tanzania, which they duly confiscated.

After some wrangling over Turle's bail bond—eventually a friend's battered old Peugeot 504 was presented as collateral—trial dates were set. Turle stood charged with dealing in prohibited game-animal artifacts, including thirty-four kilos (seventy-five pounds) of ivory, ten kilos (twenty-two pounds) of rhino horn, and fifty kilos (one hundred ten pounds) of other game trophies.[14] KWS put forward the government's most senior prosecutor to lead the charge and Turle was defended by Stephen Mwenesi, a confident gravel-voiced lawyer who was well known as a Shakespearian actor in Nairobi Amateur Theatre productions. Beard was now far away from the storm, but he did send Turle $5,000 toward his legal fees, a small but gratefully received contribution.

The court cases ran for three years. Mwenesi made forty-one court appearances and during the process the charges were changed, seemingly at random, from the weight of the trophies to the number of the trophies, and on various charge sheets, those numbers differed. Finally, in 2001, one of Leakey's KWS officials told Mwenesi that two of the state's witnesses had been sent to the United States for further training and as they were no longer available to testify, they were therefore postponing the case, seemingly indefinitely.

The massive stockpile that was Turle's eighteen trunks of Maasai artifacts, supposedly in the care of the Kenya Wildlife Service and National Museum of Kenya, has since gone missing. According to Turle, "Somebody traced the boxes down to the National Museum and found those boxes all smashed and a lot of fine, delicate pieces ruined." In the years after the court case was postponed, Margot Kiser continued her investigations of what she called "the fraud and smuggling syndicate" that she believed Turle and Beard were operating. The two wives of the principals—Turle's partner Fiammetta Monicelli and Nejma—continued to believe that their spouses had been conned by unscrupulous tribal souvenir manufacturers. So much so that Turle said he had heard that Nejma had tried to have the photograph of the *laibon* Taiyanna, posing with his father's rhino

horn *rungu,* removed from the pages of *Zara's Tales,* Beard's so-called children's book dedicated to his daughter that was to be published in 2004.[15] Equally, many of their loyal friends thought it had all been a collective con job.

It remains one of African art's unsolved mysteries.

On Sleeping Eyelids Laid

As the decade began to draw to a close, the now practiced triumvirate of Beard, Tunney, and Fahey produced two outstanding collections of Beard's works to accompany international exhibitions that were very well attended and widely talked about, and which contributed greatly to Beard's growing status as a photographic artist. In 1999, *Fifty Years of Portraits* was published and on January 16, 2000, the American edition of *Stress and Density* followed. The first was arguably Beard's most complete work since *The End of the Game*. Not only did it have a chronological logic to it, following Beard from a young shutterbug—the famous first photograph of his dog Charcoal straining at a window—to celebrity photographer/artist/collagist, but it also mixed up familiar pieces with lesser-known images, like the one taken of the preppy, tie-wearing young Beard in 1972 when he had managed to wangle a visit to the gas chamber at San Quentin State Prison.

Fifty Years of Portraits also benefitted from an erudite appreciation of Beard's life and art by his friend, the writer Anthony Haden-Guest. He said that Beard's ability to lead multiple lives at once, as with the ability to entertain a number of contradictory ideas at the same time, may be a mark of true talent. It was this, said Haden-Guest, that had led to a remarkable "uncareer," a catalog of creative accidents that had left behind a trail of great works. "Beard seems self-referential to the point of solipsism and disinclined to introspection," wrote Haden-Guest, "a paradox made possible by a strategy of propulsive anarchy, somehow kept under stringent controls

(which is a pretty good MO, if you have the stamina for it)."[1] *Fifty Years of Portraits* was the last work of consequence that Beard and Tunney collaborated on. It had taken some months to assemble the material from Beard's peripatetic life but, according to Tunney, the final edit when they put it all together took forty hours of intense work in the basement of The Time Is Always Now. Tunney was doing page-by-page edits with Beard looking over his shoulder, changing everything as was his wont. It was an intense session, but it produced one of the best books of Beard's work, perhaps the best since *The End of the Game*.

The collection *Stress and Density*, more a catalog than a book, was assembled in the same year to accompany the show of the same name at Vienna's KunstHausWien, Beard's first exhibition in Austria. It returned to core Beard themes—human overpopulation in a world where a million people were being born every four days and where millions of people were starving to death every year. The slivers of text accompanying a collection of Beard's more disturbing works reflected his darker, more misanthropic thoughts. "There is no more time to play, there is no more space to play," the text ran. "The game has come to an end, the wildlife is domesticated, out of and surrounded by national parks and it is doomed to human influence, human pressure, human manipulation, human horror. We're living in a disintegrating world . . ." There are also bleak reflections on marriage: "It's very unnatural. It's masochism and torture, the way it has been organized." He writes vividly about photography, which he describes as "such a retard profession, and the people in it are such parasites on technology." Hardly Beard at his most pleasantly pixilated.[2]

As compelling as these two collaborations were, they signaled the first signs of the end of The Time Is Always Now. The party had been chaotic and anarchic and at the same time extremely productive for the better part of a decade, but after the elephant attack, when Nejma and Tunney had that coruscating exchange in the corridor at St. Vincent's Hospital, there was a fin de siècle feeling around Broome Street. Equally, the third wheel in the Peter triumvirate—Riva—was being inexorably separated from the Beard artistic empire. Riva says he had little direct contact with Beard in

the years after the elephant attack even though he was still notionally his agent. "Between 1997 and 1999 I didn't want to talk to Beard, and he didn't want to talk to me," said Riva. "And then lawyers' letters started being exchanged. I was trying to get back money Beard owed me to pay off his bills. He still owed me $40,000."[3] Riva and Peter Tunney then did a deal whereby five Beard artworks from The Time Is Always Now were handed over to settle the outstanding bill, but Riva warned Tunney that he was on his way out "and once they had got rid of me, they would get rid of him." In March 2000, Riva's lawyer Dean Nicyper wrote to Beard's lawyer, Michael Stout, agreeing to final severance terms and the near twenty-year relationship finally ended.[4]

Although Tunney took Riva's warning seriously, even at this eleventh hour, he and Beard did talk briefly about striking out on their own, beyond the influence of Beard's newly entrenched Governess. However, Tunney says it was a one-off conversation and was never discussed again.[5]

In 2000, Beard was commissioned by *Audubon* magazine to do a story on wildlife diversity in Bhutan, the Himalayan kingdom wedged between China and India that measures its wealth in Gross National Happiness. Beard was also to get an audience with King Jigme Singye, the country's ruler, and do a portrait. Apart from a few yaks, the pair saw little wildlife. "Not a bird in the sky, not a snow leopard in the mountains," according to Tunney. They stayed in monasteries that they quickly discovered were surrounded by vast fields of marijuana. They had been warned when they arrived that smoking marijuana was strictly forbidden, although after several days Tunney succumbed, rolling a joint using toilet paper. When their guide arrived the following day and told them that, in fact, people did smoke weed despite the law, the pair's joy was complete "when we threw open our window shutters and looked out at a field of marijuana that went to the horizon, thousands of acres. We were living in it. We were like Cheech and Chong. It had taken us ten days to find out it was OK."

To help pay for the trip, Tunney had agreed to write a feature on playing golf in Bhutan. He duly turned up to play at the Royal Thimphu Golf Club on the day of the Bhutan National Open was being played and after

watching the tournament, Tunney, a scratch golfer, went a round in eight strokes below the tournament winner.[6]

The pair spent three weeks in Bhutan, a sybaritic break from the stress and density that was swirling around their New York lives. Although Tunney didn't know it, plans were already afoot to create the Peter Beard Studio, clearly intended to become the archive and marketing engine room for Beard's artworks and, equally clearly, with Nejma in charge. It was obvious that this was all being done with Beard's knowledge and approval.

By the summer of 2001, Beard was back in Montauk, and despite the turmoil going on in his business life, he seemed very relaxed. It was out there he met up with Gregory de la Haba.

De la Haba was a Harvard-educated fine arts graduate who, in his early twenties, had been commissioned by Matty Maher, the owner of McSorley's Old Ale House, the oldest and most distinguished Irish bar in New York, to do a portrait of his daughter, Teresa. She was a brooding Irish beauty who was then working behind the bar, learning how to run the business. He duly delivered the portrait and ended up dating and then marrying Teresa. Of Irish and Spanish descent, and a big man with a mane of red hair, de la Haba befriended John Tunney, brother of Peter Tunney, soon after he was married, and thus met Beard and started hanging out at The Time Is Always Now. "I must have gone there at least a dozen times," he said. "And just embraced all the masculine bravado energy Peter Beard exuded while he was working. I'd previously seen photography as a poor man's version of fine art but then I watched Beard creating a unique visual vernacular in the same way that [Mark] Rothko and [Jackson] Pollock had. It was an important lesson for me."

Those nights at The Time Is Always Now stirred in the young classical artist a need to reexamine his own work and de la Haba told his wife he needed to spend a summer in Montauk, a part of the country that had been his spiritual home as a boy. In 2001, he rented a room, and every morning he would go out onto the dunes and capture the erosion of the peninsula in charcoal sketches and chiaroscuro paintings that would sell the moment he finished them. Erosion, decay, death—these were themes

he had already picked up from his brief meetings with Beard and his hours at The Time Is Always Now.

Toward the end of that summer de la Haba was in the Shagwong Tavern when Beard arrived with their mutual friend Noel Arikian. The three spent a pleasant evening talking about art and then Beard invited Gregory back to Thunderbolt Ranch. "Come over tomorrow afternoon and bring your work," Beard said.

On his way to Beard's the next afternoon, de la Haba stopped off at White's Liquor Store in Montauk Village for a bottle of Ketel One vodka, knowing it was a Beard favorite, and arrived at Thunderbolt Ranch to find a Ralph Lauren photoshoot taking place. Armed with Clamato juice, the bottle of Ketel One, and a spliff, he and Beard headed for the cliffs, where they sat on a log and started talking about art. At one point, Beard opened the box of Gregory's drawings and after studying each one threw them onto the damp grass, as if he were dealing a deck of cards. "My precious drawings!" Gregory said. "And he had ink on his hands, so he was getting that on the work. Then he looks at me intently and says: 'Gregory, pretty art school stuff, don't you think?'" De la Haba felt deflated but deep down knew Beard was right. With all the learned skills he had, he didn't have an artistic vision. Then Beard said: "Gregory, yours is a slow maturity. But that's the best kind." They sat out on the log looking out at the Atlantic and watching the sun set. "It was the day that changed my life as an artist," says de la Haba.[7]

This generosity—sharing his artistic passions with young unformed artists—was a feature of Beard's life, from his early days in Kenya through to his autumn years in Montauk. Mandy Ruben says as a young girl in the 1970s, she would spend days painting and drawing alongside Beard, sprawled on the floor at Hog Ranch in a sea of papers and paints and assorted detritus, listening to Bob Dylan's *Blonde on Blonde* album. "He referred to his diaries as time capsule collages of his life and for me it was such a privilege to share those creative moments with him," she says. Beard was similarly collaborative with his Black staffers at the Hog Ranch Art Department who had learned everything they knew about art from

working with him. In fact, Beard always saw his artistic expression as a collaborative adventure and his vast knowledge of fine art was something he gleefully invested in friends, acquaintances, and even passing strangers.

* * *

De la Haba returned to New York at the end of August, confident he had found his artistic voice and thanked Beard for his unsentimental, unadorned critique setting him on the right track. He was to have a serious falling out with the Beard family more than a decade later, but nothing would diminish the value of that Montauk afternoon and de la Haba still speaks only in reverential terms of Peter Beard, the artist and major influencer.

Within weeks of de la Haba arriving back in the city, on that bright morning of September 11, 2001, he and Teresa watched from their home in Queens as the World Trade Center's Twin Towers came down. Then the following day, September 12, Nejma Beard served Peter Tunney with legal papers severing his relationship with her husband. Tunney's attorney Gerald Lefcourt told him that "these people" were not his friends and that they would "spit you out like a bad piece of meat." Tunney was mortified. "I told my lawyer that in nine years of blood and sweat, I've never taken any money myself, and look what I've done for Peter." He was also somewhat bemused at the timing of Nejma's legal action "the day after 9/11. It didn't seem right."

He admitted they had partied too hard, which meant they had both taken huge quantities of drugs. Although deeply hurt by the insults heaped on him by Nejma and the seeming indifference of his friend Beard, Tunney did express relief that the wild ride was over. In the end, he felt that Nejma's rejection may have saved his life. Within six months, he had gone into rehab. "Peter Riva warned me when I first met Beard that 'as long as you know up front that you're going to get stabbed in the back later, you'll be OK.' So, I was warned but it didn't lessen the blow. I reeled from that for a long time," Tunney said. "I'll tell you what I think about Peter Beard.

I'm so fucking happy for every day he had. What a goddam journey that was."

Beard soldiered on and, despite his wife's increasingly vigorous attempts to cut him off from the bad influences he enthusiastically drew around him, he clearly decided he had a lot of partying left in him. As his friends and colleagues had observed over time, the creative chaos he needed to produce his best art required the company of the very party people Nejma was trying to ban. That was the lifeblood that ran through both Hog Ranch and The Time Is Always Now in their heyday, and that was what he would seek out in the coming decade.

Since the elephant attack, he had barely been back to Hog Ranch and his links with Africa were beginning to fade. He was working on his last original African book—*Zara's Tales: Perilous Escapades in Equatorial Africa*. The publisher Alfred Knopf had paid him an advance of $15,000 at the end of 1992 but it would have to wait ten years for the manuscript to arrive. Although it was billed as a book for children and dedicated to his daughter, it read like an extension of *The End of the Game*, a narrative that reflected on his adventures in precolonial Kenya. The book contained a familiar cast of characters—Galo-Galo, his trusty Waliangulu guide; Ken Randall, the gnarled South African rhino catcher; the man-eaters of Tsavo, crocodile hunting in Lake Turkana—and, most predictably, it included photographs of Kamante and quotes from Karen Blixen.

For those who had never heard of Peter Beard, the book was an attractively packaged rehash of the old stories but as a literary work, it received short shrift from the critics. *The New York Times*'s Rob Nixon was particularly harsh, writing that "whenever Beard comes within stalking distance of drama his writing gets the shakes. He waves his arms and raises his voice, corralling italics, capital letters and exclamation marks to announce the fact that we're approaching an outsize experience," making an adult reader "feel bullied and patronized rather than seduced."

Despite his now lengthy absence from Kenya, he remained in touch with friends in Nairobi and toward the end of 2001 another scandal involving them emerged. Tonio Trzebinski, a good friend of Beard's and an in-

creasingly respected artist who was beginning to exhibit in Europe and the United States, was found shot dead in the driveway of his lover, the glamorous white huntress Natasha Illum Berg. Soon after, the British author James Fox, who had made his name with the nonfiction bestseller *White Mischief,* a lurid tale of the former colony's wild amoral times between the world wars, wrote a feature for *Vanity Fair* on Trzebinski's murder.

Several of the old Hog Ranch gang—including Julian Ozanne and Aidan Hartley—were named as active members of the artist's party set. While Beard was clearly upset with the loss of a good friend, one of the Hog Ranch hedonistic coalition, it also bore out some of his dark forebodings about the future of Kenya, indeed Africa. His long-term predictions about population explosion had been borne out. The growth of Nairobi, its suburban tentacles reaching toward Hog Ranch and doubtless soon to engulf it, replacing the jungle camp of his young days with the concrete jungle of modern Africa, had also appalled him. He saw it all as one calamity after another, modern man repeating the mistakes across the world that he had committed with such indifference in Africa. "The old Africa," he told the filmmaker Lars Bruun, "as a metaphor of the biggest thing in our lives—nature. And we are basically destroyers of nature and we're going to destroy ourselves in the bargain. That's how smart we are. We've done it in Starvo. And we'll do it in China, and in the Middle East and everywhere. Because we have not learned to be civilized."[8]

At the end of 2001, Tunney was left sitting in his empty gallery staring at the blank walls and seriously contemplating committing suicide. "One of my staff did try to kill herself because she couldn't believe what Peter had done to us," he said. "It was a very dark time."

* * *

On January 15, 2002, Peter Tunney arrived in court with two binders— some 450 pages each—that recorded all the sales from The Time Is Always Now. Despite the fact that Justice Gerard Rosenberg had ruled in Tunney's

favor, that the Beards were not entitled to enter The Time Is Always Now and take what they thought was their property, the trial judge ruled otherwise. Tunney was appalled. When he tried to argue his case with the judge, he was ejected from the court. He walked back to his gallery in pouring rain, thoroughly dejected, and when he arrived he was presented with eviction papers from his landlord. Worse was to come. At the end of the day his long-term girlfriend, Janique Svedberg, who he called Golden Girl, arrived at The Time is Always Now and told Tunney she was leaving him.

The following day, with Tunney absent, the sheriff arrived with the Beards' removers and basically emptied the gallery. One of his staff filmed the removal. Armed with this evidence, Tunney went back to court arguing that the Beards had taken a large amount of his personal possessions. The judge ruled that the entire consignment would now be deposited in the sheriff's storage facility and the parties would go through it, item by item, and determine who owned what. Eventually, Tunney told the Beards' attorney, Michael Stout, that he was tired of the legal wrangling. Stout, ironically, was a friend of Tunney's, whom he had introduced to Peter Beard. "I was free. We signed an agreement that I would never deal in Peter Beard art again," said Tunney.

Although Tunney continued to protest that not only did he not steal any of Beard's money, after the court order closing down the partnership, but he ended up stuck with a pile of Beard's unpaid bills and found himself $800,000 in debt. He estimated that in the previous few years it had cost $200,000 a month to run the Peter Beard operation. At times the constantly impecunious Beard would ask Tunney for $50,000 and Tunney would duly hand over wads of notes. "I gave Beard everything I had . . . my energy, my contacts, my clients, money, gallery, and everything. Peter was welcome to it all. He had a great career," said Tunney. "And then I got rolled. Demonized. Accused."[9]

How could he forgive Nejma, who clearly loathed him? "I more than forgive her," Tunney later said. "I love her. I love Zara and I wish them the best. I think that Nejma has had such a handful of trouble and such a wild life with Peter Beard."

* * *

In late fall 2004, Beard met yet another attractive young woman. She would end up having a yearlong affair with him, but unlike his other lovers who invariably retained abiding affection years after their love affairs had ended, she says she emerged physically bruised and psychologically damaged. Although she has provided a significant amount of corroborated evidence to support her claims of physical and emotional abuse, she has insisted on not being identified, so for the purposes of this narrative we shall call her Nancy C. Beard met her at a book party and made a play for her in what she later described as "the most unrestrained, shocking way. I was completely unformed—young, impressionable, cocky, insecure, the perfect recipe for this overpowering lunatic. He disrupted the rhythm of normal life." Beard was sixty-six, she was twenty-one and had just graduated from college, and in a ritual that has been described by many of his former lovers, Beard "zoned in" on Nancy C and everything else that was happening at the book party melted into the background.

Over the following weeks, according to Nancy C, Beard pursued her relentlessly. She said he was "obsessive-compulsive in the chase and called at every hour—he was into Leonard Cohen at the time, and he'd call leaving long phone messages with Cohen songs playing loudly in the background." He flattered her from the outset, telling her he loved her enthusiasm "and he kept repeating that he loved it that I was not a man-hater. He said: 'There is nothing uglier than a man-hater; promise me you'll never turn into a man-hater.'"

As a couple, they started circulating through Beard's well-trodden restaurants, where he had a tab, and nightclubs, where he was welcomed as a celebrity guest. As always, he never had any money or credit cards on him, and the twenty-one-year-old recent graduate paid for all the cab rides. But she readily admits she was taken by his colorful life and his literary connections: "I was so impressed he had been friendly with Truman Capote. I adored Capote," she says. At the same time, she found Beard oddly childlike and was quick to see the futility in his constant nightclubbing, insisting that

there were better environments to debate the merits of Hannah Arendt's philosophical treatises than Bungalow 8. She also began to tire of Beard's constant repetition of favorite aphorisms. "Familiarity breeds contempt," referring to his marriage, was one and, "Lilies that fester smell far worse than weeds," as per Shakespeare's doomed Sonnet 94, was another.

However, as the love affair developed, according to Nancy C, so did the violence. "He was very sexually violent, and it was never with any kind of discussion," she says. "It just happened. And it was repeated. On one occasion I said to him, 'Look what you've done to me, look at the marks.' His response was: 'Don't cut your hair, promise you won't cut your hair. It's a mistake if women cut their hair too short.' He just changed the topic."

"Bloodied and bruised," Nancy C says that on one occasion, "I needed to go on antibiotics from human bites and the doctor who was treating me urged me to press charges. In my way I was in love with him, and in another way, I was horrified. I thought I could deal with it."

Beard's response was also somewhat baffling, according to Nancy C. "The next day he would sometimes say, 'That was quite a night' and sometimes he would say, 'You're such a good sport,' which was very creepy to me. Like something from *The Great Gatsby*. He's also used old-school patrician terms like 'fresh as the driven snow,' always referring to my innocence, never about him corrupting me."

Her story has been corroborated by two witnesses, her sister and her friend with whom she shared an apartment at the time. Her roommate says she witnessed Nancy C arriving home from a night out with Beard "and I saw blood and wounds she'd had inflicted on her body. The sight will stay with me forever. She was in a state of shock and discomfort; she didn't know what to do as she was also in awe of him in a way that I couldn't understand at the time." Nancy C's sister flew into New York to support her and says she was angry and upset to see her sister in such a state. "I phoned Peter and told him I had seen what he had done to my sister," she said. "And that he had to promise me he would stay away from her and would leave her alone. I still remember the sound of him cackling gleefully at me over

the phone. He knew exactly what he had done, and he wanted me to know that he wasn't the least bit sorry."

Nancy C also claimed there were more women like herself who had been attacked by Beard although this has been hard to confirm.

When confronted with these allegations of careless violence, Beard's previous mistresses and long-term female friends expressed astonishment bordering on disbelief. Marella Oppenheim, who was about to open her *Remembering Peter Beard* photographic exhibition in Arles, said: "He wasn't that kind of person. He didn't have violent tendencies in sex . . . he was a lover not a fucker. It's impossible." Rikke Mortensen said: "At no stage in our relationship was he ever violent with me. Never. He was always gentle. I just don't believe it." And Maureen Gallagher, whose relationship with Beard spanned more than twenty years, said that "If I had a tiff with him, then went to the bathroom, when I came out, he would be gone. And I wouldn't see him again for five days. He hated confrontation. This is not the Peter Beard I knew. I don't believe it for five seconds."

However outraged these women were, the accusations were difficult to ignore, because of two particularly violent incidents in his past, one unspeakable and one shocking. Having punched a pregnant Cheryl Tiegs in her stomach causing her to miscarry, Beard appeared to show remorse—both of them lying on a bed and crying at what they appear to agree was a never-to-be-repeated moment of rage. But later Cheryl, knowing that he was capable of this violence, showed trepidation borne out of "real fear" the night at Thunderbolt Ranch that she told Beard that she wanted a divorce. There was also the matter of Richard Avedon's cat. As much as he loved wild animals, Beard was impatient with, and had little sympathy for, domestic pets, and when Avedon's cat strayed onto Thunderbolt Ranch, Beard beat it to death with a rock. This happened in the mid-1990s and Rikke Mortensen witnessed the killing. She says that when Avedon's "people" came looking for the animal, Beard denied ever seeing it. "I was shocked. And I hate telling that story," she says.[10]

The point about Beard is that the darkness was never far away. Whatever

clinical psychological ailment afflicted him—whether he was bipolar, or schizophrenic as some said, or sociopathic as others claimed—it lay dormant in him for most of his life, occasionally manifesting itself in deep depression and withdrawal and at other times in sudden outbursts of violent behavior. Back in the early 1970s, Mirella Ricciardi remembers Beard taking to his camp bed at Hog Ranch "for days, it might have been weeks. He was unable to function—he was wounded and lost. I just hovered at a discreet distance. There was nothing anyone could do for him. Deep down in his soul there was a darkness."

Beard told Nancy C that a few years before they met he had had arsenic poisoning and that it had gone to his brain. "He told me he was as mad as a hatter. And he went on about it," she said. This may have been an obtuse attempt to explain his wayward behavior but given that he was a notorious mythmaker, it is equally possible that the explanation was simply a lie. With Peter Beard, nothing was entirely clear.

Eventually, after almost a year in what was a torrid relationship, Nancy C decided to leave Beard and New York and start a new life in a different city. "He was very sad when I left," she says. "He'd leave telephone messages, weeping in some and saying: 'I've obviously done something to upset you.'" She said to this day she is profoundly affected by her violent time with Peter Beard. "He was truly sadistic and the thing about his art—the blood is there, the girls are there, the animals are there. It's all there. I thought I could deal with it. I was in over my head," she said. "It took me years to make sense of it."

* * *

Beard did not discuss Nancy C with anyone, not her presence in his life for almost a year, nor her sudden flight. As with so many of the traumatic events that swirled around him over the years, he merely put it behind him and moved on without outward regret or introspection. Instead, on January 22, 2005, he celebrated his sixty-seventh birthday with a party at one of his favorite Manhattan haunts, Cipriani Downtown. Evidence of the long-

term relationship with the restaurant and its owners remains on the walls today—enormous, intricate, dynamic collage works that represent some of his most intense artistic performances. They had been issued to Cipriani as accounts settled, covering years of food and drink that always appeared, as if by magic, at his table. Clearly in the back of house someone was keeping a tab of the meals served and the bottles of Moet & Chandon opened. The same went for the two restaurants around the Beards' Fifty-seventh Street apartment—Nello and Amaranth—whose walls are crammed with his artwork, representing years of food and drink. However, the two enormous Peter Beards in Cipriani Downtown tower over the others as great representations of the artist at the peak of his powers.

Not long after his birthday party, back among the palm trees and poolside murals of Amy Sacco's celebrity-crammed club, Bungalow 8, Beard came across yet another young woman who was to play a part in his life in the coming years. Natalie White was seventeen years old, from Fairmont, West Virginia and had been in New York for only a few weeks. She was from a churchgoing, middle-class family—her father was an epidemiologist and both parents were Sunday school teachers—and although she possessed a natural intelligence, she did not think much of her future prospects in West Virginia. She could already see her school friends drifting toward early pregnancies, early marriages, and humdrum small-town futures in one of America's poorest states. So, on graduating from high school she decided that instead of taking up the offer of a college scholarship, she would try her hand at modeling in New York.

Her first few weeks in New York had been rather dispiriting, slogging away as a catalog model, which she loathed, and struggling to find accommodation she could afford. She'd found an unappealing apartment in a bad part of Flatbush and while waiting for the previous tenants to move out, she had rented a locker in a twenty-four-hour gym and that had become her temporary home. Just as she'd been having thoughts of packing up and going back to West Virginia, she decided to at least have a good time in her last days in New York. She googled "the best nightclub in New York," and Bungalow 8 came up. Being a statuesque young beauty, White

slipped past the velvet rope as if she were a Hollywood starlet. That was the night she met Peter Beard and the course of her life changed.[11]

Possessing classic model looks, at almost six feet tall she also had a superb athlete's body (she was a track star at school), and possessed a raw self-confidence that Beard, in the half-light of Bungalow 8, found quite disarming. He told her that he wanted her to be his muse. "I asked him what a muse was, and he burst out laughing," she said. "Then he told me that he was a photographer and that it was quite appropriate for a photographer to have a muse." Although somewhat wary of this rather disheveled older man standing in front of her, Natalie suggested he put her number in his mobile phone. Beard told her he didn't have a mobile and he wrote his name and home number on a napkin and gave it to her. Natalie said she would think about his invitation.

The following day Natalie looked up the name Peter Beard and realized that she'd been talking to one of the most famous photographers in Manhattan. She also discovered that at sixty-eight, he was older than her grandfather. By the end of summer, Natalie White had become Beard's latest muse as well as lover.

Stress and Density— Surviving the 2000s

Peter Beard was never one to ponder too deeply on past events and the sudden and dramatic departure of Peter Tunney from his life, not long after the ousting of his reliable and trusty manager Peter Riva, did not appear to affect his ability to embrace life with the same untethered energy he'd always employed. He made no attempt to contact his former business partners and did not feel the need to explain the peremptory dismissals. Nor did he thank them for years of fruitful partnerships. No reflection. No regrets. Onward.

The business side of his life was now being run by Nejma through the Peter Beard Studio and for the time being, at least, she was still working with David Fahey in Los Angeles and Michael Hoppen in London. Three major shows at the Hoppen Gallery—in 2002, 2004, and 2006—were great successes and helped further establish Beard in the UK as both a photographic artist and as a wild American life-force-about-town. On each opening night there were lines around the block and down the King's Road, the majority of the people attracted by the presence of the artist himself sprawled across the floor working frantically on another piece or holding forth to a cluster of attractive women all seemingly in his thrall.

Not surprisingly, the press also became engaged. In London's *Sunday Times Magazine*, the much-celebrated feature writer A. A. Gill eulogized about Beard being in perpetual motion. "I realize that what makes Beard

such attractive company is that he is a child," wrote Gill. "Not childlike in the sickening Californian therapy sense of getting in touch with your inner toddler but properly childish: scraped knees, dirty fingers, big grin." Gill later described Beard's images as not quite art and not quite photography, but "the leaves of a well-thumbed life." Another glowing feature prefacing a Hoppen Gallery exhibition was written by Anthony Haden-Guest, the art critic and close Beard friend, in the *Financial Times*. Haden-Guest made the point that although there is a lot of autobiography in Beard's work, there is "little by way of intimate revelation." To which Beard had replied: "Good. Good. I hate whining, don't you?" It must have pleased Beard that two British journalists intuitively got him, and that he had been received in the UK with the same enthusiasm he had been at home.

Evenings in London were inevitably spent on the town, mainly long dinners with various groups of friends, admirers, and hangers-on. Philippe Garner, who would not be described as any of these things, was, in fact, the international head of photographs at Christie's when he joined one of the post-Hoppen dinner parties at the Chelsea Arts Club. Despite having monitored Beard's work since he was a schoolboy in the early 1960s and having been championing his work at Christie's, he had never actually met him. That evening at the Chelsea Arts Club changed everything. "We sat next to one another, and it was as if it was just the two of us at dinner," Garner said. "We just talked, talked, talked and he made me feel as if I was the only person in the room. The intensity, engagement, the conversation. Now I really got what Beard was about."

While Beard was working his charm on a new circle of admirers, promoters, and commercial partners across Europe, in New York Peter Tunney was finally closing down The Time Is Always Now. The party was well and truly over but Tunney had refused to fold. His first act after separating from Beard had been to rename the gallery It's About Time. Out of the detritus left behind from the gallery's heyday he had made 156 Peter Tunney pieces of art and through the year had sold them for around $600,000, finally paying off the debts that Beard had left behind. Virtually homeless, he had also moved into a room above Crobar nightclub and had spent almost a

year there. In his final act of absolution, Tunney checked into rehab and emerged clean and sober in February 2005. He was forty-four years old.[1]

Meanwhile, Nejma, having established herself as executive director of the Peter Beard Studio, set about protecting the ownership of her husband's artistic legacy and contesting what she saw as illegal possession of his artworks. Clearly, with no experience in the field, she would be challenged. However, for the time being she was lucky in that the main gallerists with which the new studio had retained relationships—the Hoppen Gallery in London, Gallerie Kamel Mennour in Paris, and LA's Fahey/Klein Gallery—were helpful and happy to do business with the new hierarchy. All three hosted successful shows in the early 2000s, mainly based on Beard's new Living Sculpture collection. The most significant initiative, however, came from David Fahey who approached Benedikt Taschen, the founder of the Taschen publishing house, with a proposal for a lavish, ambitious retrospective book that would span Beard's entire career.[2]

It took some time for Taschen to agree to what would be the most expensive project the publishers had launched, but finally they did agree. Fahey worked on a contract with the Beards' lawyer Michael Stout, hired Ruth Ansel, the respected designer who had been responsible for the 1977 version of *The End of the Game*, and production of Beard's most important book began. Although he is a most modest man and would be reluctant to admit this, David Fahey was the driving force behind what has become Taschen's most successful book. The retrospective, which was published in May 2008, came out in two versions. One was an exclusive leather-bound two-volume collector's edition (14 x 20 inches weighing forty-one pounds, with its own bookstand), with the first 125 copies including a gelatin silver print signed by the artist of Fayel Tall (1987) and the second 125 a similar signed print entitled *965 Elephants* (1976). The second version was a 770-page edition that was limited to 2,250 copies. This mammoth, beautifully produced work contained the most comprehensive coverage of Beard's creative life to date.

However, it was in the years after the publication of the Taschen book that Nejma clearly decided to no longer formally deal with the galleries that

had been the engine rooms of Beard's commercial success. The Hoppen Gallery's fourth and final major Beard exhibition had been in November 2006 and although both Hoppen and Fahey/Klein in LA continued to sell Beard's work there was a distinct feeling that Nejma now wanted to go it alone. Friends had noted that she felt the gallerists were taking too large a cut from the sales of artworks, a stance that chimed with Nejma's apparent worldview that everyone outside Beard's close family was "leeching" off him. It was a slow, unspoken separation that the gallerists would take philosophically because they had no choice, but that nevertheless disappointed them. They had, after all, played a key role in bringing Beard, the artist, to the wider world at a time when he was relatively unknown. However, they were careful not to anger Nejma as they realized that she was now the keeper of the keys.

At the same time as attempting to run the Beard business Nejma also appeared to be coming to terms with some aspects of her husband's errant behavior. Now that Rikke Mortensen had evolved from lover and threat to the Beard marriage to loyal friend, Nejma saw fit to try to embrace her, even co-opt her into making sure Beard stayed on the rails. She had encouraged Beard to escape the temptations of Manhattan friends and, more particularly, New York nightlife, by having him spend more time in Cassis, where she argued he could work without the nocturnal distractions that interfered with his artistic production. To that end she hired a Muslim woman everyone knew as Nina—her name was Nadia Arab—as a housekeeper and a minder. Over a champagne lunch in New York she attempted to persuade Rikke to travel out to Cassis at the next convenient opportunity to check on Peter and make sure he was productive, relatively drug-free, and relatively celibate. "It was like two mothers talking about a delinquent child," Rikke said.[3]

When Rikke visited Beard in Cassis in the autumn of 2007, she discovered that none of Nejma's demands were being adhered to. Most disconcerting was that Nina was now clearly Peter's latest lover, and also that Beard's artwork was allegedly being passed on to criminals operating out

of Marseilles, which is just fifteen miles from Cassis and a notorious center of organized crime. Beard seemed blithely unconcerned either with his new lover's supposed connections in Marseilles or with suggestions that she may be selling his artwork behind his back. In fact, Rikke concluded with some pleasure, here he was just a year short of his seventieth birthday and he seemed to have retained the same reckless, carefree character traits that had made him so appealing to her when he was in his fifties, before the elephant attack.

In truth, Beard's wild, prankish, adolescent nature could never be contained even in these later decades. While clearly Rikke had let her down, Nejma continued to informally employ a wide coterie of friends and minders to keep an eye on her errant husband in the hope that constant surveillance would slow him down. It didn't. Her Paris friends Rene and Martine de Menthon had been charged with accompanying Beard to a launch party in London's Hyde Park for *Above* magazine. What the minders had not computed into their operation was the sudden presence of Julian Ozanne, unquestionably one of the more rebellious and reckless of his Kenyan friends over the years. While the launch party was in full flow, Beard and Ozanne sneaked out a side door and began walking briskly across the park. When they saw the French couple had spotted them leaving and were in pursuit, they began running. As they reached the end of Hyde Park, they hailed a cab and disappeared into the night.

They spent the evening at a series of parties across London, ending up at a party in Park Lane at the home of the socialite Mollie Dent-Brocklehurst. In the early hours of the morning, Ozanne called it a day and went home, leaving Beard behind in full party mode. "He called me early the following morning. He was still there and tried to persuade me to come back," Ozanne said. "Nejma blamed me for leading him astray that night. But it was all Peter's idea."

This was Beard unanchored. Beard without Africa but with one of his African fellow travelers at his side. Although friendships like the one with Ozanne occasionally provided him with a visceral link to his African heyday,

Nejma would soon start shutting these down and cutting off his remaining links with his more hedonistic allies.[4]

* * *

Back in Manhattan, Beard's relationship with Natalie White was gathering pace. Having accepted the role of artist's muse, Natalie was quickly introduced to Beard's old friend Elizabeth Fekkai. Over the years Elizabeth had sold many of Beard's works to her network of affluent friends. Although Nejma was now attempting to gain full control of the commercial side of Beard's artistic output, he was quite happy for Elizabeth to do deals on the side because it meant cash in the pocket. He felt Nejma's control of the purse strings came with conditions, the most onerous being that he make a greater commitment to monogamy, but also that he spend more time at the family apartment at the Osborne on Fifty-seventh Street.[5]

Natalie soon moved into Elizabeth Fekkai's apartment, which ironically was in the building at 829 Park Avenue that Beard had lived in with Cheryl Tiegs in the late 1970s. Increasingly, Beard also started spending time in the Fekkai/White apartment, spreading his art pieces across the floor and generally generating the chaos that went with the Beard creative process. Natalie was flattered and surprised that Beard included her in photoshoots with established models like Petra Němcová, Alessandra Ambrosio, Irina Shayk, and Ana Beatriz Barros. Her confidence was boosted further when the photographer Michael Dweck used her in a photographic assignment for *Playboy* magazine titled "Mermaids," an evocative underwater shoot that Dweck would turn into an art book. Her only concern was that were her religious parents to see nude photographs of her in *Playboy* they would be most upset, a problem Dweck circumvented by covering Natalie's face. "What I did realize," she said, "was that I looked really good naked." This self-realization would serve her well in the coming years. She became more self-confident, borne out by her ability to operate independently of Beard.[6]

Concerned about the time Beard was spending with Natalie White,

Nejma arranged to take him on a two-week vacation in Turkey and then back to Cassis, where her husband could work on pieces she had commissioned and that he had been slow in finishing. As he was leaving Manhattan, Beard assured Natalie he would be in touch and that they would be reunited soon. However, after more than a month passed without any communication from Beard, Natalie became increasingly frustrated at the silence. She decided to do something about it and bought herself an airline ticket to France.

Natalie arrived in Cassis having never traveled abroad before and not speaking a word of French. Having booked herself a room at the Hôtel Cassitel in the center of Cassis, she slept off her long-haul flight and the following morning took to the streets of the town bearing a cardboard sign that read simply: Peter Beard. "I wandered around the port pointing at the sign, hoping people would recognize the name," she said. "It didn't take long. This tall African-French guy said he knew him, and he led me through the port, down a narrow street, to a restaurant, the Vieille Auberge." A sign with Beard's name pointed to a bell. Suddenly Natalie was in an apartment above the restaurant, standing in front of Peter Beard, who immediately, spontaneously expressed undiluted pleasure at seeing her.

Beard apologized profusely for not making contact—no phone, he'd mislaid her number, Nejma was keeping him in Cassis because they were behind on commissions—and said Natalie should stay on with him in Cassis. This was typical of Beard—impulsive, impractical, failing to take the prevailing realities of daily life into account. Just as he was issuing his invitation, the apartment door swung open and there was Nejma, back from her stroll around the town. Natalie managed to say, rather lamely, "Hi, Nejma" and then Nejma launched herself at the intruder with a hairbrush in hand, shouting: "What are you doing here? I don't want to know you. Get out of my house."

For a moment, Beard tried to convince Nejma that this was not who she thought it was, Natalie White. "Peter said I was someone else and that I was there with my mother . . . and Nejma paused," said Natalie. "And started apologizing. Then she took a closer look and recognized me. She

came at me again with the hairbrush and I had to lock myself in the bathroom."

Beard managed to persuade his wife to leave the apartment so he could sort everything out. After Nejma left, Beard asked Natalie for the phone number of the hotel she was staying in, wrote it on a piece of paper, and hid that in his shoe. The following day Beard and Natalie took a train to Paris, and they would spend the next three weeks at the Lenox Hotel working on collages, partying through the night, and generally enjoying the life that Peter Beard reveled in most and found the most artistically productive.

Monty Python-esque encounters such as this one in Cassis were becoming more frequent as Beard's instinctive recklessness and rebelliousness came up against Nejma's increasing determination to bring him to heel. At this particular time in the mid-2000s his major accomplice happened to be Natalie but over the following decade the names of the coconspirators, be they sexual, drug-related, or mercenary, kept changing, and the effect was the same. However much his wife tried, whatever means she employed to try to constrain him, he always managed to skip over the fence and disappear into the netherworld that had always been his favorite habitat.

* * *

Having celebrated his seventieth birthday in 2008 at the VIP Room in Paris, in the company of the usual armful of models, this time led by Claudia Schiffer, Beard headed back to Hog Ranch for a brief stopover before flying on to Botswana to shoot the 2009 Pirelli calendar with another string of models. The stopover was eventful both for Beard and his longtime Hog Ranch companion Gillies Turle. Over recent years, Beard had been made aware that a Frenchman of questionable virtue by the name of Patrick Amory may have been stealing artworks done by the Hog Ranch Art Department, and repurposing them and selling them as Beard originals.

Amory was a controversial French journalist and photographer who for some time was friendly with Beard and spent time at Hog Ranch. He passed himself off as a peace envoy for UNESCO, however UNESCO has denied that he had participated in peace missions and the UN organization's executive director warned him in December 2002 to stop claiming UNESCO links. Furthermore, Beard's trusty assistant Mischa Haller insists that Amory had stolen a batch of his photographs. "I took some amazing photographs of Peter covered in blood and Amory told me when he returned to Paris he would develop all my film, show it to *Paris Match* and get them published," Haller said. "I was young and naive and that was the last I saw of my photographs. Amory did go to *Paris Match* but told them they were his photographs and published them under his name." It was later reported that Beard himself lodged a criminal complaint against Amory, claiming that he had forged Beard's signature on a number of photographs, however whether or not that case actually went to court is moot.

On that stopover at Hog Ranch, as they sat around the campfire one night, with Jochen Zeitz, the CEO of Puma shoes who had recently bought Segera Ranch in Nanyuki, Beard confronted Turle about his relationship with Amory. Someone close to Beard had told him it was Turle who had given Amory access to the Beard archive and thus had facilitated the fraud. Turle was mortified. Here was his friend of more than thirty years insinuating that he was an active participant in a massive art fraud. Beard said that if Turle didn't give him something in writing rejecting the accusations, "It will look bad for you."

Turle was sure that Nejma had somehow persuaded Peter Beard that his old friend had been complicit in the Amory scam, and that wounded him almost as much as Peter thinking it himself. He remembered how, decades earlier, Nejma had written so fondly to him from Germany. In the letter in which she'd thanked him for his loyalty and help all those years before, she described him as "the last of the honorables (a la Nancy Mitford)" writing "so much love I can't express but if you ever need me you can count on me."[7] Clearly Nejma had forgotten. Turle hadn't.

Nevertheless, Turle sat down and wrote Beard the required letter,

heading it "The French Connection." He pointed out that Amory "has been known to you for many years and you have worked closely with him on some sensitive projects both at Hog Ranch and in Paris and he has been a regular visitor to Hog Ranch over the years." He said accusations that he, the Hog Ranch Art Department, or the staff were involved in improper behavior, were "clearly ungrounded, ill-founded and quite possibly of ill intention." And he went on to say that "I categorically state that at no time ever have I had any dealings, discussions, correspondence, phone calls etc with him (Amory) concerning your artwork."[8]

In fact, after a little detective work it became clear to Turle exactly how Amory might have managed to get into the Hog Ranch artistic archive. The Hog Ranch artists all took the weekends off and the only person with the keys to the artwork was a woman called Tabitha who, ironically, Nejma had hired to look after baby Zara. It was on Saturday afternoons that Amory would appear at Hog Ranch and, according to the staff Turle had interrogated, it was Tabitha who had handed over the keys.

Peter Beard was delighted to read Turle's riposte and wrote a note apologizing "for the ruffled feathers. All's well that ends perfectly." Turle says they never discussed the matter again.

By April, Beard was in Botswana leading another gang of models through the African wilderness in the company of wild animals. It was a lucrative commission to shoot the 2009 Pirelli calendar, and the models included Lara Stone and Rianne ten Haken, who would both feature on the calendar's cover. Rianne was twenty-one, had never been to Africa before, and had never heard of Peter Beard, the assignment having been made through her Paris agency. The two locations chosen were Abu Camp, where the American Randall Moore had trained a small group of African elephants as much as one can train these wild animals, and Jack's Camp, a famous safari outpost on the edge of salt pans owned by the Bousfield family, longtime Beard friends. Beard made it clear from the outset to the models and the attendant staffers that this was an art project and not a fashion shoot.

The entire production took just under two weeks to complete, and the models remembered it as an extraordinary experience, most of all the intensity of Peter Beard in full creative flow. "He seemed to have no boundaries, so when we were shooting, I could see how he'd have been attacked by elephants," said Rianne. "He had no fear. There was just this creative intensity. It carried us all along with it."[9] The result was a Pirelli calendar like none before it, a lurid collection of powerful images that flaunted wild women and wild animals in the same space. It reflected Beard's running themes of "stress and density" and women as living sculptures. The calendar was received warmly by many friends and colleagues; however, the critics, his traditional gallerists, and the art establishment described the work as shallow and rather tacky. Beard was unrepentant, gleefully pocketing a million-dollar fee and pleased that Nejma, who had set up the deal, had found some satisfaction as the head of Peter Beard Studio.

Natalie White was notably absent from the Pirelli calendar shoot, and friends had assumed this was on instruction from Nejma. However, Beard made sure that images of Natalie were collaged into the final artworks. And it was not long before they were together again in Cassis, this time staying in "the big house on the beach," accommodations helpfully provided by the Cassis Town Council, according to Natalie. Here Natalie first encountered Nina (Nadia Arab), the housekeeper-cum-maid, who was by this time clearly much more than a housekeeper.

Beard referred to Nina as the Maid and told Natalie that Nejma had hired her and was paying her salary. Nina barely spoke English. There was a point when she was clearly in charge of Beard's cash flow in Cassis. In late 2009, Elizabeth Fekkai flew to Cassis with $10,000 for Beard at his request. When they met in her hotel he was with Nina, whom Elizabeth had not met before. She handed Beard the cash, and he passed it straight on to Nina, who put it in her bag. "The next day I met up with Peter in a local bar," said Elizabeth, "and I asked him what he had done with the cash. He said Nina had lost it. I was flabbergasted and challenged him. He claimed she had put the cash behind some books and could not find it.

I said, 'She's stolen the money, hasn't she?' He said yes, but that she really needed it. It was a typical PB state of affairs."[10]

Beard then instructed Elizabeth to leave Hotel Les Roches Blanches, the best hotel in town, in case Nejma discovered she was in Cassis. "So, I stayed on in a distinctly less salubrious hotel," said Elizabeth, "and kept on helping Peter work on his photographs in a make shift art studio for the next three days."

Around this time, both Natalie and Rikke Mortensen had made trips to Cassis, Rikke at Nejma's request to make sure Beard was behaving responsibly and producing the commissioned pieces of art. It was on her last visit to Cassis that Beard asked Natalie to marry him, and he suggested that perhaps they would even have children. He said he would divorce Nejma. Natalie did not hesitate to turn him down. "I was in love with him, but I needed to have a life outside Peter Beard," she said. "I didn't want to follow the path of all the other Peter Beard exes. Also, I was so young—just 21 by then—and I didn't know how I would be able to tell my religious parents." Up to that point Natalie's parents were convinced her relationship with the famous photographer was purely professional and when the *New York Post*'s gossip column, Page Six, carried stories about "Beard and his girlfriend Natalie," her mother would phone from West Virginia laughing at how the press had made the cardinal error of assuming they were romantically linked. For Natalie, it was easier to go along with the deception.

Meanwhile, the distress that this affair had caused Nejma was something that Beard just seemed to accept as if it were just one of the vagaries of modern married life. Not only did he seem quite indifferent to Nejma's feelings, but he appeared to be rather amused by the turbulence this affair was bringing to his domestic arrangements. In one piece of artwork Beard created a photomontage which showed a semi-naked woman with her hands around the throat of another semi-naked woman, Natalie White. The inscription accompanying the image, in Beard's copperplate hand, read: "There's a lot of women out there who want to strangle that Natalie

V White. In fact, and more specifically, notorious Nejma Khanum Beard from the wilds of Kenya has long suggested a devilishly drawn-out Kung Fu type STRANGLING with windpipe-crunching knuckle dusters." And below the image, further copperplate writing declared: "Ahhhhhhhh you can hear them now. This lurid dream has obsessed the Afghan trench-warfare terrorist, sleepless and scheming all through the scary Osborne nights."[11]

The reference to his long-suffering wife as an Afghan trench-warfare terrorist was a frequent term of abuse and led friends to question the well-being of this long-running marriage in absentia. When in New York, according to friends, Beard spent more time at Natalie and Elizabeth's shared apartment than he did at the Osborne, although Nejma continued to attempt to lure him home, sometimes pleading, sometimes threatening to cut off the many medications that he was now taking for various ailments. But for the time being, at least, Nejma seemed prepared to endure the humiliation and the public flaunting of various lovers.

However, after Beard's marriage proposal in Cassis, he and Natalie slowly ceased to be lovers but would remain close friends and professional colleagues for some years to come. Beard's ability to retain the loyalty of a long line of former lovers over the decades was a quality that is rare in lotharios. From Minnie Cushing and Cheryl Tiegs through to Rikke Mortensen and Natalie White . . . all maintained some kind of contact with the aging roué and all speak of retaining a fondness for him.

Beard and Natalie's lingering relationship was not, however, viewed kindly by some, most particularly Nina the Maid, who had started to see herself as Beard's principal mistress. In the summer, Beard and Natalie had met up in Paris and were staying at the Lenox Hotel working on post-production of the previous year's Giant Polaroid shoot. Beard had been in Cassis. At Nejma's behest he had been spending a lot of time in Cassis as the remote Riviera idyll was supposed to keep him at arm's length from the temptations of his Manhattan life—drugs, drink, and women.

Peter caught the train to Paris from Cassis and soon enough he and

Natalie were working on art pieces. They had been there a month when Elizabeth Fekkai joined them. All of this activity in Paris had clearly bothered Nina, as had Beard's long absence from Cassis, so she also took it upon herself to catch the train to Paris. "We had been out partying one night and had just got back to Elizabeth's room when Nina burst in," said Natalie. "She was screaming at Elizabeth in French and Elizabeth was translating for me. She wanted to know if I was having an affair with Peter. I was terrified and was hiding behind the bed."[12]

The noise alerted Beard, who was in a neighboring room. He came down the hallway dressed only in a T-shirt and appeared at the door, clearly "pleasantly pixilated." He asked what the noise was about. Nina confronted him and wanted to know "do you want me or Natalie" to which Beard, with a wry grin, replied: "Well, I'd like to have you both." Nina then slapped him as hard as she could and stormed out of the room. The end of another perfect Peter Beard evening. He just burst out laughing.

Although Beard seemed to thrive on such drama, even he returned to New York somewhat exhausted by the never-ending crises, mainly of his own making. It was autumn, and as soon as he got back he and Nejma fell into acrimonious arguments about his behavior, and he began to crave a little peace and tranquility. In previous times, he would have turned to Rikke Mortensen, his calm, down-to-earth European traveling companion and paramour who for two decades had provided some measure of emotional ballast to his frenetic life. But like Tunney, like Riva, like Gillies Turle, the serene Dane was now very much in Beard's past.

Beard and Rikke had spent meaningful moments together for the last time the previous autumn. He had called her out of the blue to tell her that he was on his way to the launch of the Pirelli calendar in Berlin and he wanted to stop over in Copenhagen, the city that had given him some of his best days of his life. Since that first pilgrimage to meet Karen Blixen fifty years earlier, he had been a regular visitor, initially to spend time with the baroness's extended family, but over the last several decades to be with Rikke and her circle of friends. Even now, long after they had ceased to be lovers,

Beard shared a special bond with this woman, and Rikke, despite now rais-
ing children with a long-term partner, still felt an inexplicable tie to the now
aging American wild man.

So that autumn they hatched a plan. Rikke had friends who were close
to Frederik, the crown prince of Denmark, and when Nejma demanded
to know from Rikke the commercial purpose of Beard traveling to Den-
mark, she obfuscated and told Nejma that he had been commissioned to
do a portrait of the crown prince. Beard was soon on a flight to Copenha-
gen. "Peter spent a month here, and we had the most wonderful time," re-
membered Rikke. "As always, he charmed everyone." A private dinner was
arranged at Beard's favorite Copenhagen restaurant, Lumskebugten, with
the crown prince and a small group of friends. Not surprisingly, Prince
Frederik and Beard hit it off, so well that he invited Beard and Rikke to
lunch the following week at the royal summer residence, Fredensborg Pal-
ace. In the week between the two royal occasions, Beard worked on a pho-
tographic piece of art that featured a portrait of an African male lion, and
duly presented it to the prince at the lunch. It was, according to Rikke, an
intense and beautiful work and the crown prince was delighted.[13]

For the duration of Beard's time in Copenhagen, Rikke was tied up
with family matters and work commitments while Beard, having now in-
troduced himself to a wide circle of Copenhagen's younger partygoers,
was roaming around the city from social event to social event. Having
promised Nejma that she would make sure Beard arrived in Berlin in a fit
state for the official launch of the Pirelli calendar on November 20, Rikke
became a little concerned at the stories she was hearing about his partying
in the last week of his sojourn. She had known him too long to think she
could control him and did not even try. She was to meet him at the hotel
and then hand him over to two young Danish beauties he had met previ-
ously on the London party circuit and they were to entertain him at their
family country house before taking him to the airport to catch his Berlin
flight.

Rikke arrived at Beard's hotel at eight A.M., just as the last of that

night's party girls was leaving, to find her former lover bedraggled and exhausted. "I knew Nejma would be furious," Rikke said. "He was in a terrible state." As they stood outside the hotel, waiting for the young Danes to pick him up, an exasperated Rikke snapped: "Peter, I'm so happy I'm not your mother." "So am I," he replied. Her worst fears were later realized when, on arrival in Berlin, he needed a wheelchair to move him through the airport. It was the day that Nejma finally blacklisted her.

Those last moments standing outside the hotel proved to be poignant for the pair. It was the last time they would ever see each other. Rikke's place in Beard's life had often been underplayed, even overlooked—she was "the Danish girlfriend" in so many captions—but theirs was arguably his most stable and consistently loving relationship. She was a freewheeling, liberal Scandinavian without airs or graces. Sensible, grounded, and emotionally intelligent, she brought out the best in him because she made no demands of him. For years, they traveled the world together, to his exhibitions in Tokyo, Milan, Paris, and through Africa, and as she had learned early on that simply getting him from A to B without incident or emotional meltdown was a good result, she happily organized him. "He wanted someone to lead the way. It was always like that. I always had to make sure he made it to the airport, to meetings, to galleries," Rikke remembered. "We had a relationship where we knew the rules and because of our age difference we knew it wasn't going to last forever."

With Rikke, Beard was like a child, a lovestruck teenage boy. In the 1990s, he would spend hours on the phone to her when they were apart, mostly lying on the floor in The Time Is Always Now, just talking, talking, talking. In those days, international telephone calls were expensive and Peter Tunney told Rikke at the time it would have been cheaper for him to fly her to New York than it was to maintain and pay for the endless long-distance telephone affair.

Rikke also provided Peter with an umbilical connection to Denmark, home of Karen Blixen and the extended Dinesen family, who Beard embraced with more warmth than his own biological family. Over the years he made around a dozen trips to Copenhagen, often for months at a time.

But after that final joyful month in the Danish capital with the crown prince, his Dinesen family friends, his dear Rikke, and a whole party full of the young Danes he had connected with, he never returned and they never spoke again.

* * *

Back in the maelstrom that was the emotional and financial tug-of-war between Nejma and Beard's Manhattan group of friends, led by Natalie White and Elizabeth Fekkai, Beard was now allowing himself to be persuaded that his once-trusted friends were double-dealing. Ever since his old management team of Tunney and Riva had been driven out of his life, Beard had made secret financial trysts with the likes of Elizabeth Fekkai. He was always short of cash and as long as Nejma held the purse strings, he would be obliged to curb his wayward behavior. But he could not, and would not, curb his wayward behavior. His life was his art and vice versa. As the British gallerist Michael Hoppen said: "People who bought Peter Beards knew what they were getting—they were buying a representation of a lifestyle they could only dream about."

So, as early as 2007, he had made a deal with Elizabeth Fekkai that gave him some financial independence from the Peter Beard Studio. When he signed the document authorizing Elizabeth to legally sell his work, the pair discussed how best to create a bank account for him. "I asked him to come to the bank with me and open up an account," said Elizabeth. "He said he couldn't because Nejma would find his bank card or checkbook and confiscate it. So, I opened a savings account attached to mine that would only have his money in it." Thus, the money from any artwork sales went into that account, so, too, the money from the Giant Polaroid shoots.[14]

This had worked well until, in the first weeks of 2011, Beard became convinced, most likely by Nejma, that Elizabeth Fekkai was not dealing honestly. That spring, Elizabeth received a letter from Beard addressed to her via her lawyers. It was terse, and it shocked her deeply. It read: "Dear Elizabeth I am writing to confirm that the April 13th letter sent

to your lawyer by my lawyer John Thomas was sent at my direction and represents my wishes. Please do me the courtesy of returning the works, providing the accounting, and making the payments as soon as possible, in compliance with my lawyer's instructions." It was signed Peter Beard. Underneath was a handwritten note: "PS Also very interested in the logic behind those leaks to the girls at Page Six re Natalie underage? Etc Etc."[15]

Elizabeth was mortified. And she found it hard to believe that a friend whose interests she had assiduously protected, at his own request, over the years had suddenly turned on her. Although she knew she owed him money for a piece she had recently sold to Jay McInerney and his wife, Anne Hearst, she said, "I simply hadn't wanted to hand the money over in Cassis because that meant Nina would have control of it. And Peter probably wouldn't see any of it."

However, that terse note, together with the suggestion that Elizabeth was leaking gossipy stories to the *New York Post*, marked a sudden halt in relations between the two. Elizabeth had no doubt that someone had persuaded Beard he was being cheated and, being susceptible to such persuasion, he canceled his business agreement with her and, according to Elizabeth, "He didn't want to talk to me again."

For the next two years, there was no communication between the two former friends. Then, on a bleak winter's day in Manhattan in 2013, something extraordinary happened. On Friday, February 8, a massive snowstorm hit the northeast and engulfed Manhattan in a whiteout. New York City mayor Michael Bloomberg told people to stay at home and most of the city obeyed instructions. Elizabeth Fekkai didn't. She was so determined to see the major Jean-Michel Basquiat exhibition at the Gagosian Gallery on West Twenty-fourth Street that had opened the previous day that she decided to brave the snowstorm. As she struggled along an empty snow-swept sidewalk on West Twenty-fourth she saw through the blizzard a solitary figure approaching her. As the figure drew level, she recognized Peter Beard.

"I just shouted out 'Peter!' and we fell into each other's arms," Fekkai

recalled. They found refuge in a bar, and she told Beard why she had refused to send the $13,000 she owed him to Nina in Cassis after Nina had refused to put Beard on the phone. "Suddenly we were together again. I called Natalie, who was living nearby, and yelled at her to come down to the bar. We hadn't spoken to him for two years. It was so good to be back with him."

Who Shot Natalie White?

It was on November 13, 2013 that Gillies Turle left his beloved Hog Ranch for the last time. The ramshackle bush encampment had been his home for thirty-three years. By now, Beard's top camp was completely deserted except for the *ascaris* (guards) and the solitary figure of Solomon Wasimigo in the Hog Ranch Art Department studio, still illustrating Beard's photographs. Turle's own lower camp had been dismantled to leave just two stone chimneys as the final pieces of evidence that humans had once flourished in this forest habitat. Beside the chimneys was the stone marker where Rocky the marsh mongoose, one of the many domesticated animals that played a big part of Gillies and Fiammetta's time there, was buried.

The natural world had already begun to reclaim its space, and the clearings that had been shaped by those transient humans were quickly turning back to wild, unkempt bushveld. Warthogs, giraffes, suni antelope, bushbuck, and tree squirrels were even more prevalent than in Hog Ranch's heyday and the birds—purple grenadiers, indigo waxbills, bronze mannikins—were everywhere now that the humans had left. Beard's top camp generator, which had long provided the audial heartbeat of the camp, had long since stopped purring.

As he drove away for the final time, Turle looked back at the tall Terminalia tree in front of his veranda and realized that he was bidding farewell to the ghosts of Hog Ranch's glorious past. Kamante and his wife, Wambui, were long dead, buried on the plot in Ranguti that Karen Blixen had

bought him when she left Kenya in 1931. Nathaniel Kivoi, the principal artist in the Hog Ranch Art Department, continued to live on his farm in Nyeri, and Mwangi Kuria, the dreadlocked wild man, was still drinking too much in Ongata Rongai.

Radio and Mbili, the two vervet monkeys that had lived at Hog Ranch, were long gone, having been transferred to an animal orphanage after the Kenya Wildlife Service threatened to confiscate them because of a combination of arcane wildlife rules and a vendetta directed at Gillies Turle. They were both surely dead now.

The remnants of ashes of the long-extinguished campfire that overlooked Ongata Rongai, and on the distant western horizon the four knuckles of the Ngong Hills, blew in the evening wind. That campfire had been the focal point of decades of spirited conversations among the passing artists, journalists, politicians, fashion models, conservationists, diplomats, Maasai tribal elders, and the rest. Turle remembered how Mbuno would carry around the canapés on a large wooden board; cocktails would be served, joints would be rolled, and all this would lubricate the conversations late into the night, with Peter Beard the eager ringmaster. All that was now in the distant past.

"It had been more than a home to me; it had been a sanctuary where I evolved, almost a cocoon from which a different person emerged," Turle recalled. "It had been a University for Maturity and my classroom, a safe and secluded space in the womb of nature. Fiammetta and I were both so grateful to Peter for our years at Hog Ranch together."[1]

Turle's slow extrication from Hog Ranch had begun some years earlier, on Christmas Eve in 1997. That night he and Fiammetta were driving back home along the Langata Road, not far from Hog Ranch, having just picked up Fiammetta's son and his young girlfriend from Nairobi airport, when they were attacked by a carload of armed robbers. The criminals drove up alongside the vehicle and yelled at Turle, one waving a submachine gun in his direction, another ostentatiously brandishing a knife. They drove him off the road and once they had forced everyone out of the car at gunpoint,

they separated Fiammetta from the others. When Turle protested, the butt of the machine gun was smashed into his face, shattering his cheekbone. The two cars were then driven into the forest and when they stopped the four victims were told to lie facedown on the earth while they were robbed of all jewelry, cash, and valuables. There was a brief moment when Turle thought they might be executed but the criminals suddenly took off in their car and it was over.[2]

As soon as they arrived at Hog Ranch that night, Fiammetta started talking about getting out of what everybody agreed was an increasingly dangerous Nairobi. Although the very thought of leaving Hog Ranch seemed "unthinkable, almost heretical" to Turle, its remoteness made them ever more vulnerable. A robbery while they were abroad the following year confirmed the wisdom of their decision and the couple bought a ruin on the island of Lamu—the sybaritic location just off the Kenyan coast that has become one of the country's most prominent luxury vacation resorts—and began rebuilding the property and their lives there. As the years passed, Turle visited Hog Ranch less frequently and then, having pulled down almost all the structures at his lower camp—he had left Beard's upper camp undisturbed—he finally cut himself adrift on that November day in 2013.

Peter Beard had actually sold Hog Ranch to the wildlife charity African Foundation for Endangered Wildlife back in 1996, just before the elephant attack. As part of the deal, Beard and his family had lifetime tenancy and because the AFEW chairman Rick Anderson knew Turle well—he had been captain of the polo team Anderson played on back in the 1960s—they were happy for him to stay on until Beard died. The reason Beard had sold Hog Ranch was that he owed the Kenyan government upward of $45,000 in conveyancing fees and back taxes and the offer of continued tenancy while relieving him of his financial responsibilities had been too good to ignore. The deal was that AFEW would pay the $500,000 asking price at $25,000 a year for twenty years and the first few tranches would settle the outstanding debts.[3] By the time Turle had packed up his tent, there were but a few more payments to be paid. Soon Hog Ranch would become a

wildlife sanctuary and Peter Beard's residency would become part of Kenyan history. Or so everybody thought . . .

* * *

Meanwhile, back in Manhattan, Beard was living out his post-Africa years in the kind of rackety, untamed manner that had marked his entire adult life. He was now in his seventies and while a man of less robust constitution may have settled for pipe, slippers, and genteel walks around his Montauk property, Beard had retained his taste for all-nighters, mixing creative work with drug-taking, partying, and socializing in the many Manhattan restaurants where he was running a tab. Cipriani Downtown remained his favorite restaurant and one freezing cold March night in 2009 he was there with Natalie White and a table full of friends celebrating their collaborative Giant Polaroid shoot. According to Natalie, Beard had approached her about creating new artworks that were outside the influence—and financial control—of Nejma and the Peter Beard Studio. He told her he needed money of his own.

As the dinner was coming to an end another Cipriani regular, the sculptor Arturo Di Modica—whose bronze *Charging Bull,* the symbol of Wall Street power and aggression, stands on Bowling Green—approached and challenged Beard to photograph Natalie on the bull. Beard took up the challenge immediately and the drink- and drug-fueled Cipriani gang jumped into cabs and headed straight downtown to Wall Street. Soon a topless Natalie was perched on top of the bull like a rodeo cowgirl with Beard snapping away with a point-and-shoot camera. The story made it into the following day's *New York Post* with Beard describing his muse on the Di Modica bull as his "stimulus package" and telling the Page Six gossip columnist: "It's the only thing I've ever done in finance."[4]

While such childlike pranks were part of his everyday life, his core activity remained making collage art. His past works were now selling for considerable sums. At Christie's in New York at a Peter Beard auction, according to the writer Jon Bowermaster, pieces were selling for between

$400,000 and $500,000 each. At Christie's in London in November the same year, the image of Fayel Tall sold for almost £40,000 ($55,200) after a reserve price was set at £30,000 ($41,400). And just over a year later a version of *Orphan Cheetah Triptych 1968* sold for $662,500 at Christie's in New York. Business was clearly booming.

In Manhattan, where he was now spending most of his time, Beard was constantly picking up stray acquaintances—people he'd met at wildlife benefits, at art shows, or at any one of the nightclubs he frequented. He would embrace them as if they were old friends and then engage them in intense conversations, in shared enthusiasms, and sweep them up on the Peter Beard Magic Carpet Ride. One such acquaintance was the writer Gary Lippman, who vividly remembered a night in New York with Beard.

Lippman had met Beard years earlier at a benefit for Carter Coleman's Tanzanian Forest Conservation Group and had followed him through an evening of parties and nightclubbing. They had also bumped into each other at social events and occasionally talked on the phone. So, they had spent time together. Then, on this particular night in the spring of 2013, Lippman received a call from his friend, the gallerist Emerald Fitzgerald, saying that she and Beard were about to have dinner at a restaurant near his Osborne apartment. It had been the first time he had seen Beard in some years and was surprised at how stooped he'd become and how gingerly he moved. However, Beard's energy and enthusiasm triumphed over his physical ailments and Lippman and his wife, Vera, enjoyed a splendid dinner. "He was particularly taken by Vera, a beautiful Hungarian, saying he loved her lips and compared her earrings, which were made from dried red Magyar paprikas, to a dish he had had at Nobu restaurant. He also said over dinner he wanted to photograph her," said Lippman. "He said he was also taken by the colorful jacket I was wearing."

After dinner, which, unsurprisingly, Lippman paid for, Beard invited them all back to the Osborne, where he was staying alone, as Nejma was at Thunderbolt Ranch. Once there, the party was treated to an artistic tour of Beard's back catalog, with Beard showing his guests his diaries, works in progress, and family photograph albums as if they had always been close

family friends. As they were looking through the prints and artwork, Lippman would praise Beard for particular pieces and Beard would respond by saying, "Well, I think you can have that one if you want it. Take it—it's a gift." While Lippman was touched by his host's instinctive generosity, he was also aware of the recently published *New York* magazine article that had detailed this munificence as well as Beard's propensity to pay restaurant and bar bills with his art, and how Nejma was now attempting to claw back pieces that had been acquired in this somewhat informal manner. As he did not like the idea of being sued by Beard's absent wife, Lippman graciously declined his host's offers.

Finally, Beard jumped up and said, "Let's get to work." Using Lippman's BlackBerry and his own small point-and-shoot camera, Beard art-directed a photo session with Vera. Lippman says he showed the same intensity that he employed when doing his artwork, instructing Lippman on where to place a standing lamp so the lighting was just right and Vera on how and where to sit. Then he said he wanted to do pictures with Lippman and went into his bedroom, emerging wearing a brightly colored Hawaiian shirt he thought would go with Lippman's Moods of Norway jacket. The two posed and Vera took the photographs with Beard's point-and-shoot. What struck Lippman most forcibly was that Beard's childlike enthusiasm for the process, the taking of the photographs, far outweighed his interest in the results. Once they had finished taking the photographs, he suggested they all go downtown to Emerald Fitzgerald's Rox Gallery to have a look at the *Who Shot Natalie White?* exhibition, due to open the following week.

By the time they arrived at the Rox Gallery, it was after midnight, but Emerald opened it up and Beard took the group on a tour of the artworks, some of which were his own. As the night wore on, Natalie White and a group of her friends arrived, pizzas were ordered, drinks were had. At around three A.M., Lippman told Beard he was going to head home and asked if he wanted a lift. At first Beard accepted, hesitated for a moment, and then said that some of the others, the younger crowd, were going on to the Electric Room in the Dream Hotel, a trendy basement bar, and he was

thinking of joining them. "He paused for a second, an angel on one shoulder, the devil on the other," said Lippman. "And the devil won. And then he said, sweetly and with genuine concern: 'I hope you guys don't mind.'"

As he was leaving, he overheard Beard negotiating with his young clubber friends, telling them if he went with them to Electric Room, he was going to need cab fare home and a tip for the doorman for coming in late. It was probably the first time these hip young bohemian New Yorkers had ever had to pay out a tip to a doorman.[5]

A week later the *Who Shot Natalie White?* exhibition opened at the Rox, curated by Gregory de la Haba, the young artist who had been so influenced by Beard, and featuring photographs of the young model taken not only by Beard but also twenty-five other photographers including Michael Dweck, Will Cotton, Raphael Mazzucco, and Sean Lennon. According to the *New York Post*'s Page Six, "the whole experience oozes sex but delivers a broader message of primal fearlessness and self-realization." Peter Beard was at the opening party and the exhibition was so loaded with primal fearlessness that local residents tried to get it shut down, offended by the large nude photograph of Natalie in the Rox's window. The police were called and, after investigating the contents of the exhibition in Natalie's company, they decided that neither the principal model nor the photographs of her posed any great threat to the neighborhood's moral well-being.[6]

The publicity, however, did the young muse from West Virginia no harm at all. The Rox Gallery exhibition was her first showing of Polaroid self-portraits she had created the previous year, saying at the time, "Instead of going to art school I learned from some of the greatest artists out there." Principal among these, of course, was Beard who, Natalie said, in the early days of their relationship, "Just talked art at me. I was the only person he'd met in his life who didn't know who Francis Bacon was. He wanted an opinion that was unadulterated, even untutored. He got that from me."

During their time together Beard happily tested his muse's "unadulterated opinion" against artistic convention, as he did one night at the Gramercy Park Hotel. Although the couple were standing with Julian Schnabel, an old friend and Montauk neighbor of Beard's, Natalie had not been prop-

erly introduced and had no idea who he was. As the three stood looking at a Schnabel painting hanging over the fireplace in the Rose Bar, Beard nudged Schnabel then asked Natalie what she thought of that particular painting. "I think it's crap," she replied. "It's one of the worst paintings I've ever seen." Beard burst out laughing and Schnabel responded tersely, "I painted that. And I'm the closest thing to Picasso you'll ever meet." It was probably the first time the celebrated artist had ever heard such brazen criticism of his work, which was why Beard had provoked his young, ignorant muse into responding thus. It was the kind of disruptive, anarchic behavior that Beard reveled in, and it gave him great pleasure to see revered figures, such as Schnabel, squirm.

Toward the end of 2013, following the success of the *Who Shot Natalie White?* exhibition, Natalie began developing ideas for another Polaroid shoot, this one more ambitious and involving some of the big-name models she knew Beard would be able to bring to the party. Beard was spending more time at the Natalie/Elizabeth Fekkai apartment than he was at the Osborne, working on his own pieces, still spread across the apartment floor. He immediately agreed to work with Natalie on a Giant Polaroid shoot and at the end of October, at a party at Cipriani Downtown to celebrate Natalie's twenty-fifth birthday, the pair signed a deal to collaborate on the project.[7] It was a contract that would end up as the centerpiece of a rancorous court case, but at the time of the agreement, the pair embraced the project with mutual enthusiasm and called their great friend Noel Arikian out in Montauk to join them and film the project in progress.

For the first two-day shoot they brought in a group of models who, it was agreed, would be paid in signed photographs from Beard. Among the models were former *Baywatch* star Pamela Anderson, the supermodel Helena Christensen, and their more contemporary peers, Nina Agdal, Alessandra Ambrosio, Hannah Davis, and Ana Beatriz Barros. In all, some thirty models trooped in and out during the shoot and, as with all Peter Beard photoshoots, it was a swirling circus of technicians, models, fixers, friends, and hangers-on. It was a party.

At around this time another character came on the scene and, as was

often the case, Beard embraced his new friend with the warmth and enthusiasm that he usually reserved for beautiful young women. Bernie Chase was something of an entrepreneur who described himself as a "car dealer, art collector, pop-culture museum curator and clockwork enthusiast." He had also had some association with the Rolling Stones, most significantly with Ronnie Wood. Chase and Wood had co-curated an art exhibition entitled *Faces, Time and Places,* featuring more than a hundred works painted by Wood, at a Broome Street Gallery a few doors away from the old The Time Is Always Now gallery. It was here Chase met Natalie White and, soon after, she introduced him to Beard.

So, by the time Beard and Natalie White were ready to set up the Giant Polaroid shoot, Bernie Chase had made it known that he was interested in getting more involved in the Manhattan art scene, and he seemed like the perfect financial collaborator. While Natalie invested $100,000 in the shoot, all her profits from the *Who Shot Natalie White?* exhibition, Bernie rented ten rooms at the Soho Grand for six weeks to house Beard and attendant collaborators to work on Giant Polaroid postproduction as well as further commissions he'd agreed to with Beard. According to Chase, Beard agreed for him to buy two works in progress and that he would pay $50,000 for the piece called *Snows of Kilimanjaro* and $30,000 for *765 Elephants* and then for a third piece, *Paradise Lost,* Chase would pay $40,000. The deal was done in Beard's home away from home, Natalie White's apartment.[8]

Once the work had started in the Soho Grand, Chase made it clear to everyone that he was not a "drugger or a drinker" and made it his mission to keep his client Peter Beard away from the bad influences to which he was so easily drawn. And to that end he hired a limo driver who had previously worked for Beyoncé to not only transport Beard around Manhattan but also to follow him into clubs like Provocateur and restaurants like Cipriani Downtown to keep an eye on him and keep the bad influencers at arm's length. He also hired Eva Bastianon, who had worked for Natalie White, as Beard's artistic assistant.

This mission to keep Beard as drug-free as possible was enthusiastically

supported by both Natalie and Elizabeth Fekkai and a new recruit to Team Beard, his latest girlfriend Ingrid Levin. She was, in modern parlance, an "exotic dancer," although Natalie and Elizabeth said straight-out that she was a stripper. An item in the *New York Post*'s Page Six gossip column claimed that Beard and Ingrid met at a Julia Margaret Cameron exhibition at the Metropolitan Museum, whereas they actually met in Sapphire, the strip club where Ingrid was working. Originally from Colombia, she had been married to a lawyer, but he'd ended up in jail and she was left having to support their young daughter on her own and was thus reduced to stripping in men's clubs. But Beard's current spiritual mentors—Natalie and Elizabeth—both approved of Ingrid, who was warm and kind and had Beard's well-being at heart. With such a protective cordon Beard went to work on the Giant Polaroid artworks and on the commissioned and paid-for pieces for Bernie Chase himself.

The World of Peter Beard was, however, never that simple and one night he slipped through the protective cordon and went clubbing into the early hours, creeping past Chase's bodyguard/chauffeur, and avoiding the vigilant gazes of Natalie and Elizabeth. He ended up, as he so often did, at Provocateur nightclub and by the early hours of the morning had two Russian hookers in tow. Beard's friends believe he thought they were just eager, friendly, pretty girls who were probably into drugs and having a good time, and that he would not have figured out they were hookers. Whatever the truth is, he decided to take them back to his family apartment at the Osborne and there they were as the sun came up on November 13. What happened when Nejma discovered her husband had arrived home with two Russian call girls is not clear. However, soon after, a message went out to emergency services that a man at the Osborne was suicidal and required urgent transfer to St. Luke's–Roosevelt Emergency Psychiatric Center for observation.

Beard reluctantly spent the next two days in St. Luke's–Roosevelt and when he finally got access to a telephone, he called Elizabeth Fekkai and Eva Bastianon. He told them he was neither suicidal nor insane and asked for their assistance in getting him released. They went to work immediately and

contacted Beard's lawyer, Michael Stout, who said an authorized statement from Beard was needed to free him from the psychiatric unit. Beard duly wrote a signed letter, saying, "I am of sound mind, I have no suicidal intentions and wish to be released from St. Luke's-Roosevelt as soon as possible." It worked. He was allowed to leave midafternoon on November 16.

While his friends Elizabeth and Natalie White waited in a limo outside St. Luke's–Roosevelt as arranged, ready to scoop him up and take him back to the Soho Grand to resume work, Eva Bastianon stepped forward and entered the facility to meet him in the hospital's reception area. Beard's daughter, Zara, who was now twenty-one, was also there, presumably hoping to take her father back to the family apartment at the Osborne. As Eva, Beard, and his daughter got into the elevator, Zara began crying. She begged her father to come home. Anticipating the presence of a Beard family member, Eva had taken advice from her lawyer to neither make eye contact nor to speak to that person. She held her ground in the elevator as the tearful Zara stared directly at her and proclaimed: "What is all this fucking darkness?" repeating a much-favored line of her mother, Nejma. For once Beard spoke out: "Stop this. I am working on a project, and I have to get back. Stop the crying, Zara."[9]

Beard and Eva piled into the waiting limo and drove straight to the nearest Gap store, where the women fitted Beard out with $500 of warm clothing—sweatpants, flannel shirts, and a large cozy jacket. Then they headed to the Soho Grand where Bernie Chase and the team were waiting for Beard to resume his work. He was soon in full flow, putting finishing touches to the artwork from the first Giant Polaroid shoot. Within days, work had started on the second Giant Polaroid shoot with a new parade of models, old and young, and although there was the same party atmosphere that Beard found most conducive to working, his main minders—Bernie Chase, Natalie, and Elizabeth—were keeping a close eye on his drug ingestion. On occasions when Beard left the Soho Grand, Bernie would search his room and, whenever he found a bag of cocaine hidden away, he'd flush it down the toilet. When he told Beard what he had done,

Beard merely shrugged his shoulders and smiled, apparently regarding it as unavoidable collateral damage.

Beard's physical bravery had been one of his standout characteristics since he was a boy. It had carried him through hardships and ordeals in Africa, most notably the elephant attack in 1996, and had remained with him through the various operations of recent years that had included hip replacements and cancer surgery. Now, in his seventy-fifth year, and still obdurately refusing to admit to pain or suffering, he was in clear discomfort. Bastianon noted he had ongoing stomach problems and when he would start dry retching, she and his girlfriend Ingrid would be on hand to administer a brew of baking soda and water. According to Elizabeth Fekkai, he had a prescribed stomach medicine back at the Osborne, but Nejma had refused to give it to him if he didn't return home. "I had to leave an emergency message after hours with his doctor to get him to call in a new script," recalled Fekkai, "and then I'd have to go to the pharmacy at all hours to pick it up."

Between Natalie White's financial input and Bernie Chase's investment, there was considerable money going around and whenever Beard needed cash, he was given the required sum, whatever he needed. He once asked for money to give Ingrid for repairs to her breast implants, and $10,000 in cash was quickly handed over. For some time now Nejma had been refusing to give her errant, absentee husband any money from the sale of his artworks through the Peter Beard Studio, which she was running, unless he returned to the Osborne.

During the Giant Polaroid shoot, Beard's companions were also aware that he had been suffering serious problems with his teeth. In fact, he barely had teeth, rather filed-down posts that were waiting for dentures to be fixed into place. Elizabeth had noticed that Beard now had wads of paper jammed around the posts and he explained that it was the only way he could chew his food. "I said, 'Are you crazy? We need to sort this out,'" Elizabeth recalled. "So, I called his dentist, Steven Butensky, who was also a friend of mine, and told him he had to get Peter in and make him some

teeth." Butensky told Elizabeth that Beard's teeth had already been made and were at his office. Apparently, Nejma had not wanted to pay cash for the teeth, she had wanted to trade art for them. Butensky, having already traded dental work for artworks, wanted money. Elizabeth immediately arranged an appointment for Beard at Butensky's dental surgery and paid the required $26,700 from the Beard account she was managing.[10]

As the shoot neared its end, the gathered associates—Bernie, Natalie, Elizabeth, Eva Bastianon, and Ingrid Levin—felt they had kept him in check quite successfully. Then, as they finished the final shoot, with everyone exhausted and ready to go to bed, Ingrid let her guard down and the assorted enablers were all over them, supplying coke, dope, whatever Beard wanted, through the night. They went out on the town, and Beard ended up back at the Osborne as the sun was coming up, attempting to get back into his first-floor apartment. He later told friends Nejma had refused him entry. He apparently spent the first hours of November 22 lying on the marble floor of the Osborne's lobby restlessly tossing and turning.[11]

Later that day Beard was driven to his Montauk home, where Zara was waiting.[12]

During the night he suffered his first stroke. Zara woke up to the sounds of her father gasping and trying to drag himself across the floor to the bathroom, apparently attempting to run a hot bath and warm his cold body. Zara called her mother and while she was waiting for the ambulance to arrive, Zara identified classic stroke symptoms—he was paralyzed on his left side and was unable to stand or walk or form a smile on the left side of his face. The medics confirmed that he'd had a stroke in his sleep and later that day Beard was transferred to New York Presbyterian Hospital on East Sixty-eighth Street.[13]

Having settled into his hospital room and starting to recover, Beard discovered that his old friend Peter Duchin had also just been admitted to New York Presbyterian with a similar condition.

The two old Yalies, who ran together as young men and had remained friends throughout their lives, had both suffered strokes on the same day. But while Duchin was grateful not to be impaired and happily accepted

the hospital's recovery program, Beard was straining at the bit within twenty-four hours of admission and was desperate to get out. He complained to Duchin about the medication he was being given and told him, "I can get better meds at home."

Such was Beard's iron constitution that after just two days in the hospital, he was discharged and returned to his apartment at the Osborne. He appeared to recuperate quickly and, according to Bernie Chase, was eager to get back to work at the Soho Grand. On December 10, Bernie Chase picked up Beard from Fifty-seventh Street and took him downtown to the Soho Grand where he happily resumed postproduction work on the Giant Polaroids.

(According to Zara Beard's affidavit in the court case between her parents and Natalie White "on or about December 10 my father left the apartment without his jacket or shoes to speak with Bernie Chase who the doorman advised me had arrived unannounced and was waiting in the lobby of our building. According to the doorman my father got into the car with Chase.")[14]

On December 20, 2013, Gary Lippman and Vera were married at City Hall and after a quiet celebratory lunch they were wandering through SoHo when Natalie White called Gary. "I'm with Peter at the Soho Grand, working on an art project," said Natalie. "Why don't you come by." When they arrived, they found Natalie and Beard working on the Giant Polaroids. "Peter was wearing sweatpants and told us about his recent stroke," Lippman said. "He was saying how good his doctor at New York Presbyterian Hospital was. He didn't seem impaired at all, just a little less vigorous than he had been in the old days but perfectly capable of working on his Giant Polaroid project and still retaining his mischievous glint in his eye," which suggested to Lippman that Beard was just fine.

The following day Zara drove to the Soho Grand and picked up Beard and they drove out to Thunderbolt Ranch,[15] with no further health scares, to spend Christmas with his family. He spent several weeks out there, and it was during this period he began to convince himself, or allowed himself to be convinced yet again, that the Manhattan crew were taking advantage

of him. He decided to do no more work on the Giant Polaroid project and did not return to the Soho Grand.

He did, however, move briefly into the Bowery Hotel in February, to spend a few days and nights with one of his most enduring mistresses, Maureen Gallagher, the woman he called the ultimate living sculpture. "We had a great few days," Maureen remembers, "and we were just goofing around, just like the old days. He did promise me he would get me some of his art. I've never had a copy of *The Night Feeder*. He did promise me a copy. But it never happened." Maureen said they were in and out of each other's lives for twenty years "and he told me that I was the love of his life." She said that usually when they hooked up, as they had at the Bowery, they would spend six months seeing each other, and then drift apart again. This time, she was unceremoniously bundled out of their room because Beard told her his lawyer was going to hold a meeting in there. "I had to remove all my things from the room within 10 minutes," Maureen said. "I had to throw all my shit in the stairwell and wait for them all to leave. I was devastated."[16]

It was the last time she saw Beard, but however humiliating that last tryst was, she remained loyally in love with him until the day he died.

At around the same time, the publishers at Taschen were beginning to prepare the fiftieth anniversary edition of *The End of the Game,* and Beard asked the novelist and travel writer Paul Theroux if he would write the introduction of the new edition. The pair met in Manhattan over drinks and immediately struck up a warm friendship. Theroux's own experiences as a schoolteacher in Malawi and later running rural education projects in Uganda bestowed on him a similarly bleak vision of the future of the continent as Beard's. He says he had tried to remain hopeful, "but eventually I saw that no one in the government really cared, and the aid agencies were self-serving and that—being wide open, full of possibilities and people looking for handouts—Africa was a free-for-all. Peter ably documented it in his photographs."

Theroux duly wrote just the kind of dyspeptic introduction Beard was looking for, sharing his despair at the West's destructive intervention in

the continent. "In spite of all the anti-poaching campaigns and the horrific imagery in Peter's pioneering book, the killing of elephants for their ivory in Africa is perhaps greater now than at any time in history," he declared.

The two men maintained contact over the coming years, and Theroux says that the trait he admired most in Beard was his generosity. "Yes, he had influence, good looks, and many friends, but he was one of the least selfish people I have known. To me, he was a kind of Sun King—always responded to a message from me, always rewarding me with friendship, and I think that was his appeal, that he made himself available to a fault. I've come across many writers, artists, journalists, and always they seemed to me self-involved and rather mean and somewhat unbalanced. Peter was wholly sane, completely involved in the world and to my mind a wonderful artist and a great soul."

In April, Beard and Nejma flew out to Kenya following the death of her father the previous month. Beard took this moment to spend a last few days at Hog Ranch, now rather run-down and neglected, as Gillies Turle had long since departed. On that visit, Nejma yet again turned on an old former friend and accused him of stealing Beard's artwork. This was Guillaume Bonn, the Franco-Kenyan photographer who had aroused Nejma's displeasure some years earlier by publishing a book perfectly legitimately with an accompanying DVD, entitled *Scrapbooks from Africa and Beyond*. The hourlong film, an excellent piece of work marking Beard's last days in Africa, is notable because it captured the harsh aftermath of the 1996 elephant attack and provided powerful evidence of Beard's bravery and devil-may-care approach to life. Up until then Nejma had had perfectly convivial relations with Bonn. Now her accusations centered around a missing print from the Hog Ranch kitchen years later, which Bonn had allegedly grabbed and stuffed under his jacket, then sprinted into the woods with Hog Ranch staff in pursuit.

On one of his last days at Hog Ranch, Peter Beard, with an old friend in tow, listened to the accusations as described by one of the Hog Ranch staffers who, the friend said, was clearly playing to Nejma's version of events. When the staffer finished his narrative, the friend turned to Beard

and said: "Peter, it's clear to me that this story is an absolute bullshit lie from start to finish."[17] Beard just burst out laughing, as if he knew very well it was a preposterous fabrication but was going along with the account to please his wife. This was a familiar scenario in Beard's later years when his interest in keeping the peace with his increasingly hostile wife overrode any attempts to align himself with the truth. Typically, in such circumstances he would just shrug his shoulders and say, "It's all bullshit anyway." Unfortunately, this left behind a trail of betrayed friends and broken friendships.

At the end of that final Kenyan visit, Beard's old friend Tony Archer held a lunch for Peter and Nejma, a most convivial affair with much talk of the old days. Gillies Turle was in Nairobi that day and was eager to see Beard. He'd been told by Tony Archer to wait until Nejma had left the lunch and then come over, which is precisely what he did. Then for an hour or so the two old friends, the two proprietors of Hog Ranch's history and mythology, talked of the good old days and then parted for the last time. It was a poignant and all-too-brief meeting but, as Turle later observed, it was better than not meeting up at all.

19

Sorry About All the Bullshit, Man

Nejma once proudly told an old Nairobi friend Davina Dobie that in the early 2010s she had forty-four court cases running over the use and ownership of Peter Beard's artwork. This may have been an exaggeration, but she was most assuredly issuing writs against many people who thought they were working with, indeed alongside, Beard at his own request. One such target was his former collaborator and lover Natalie White, and the language and sentiments expressed in the lawsuit were familiar to anyone who had suffered Nejma's wrath in the past. It read: "This is a case about how Defendant Natalie White used lies and deception to leech onto well-known 76-year-old wildlife photographer Peter Beard in an effort to take advantage of his celebrated artistic talents, all in the name of enriching herself at his expense. Now, through an unconscionable purported consignment agreement which White duped Mr. Beard into signing at a nightclub during a night of drinking, and another alleged oral agreement, she continued to exploit him for her own personal and financial gain."

Among the accusations leveled against Natalie in this suit, filed in September 2014, were that she "pursued Mr. Beard in an effort to be a constant figure at his side, falsely branding herself as Beard's model muse" and that Natalie and Elizabeth Fekkai had "sold, copied and given away various Beard works from the (Giant Polaroid) photo-shoot without Beard's permission and

without remitting a dime to him." Further serious accusations were followed by a damning depiction of Peter Beard himself, describing him as someone who "suffers from memory loss, confusional episodes, hearing and vision loss, as well as other serious mental and physiological impairments, and lacked the capacity to contract at the time of the agreements."[1] It was hardly a flattering portrait of a man of whom his assistant at the time, Eva Bastianon, had said she was unable to keep up with, a man who, even now, well into his seventies, had such a voracious appetite for life that many of those who were decades younger were left trailing in his wake.

The Beards were responding to an initial lawsuit that had been filed by Natalie White's attorneys back in May 2014, when they were still in Kenya. In that lawsuit Natalie claimed to have invested her life savings of $100,000 in the Giant Polaroid project and that she and Beard had signed a contract that would give her fifty of the one hundred photographs to sell and thus recoup her outlay. At the time of the lawsuit, she had received only sixteen images and she claimed that Nejma, who she described as "possessive and estranged . . . forbade Mr. Beard, and actively prevented him, from abiding by his contractual commitment."

These lawsuits kicked off an unedifying period in the life and times of the Beards, when they appeared to be almost constantly in court, suing everybody in sight either for possession of unsigned artworks or for generally "leeching," to use Nejma's oft-repeated phrase, off Beard's celebrity. Suddenly, anyone in possession of a piece of Beard artwork was in danger of ending up in court or, at the very least, being challenged about the legitimacy of ownership. In some cases, these involved pieces of work that had been bought decades earlier at The Time Is Always Now. The Beard family, with Nejma at its helm, appeared to be going after everyone. Beard himself seemed to be going along with it, much to his friends' distress, in some instances turning against old allies and giving evidence in court that wildly contradicted events as they remembered them taking place.

As the Beards were beginning to resolve the Natalie White suit and countersuit, they went after Bernie Chase. Nejma testified that she and

her husband had launched this particular lawsuit because Chase was "a pathological liar" and "a parasite" who was trying to steal artwork from her husband. She also stated that Natalie White and Elizabeth Fekkai were "involved in the scheme."[2]

Beard claimed that he had neither agreed to sell Chase the three works of art in question—*Snows of Kilimanjaro, 765 Elephants,* and *Paradise Lost*—nor had he been paid for them in the first place. In court Beard was asked to confirm an affidavit he had signed in connection with the lawsuit. He said he had not read it before signing it, saying, "It was just words. Unbelievable. In a huge area of bullshit." He also apologized to Chase from the dock, saying, "Bernie, I didn't say that. It's not even my signature." Beard denied having been hospitalized for a dangerous quantity of drugs in his system although he said he "possibly had a little, not too much, marijuana" and there "could have been cocaine."

After Beard's bumbling performance a recess was called, after which his lawyers said that he was too stressed to continue his deposition.[3]

In Chase's deposition he explained that he and Beard had "hit it off" after being introduced by Natalie White, after which the pair agreed that he would pay Beard $80,000 for the two works and a further $40,000 for the third. And that these payments had, by mutual agreement, been made to Natalie White, some of which contributed to Beard's much-needed dental work and some to his girlfriend Ingrid Levin's breast surgery. He also revealed he had paid more than $80,000 for rooms and charges at the Soho Grand between October and December 2013. He also denied that Beard had been impaired in their time working together and said that he had appeared "lucid, coherent, and in command of his faculties" as had been demonstrated by "the outstanding works he created at the time."

Chase's case was supported by evidence from Natalie, Elizabeth, and Eva Bastianon, all confirming his side of the story. Natalie revealed that Beard had complained to her that "other people" controlled his finances and that he wanted her to help him generate income without the involvement or interference from these other people. At her deposition Natalie

made it clear that she meant Beard wanted to make money without Nejma having access to it. She said normally she would receive a 15 to 20 percent commission on works she sold for him. She also explained how Elizabeth Fekkai had opened a savings account for Beard, at his request, and how the two women made cash withdrawals for Beard on demand, pointing out to the court what everybody had long known about Beard—that he had never carried either credit cards or a mobile phone.

While Natalie and Elizabeth were unquestionably working with Beard at his request and their collaboration was a long-standing one borne out of mutual affection, Chase's arrival on the scene was brief and somewhat more opportunistic. Although he said he had been a fan of Beard's work for years, he was regarded by many as a wheeler-dealer always on the look-out for the quick chance. When Natalie introduced the two men, she saw him as a wealthy, flashy, slightly disreputable character who could help finance the Giant Polaroid shoot. He had instinctively seen a way of making good money out of Beard's art and although he undoubtedly bought the three disputed pieces in Natalie's apartment with a handshake as he claimed, he knew he was getting a real deal.

Although he didn't conceal this from Beard, Chase had not bought the three pieces for himself. He initially claimed to have bought them for friends—one was signed "special delivery" to Bob Dylan, another to Mick Jagger, and the third to his son—but they were actually bought through his art company SVSD and at least one piece was on display in February 2015 at the opening of Hoerle-Guggenheim, a New York art gallery in which he was an investor. A few months after the gallery opened, a staff member at Hoerle-Guggenheim offered the London gallerist Michael Hoppen two of the works for sale—*Snows of Kilimanjaro* for $320,000 and *Paradise Lost* for $240,000. Understandably perhaps, Chase's affection for Beard's artwork took second place to his commercial instincts.

Equally understandable was Nejma Beard's burning antipathy toward Bernie Chase. He had visited her at the Peter Beard Studio at the time he

was helping underwrite the Giant Polaroid shoot, claiming to be representing Ronnie Wood and the Rolling Stones and wanting to buy Beard art from the studio for his clients. He made no mention of the fact that he was meeting with her husband on the side, had bought three works from him in a handshake deal, and that he was helping finance the Giant Polaroid shoots. In his New York State Supreme Court deposition, Chase admitted to lying to Nejma about representing the Rolling Stones and equally admitted not mentioning that he was funding her husband's off-piste operation.[4]

Around the same time Chase was also found to have bought several small pieces from Beard's Montauk friend Noel Arikian and between twenty-five and fifty pieces from Anthony Caramanico, Beard's friend and sometime caretaker at Thunderbolt Ranch. Both men had had long and close relationships with Beard over the years and both were frequently given artwork in exchange for favors done; Arikian still has a large assortment of Beard artwork on the walls of his house. Caramanico's was a more significant collection and Chase admitted paying some $400,000 for it.[5] As it happened Chase also managed to persuade Beard to sign and thus authenticate many of the Caramanico pieces, while the pair were still working on the Giant Polaroid shoot, and that added exponentially to the value of the photographs. As always, Bernie Chase knew how to turn a profit.

Part of the problem was Beard's profligacy and his willful irresponsibility with money. All his life he had refused to carry credit cards and when not depending on the generosity of friends and hangers-on to pay bar and restaurant bills, he would be happily giving away artworks to settle his bills. He was equally generous with friends and acquaintances, offering valuable pieces at the merest whim, even to people he had just met, as had been the case with Gary and Vera Lippman.

All of which made Nejma incandescent with rage. Since she had dispensed with the services of Beard's longtime commercial partners, Peter Riva and Peter Tunney, and had more recently loosened her ties with the loyal, long-term

gallerists David Fahey and Michael Hoppen, she'd been attempting to control the Peter Beard art market via the company she presided over, Peter Beard Studio, LLC. The major hindrance was not, as she seemed to believe, the "parasites and leeches" who were out there feeding off Beard's generosity, but her wild, wayward, and headstrong husband himself. Decades earlier, when Beard and Nejma had first escaped the confines of her Kenyan Muslim household, old friend Mirella Ricciardi had asked Nejma if she was sure she was doing the right thing running away with Peter Beard. "Don't worry, Mirella. I'll tame him," she had said.[6] And yet, up to this point, it was something she had signally failed to do.

At the end of the round of court cases, Natalie and the Beards settled out of court and in the Bernie Chase case, Judge Charles Ramos found in favor of the Beards, although Chase immediately lodged an appeal, and that case continues to rumble through various courts. It seemed that being involved in litigation was second nature to Nejma, the daughter of a High Court judge whose two brothers were also lawyers in her native Kenya.

During this litigious period, it was not just the Beards who were issuing writs. They were also on the receiving end. At the beginning of 2017, the actor and comedian David Spade sued Peter Beard Studio in Los Angeles Superior Court over a piece of artwork Nejma had refused to authenticate. He had bought it from The Time Is Always Now in December 2001. In all, he had purchased four Beard pieces and in 2014 had sold two of them for considerable profit. One—*Orphan Cheetah Triptych (1968)*, which Beard had come to loathe—was sold for a record $765,000 by David Fahey. The disputed work was *Untitled (Elephants)* and, according to Spade's lawsuit, he'd believed "it was an authentic, completed and signed work by Mr. Beard that was authorized by Tunney to sell."[7]

In fact, when Spade had approached Fahey to sell the piece, the LA gallerist had assumed authentication would have been a formality, given that he had an invoice from Tunney and that Beard had signed the piece, albeit using the word *Ndefu* (a Swahili word meaning "long") which was

the name of Beard's company, rather than his own signature. Fahey said he could DHL a copy of the invoice with the rolled-up artwork to Nejma and Peter could then sign it. Nejma refused point-blank. Months later Fahey phoned Nejma to explain the issue from his client's side, but she said she could not talk to him about the case, presumably because she regarded it as sub judice. Fahey quite understood her position.

An old friend also took them to court in 2016. Judith Young-Mallin, the surrealist art collector and author, sued the Beards for $200,000, claiming they had stolen back a diary Beard had given her three decades earlier. She said Beard had given her the diary in exchange for allowing him to store his possessions in her art-filled Greenwich Village apartment while he was going through his divorce with Cheryl Tiegs in 1986. A year earlier Young-Mallin had decided to donate the elaborately decorated diary to a museum. When the museum asked for authentication, Young-Mallin took the diary to Nejma, expecting her to sign off on it; instead she took back the diary. Judith Young-Mallin died in New York in September 2020.[8]

In the middle of all this legal activity, the Peter Beard Studio decided to put together a summer retrospective entitled *Peter Beard: Last Word from Paradise* at Guild Hall in East Hampton, New York, ironically just a few weeks before their nemesis Natalie White had chosen to exhibit at the Gallery Valentine, which was just around the corner. That show was set to feature "never-before-seen photos" from the 2013 Giant Polaroid shoots. Even though the court found in Natalie's favor, Gallery Valentine owners Ryan Ross and former Sony Records impresario Tommy Mottola received a threatening letter from the Beards' attorney Judd Grossman.[9] The letter claimed violations of copyright law and accused the gallerists of being "opportunists," although for once Nejma's standard terms of abuse, "leeches and parasites," were missing. Grossman threatened "immediate injunctive relief" as well as "monetary damages." Neither the gallery nor Natalie White believed these legal threats had any merit and went ahead with the exhibition.

The Beards' Guild Hall exhibition was remembered by Beard followers

as a strange affair. First, Gregory de la Haba, by this time an artist, exhibition curator, and art critic of some reputation, had driven out to the Guild Hall to review his mentor's latest exhibition for his own art publication *Quiet Lunch,* arriving with the photographer Michael Halsband. When he got to the front door, security told de la Haba he was banned from entry. Halsband was allowed in. Instructions had come down from Nejma Beard that de la Haba was persona non grata, a dubious accolade Gregory assumed he had earned because he had curated the *Who Shot Natalie White?* exhibition which had celebrated one of Nejma's enemies as principal muse. As it happened, de la Haba hung around outside Guild Hall waiting for his friend Halsband to reappear and as the show wound down, so Peter Beard emerged into the evening light. "Hey, Gregory, how are you?" Beard said warmly. "Sorry about all the bullshit, man."

Another attendee at the exhibition was Susan Zakin, the investigative journalist who had been working on the controversy surrounding Beard and Gillies Turle's *Art of the Maasai* artifacts. She was very eager to meet Beard, rather hoping to discuss some of her findings supporting the Beard-Turle assertion that they had discovered a treasure trove of previously hidden Maasai traditional artifacts. Among her major sources had been the respected anthropologist Rod Blackburn, a friend of Beard's, in the United States, so she felt they had a great deal to discuss. She arrived at Guild Hall, having failed to connect with him over several years as she had always been blocked by Nejma, who had claimed that his health was too poor for him to do interviews. When she met Beard, she explained that Nejma had refused to let her interview him, and he said bitterly: "I don't care."

Zakin also handed Beard a signed copy of her first book, a history of the US conservation movement, and as she was attempting to make conversation, a burly bodyguard snatched the book from Beard and soon admirers were engulfing him. An awkward conversation with Nejma ensued but then Zakin left the exhibition chastened and disappointed.[10]

Nejma, by this time, was constantly trying to claw back old photographs, old collages, and small pieces, often at the cost of decades-old friendships. In fact, as time passed, she seemed increasingly uninterested in maintaining ties with any of her old friends—not the least because most of them had been established through Peter Beard. And this coincided with her determination to organize, monetize, and control the Beard art catalog, a herculean task that was made all but impossible by her husband's decades of trading and generously gifting his art for questionable commercial return.

Some of Beard's old Kenyan friends were convinced that Nejma's motives were more mercenary than altruistic and what baffled many was why Beard seemed to endorse her bad behavior without question. Calvin Cottar was one who was particularly stung by Nejma's harsh rebuttals. When Calvin's mother, who had welcomed Beard into the Cottar family home in his early Kenyan days, was dying of cancer, he contacted the Beards, asking them if they would send a piece of Beard art for his mother for old times' sake. "All Peter's pictures of lions charging and buffalo shot were taken when he was with my dad," said Cottar, "and I know my mum would have loved to have had a reminder of those days. I thought Peter would say yes—the old Peter certainly would have. But Nejma replied, basically telling me to fuck off, and saying that they didn't do charity. I was disgusted."

By now, Nejma's mission seemed to be to pluck every dollar from the artistic money tree. In one such mercantile confrontation in 2015, she casually discarded a close friendship with Jay McInerney and his wife Anne Hearst that had gone back decades. It started when Sotheby's conducted an auction on behalf of the Africa Foundation, a wildlife NGO Beard supported and to which he had offered a particular piece of art, a dramatically beautiful piece featuring the model Magritte Ramme lying naked beside two record-breaking elephant tusks in the British Museum. Although the McInerneys had forgotten to bid on the piece at the time, an art dealer friend called after the auction to tell them that it had not sold. They then visited the gallery where the piece was hanging

and asked for the reserve price. The reserve was in the low hundreds and the delighted couple bought it to add to their already impressive Beard collection.

Weeks later Anne Hearst received a message from Nejma saying they hadn't paid enough for the piece and that it was worth much more. Anne was indignant. Soon after, Jay received a telephone call from Peter Beard who, after gleefully recalling their clubbing times together in the 1980s, then cut to the chase—he told his old friend he thought he could afford to pay much more for the artwork. "I told him the point was I paid the reserve price for the piece and that was that," McInerney recalled. "Then I said, 'Is Nejma standing right beside you?' And he said, 'Yes.'"

What baffled so many of the couple's friends was why Nejma would sacrifice lifelong attachments for what appeared to be relatively small financial gains and, more importantly, why Peter Beard was prepared to go along with it. These were, after all, his friends. In Nejma's case it became increasingly apparent that this socially awkward, skittish, chain-smoking woman from a harsh, isolated Muslim background had never quite come to terms with the social milieu Beard inhabited. At his exhibitions she would be found hanging around the doorway smoking cigarettes while her husband was swirling about at the center of the gallery enchanting every beautiful woman in sight and at the same time charming most of the men. Even at Hog Ranch, which, after all, was one of her marital homes, she would be in the shadows of the flickering campfire while Beard and friends were all holding forth at the center of the fire's glow. Wherever and whenever she was in his company she seemed merely a neophyte and more than that . . . the perpetually wronged woman. And so she did what Jacqueline, Picasso's much-loathed Governess, did. She took control of her principal asset and slowly cut him off from the sources of his energy, his inspiration, his creative endeavors—people. Arianna Huffington's scathing assessment of how Jacqueline Roque gained control of the great artist's world bears repeating here: "Picasso became the tool through which she could assert her will over the rest of the world, the means through which she could experience a sense of power

that, even if her imagination had not been limited as it was, she could never have imagined possible." As always, Peter Beard was right when he bestowed the title of Governess on Nejma from his hospital bed in New York.

20

The Prisoner of Thunderbolt Ranch

After 2017, Nejma finally had Peter Beard to herself. He could no longer jump the fence to head off to nightclubs or to sneak out for drug-fueled binges with some of his more salacious acquaintances. Having by now suffered three strokes and been advised by his doctors to take it easy, Beard was finally slowing down.[1] At the same time, Nejma was now repelling all requests from most of her husband's old friends to visit him, arguing that they would bring drugs to Thunderbolt Ranch and thus lure Beard down the road to hell. It was, in fact, a somewhat misguided judgment call, first because most of those wishing to visit Beard did not take drugs, and second because he had his own supplies, as his old Kenyan friend Davina Dobie discovered when she managed to break through the Nejma cordon sanitaire back in 2013. She and Beard had worked on a painting together and Davina headed out to Thunderbolt Ranch to pick it up. "Nejma was furious when I went out there," Davina remembered. "She didn't want anyone to see Peter, but I said this is my painting and I'm coming to pick it up." She had also taken her daughter Tanira out with her and while Nejma was walking Tanira around the property, showing her the burnt-out mill, Beard and Davina were in his living room/studio. "He said conspiratorially 'Big D, Big D, come and sit over here' then he brought out one of his diaries, opened it up, and there was a packet of cocaine tucked inside. 'Want a line?' he said with a wicked grin."[2]

However, Nejma's campaign to cut Beard off from his wide circle of acquaintances and connections dated back some years and involved not just visits to Thunderbolt Ranch but even attempts to contact him by mail. Sometime in 2014, Cheryl Tiegs had just finished a celebratory graduation dinner at Nobu restaurant on Fifty-seventh Street with her son, Zachary. She was last to leave and as she was walking down the restaurant's stairs she heard someone calling out, "Cheryl, Cheryl . . . Hello." She turned around and "I thought that's a handsome man. Then I realized it was Peter Beard." They had not seen each other for more than thirty years. He was sitting in a booth with his daughter, Zara, and a few friends, and they all politely moved away to give Cheryl and Peter a few moments alone. "I told him he had been the love of my life," remembered Cheryl. "And that I was sorry that any of the things I may have said at the time had hurt him. I told him that I did love him deeply, and he said that he thought about me too. Which wasn't the same thing." Beard then asked Cheryl if she knew he had had several strokes. She replied that not only had she known but she had written him a letter commiserating and asking after his health post-stroke. Beard said: "I didn't see the letter. It's my wife. She would have hidden the letter. She hates me." Cheryl laughed and said: "Peter, you're an easy person to hate."[3]

What many of the old acquaintances wondered was why Beard allowed Nejma to rule his last years in such an authoritarian manner and why he supported her aggressive vilification and isolation of them. After all, Peter Beard had spent his life shaking off the shackles of conformity, bucking against conventional wisdom, turning his back on orthodoxy. He was a rebel in so many ways and yet here he was, obeying instructions from someone he told many people he had married only to help get her a green card and to liberate her from her strict Muslim family in Kenya.

After not seeing Beard for some time, Peter Tunney bumped into his former friend and business partner at Cipriani Downtown, the restaurant that was just a block away from The Time Is Always Now and that they had once regularly frequented together. Suddenly they found themselves standing in front of each other having last been separated by a rancorous court

case in 2001 and a campaign of vilification directed at Tunney by Nejma. Tunney introduced Beard to his new wife, then looked him straight in the eye and said: "What the fuck?" Beard placed his wrists together as if bound and said: "I'm handcuffed, buddy. I'm so sorry."

Was he really handcuffed? Was he really a prisoner at Thunderbolt Ranch who was occasionally able to scale the perimeter fence, flee into Manhattan and indulge in his chosen sins, mainly drugs and women? Life-long acquaintances have said that Beard, despite professing adoration to a string of women in letters and endless international phone calls, never really loved any one of them, that the sociopath in him permitted only one true love, and that was Zara. He constantly referred to Nejma as "the professional mother," but he more than likely meant she was the true matriarch of the family, running and, most importantly, controlling the Beards' business in ways that he simply couldn't. When it suited him, she was the bad cop he needed to keep things on the rails.

One of Beard's most commonly observed social traits throughout his life was his ability to befriend anybody in an instant, whatever their background or interests or modus operandi. So it was with Jacques Guillet, one of those all-purpose Manhattan entrepreneurs who dabbled in everything from property development to film production. When he and Peter had become friends in 2006, he was dealing real estate in Harlem and they spent some time together, with Jacques taking Beard to job sites where he seemed to enjoy learning about the minutiae of property renovation. Jacques remembers they had an easygoing, freewheeling friendship and "Peter was really great fun to be with." Then, in September 2019, after trying unsuccessfully to reach Beard by phone in Montauk for more than a year, he decided to drive out to Thunderbolt Ranch to see how his old friend was doing. He remembers it was a lovely fall afternoon and he drove out with his friend, the art collector Imre Pakh, arriving sometime after lunch and finding Beard in the garden, playing with a dog. Guillet said that Beard seemed delighted to see them, and they spent some time together before Beard had to go off to a doctor's appointment. They walked along the cliff adjoining Beard's property shooting the breeze. "It was re-

ally good to see him after such a long absence," remembers Guillet. "And he was clearly glad of the company. He was a little frail but was engaged and perfectly *compos mentis*."

The following morning Guillet received a call from the local police telling him that the Beard family had asked that the next time he wanted to visit he should call in advance and make an appointment. "Nejma doesn't like me," Guillet said. "She sees me as part of a group of sycophants who are seeking celebrity by being associated with Peter. Which is just nonsense." That was the last time Guillet saw Beard.

An even more harrowing exchange with Nejma and daughter Zara was experienced by Paul Forsman, former male model, photographer, Hamptons resident, and good friend of Peter Beard's since the late 1980s. Forsman, who is married to the heiress Cornelia Erpf, had also tried to contact Beard for more than a year, phoning Thunderbolt Ranch, leaving messages, but never getting a response. One fall Sunday he and another one of Peter's friends, the artist Conrad de Kwiatkowski, decided to drive out to Montauk and hopefully see Beard. They left their car at the next-door neighbor's property and walked across to Thunderbolt Ranch where they found Beard, who was clearly delighted to see old friends. "We told him we were next door at the old Richard Avedon house," said Forsman. "And he said he wanted to come over with us. So, we started walking through the bush, Peter leading the way.

"Suddenly, Nejma came out of the house and started yelling at us, saying we weren't allowed on her property and that Peter was not well enough to come with us. She accused us of trespassing and ordered us to leave. Peter told her that we were not trespassing and that it was his property anyway. He told her he was coming with us and he did."

The three friends then managed to spend an uninterrupted hour sitting out in the fall sunshine on Montauk Point looking out over the Atlantic Ocean. And then Beard's family returned. "Zara arrived and said, 'Dad, let's go. We don't need to hang out with these people.' To which Peter told her that we were his friends, and he was staying." The row escalated and, according to Forsman, Zara became verbally abusive, shouting at her father

that he had "to get the fuck out of here." At this point Zara threatened to call the police. As the exchange had become increasingly hostile, Beard decided to relieve his friends of further suffering and reluctantly shuffled off in Zara's wake toward the parked car, where an equally angry Nejma was waiting. "That was the last time I saw Peter," said Forsman. "It was sad to see him led away like that after we'd had such a pleasant time just sitting around talking."

In January 2018, Peter Beard celebrated his eightieth birthday with a small party in the Hamptons. His loyal nephew, Alex Beard, was not invited but had seen him a year earlier at Anson Beard's eightieth, where he told a friend that he thought "Peter was no longer sharp." Alex had fled Manhattan in 1994, tired of being in the shadow of his infamous uncle and eager to set himself up as an artist in his own right. He has lived and worked in New Orleans since then. Beard's old Yale buddy Peter Duchin, now a resident of the Hamptons, did attend the party and by this time he was visiting his old friend at Thunderbolt Ranch quite often. They would go out and sit on the rocks and talk about art, old times, and the pretty women they had both chased after in the 1960s. (Duchin's assistant Adelle Dyett, a Trinidadian, described the two womanizers as "panty runners.") "His brain was probably damaged, and he didn't track," Duchin remembers, "but I'm pretty sure he didn't have a disease like dementia. It was just a lack of ability to continue an idea. He seemed to be completely aware of it, but he wouldn't have said anything out of pride. He'd have been curious about it. He'd have said, 'It's fucking weird.'"

Another of the few who managed to penetrate the Nejma cordon sanitaire was the author and Africa hand John Heminway who, in the early 1960s, had followed in Beard's footsteps by traveling to Africa as a sixteen-year-old with Darwin's grandson Quentin Keynes and then some years later returning under his own steam and forming an ineluctable bond with East Africa. It was in 1966 when he had first walked into the Thorn Tree Café. "And there was Peter Beard with this extraordinarily beautiful woman," said Heminway. "Of course, I knew who he was. I looked at him and thought that was the meaning of being a man in Africa. He was so

very handsome, very laid back, and he had just swum through crocodile-infested waters. To my regret, I didn't drum up the nerve to go over and talk to him." However, they did become friends and throughout their lives their paths continued to cross in Africa and in New York. He was also one of the few of Beard's friends Nejma allowed to visit at Thunderbolt Ranch. Heminway was last there in the summer of 2018, and he noted that "Peter was obviously failing. It was sad to see because at his peak he was wonderful—he had no sense of himself, he had no interest in creature comforts as most of us have, and he was a natural child of the bush."

In death Beard, for all his well-known faults, has remained loved while his widow remained feared. As one gallerist, too nervous to be identified, said: "Nejma is a woman scorned and thus very dangerous. The way he treated her [was not good], even though he trusted her, and she was the gatekeeper. He gave her the keys. I always assumed she wanted to pay him back somehow." Many argue that her most pitiless act of revenge was to accuse Beard of sexually molesting their daughter publicly in *Vanity Fair* magazine and to any friends who were prepared to listen in the 1990s. However, in the months following Beard's death, Nejma tried to rewrite the narrative of these molestation charges, implying that misinformation had come from a source whose identity she refused to reveal. Following up, Zara herself told a journalist that the molestation charges had been fed to her mother by a close connection of Beard's and that Nejma, rather than being the initiator, had been the unwitting victim. This does not, however, jibe with what she told *Vanity Fair*'s Leslie Bennetts at the time those accusations were first made public. She had said to Bennetts that "this is something that's very, very serious. I literally begged him to go and get help, but he didn't want to . . . I did my best to help Peter out of this, but when he refused to deal with the situation that existed in our family, I had to leave."[4]

Long after Peter Beard's death, the molestation accusations continued to hang in the air like a toxic cloud, providing seeming evidence to his enemies that beneath the laid-back exterior and the stoned affability lurked a dark and threatening character, a sociopath capable of molesting his own

daughter. However, to his friends and admirers, many of whom Nejma regarded as no more than "a bunch of hangers-on and sycophants and third-rate human beings,"[5] he remained a flawed but magnetic and fascinating life force whose presence greatly enhanced their own lives. Needless to say, these friends were adamant that it was out of the question such a proper, sometimes conservatively modest, WASP would do such a thing to his precious daughter. "Zara was the only thing that Peter loved," said Peter Tunney. "For all the affairs, Peter actually lived a loveless life and didn't give a shit about anything. He just loved that little girl."[6]

Such is the residual affection for Beard that early in 2021, a year after his death, when Guillaume Bonn held a free screening of his film *Peter Beard: Scrapbooks from Africa and Beyond* at an informal beach bar on Kenya's Manda Island, he was expecting a small number and was surprised that more than a hundred people turned up. The film was received rapturously and confirmed to Bonn that Beard's legacy would live on. Among the notable—and it must be said most ironic—scenes in the film is a sequence of Nejma explaining how Beard had come to propose marriage to her. She says he had arrived in a three-piece suit—a most uncharacteristic sartorial flourish—"and he goes down on his knees and cries for four days. No woman can resist a man who cries for four days. He said, 'You don't understand. I'm a one-woman man.' He said, 'I'm going to be so faithful, and I'll never leave you.'"[7] Nejma admitted she believed this. Beard's friends found it barely credible that he cried for four days over a marriage proposal, given his views on marriage, particularly as he constantly repeated to friends that he had only married Nejma to help her get her a green card.

A mile away from the Manda Island screening on neighboring Lamu Island, Gillies Turle and his longtime partner and fellow Hog Ranch resident Fiammetta Monicelli were leafing through old notes and mementos from the camp's glory days. Turle brought out photographs of them sitting around the Hog Ranch campfire, of him cozying up to Iman, both radiating youthful enthusiasm and optimism, of Beard feeding Thakar I, the largest and most aggressive of the camp's warthogs. Then he found a more

recent black-and-white photograph of Nejma and Peter at Thunderbolt Ranch. To me, "Nejma looks like a prison warden," he said ruefully.

Soon after the Manda screening of Guillaume Bonn's film, a small group of old friends of Beard's who were traveling through Kenya attempted to visit Hog Ranch in the company of Rick Anderson, chairman of the wildlife conservation charity AFEW (African Fund for Endangered Wildlife) that had bought Hog Ranch back in 1996. They arrived at what was now a run-down, overgrown remnant of Hog Ranch, and were immediately confronted by *ascaris* (security guards) who had been employed by Nejma to guard the property and repel intruders. Anderson tried to explain that AFEW now owned the property and that he was clearly entitled to be on land his organization owned. The *ascari* was equally emphatic that his employer—whom he identified as Nejma Beard—was in charge of who entered Hog Ranch and who was prohibited, and he thrust a document at the speechless Rick Anderson. It was a "Visitors' Agreement" addressed to those whom had been granted permission to be on the property. It contained a long list of terms and conditions intended to protect the Beard family from intrusions, and it even stretched to reimbursing "the Beards for any attorneys' fees and other costs that are reasonably required to incur to enforce this agreement . . . and I agree that they will have the right to obtain an injunction or similar equitable relief to affect such enforcement." As he read this, even the mild-mannered Rick Anderson began to bristle. "Has anybody come here and signed this?" he asked the guard. "No," he replied. Here Nejma was waging another legal war, this time to retain rights in respect to a property her husband had actually sold twenty-five years earlier.

* * *

Beard's presence both at Hog Ranch and at Thunderbolt Ranch may already be a fading memory but months after his death people were still speaking of him in the present tense, as if he were still alive. Even the much-maligned Peter Tunney said he still does Google searches for the name Peter Beard from time to time because "I miss him, and I don't like it that we don't

have him anymore." The various former lovers—Maureen Gallagher, Rikke Mortensen, Carrie Gammon, Marella Oppenheim, Natalie White—all expressed similar sentiments. Maureen said that "from the first touch—hand in hand—everything stopped. It was like being on drugs. It was as if we had known endless shared secrets. I miss him all the time."

More prosaically, there is the ongoing debate about Beard's artistic legacy. As with every other aspect of his life, this is complicated. The art dealer Philippe Garner said that as much as he admired Beard as a significant artist, "What I found troubling is not so much that he was prolific but sometimes you had the sense that he was lazy . . . and that he would let out lesser work to pay bills. That was frustrating to observe. He should have been more disciplined about what he released, and he'd have been richer for it. But could anyone have had that conversation with him? I don't think so. How much is out there? Not enough to satisfy what I imagine will continue to be the demand." The problem may, however, be the art market in the wake of the COVID-19 pandemic. Denise Bethel, former chairman of Sotheby's photography department, who remembers "selling for good money ($156,000) the *Night Feeder* in 2006," considers Beard "a mixed media artist. I've been a fan since I bought *The End of the Game,* so for me he will stand the test of time. But things go in waves, and everyone is trying to figure out what's going to happen now so many of the auctions are virtual. Live auctions, with their cocktail parties etc. will continue for the bigger auctions—big painting sales that bring in $100 million—but the smaller categories, photographs, and prints, they're doing well enough as virtual entities. But I don't know how you appreciate a great Peter Beard artwork virtually."

After Peter died, one of the people Nejma phoned to discuss his art legacy was Michael Hoppen, the London gallerist who had played a significant part in making his name in London. She had presumed Hoppen had sold a great deal of work to museums and was clearly disappointed when he told her he had not sold a single piece. "Nejma assumed that every museum would be running around trying to get hold of his work. But we never found that to be the case. I told her that the museums did not seem

to be interested in Peter's work," Hoppen said. "Of course, he should be in museums. But when he was alive Peter wasn't interested—he didn't regard that as confirmation of his talent."

It is also argued that Beard will be remembered most for his extraordinary diaries, those bulging, voluptuous collections that chronicled his wild, raucous life in the most lurid and vivacious form. Owen Edwards, certainly one of Beard's most astute observers in the 1970s, best described the diaries as "a combination of adolescent daydreaming, fiendish detritus, cosmic dandruff, frantic tangible psychotherapy."[8] There could be thirty, forty, or fifty—nobody is quite sure—in existence and all in the care of Nejma, and how she chooses to share them will probably determine her errant husband's artistic legacy. She has yet to declare her intentions.

Nejma's first commercial move after Beard died was to set about organizing a Beard-Bacon exhibit with London gallerist and friend Pilar Ordovas. In the spring of 2021, the so-called *Wild Life* exhibition at the Ordovas Gallery in Savile Row opened amid the constraints and cautions of the COVID-19 pandemic that had discouraged social mingling for more than a year in London. It was, therefore, the antithesis of a Beard gallery opening in his heyday. These were the boisterous social occasions of the 1990s and 2000s when Beard himself would be the central attraction at his openings, invariably sprawled across the gallery floor hand-working his photographic art pieces while surrounded by phalanxes of women. Nevertheless, however subdued, this exhibition was still an important opening statement from Nejma, associating Beard with the most important figurative artist since Picasso and emphasizing the intellectual and artistic bonds the two men shared. Some of the critics and gallerists, however, expressed disappointment. As one gallerist said, "Peter himself would have ripped that show up, turned it upside down, and started again." Beard's great exhibitions in the 1990s throbbed with excitement, reflecting a more optimistic time, whereas this show may be regarded as Beard appropriately conjoined with his fellow dark, artistic pessimist fellow traveler Francis Bacon. This age of COVID is a somber manifestation of the forebodings both men shared. As Beard told the journalist Edward Behr: "I think we are, as Bacon suggested, living a

meaningless life between birth and death. We don't know what consciousness is, we don't know what reality is, we don't know what time is. We are ants on an ant hill."[9]

Added to Beard's gloomy outlook on the future of Homo sapiens was his personal waywardness. He operated on a different plane of social irresponsibility from most people, and to the end remained an unpredictable and, in many ways, unknowable figure. Throughout his life he bore no fiscal accountability and thus depended on the likes of Monty Ruben, Rajni Desai, and John Heminway—three loyal acquaintances whose largesse was never repaid in money or kind—to pay wages, rates, and miscellaneous overheads at Hog Ranch throughout the thirty-odd years he owned it. People adored him, constantly seeking him out, and yet many said that he had no friends. There is no better example of that dichotomy than back in the late 1960s during his bleak five months in New York's Payne Whitney Psychiatric Clinic, after attempting suicide. His one constant companion, Alistair Graham, said there were no other visitors: "I was the only person who took any interest in him. He had no other friends."

Strange as it may appear that someone who was constantly surrounded by admirers, male and female, was actually friendless, it was an observation many of those close to Beard have made over the years. What they meant was that he did not appear to form conventional relationships with people. He would woo a woman with the driven vigor of an infatuated teenager and then repeat the same scenario with another the very next night. What was remarkable about these love affairs was the jilted lovers invariably seemed to forgive him and retain a fondness and loyalty to him that would last a lifetime. Equally, he would engage male companions and business partners with a similar ardor, a passionate immediacy, but then discard them quite carelessly, as he did with both Peter Riva and Peter Tunney. In this respect Peter Beard was quite clearly sociopathic. Peter Riva remembers that Beard "would come back from his night's carousing to our house or apartment, and he would fall asleep in the kids' beds in the daytime, keeping the bed warm until they came home from school, then he would go out and party more. And then, in the last years, he wouldn't even say hello to my kids

on the streets. He had a brutality and a meanness that was highlighted by the fact that he was never anybody's good friend. He was forever using people."

He was a Byronic figure with a mean streak that occasionally manifested itself in violence. But he was also a man who could display kindness, gentleness, and concern. He was capable of killing Richard Avedon's cat because it irritated him and yet on another occasion, he climbed inside a chimney in Montauk to rescue a trapped sparrow.[10] He could treat women with appalling cruelty and yet remains remembered by so many former lovers as tender and considerate, someone who enhanced their lives. These are inescapable truths and yet here was a man who was also a charismatic artist, driven by a passionate pursuit of an artistic expression that remains thrilling in its dark intensity. As the art historian Drew Hammond observed: "The most important thing in Peter's life was art. It was certainly more important than money, more important even than nature." Peter Beard was most assuredly a twentieth-century force of nature and those who knew him will not forget. Whatever the commercial value of the art he left behind, and whether or not his work finally finds a place in the art museums of London, New York, Tokyo, Los Angeles, and Paris, the most important point about Peter Beard's art is that it is already out there. His pictures are everywhere. At the Paris Bar in Berlin, in the restaurants of Cassis, dominating the dining room at Cipriani Downtown in Manhattan, at La Stresa, the Italian restaurant off the Avenue Montaigne in Paris. It is as Peter Beard would have wanted it.

And as his art was driven by a furious intensity so was his passionate engagement with the matter of mankind and our relationship with nature. Beard was no prophet, nor was he an environmental scientist, nor even a dedicated wildlife conservationist. What he had was a visceral connection with the wilderness and its inhabitants. It is where he found his most intense emotional and intellectual connection. But his viewpoint was dark and pessimistic. Apocalyptic. Many of his friends said that he had died just as the pandemic he predicted was beginning to take hold across the world. He would have abhorred such deification but in an interview in

1996, soon after an elephant had almost killed him, he said: "Human beings are not going to stop. They don't know when to stop. The only thing that will stop them are all the diseases that everybody is spending all their money fighting. We're sucking the juices out of the earth to fight the diseases that nature wants us to have. Because we're too greedy and we've taken over too much." As always, Peter Beard had impeccable timing.

Epilogue

When he died in the spring of 2020, soon after his eighty-second birthday, Peter Beard left behind a web of mysteries, as he had done throughout his life. Although Dave Schleifer, the man who had found his body three weeks after Beard had disappeared, didn't find anything unusual in the manner of his death and the local East Hampton town police concurred, saying there was nothing suspicious about it, Beard's friends far and wide wondered aloud. How could his body go undetected by police dogs or by drones? How could a body be exposed to the wilds of Montauk for all this time without being attacked by animals? And how come the cause of his death has never been revealed, after his family chose not to release the results of the official autopsy? For many, the end for this enigmatic contrarian, who blazed through the second half of the twentieth century and lit up so many lives, was as it should have been. As his old Hog Ranch co-habitué Fiammetta Monicelli said, "Like an old elephant, he went off to die. In a [state] park. Perfect end."

My great disappointment was that Beard's daughter, Zara, persuaded close family members to avoid talking to me. She told them that I was a horrible person, a judgment based apparently on the opening sentence I had written in an appreciation of Beard that had appeared in *Air Mail,* Graydon Carter's digital magazine, in the first days after he'd gone missing. That sentence read: "When I first heard Peter Beard disappeared, I laughed out loud." I then went on to explain that I thought he had jumped the fence

and run off into Manhattan, as he was wont to do, and that "anyone who knows him well will tell you that even in his diminished state, in his 80s, his instinctive wildness, his reflex flirtation with recklessness, would have him do it again."

Zara clearly misunderstood my attempt to celebrate her father's untamed spirit, and yet it was that very quality that made him such a romantic, charismatic character to those of us who are more bound to conformity. And that is most of us.

In the summer of 2021, I traveled out to Montauk and had lunch at the Shagwong Tavern with four of Beard's local amigos—Paul Forsman, the former model; Tony Caramanico, former Thunderbolt Ranch resident and the so-called Surfing Mayor of Montauk; Noel Arikian, Beard's framer and friend from the 1970s; and Gregory de la Haba, the young artist whose creative career had been transformed by Beard's unflinching and yet generous appraisal of his work. These were not Beard's celebrity acquaintances who had posted their "loss" on social media and been interviewed by so many celebrity magazines to stake their personal claims in the Beard narrative. Rather they were the good, longtime friends who had embraced his eccentricities, foibles, and peccadilloes, and held him close anyway. "He would hit on your girlfriends," Tony said. "He hit on my girlfriend Joan. Remember that? It was ridiculous. He was the ultimate playboy." And they all laughed out loud. Everywhere I traveled while researching this book— Paris, Copenhagen, Cassis, Nairobi, Tsavo, Lamu, the Maasai Mara, New York, Montauk—I encountered similar expressions of genuine affection. Most people I spoke to said their lives had been improved by knowing Peter Beard. Yet at the same time this much-loved character was apparently capable of heartlessly abandoning old friends and colleagues without a second thought when, in the latter years, Nejma took against them, as she did more and more.

His place in history, however, will be determined not by his personal popularity, his nonstop drug ingestion, his serial womanizing, or his passionate defense of the wilderness but by his artistic legacy, and that part of his life remains the most difficult to accurately assess. This is particu-

larly ironic given that art was the core raison d'être of Beard's, but it is the nature of the business that makes success, recognition, and a place in art history so elusive. If the assessment of Beard's friend, the art historian Drew Hammond, is correct then he should be placed alongside such twentieth-century photographic artists as Jeff Wall, Andreas Gursky, Bernd and Hilla Becher, and Edward Steichen. However, as so many of his most supportive gallerists have pointed out, unlike the luminaries listed here, Beard never had his work hung in a reputable museum. Or any museum for that matter. Whether his widow, Nejma, who now has sole control of his artistic legacy, can change this remains to be seen. Her first initiative after his death—the 2021 Beard-Bacon exhibition in London—was met with a mixed reception, however it was generally agreed that the artistic relationship between the two deserved to be highlighted and could only benefit Beard's reputation. Beard's many admirers now await Nejma's next initiatives.

Acknowledgments

I am indebted to the innumerable witnesses to Peter Beard's life whom I met, interviewed, and befriended while writing this book. They were not only generous with their time and recollections but also became friends along the way. Beard would have approved.

First, my eternal thanks to my agent, Laura Yorke, whose patience and thoughtful guidance calmed me significantly through extended periods of overexcitement. She was also a generous hostess who gave me the run of her wonderful apartment on the Upper East Side. And our mutual friend Michael Shnayerson, who was partly responsible for this book being commissioned, has been a great friend and fellow traveler and, together with his wife, Gayfryd, has also dispensed hospitality and good conversation liberally in New York. Also in New York, many thanks to Charles Spicer and Sarah Grill at St. Martin's Press, who steered this manuscript through with great fortitude. And as a bonus the peerless, ageless Peter Duchin recalled his long association with Peter Beard with waspish wit, no pun intended.

Among the most significant collaborators in pulling this story together were two of the Three Peters—Riva and Tunney. Of course, Beard was the third leg of this pot and between them they ruled the roost between 1982 and 2002. Both Riva the agent and Tunney the gallerist provided vivid descriptions, observations, and extensive documentation about their

client's halcyon days and in whose company Beard produced his most important work.

Peter Beard's female companions over the decades shared information, letters, documents, and their personal stories, thus trusting me to place each of them accurately and compassionately in the narrative. I have no doubt that I shall find out if I succeeded. It was a pleasure spending time with Cheryl Tiegs, just chewing the fat and raking over the time when she and Beard were the Beautiful Americans. She also trusted me with her archive of letters, which told a profound story. So too Rikke Mortensen, Beard's lover, constant companion, and dear friend two decades later. Being a centered, sensible Dane, she provided crucial insights into Beard's strong Danish links, from Karen Blixen's time through to the Rikke years and beyond. Blixen's grandnephew Morten Keller was also a very helpful witness. Together in Copenhagen they led me through the world of Karen Blixen, the emotional and intellectual springboard for Beard's Africa adventure.

A collection of gallerists and fine-art experts helped me understand photographic art and Peter Beard's place therein. Principal among these are Michael Hoppen, David Fahey, Philippe Garner, and Drew Hammond. The mysteries of the fine-art market are somewhat baffling to outsiders such as this author and these experts showed patience walking me through the maze. So too Annalyn Swan, who coauthored the magisterial biography *Francis Bacon: Revelations,* and who explained Bacon and his relationship with Beard with great clarity.

My wife Adriaane Pielou's research into the Beard dynasty has given this book historic ballast. She is a fine journalist and has contributed enormously to this book.

In New York, my old colleague, friend, and researcher supreme Joyce Pendola shared the ride with her usual good humor. We worked hard but our dinners with Diana La Guardia kept this rusty machine appropriately oiled. Equally convivial, and informative, were the ongoing engagements with Elizabeth Fekkai and Natalie White, who generously provided insights into Beard's later years. Mark Greenberg, a key Beard collaborator,

was equally liberal with his time and expertise. Also in New York, Maureen Gallagher, the object of probably Beard's most remembered photograph, *Night Feeder,* was a candid witness. And above all there was my bighearted Montauk road trips companion, the artist Gregory de la Haba, a Peter Beard acolyte who reveled in digging around the Beard artistic legacy. He and his beautiful wife, Teresa, who conveniently own McSorley's Old Ale House in Manhattan, have been entertaining companions and loyal friends. In Montauk, Noel Arikian and Dave Schleifer assisted frequently. Upstate, Beard family friend and biographer, Jon Bowermaster, helped explain Peter's turbulent relationships with the East African conservationists.

In Kenya, Gillies Turle and Fiammetta Monicelli were great company in Lamu and, as significantly, were the perfect witnesses about the Hog Ranch years. Fiammetta's charming *Hog's Tales: Camp Life in Africa* was an added treat. Two old Beard Nairobi family friends, Anna Trzebinski and Mandy Rubin, walked me through their beloved Peter Beard's early years in Africa. In Tsavo, the sons of Bill Woodley, Bongo and Danny, brought the Starvo story up to date. My perennial traveling companion Nick Van Gruisen shared a memorable Kenya trip in the middle of COVID constraints, and during my research contributed relevant observations, based on his forty years of experience in Africa.

There are many others who asked to remain unidentified as they feared retribution from the sole proprietor of Peter Beard's estate. I raise my glass to them and thank them for their anonymous assistance.

Selected Bibliography

Beard, Anson M. Jr. *A Life in Full Sail*, edited by Patricia Beard. TidePool Press, 2012.

Beard, Peter. *The End of the Game*. Chronicle Books, 1988.

Beard, Peter. *Fifty Years of Portraits*. Arena Editions, 1999.

Beard, Peter. *Longing for Darkness, Kamante's Tales from Out of Africa*. Harcourt Brace Jovanovich, 1978.

Beard, Peter. *Stress & Density*, curated by Peter T. Tunney. KunstHausWien, 1999.

Beard, Peter. *Zara's Tales: Perilous Escapades in Equatorial Africa*. Alfred A. Knopf, 2004.

Blixen, Karen. *Out of Africa*. Penguin Books, 1937.

Blixen, Karen. *Shadows on the Grass*. Random House, 1961.

Bonn, Guillaume. *Peter Beard: Scrapbooks from Africa and Beyond*. Empire Editions, 2006.

Bowermaster, Jon. *The Adventures and Misadventures of Peter Beard in Africa*. Bulfinch Press, 1993.

Bull, Bartle. *Safari: A Chronicle of Adventure*. Viking Press, 1972.

Colacello, Bob. *Holy Terror: Andy Warhol Close Up*. Vintage Books, 1990.

Gefter, Philip. *What Becomes a Legend Most: A Biography of Richard Avedon*. Harper-Collins, 2020.

Graham, Alistair. *The Gardeners of Eden*. George Allen & Unwin, 1973.

Graham, Alistair. *Eyelids of Morning: Mingled Destinies of Crocodiles and Men*, photographed by Peter Beard. A&W Visual Library, 1973.

Haden-Guest, Anthony. *The Last Party*. William Morrow & Co., 1997.

Hanley, Gerald. *Warriors and Strangers*. Hamish Hamilton, 1971.

Hartley, Aidan. *The Zanzibar Chest: A Memoir of Love and War*. HarperCollins, 2003.

Malone, Michael P. *James J. Hill: Empire Builder of the Northwest*. Oklahoma Western Biographies, 1996.

Martin, Albro. *James J. Hill and the Opening of the Northwest.* Oxford University Press, 1976.

Matthiessen, Peter. *The Tree Where Man Was Born.* William Collins Sons, 1972.

Monicelli, Fiammetta. *Hog's Tales: Camp Life in Africa.* Jacaranda Designs, 2003.

Owen-Smith, Garth. *An Arid Eden: A Personal Account of Conservation in Kaokoveld.* Jonathan Ball, 2010.

Parker, Ian, and Mohamed Amin. *Ivory Crisis.* Chatto & Windus, 1983.

Peppiatt, Michael. *Francis Bacon: Anatomy of an Enigma.* Weidenfeld & Nicolson, 1996.

Radziwill, Lee. *Lee.* Assouline Publishing, 2013.

Ruben, Hilary. *African Harvest.* Harvill Press, 1972.

Shriver, Lionel. *Game Control: A Novel.* HarperCollins, 2003.

Stevens, Mark, and Annalyn Swan. *Francis Bacon Revelations.* William Collins, 2021.

Taraborrelli, J. Randy. *Jackie, Janet & Lee: The Secret Lives of Janet Auchincloss and Her Daughters Jacqueline Kennedy Onassis and Lee Radziwill.* St. Martin's Press, 2018.

Taylor, Stephen. *The Mighty Nimrod: A Life of Frederick Courteney Selous.* William Collins, 1989.

Thurman, Judith. *Isak Dinesen: The Life of a Storyteller.* St. Martin's Press, 1985.

Turle, Gillies. *The Art of the Maasai.* Alfred A. Knopf, 1992.

Ward, John. *The Animals Are Innocent.* Headlines Book Publishing, 1991.

Warhol, Andy. *The Andy Warhol Diaries*, edited by Pat Hackett. Warner Books, 1989.

Wheeler, Sara. *Too Close to the Sun: The Audacious Life and Times of Denys Finch Hatton.* Random House, 2006.

Notes

1. Montauk 2020—When the Lions Stopped Roaring

1. Author interview with Dave Schleifer, August 2, 2020.
2. Warhol on the Stones in Montauk, *Andy Warhol's Exposures*, Grosset & Dunlap, 1979.
3. Author interview with Dave Schleifer, August 2, 2020.
4. Author interview with Anne-Laure Lyon, October 3, 2020.
5. Author interview with Noel Arikian, October 10, 2020.
6. Author interview with Dave Schleifer, August 2, 2020.
7. Author interview with Anna Tzrebinski, February 24, 2021.
8. Author interview with Philippe Garner, September 25, 2020.
9. *Charlie Rose*, PBS, November 30, 1993.
10. *Andy Warhol Diaries*, edited by Pat Hackett, 543.
11. *A Study of Peter Beard*, documentary film by Lars Bruun.
12. Author interview with Nell Campbell.
13. "The Collector," Doon Arbus, *Rolling Stone*, November 16, 1978.
14. Author interview with Jon Bowermaster.

2. Dynasty

1. *Brooklyn by Name*, Leonard Benardo and Jennifer Weiss, 58.
2. *James J. Hill: Empire Builder of the Northwest*, Michael P. Malone, 7.
3. *Erie Basin—A History of Its Early Years*, RedHookWaterStories.org/William Beard.
4. *Forgotten New York: View of a Lost Metropolis*, Kevin Walsh.
5. "The 7 Hottest New York Fashion Week Venues," Vogue.com, September 16, 2016.
6. "Blue Collar Section of Brooklyn Reopens Old Port to Cruise Business," Associated Press, EastBayTimes.com, April 15, 2006. Beard Street, RedHookWaterStories.org/William Beard.
7. Ibid.
8. *James J. Hill: Empire Builder*, Michael P. Malone, 165.
9. *James J. Hill & The Opening of the Northwest*, Albro Martin, 113, 189.

10. Ibid., 526.
11. Ibid., 614.
12. *James J. Hill: Empire Builder*, Michael P. Malone, xi.
13. *A Life in Full Sail*, Anson M. Beard Jr., 21.
14. Ibid., 64.
15. Author interview with Tony Hoyt, August 27, 2020.
16. Author interview with Patricia Beard, October 19, 2020.
17. Author interview with Peter Duchin, April 6, 2021.
18. *A Life in Full Sail*, Anson M. Beard Jr., 21.
19. Interview with Sam Beard by Ken Mammarella, *News Journal*, https://www.delawareonline.com/story/news/2015/11/25/sam-beard-blazes-path-community-improvement/76055096/.
20. Author interview with Rikke Mortensen, August 29, 2020.
21. Author interview with Peter Duchin, April 6, 2021.
22. Author interview with Peter Tunney, May 12, 2020, "We found a folded piece of paper from 1949 in the boxes in the basement of TTIAN. It was dated 1949."

3. Into Africa

1. *Out of Africa*, Karen Blixen.
2. *Isak Dinesen: The Life of a Storyteller*, Judith Thurman.
3. Author interview with Anthony Hoyt, August 27, 2020.
4. Letter from Ken Tinley to Peter Beard, January 19, 1990.
5. Author interview with Ivory Serra, October 18, 2020.
6. Author interview with Danny Woodley, February 19, 2021.
7. *The End of the Game*, Peter Beard.
8. Ibid.
9. *Too Close to the Sun—The Audacious Life and Times of Denys Finch Hatton*, Sarah Wheeler.
10. Ibid.

4. Beginning of the End of the Game

1. *New York Times*, December 17, 1963.
2. *The End of the Game*, Peter Beard, 44.
3. Author interview with Rikke Mortensen, August 29, 2020.
4. Author interview with Morten Keller, August 31, 2020.
5. Letter from Karen Blixen to Peter Beard, August 14, 1961.
6. *Out of Africa*, Karen Blixen, 300.
7. *The End of the Game*, Peter Beard, 20.
8. Ibid., 91.
9. *The Man-Eaters of Tsavo and Other East African Adventures*, J. H. Patterson.
10. *The End of the Game*, Peter Beard, 206.
11. *The Adventures and Misadventures of Peter Beard in Africa*, Jon Bowermaster, 50.
12. *The End of the Game*, Peter Beard, 226.
13. Ibid., 20.
14. Author interview with Gillies Turle, February 22, 2021.
15. *The End of the Game*, Peter Beard, 222.

5. Conservation Wars

1. *The Adventures and Misadventures of Peter Beard in Africa*, Jon Bowermaster, 63.
2. *The Gardeners of Eden*, Alistair Graham, 198.
3. Notes from Alistair Graham.
4. Draft paper "Laws in Africa," Ian Parker.
5. *Eyelids of Morning: The Mingled Destinies of Crocodiles and Men*, Alistair Graham and Peter Beard, 11.
6. Author interview with Resource Africa's Julian Sturgeon.
7. Interview with Edward Behr from *Peter Beard Scrapbooks from Africa and Beyond* by Guillaume Bonn, 81–82.
8. *The Adventures and Misadventures of Peter Beard in Africa*, Jon Bowermaster, 57.
9. Ibid., 53.
10. Notes from Alistair Graham.
11. *A Study of Peter Beard*, film directed by Lars Bruun.
12. *The Adventures and Misadventures of Peter Beard in Africa*, Jon Bowermaster, 92.
13. Notes from Alistair Graham.
14. "Extreme Wildlife Declines and Concurrent Increase in Wildlife Numbers in Kenya: What Are the Causes?" Joseph O. Ogutu et al., University of Hohenheim, Stuttgart, Germany, 2007.
15. Dick Laws's letter to the editor, *Swara* magazine, October 31, 1978.

6. Salon in the Bush

1. Author interview with Minnie Cushing, April 27, 2021.
2. *The Adventures and Misadventures of Peter Beard in Africa*, Jon Bowermaster, 67.
3. *Hog's Tales: Camp Life in Africa*, Fiammetta Monicelli, 104.
4. "The Collector," Doon Arbus, *Rolling Stone*, November 16, 1978.
5. Author interview with Minnie Cushing, April 27, 2021.
6. Ibid.
7. *Holy Terror: Andy Warhol Up Close*, Bob Colacello.
8. Author email interviews with Alistair Graham.
9. "The Collector," Doon Arbus, *Rolling Stone*, November 16, 1978.
10. Ibid.
11. Email interview with Alistair Graham.
12. *The Adventures and Misadventures of Peter Beard in Africa*, Jon Bowermaster, 112.
13. Author interview with Gillies Turle, February 22, 2021.
14. *African Harvest*, Hilary Ruben, 48.
15. Ibid., 49.
16. Author interview with Mandy Ruben, August 17, 2020.
17. Court document signed by James M. Hall, US Consul in the Mexican State of Chihuahua, May 8, 1970.

7. Let's Spend the Night Together—Those Montauk Summers

1. *Holy Terror: Andy Warhol Up Close*, Bob Colacello, 72.
2. *Saturday Review* article by Terry Southern, August 12, 1972.

3. *The Adventures and Misadventures of Peter Beard in Africa*, Jon Bowermaster, 130.
4. *Holy Terror: Andy Warhol Up Close*, Bob Colacello, 167.
5. *Francis Bacon Revelations*, Mark Stevens and Annalyn Swan, 555.
6. Article by Owen Edwards, *Village Voice*, December 1975.
7. *Holy Terror: Andy Warhol Up Close*, Bob Colacello, 241.
8. Barbara Allen obituary, *London Times*, August 15, 2020.
9. Author interview with Mirella Ricciardi, July 7, 2020.
10. *Out of Africa*, Karen Blixen, 63.
11. Iman interview transcript with Kathy Eldon, 1985.
12. Ibid.
13. *What Becomes a Legend Most: A Biography of Richard Avedon*, Philip Gefter, 10.
14. *Holy Terror: Andy Warhol Up Close*, Bob Colacello, 340.
15. Article by Owen Edwards, *Village Voice*, December 1975.
16. "Is Photography Art," *Interview*, Issue 75, November 1975.
17. Peter Beard Paper, ICP Lecture Series, February 5 and 8, 1976.
18. Author interview with Ron Cayen, December 2, 2020.
19. "The Collector," Doon Arbus, *Rolling Stone*, November 16, 1978.
20. Author interview with Ron Cayen, December 2, 2020.

8. The Beautiful Americans

1. Author interview with Cheryl Tiegs, August 1, 2021.
2. *New York* magazine article by Alexander Cockburn, May 3, 1976.
3. Author interview with Calvin Cottar, March 2, 2021.
4. Letter from Bill Woodley to Cheryl Tiegs, July 1978.
5. Letter from Cheryl Tiegs to Peter Beard, October 30, 1978.
6. "Stan Dragoti's Ordeal," *People*, July 30, 1979.
7. Author interview with Cheryl Tiegs, January 8, 2021.
8. Author interview with Peter Riva, January 26, 2021.
9. Author interview with Tony Caramanico, June 5, 2021.
10. Ibid.
11. Author interview with Cheryl Tiegs, January 8, 2021.
12. Author interview with Tony Caramanico, June 5, 2021.
13. Author interview with Cheryl Tiegs, July 29, 2021.
14. Author interview with Pat Beard, March 29, 2021.
15. "Great White Photographer," Donald Katz, *Outside*, Aug/Sept 1982.

9. Out of Out of Africa

1. Author interview with Gillies Turle, February 23, 2021.
2. Author interview with Fiammetta Monicelli, February 23, 2021.
3. Ibid.
4. Letter from Peter Beard to Cheryl Tiegs, December 1983.
5. Ibid.
6. Author interview with Tony Caramanico, June 5, 2021.
7. Author interview with Mark Greenberg, August 26, 2020.

8. Author interview with Carrie Gammon, June 8, 2021.
9. Author interview with Marella Oppenheim, August 19, 2020.
10. Author interview with Jay McInerney, September 3, 2020.
11. Author interview with Morten Keller, August 30, 2020.
12. Thomas Dinesen archive notes.
13. Ibid.
14. Ibid.
15. Letter from Clara Svendson, Peter Riva archive.
16. Email exchange with Alistair Graham, August 2, 2020.
17. *New York Times* article by Alan Cowell, September 13, 1981. Also, author interview with Alan Cowell.
18. Author interview with Peter Riva, July 30, 2020.
19. *Kenya Times* article June 12, 1985. And documents.
20. "The Wild Life of Peter Beard," Kent Black, *M Magazine*, January 1987.
21. *Isak Dinesen*, Judith Thurman, 273.
22. Six million will do very nicely . . . Note written by Francis Kimani.
23. Author interview with Janice Dickinson, July 15, 2020.
24. Ibid.
25. Described in *Hog's Tales* by Fiammetta Monicelli, privately published book.
26. Author interview with Antony Rufus-Isaacs, December 16, 2020.
27. Author interview with Gillies Turle, February 22, 2021.
28. Author interview with Mirella Ricciardi, July 7, 2020.
29. Author interview with Drew Hammond, February 2, 2021.

10. Of Man and Nature

1. *The Adventures and Misadventures of Peter Beard in Africa*, Jon Bowermaster, 54.
2. Author interview with Peter Riva, December 7, 2020.
3. US District Court Summons, Peter Riva Productions, August 30 and November 1, 1988; Peter Beard transcript conversation with Terry Mathews, February 13, 1987.
4. Author interview with Danny Woodley, February 19, 2021.
5. Author interview with Calvin Cottar, March 2, 2021.
6. *The Adventures and Misadventures of Peter Beard in Africa*, Jon Bowermaster, 59; *Zara's Tales*, Peter Beard, 64.
7. Author interview with Mark Greenberg, August 26, 2020.
8. Ibid.
9. Ibid.
10. Author interview with Maureen Gallagher, October 7, 2020.
11. Author email interview with Dr. Margaret Jacobsohn, May 26, 2020.
12. Peter Beard article in *Rolling Stone*, December 13, 1990.

11. The World of Moi

1. Author interview with Gillies Turle, February 23, 2021.
2. *Charlie Rose*, PBS, November 30, 1993.
3. Author interview with Rikke Mortensen, August 29, 2020.

4. Author's own notes and writings on Julie Ward trial—February/March 1992.
5. Ibid.
6. Ibid.
7. "Police Reinvestigate Julie Ward Murder in Kenya," *The Guardian*, April 13, 2010. https://www.theguardian.com/uk/2010/apr/13/police-reinvestigate-julie-ward-murder#:~:text=A%20team%20from%20the%20Metropolitan,the%20Masai%20Mara%20game%20reserve.
8. Author interview with Gillies Turle, February 22, 2021.
9. Author interview with Richard Leakey, October 1998.
10. Book review by Donna Klumpp Pido, *African Arts*, April 1994.
11. Research paper by Sheena Gidoomal and Samuel Lotiti, September 1991.
12. Author interview with Gillies Turle, February 22, 2021.
13. "African Dreamer," Leslie Bennetts, *Vanity Fair*, November 1996.

12. The Time Was Always Now

1. Author interview with Peter Tunney, May 12, 2020.
2. Author interview with David Fahey, January 27, 2021.
3. Ibid.
4. Author interview with Peter Tunney, May 12, 2020.
5. Francis Bacon interview on UK television's *South Bank Show with Melvyn Bragg*, 1985.
6. Author interview with Rikke Mortensen, May 13, 2020.
7. Author interview with Peter Riva, January 26, 2021.
8. Ibid.
9. *Charlie Rose*, PBS, November 30, 1993.
10. Author interview with Rikke Mortensen, August 29, 2020.
11. Author interview with Rikke Mortensen, May 13, 2020.
12. Peter Beard letter to Nejma dated April 20, 1994, dateline Tokyo.
13. Letter from New York State Department of Social Services, May 19, 1994.
14. Letter from Peter Riva to Leonard Spielberg, January 19, 1996.
15. Letter from Drew Hammond To Whom It May Concern, March 1996.
16. Letter from Peter Beard to his brother Anson, January 22, 1994.
17. Letter from Peter Beard to Judith Grandes, March 23, 1996.

13. Elephant Memories

1. Author interview with Peter Tunney, May 12, 2020.
2. Author interview with Andy Moses, January 10, 2021.
3. Author interview with Alex Beard, June 25, 2020.
4. Author interview with Peter Riva, December 7, 2020.
5. Author interview with Rikke Mortensen, August 29, 2020.
6. Author interview with Peter Tunney, January 11, 2021.
7. Author interview with Calvin Cottar, March 3, 2021.
8. *Peter Beard: Scrapbooks from Africa and Beyond*, film by Jean-Claude Luyat and Guillaume Bonn.
9. Author interview with Guillaume Bonn, June 1, 2020.

10. Author interview with Rikke Mortensen, August 29, 2020.
11. Author interview with Peter Tunney, May 12, 2020.
12. Author interview with Dominic Cunningham-Reid, June 24, 2021.

14. Enter the Governess

1. Author interview with Dr. Andrew Feldman, March 27, 2021.
2. "African Dreamer," Leslie Bennetts, *Vanity Fair*, November 1996.
3. *Picasso: Creator and Destroyer*, Arianna Stassinopoulos Huffington (New York: Simon & Schuster), June 1988.
4. Ibid.
5. "The Battle For Picasso's Multi-Billion-Dollar Empire," Milton Esterow, *Vanity Fair*, March 2016.
6. Author interview with Peter Tunney, January 11, 2021.
7. Author interview with Peter Riva, December 7, 2020.
8. Author interview with Peter Tunney, January 11, 2021.
9. Author interview with Ralph Bousfield, May 26, 2020.
10. Author interview with Peter Tunney, June 2, 2021.
11. *A Study of Peter Beard*, film by Lars Bruun.

15. The Artist as Exhibitionist

1. Author interview with Denise Bethel, March 31, 2021.
2. Author interview with Philippe Garner, September 25, 2020.
3. Article in 1855 issue of *The Crayon*.
4. Britannica article "Photography as Art."
5. Author interview with Drew Hammond, February 2, 2021.
6. Author interview with Denise Bethel, March 31, 2021.
7. Article by Michael Prodger, *The Guardian*, October 19, 2012.
8. Author interview with Michael Hoppen, November 4, 2020.
9. Author interview with Brian Stewart, July 1, 2020.
10. Ibid.
11. *Charlie Rose*, PBS, November 30, 1993.
12. Author interview with Richard Leakey, October 1998.
13. "The Secret Life of Peter Beard," article on Maasai artifacts by Susan Zakin, *Journal of the Plague Year*.
14. Author interview with Gillies Turle, February 21–23, 2021.
15. Ibid.

16. On Sleeping Eyelids Laid

1. *Fifty Years of Portraits*, Peter Beard.
2. *Stress & Density*, Peter Beard, September 1999.
3. Author interview with Peter Riva, July 31, 2021.
4. Fleming, Zulack & Williamson letter from Dean Nicyper to Michael Stout, March 24, 2000.
5. Author interview with Peter Tunney, May 30, 2021.
6. Author interview with Peter Tunney, June 2, 2021.

7. Author interview with Gregory de la Haba, October 10, 2020.
8. *A Study of Peter Beard*, a documentary directed by Lars Bruun.
9. Author interview with Peter Tunney, January 11, 2021.
10. Author interview with Rikke Mortensen, August 29, 2020.
11. Author interview with Natalie White, October 8, 2020.

17. Stress and Density—Surviving the 2000s

1. Author interview with Peter Tunney, May 12, 2020.
2. Author interview with David Fahey, June 1, 2021.
3. Author interview with Rikke Mortensen, August 28, 2020.
4. Author interview with Julian Ozanne, May 15, 2020.
5. Author interview with Elizabeth Fekkai, October 8, 2020.
6. Author interview with Natalie White, October 8, 2020.
7. Letter from Nejma Amin to Gillies Turle, February 21, 1986.
8. Letter/note from Gillies Turle to Peter Beard.
9. Author interview with Rianne ten Haken, September 24, 2020.
10. Author interview with Elizabeth Fekkai, October 18, 2020.
11. Reproduction of Peter Beard artwork.
12. Author interview with Natalie White, October 8, 2020.
13. Author interview with Rikke Mortensen, May 13, 2020.
14. Author interview with Elizabeth Fekkai, October 18, 2020.
15. Letter from Peter Beard to Elizabeth Fekkai, dateline Cassis, April 16, 2011.

18. Who Shot Natalie White?

1. Gillies Turle's unpublished memoir, *Lonely in the Clouds*.
2. Ibid.
3. Author interview with Rick Anderson, AFEW chairman, February 5, 2021.
4. *New York Post*, Page Six, March 19, 2009.
5. Author interview with Gary Lippman, August 27, 2020.
6. *New York Post*, April 17, 2013.
7. Legal agreement dated November 14, 2013 between Peter Beard and Natalie White LLC.
8. Author interviews with Bernie Chase, October 18, 2020 and May 13, 2021.
9. Author interview with Eva Bastianon, January 30, 2021.
10. Author interview with Elizabeth Fekkai, October 19, 2020, and email correspondence with Elizabeth Fekkai, May 14, 2021.
11. Email correspondence with Elizabeth Fekkai and Natalie White and separate note from Natalie White.
12. Zara Sophia Beard affidavit US District Court in Beard v Natalie White, filed October 14, 2014.
13. Email correspondence with Peter Duchin, May 12, 2021.
14. Zara Sophia Beard affidavit US District Court, filed October 14, 2014.
15. Zara Sophia Beard affidavit US District Court in Beard v Natalie White, filed October 14, 2014.
16. Author interview with Maureen Gallagher, May 8, 2020.
17. Author interview with Aidan Hartley, July 24, 2020.

19. Sorry About All the Bullshit, Man

1. US District Court, Southern District of New York, Peter Beard, Nejma Beard & Peter Beard Studio LLC against Natalie White LLC. Complaint filed September 30, 2014.
2. Beard v Chase published by NY State Law Reporting Bureau, June 21, 2018.
3. Ibid.
4. Bernie Chase deposition, Supreme Court of the State of New York, April 6, 2016.
5. Ibid.
6. Author interview with Mirella Ricciardi, June 17, 2020.
7. Artnet News, article by Eileen Kinsella, February 3, 2017.
8. *New York Post*, Page Six, May 14, 2016.
9. *New York Observer* article by Guelda Voien, June 30, 2016.
10. Emails from Susan Zakin, July 4, 2021.

20. The Prisoner of Thunderbolt Ranch

1. Peter Beard interview with Michael Shnayerson, 2017.
2. Author interview with Davina Dobie, June 22, 2021.
3. Author interview with Cheryl Tiegs, January 8, 2021.
4. "African Dreamer," Leslie Bennetts, *Vanity Fair*, November 1996.
5. Ibid.
6. Author interview with Peter Tunney, January 11, 2021.
7. *Peter Beard: Scrapbooks from Africa and Beyond*, film by Jean-Claude Luyat and Guillaume Bonn.
8. "Peter Beard: The Toast of Society Photographers," Owen Edwards, *Village Voice*, December 29, 1975.
9. *Peter Beard: Scrapbooks from Africa and Beyond*, film by Jean-Claude Luyat and Guillaume Bonn.
10. Author interview with Dave Schleifer, October 10, 2020.

Index